Getting Your Shot

ERIC PETERSON — WOODLAND HILLS, CALIFORNIA

Getting Your Shot

STUNNING PHOTOS, HOW-TO TIPS, AND ENDLESS INSPIRATION FROM THE PROS

NATIONAL GEOGRAPHIC

WASHINGTON, D.C.

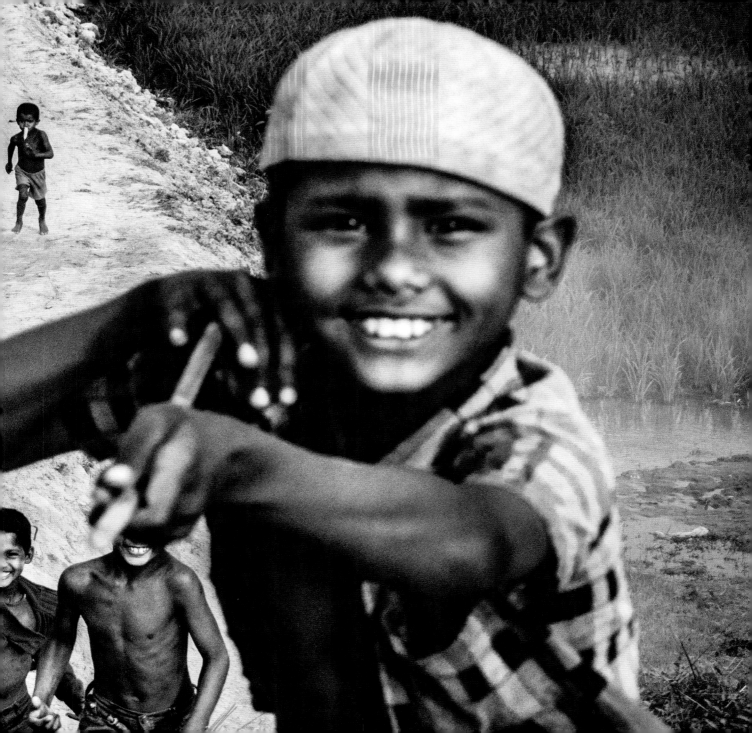

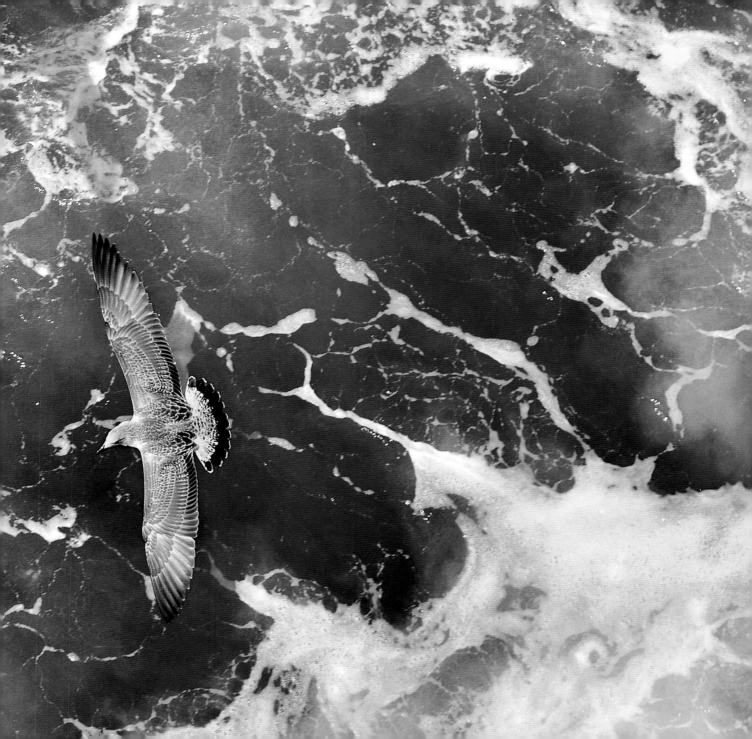

Contents

Introduction

Many of us can trace our passions to a childhood experience, a second or a fleeting encounter woven into daily life, that seemed unremarkable at the time. A favorite teacher introduced you to a foreign idea, or a relative shared the story behind a treasured object, and curiosity was planted. This vividly recollected moment may have inspired you to become a traveler, a nature buff, a great cook . . . or a student of photography.

As a junior high school student, I discovered photo books in the school library. Heavy as doorstops, they leaned against the art books in a slim section that included *The Photographer's Eye* by John Szarkowski and *The Bitter Years,* monographs by Walker Evans and Dorothea Lange—the Farm Security Administration photographs. These FSA photographers were storytellers, documentarians of the Great Depression. I saw photographs of people who had been forced from their homes and people facing uncertain futures. I distinctly remember a feeling of awe that their personalities seemed to emerge from the page. I was a hatchling, imprinted for life by the power of the photographic image.

There is something magical about photography. For me, photography began as a place to hide—behind the camera, under the dark cloth, in the darkroom. But then it became a portal into the world. Through work as a newspaper photographer, on assignment for *LIFE* magazine and *Sports Illustrated,* and during the past 25 years shooting for *National Geographic*, I have logged countless miles to Zambia, Cambodia, Antarctica, and beyond. Today, the *National Geographic* magazines that carry my byline could fit in a knapsack—the same knapsack I am still filling with cameras to step back out through that door.

But the images on those magazine pages are just the highlights of voyages that stretched for years and, in the end, humbled me. I spent months in a remote village in China, where I mined photographs from everyday experience—like the image of a young Dong girl, wearing her favorite hair ribbons as she walked through the family rice field (right). What you don't see is me trudging miles to find the scene and then waiting days for the moment and the perfect light to come together. Mud up to our knees. You can't see the interpreter repeating every conversation three and four times so that we could understand every detail. You don't see the fact that this girl had just visited her coffin tree, planted at her birth to provide the wood she will be buried in.

It is difficult to teach someone how to choose the critical moment to save as a photograph. It has been

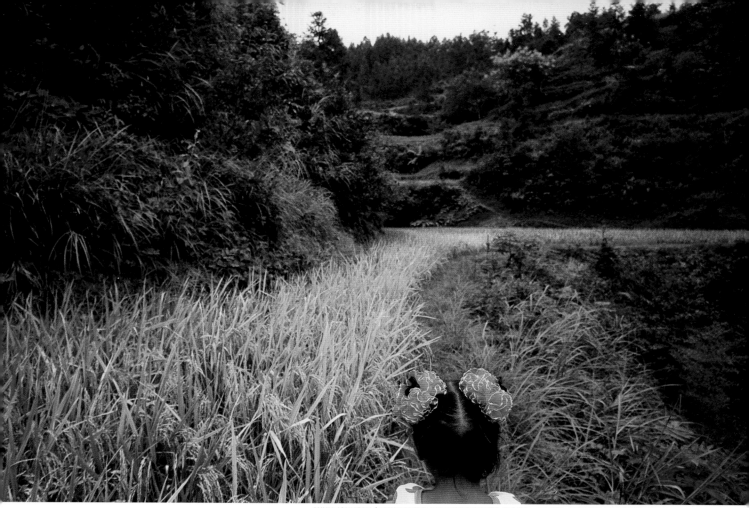

LYNN JOHNSON / A YOUNG GIRL WANDERS IN RICE FIELDS — DIMEN, GUIZHOU PROVINCE, CHINA

a challenge as well as a pleasure to share the magic of photography with students at the National Geographic Photo Camp in Botswana, in Kenya, and in the United States, and to mentor master's students at Syracuse University's S.I. Newhouse School of Public Communications. Each budding photographer is a visual storyteller who can open a door into a culture, an environment, or his or her own psyche. My role is to help them all sharpen their skills and aspire to excellence.

Being a judge for National Geographic's Your Shot felt like an extension of teaching. Your Shot is a global community in which the kind of learning and sharing I usually do with my students in person

takes place online. The field assignments and the gorgeous photos in this book represent some of the best content posted to this vibrant online community. *Getting Your Shot* pairs beautiful and powerful photos with new critiques and tips from National Geographic photography experts. I hope this combination will serve as both a learning tool and an inspiration to everyone who reads this book.

Your Shot began in 2006 as a way for aspiring photographers to get published on the pages of *National Geographic* magazine. After a dozen years in existence, Your Shot has almost a half million members from 196 countries.

Every month, a National Geographic photographer or editor posts an assignment that sends members out in the field to shoot photos based on a particular theme. Members then post their images on the Your Shot website and receive expert feedback and commentary from the National Geographic expert who is hosting the assignment.

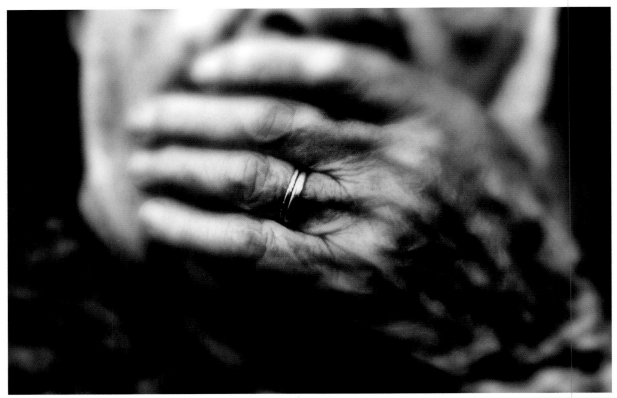

KONSTADINOS XENOS

I was asked to participate in the month of February, and the topic was love. Photo editor Elizabeth Krist, photographer Maggie Steber, and I were to judge the entries and choose our favorites.

It was two o'clock in the morning when I went to the pull-down menu on National Geographic Online and clicked Your Shot. My screen filled with images, studded with heart symbols and thumbnail portraits of Sai, Kristi, Hasan, Nikola. They were from India, South Carolina, Ukraine, Malaysia. A photo of a mountain in bland light. A shot of a favorite cat. This was love?

The pictures couldn't have been more different from my own. My assignments deal with subjects like life-threatening diseases, vanishing languages, and women challenged by rural poverty. This grid of cute puppies and sweethearts featured pastel colors, wandering framing, and a heavy dose of cuteness.

How, I asked myself, can I teach thousands of people with varied levels of expertise in photography about f-stops and lens choices? I decided to bypass technique and go straight to the heart: Together we dove into truth, frame design, emotional depth, and power. And I discovered that these photographers wanted not just to be seen, but also to be heard. As they shared their stories on the website, their intentions became clearer and the quality of their photographs improved. A standout photo appears at left.

This worldwide community can serve as an inspiration for photographers of all skill and experience levels. It doesn't really matter how expensive your camera is—DSLR or smartphone—or whether you call yourself a pro, a hobbyist, or a beginner. We are all driven and competitive. We are addicted to looking through that minuscule window to witness the wide world—addicted to the rush in the body, to the privilege of documenting a moment, to the sense of purpose that lifts us above the everyday.

As photographers, we can challenge biases with our deeply individual styles, diverse insights, and hard work. The most lasting exchange is not the recording of the image but the bond that develops from listening and sharing stories—right there in the living room, field, hut, truck. That is the story to honor. The image carries the power of the message within the beauty of form.

In those early-morning hours in my dark house, it was confirmed that what is important about photography is passion and love. The tiny strangers on my computer screen inspired my passion for growing, for changing, for thinking, for seeing, and for creating a community of seers who can show others how they see the world.

Never stop asking yourself:

Why do I photograph?

What am I trying to say?

All the rules presented in this book are valuable—composition, quality of light, the rule of thirds. Study them. Practice them. Then break them.

Through this book, we hope you will be inspired to make the world your own, on your terms, in your very own shots.

– LYNN JOHNSON, *National Geographic* Photographer

About This Book

Just as National Geographic photographers go on assignment to capture amazing images, *Getting Your Shot* sends you out on assignment—and provides the ideas and know-how to get you started. Beginning with the fundamentals of photography in "The Tool Kit," the book then moves into 17 themed photography assignments, each hosted by a National Geographic photography expert.

The stunning photos and exciting assignments in this book have been cherry-picked from Your Shot— National Geographic's vibrant online photo community, with almost a half million members around the world.

Your Shot is so visually breathtaking and inspiring that we decided to turn it into a book. We've added expanded commentary and hundreds of how-to tips from 22 National Geographic experts. Now it's time to take *your* shot!

 THE TOOL KIT

The first section of the book introduces you to the basics of photography. It covers everything from what kind of camera and equipment you should use to basic information about composition, lighting, focus, and more.

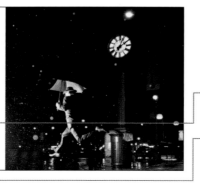

THE ASSIGNMENTS

A National Geographic editor or photographer introduces each assignment, encouraging readers to shoot images based on a fun and challenging theme. Assignments are appropriate for photographers of all skill levels.

 Assignment Description

 About the Expert

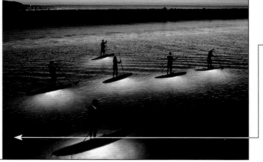

THE PHOTOGRAPHS

Our editors and photographers have selected Your Shot photos that successfully represent the theme of the assignment. These experts tell you what's great about the photos and why they were included. Some pages pair photos with how-to photography tips; others include the photographer's story behind the picture.

———— How-To Tips

———— Why This Photo Works

———— The Photographer's Story

THE PHOTOGRAPHER'S NOTEBOOK

Want to know more about the photos in this book? Here you'll find information about each image—including all available technical information, such as the camera model, focal length, shutter speed, and aperture.

You will also find a helpful glossary of photography terms on pp. 278–279.

The Tool Kit

Basic Skills for Getting Your Best Shot

GETTING STARTED

Whether you are using a camera to document rare birds, to capture your family's beach vacation, or to shoot the architecture of a beautiful building, photography is a powerful medium. It allows you to tell stories, to make memories, and to meet new communities.

To get the most out of your photos, you'll need a full set of tools, and that means more than lenses and memory cards. An understanding of the fundamentals of photography—from the basic structure of a camera to the strategies for telling a visual story—will provide you with a tool kit that you can draw upon every time you pick up your camera.

In this section you'll find information about different types of cameras and lenses, along with helpful tips on composition, technique, photo editing, and more. The goal is for you to become so familiar with your camera that you use it like you breathe. With practice, the camera becomes an extension of you rather than an obstacle.

So get out there and find subjects that capture your attention, no matter where they are—in your backyard, in the next town over, or on the other side of the world. Let your passion and unique point of view be your inspiration.

THE ANATOMY OF A DIGITAL CAMERA

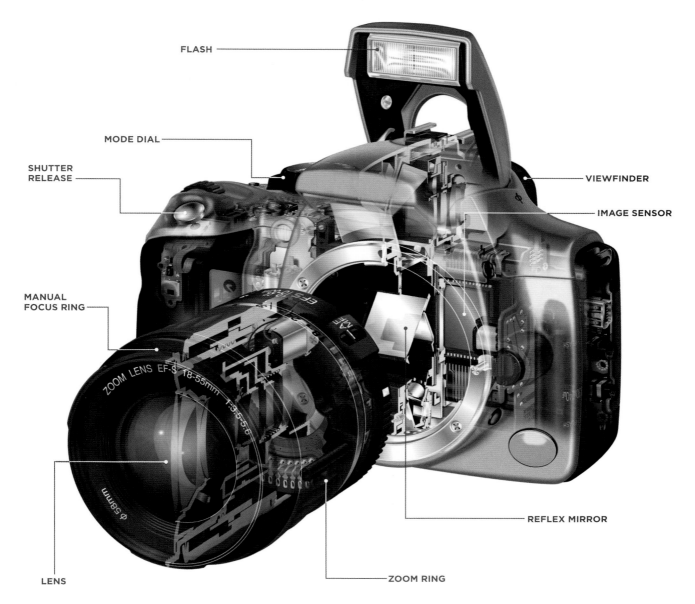

FLASH

MODE DIAL

SHUTTER
RELEASE

VIEWFINDER

IMAGE SENSOR

MANUAL
FOCUS RING

ZOOM LENS EF-S 18-55mm 1:3.5-5.6

Φ 58mm

REFLEX MIRROR

LENS

ZOOM RING

Camera Basics

With so many different cameras on the market, choosing the right one for you can be overwhelming. To narrow down your options, think about what kind of photographer you are or aspire to be. Do you want to take great pictures of your family and friends? Capture amazing wildlife scenes? Show off your latest vacation? This overview highlights the pros and cons of basic categories of digital cameras.

Most point-and-shoot cameras have two downsides. One, they give you minimal manual control over your camera's settings. Two, they tend to have lower image quality than higher-end cameras, even though they may have a high megapixel count.

These days, the camera feature in many smartphones is comparable to a point-and-shoot camera in terms of image quality. Smartphone cameras have fewer customization options and very limited zoom capabilities, but they can be useful for taking pictures on the go.

POINT-AND-SHOOT

These small, lightweight cameras are inexpensive and perfect for everyday use. You can take quick snapshots or carry them around in a backpack or purse for everyday use. They are easy to use and inexpensive. Most point-and-shoot cameras have different modes that automatically set the camera to detect faces, fast-moving objects, close-up subjects, and more. Depending on what model of camera you use, modes range from traditional scenes (such as Portrait, Landscape, and Macro—for close-ups), to even more specialized modes (such as Party, Snow, Beach, Sports, and Kids), and more.

ADVANCED COMPACT

Also relatively lightweight and inexpensive, advanced-compact cameras offer more control and higher image quality than point-and-shoot cameras do. Automatic mode is still an option, but you have the flexibility to change more of your camera's settings, including flash, shutter speed, aperture, and ISO (which refers to how receptive your camera's sensor is to light).

Many of the specialty modes on point-and-shoots also are featured on advanced compacts, so you can preset your camera for shooting a basketball game or capturing a relaxing afternoon at the beach.

The built-in zoom capability of some compact cameras is comparable to that of a much heavier and more expensive telephoto lens for a DSLR camera. And the more powerful zoom means you don't have to tote around different lenses to capture a variety of images; for example, you could shift from shooting a wide forest landscape to taking a close-up of a ladybug without changing lenses.

● DSLR

A digital single-lens reflex camera (DSLR) is the standard for professional photographers. Its image quality is much higher than that of compact cameras, and it allows as much or as little control over your photo as you like. The large sensors in DSLR cameras are better at capturing light than those of point-and-shoot or compact cameras, which means you'll end up with fewer grainy photos. They are also better at shooting in low light than other camera types.

It takes some time to get to know your DSLR camera. Try testing out different settings, such as exposure, shutter speed, and aperture, to see how they affect the final picture. While automatic mode can come in handy, learning how to control your camera manually will help you get your best shots. Once you get comfortable, you can shoot everything from professional-looking family portraits to extreme weather events.

The speed and quality of a DSLR help you capture details that other cameras would not be able to pick up. And with an endless array of lenses, flashes, and other accessories, you can put your camera to work in hundreds of different ways.

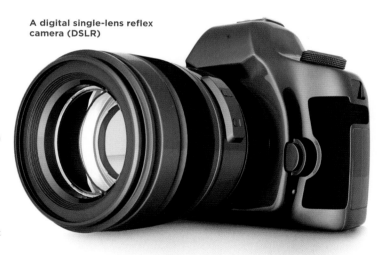

A digital single-lens reflex camera (DSLR)

CAMERA COMPARISONS: WHICH IS THE BEST CAMERA FOR YOU?				
TYPE	**PRICE**	**RESOLUTION**	**SIZE**	**WEIGHT**
Point-and-Shoot	$80–$300	10-16 megapixels	width: 3–5 inches; height: 2–3 inches	4–10 ounces
Advanced Compact	$150–$1,000	10-18 megapixels	width: 3–5 inches; height: 2–4 inches	0.5–2 pounds
DSLR	$350–$6,500	12-24 megapixels	width: 5–6 inches; height: 4–6 inches	1–3 pounds + additional weight of lens(es)

Choose the Correct Lens

>> Whether you want to shoot a tennis match or take a close-up of a butterfly, you will need the right lens for the job. The primary differentiators among lenses are focal length (the distance at which the lens begins to focus) and field of view (the area that is visible in the frame). This cheat sheet introduces you to the different kinds of lenses so that you can pick the one that best suits your needs.

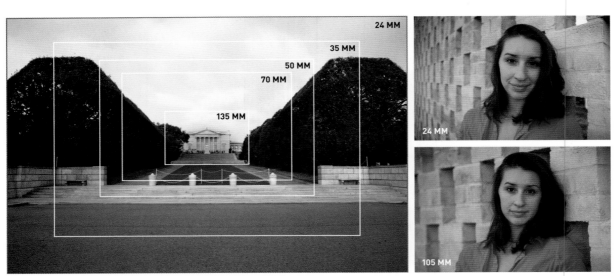

PATRICK BAGLEY — WASHINGTON, D.C.

• FIXED

A fixed lens, also known as a prime lens, has a fixed focal length—35mm and 50mm are typical. Because they have no zoom capability, these lenses are straightforward to use, and they offer high image quality for a lower cost. A 35mm focal length is considered normal because it mimics what the human eye sees. Fixed lenses are useful for shooting portraits because they have wider maximum aperture and tend to produce higher-quality images than zoom lenses do.

• ZOOM

A zoom lens can be adjusted to a range of focal lengths. Most DSLRs come bundled with a "kit zoom" that shoots at a range somewhere between 18mm and 200mm. Zoom lenses are bigger and heavier than fixed lenses are, and they tend to be

more expensive. They are convenient for travel, however, because one zoom lens can take the place of a bagful of different lenses.

TELEPHOTO

One of the largest, heaviest, and most expensive options, a telephoto lens is a powerful magnifier. You can capture distant subjects as if they were in front of you. Ideal for shooting sporting events or wildlife, this lens makes it look like you were right in the middle of the action. With the help of a tripod, a long exposure time, and clear skies, a telephoto lens can even capture shots of the moon, the Milky Way, and other celestial objects.

MACRO

This lens allows you to achieve clear focus when you are very close to your subject. It magnifies the smallest subjects, such as insects, blades of grass, and intricate patterns and textures. You can get macro effects with other lenses, but a dedicated macro lens allows for the sharpest images of tiny subjects. Macro lenses come in a range of magnification levels, from 1x (life-size) to 5x, that allow you to shoot everything from a butterfly to the colorful scales on its wings.

WIDE-ANGLE

To capture an angle wider than the eye can see, such as the angle required for a landscape or several sides of a room, you will need a wide-angle lens. These lenses come in many sizes, but their distinguishing factor is a wider field of view than a normal lens. Some image distortion will occur—lines that appear straight to your eye will look curved through the lens—but this can create an interesting, artistic perspective. Wide-angle lenses range in price from $200 to $2,000.

Fish-eye lenses are wide-angle lenses taken to the extreme. They capture the widest angle of view, causing a more dramatic curve, as if you are looking through a peephole.

LENS ACCESSORIES

Special accessories like filters and lens hoods can enhance or alter the light entering your camera's lens. Filters cover the lens and come in many different varieties. Polarizing filters eliminate glare and reflection from reflective surfaces like windows and water, while gel filters add a layer of color over your scene.

A lens hood, fitted over the front end of your lens, blocks light and helps eliminate glare and lens flare—it's useful for bright conditions like midday sun on a light background.

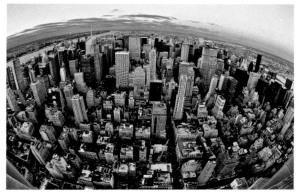

MOSHE DEMRI — NEW YORK, NEW YORK

Time to Gear Up

>> Let's face it, everyone loves gear! But beyond its irresistible luster, the right gear can also help you achieve your photography goals. Gear can help steady your camera, light your scenes, keep your camera dry, and open up new photo opportunities. Your interests and budget will, of course, determine which gear is worth your investment.

• STABILIZERS

Sometimes a camera in hand just isn't enough to get the perfect shot. If you're working with a long exposure, even the slightest movement can make your photo blurry. When you need a little extra support and there's no flat surface nearby, these stabilization tools will help keep your camera steady:

TRIPODS are three-legged stands that attach to the bottom of your camera. They steady the camera to capture extra-sharp images or hold the camera still for long-exposure shots.

MINI TRIPODS are smaller for when you need to pack light. You can stand them up on a table, and some even have flexible legs that you can secure around uneven surfaces, such as branches or large rocks.

A **MONOPOD** is a pole that attaches to your camera for extra support but does not provide the total control of a tripod. A monopod can steady a long, heavy lens for sports photography or hold your camera still for a macro shot. You can even attach a "selfie stick" to your camera or smartphone when you want to take self-portraits.

• REMOTE SHUTTER RELEASE

This device syncs with your camera so you can trigger the shutter from a distance. This device allows you to take self-portraits without holding the camera at arm's length. For a long-exposure shot, a remote-release device gets rid of the slight movement of the camera's body caused by pushing the shutter button.

Cable-release triggers let you shoot from as far away as your cord can take you, while radio-remote

triggers are wireless and can work from up to 330 feet away.

UNDERWATER HOUSING

Specialized waterproof housing kits make it possible to take your camera underwater to shoot a scuba trip or to get a unique perspective on swim practice. Underwater housing comes in many varieties, from rugged polycarbonate cases designed for specific camera models to flexible covers that also work in snow, mud, rain, and sand. These housings are waterproof from 30 to 200 feet underwater. The deeper you want to go, the more expensive the gear will be.

Waterproof point-and-shoot and advanced-compact cameras can eliminate the need for underwater housing. They can withstand depths up to 49 feet. Some waterproof advanced compacts even have interchangeable lenses.

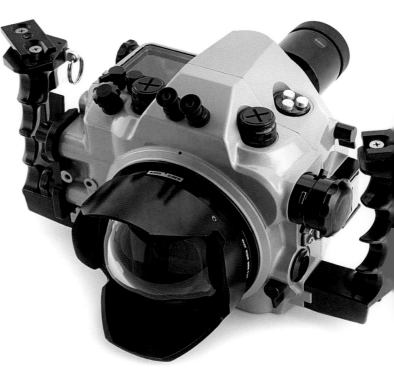

EXTERNAL LIGHTING

External flashes and additional lighting create a more customizable light source than a built-in flash. These lights can be synced with your camera to go off when the shutter is released, and they are often placed in bowl-shaped reflectors to evenly distribute the light toward a focal point. Special waterproof strobes are sealed tight so that they can illuminate murky underwater shots.

MEMORY CARDS

Most digital cameras store images with either a secure digital (SD) or compact flash (CF) memory card. Figure out which type of card you need, and stock up on cards with high storage capacity. SD cards are smaller and less expensive, but they take longer to save photo data. The larger CF cards can save your images more quickly and often at higher quality, but they are more expensive.

Compose Your Shot

>> A strong composition brings together multiple elements to tell a compelling visual story. Making that magic happen involves skill, instinct, and luck. And you have to be willing to take *a lot* of not-so-great shots first. The following basic rules of composition are the foundation of good photography, but sometimes the best shots break all the rules. So above all else, trust your gut.

● FRAMING THE STORY

Just as you frame art for your walls, you can frame a subject within a photo by shooting through an opening such as a doorway, a window, or a cave entrance. Framing can add depth to a photo and draw attention to one particular element. The frame you choose for your subject provides context to the scene and adds a layer to the story that it tells.

To keep the attention on your subject and off the frame itself, it's best to set the frame off from your subject in some way—for instance, keep the frame

out of focus, or avoid showing the full expanse of the framing object. For example, the stairwell in this photo (below) creates a barrier on the left side, guiding the viewer's eye into the frame.

The edges of the photo are also important framing tools. Decide where you want your image to begin and end. Identify what you want to include, and keep extraneous elements out of frame or out of focus to guide the viewer's eye.

● LEADING WITH LINES

Leading lines are linear elements that draw the viewer's eye to a certain point and add a sense of depth and direction to your photo. While the camera sees in only two dimensions, a leading line can create the illusion of a third dimension—imagine a fence or a road getting smaller in the distance. In addition to adding visual interest, these lines have the power to draw your viewer into the world of the photograph.

Diagonal lines that cut across the frame add drama to a photo. Vertical lines—such as tree trunks in a redwood forest—can convey height and grandeur, and horizontal lines—common in landscape photography—often create a sense of comfort and calm. Once

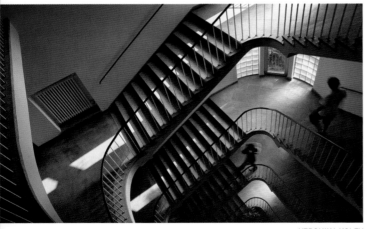

VERONIKA KOLEV

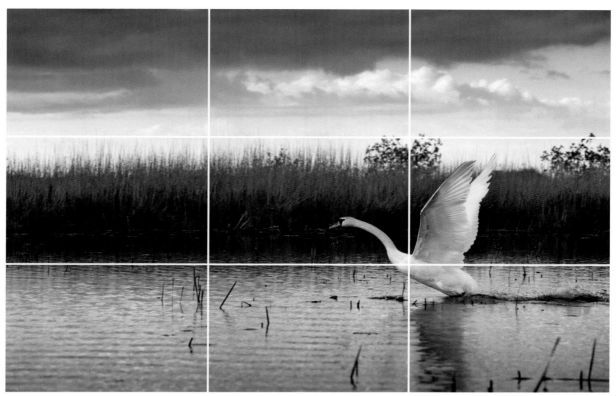

GASTON LACOMBE — PELČI, RUCAVAS NOVADS, LATVIA

you start looking for lines, you'll see them everywhere: birds flying in formation, a twisting mountain path, or the distant horizon.

● THE RULE OF THIRDS

All good photos start with a focal point: the place that the viewer's eye travels to first. While the center of the frame seems like the natural focal point, it isn't always the most interesting position for your subject. Many photographers follow a simple guideline called the rule of thirds. Imagine that your photo is split into thirds, both vertically

and horizontally. These grid lines divide your photo into nine parts. Placing your subject at the intersection of two grid lines helps guide the viewer's eye away from the center of the photograph. Many digital cameras have an option to place this grid on your viewfinder.

Balancing the main focal point with elements along the other grid lines often creates an image that tells a rich story. In this photo of a swan (above), the bird prepares to take flight against a backdrop of rain clouds. Even in a still image, you can imagine the bird continuing up and out of the frame, away from the coming storm.

Get Focused

>> Picture yourself standing in the field on the opposite page, looking at a beautiful old barn in the distance. Whether you want to zoom in on a single detail of the barn's architecture or take in the whole scene, you'll need to make decisions about your photo's aperture, depth of field, focus, and how these elements work together to craft a complete photograph.

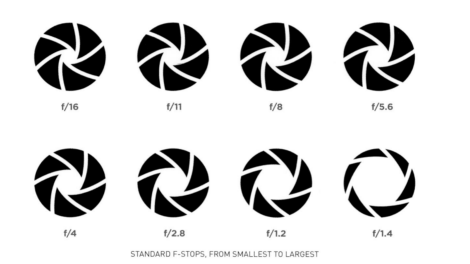

| f/16 | f/11 | f/8 | f/5.6 |

| f/4 | f/2.8 | f/1.2 | f/1.4 |

STANDARD F-STOPS, FROM SMALLEST TO LARGEST

• APERTURE

The aperture is the size of the opening in the camera lens. Like the iris of your eye, the wider the opening, the more light can reach the camera's sensor. Aperture is denoted in f-stops (see diagram above). F-stop numbers reflect the ratio of focal length to the size of the lens opening. It may seem counterintuitive, but the largest number refers to the smallest aperture, and the smallest number refers to the largest aperture.

Light conditions often govern which f-stop is optimal. In situations where the human eye might see just fine—for example, sitting around a campfire—a camera can have difficulty picking up on available light. A wide aperture, or opening—such as f/1.4—will let your camera collect as much light as possible in order to capture the scene.

When you have plenty of available light, a small aperture (such as f/16) works well for capturing

precise details, while a wide aperture allows you to capture the whole scene in sharp focus.

DEPTH OF FIELD

The depth of field (DOF) is a creative tool that allows you to emphasize important elements of the frame. DOF refers to the part of an image that appears in focus, as opposed to the part that is blurred. In images with shallow DOF, such as portraits and macro photographs, a small area of the photo is in sharp focus, while the rest fades into a blur. This blur, which is the camera's rendering of out-of-focus points of light, is called *bokeh*. A deep DOF allows the entire frame to be in sharp focus; it comes in handy for wide landscapes or busy scenes.

DOF is determined by the size of the aperture, the focal length of the lens, and the distance between you and your subject. As a general rule, a larger aperture or longer focal length creates a shallow DOF, while a smaller aperture or shorter focal length creates a deep DOF.

FOCAL POINT

The place that the viewer's eye travels to first is called the focal point. By controlling your photo's depth of field, you dictate which elements are in focus and where your focal point is. Think about how the focal point can contribute to the story you want to tell.

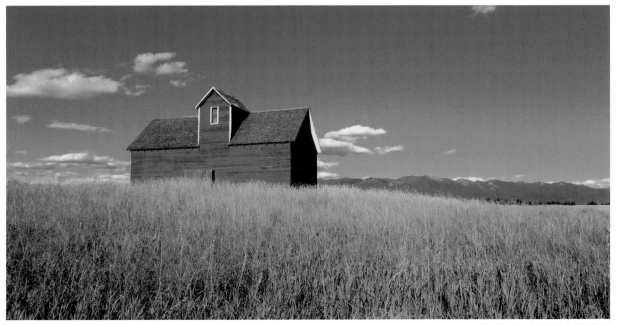

GLENN BARCLAY — PARKDALE, MONTANA

What's Your Point of View?

>> There are plenty of standard ways to shoot standard scenes, but identifying and curating your own point of view will make for more interesting and personal photos. A change from the norm can create a fun, unexpected take on a scene. Don't be afraid to look silly—stand on a chair, lie on the ground, stand in the waves, and take some risks to create a perspective that's all your own.

• SHOOTING AT EYE LEVEL

Shooting at your eye level and using the "normal" focal length, 35mm, allow you to show exactly how the world looks to you at a given moment in time. Try focusing on whatever elements catch your eye in a particular scene.

You can also show the world from someone else's eye level, thus creating a point of view that's totally different from your own. When shooting children or animals, try getting down at the subjects' level to capture a scene through their eyes. You may find inspiration by lying or kneeling on the ground and noticing what details you see for the first time.

Creating a unique and interesting viewpoint from your eye level (or someone else's) means thinking critically about how you will show the subject. Can you capture movement by using a slower shutter speed? What elements other than your subject are present? Can they act as frames or layers that create a more dynamic photograph?

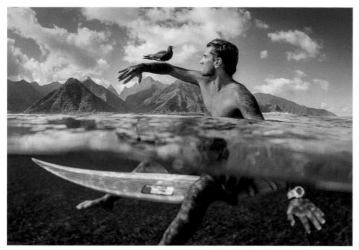

LEONARDO NEVES — TEAHUPOO, TAHITI

• THE VIEW FROM BELOW

Looking up enhances the sense of scale in an image. Try capturing a skyscraper's dizzying height from the sidewalk below. Experiment by pointing your camera straight up while you lie on the ground. Capture the path of a plane as it flies overhead, or see how light from a chandelier transforms the ceiling above it.

For context, try including other recognizable objects in the frame. You can convey just how massive a glacier is if you show how it dwarfs a hiker climbing to the top.

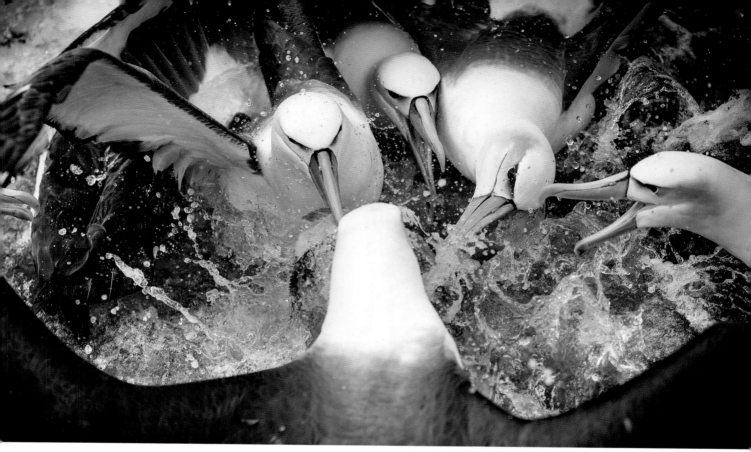

MARK BRIDGWATER — STEWART ISLAND, NEW ZEALAND

If you have a wide-angle lens, try looking from the ground up in a wooded area: Treetops will point up and away and form a curved frame for the sky above.

Getting low can also mean taking a dip. A partially submerged camera shows the line between land and sea, which can be an interesting angle in pictures of marine animals in their natural habitat or surfers paddling out to catch a wave (opposite page).

● SHOOTING FROM ON HIGH

You don't have to go skydiving or mountain climbing to get an interesting shot while looking down—though these activities do help. Whether you are peering out an airplane window at an ant-size city or standing on a chair to snap a photo of your dinner table, the view from above has the power to transform a scene. This overhead view of birds squabbling over a fresh catch (above) turns an everyday scene into an artistic, abstract image. Looking straight down can also transform your subject, so it looks almost two dimensional, like a drawing on paper. A unique angle can show what others might be unable to see.

See Beauty in Details

>> Envision the blue-green waters of the Caribbean against the white grains of sand on a beach; a yellow umbrella on a rainy, gray day; or the brilliant gold and red leaves of autumn. The colors, textures, and patterns in scenes like these make for beautiful photographs. Here are some tips for how to emphasize the most striking details in your scene.

• COLOR PALETTES

Color guides our emotional response to a photo. For example, blues and purples are cool and calm, while yellow is often associated with happiness. Different shades of the same color can change the emotion it conveys: Bright red conveys energy, love, and excitement, while dark reds are more often connected with anger or war. A lush green scene is peaceful and often reminds people of nature, while yellow-green is sometimes associated with illness.

Black and white can add a vintage feeling, or it can make the focus on your subject stronger by removing the element of color. Shadows and shapes are emphasized more in black and white, so pay attention to how they affect the composition of your photo when shooting.

The range of prominent colors in your photo is known as the color palette. How they all fit together helps guide the story your photo tells. A photo that captures a row of brightly colored houses (below, left) conveys an entirely different feeling from the muted white and tan of salt fields (below, right). By paying attention to the palettes that define your images, you will build your personal style as a photographer.

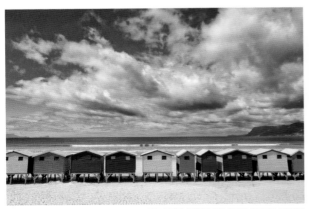

PJ VAN SCHALKWYK — MUIZENBERG, WESTERN CAPE, SOUTH AFRICA

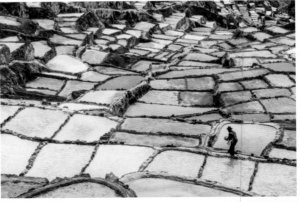

CEDRIC FAVERO — PICHINGOTO, CUSCO, PERU

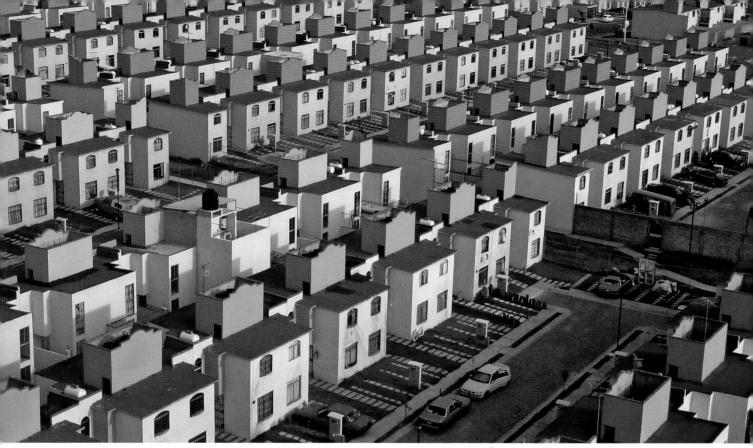

PATTERNS

The human brain is wired to seek out symmetry and patterns. We notice whorls and ridges of a fingerprint; stark lines of tree trunks in winter; or rows of identical, brightly colored suburban houses (above). When you turn everyday experiences into abstract patterns, you use the photographer's power to make a unique statement.

Pattern-breaking elements are also common in good photos. Any contrasting object (in size, color, shape, or texture) draws the focus to itself. By interrupting your viewer's expectations, you can tell a richer story. An old house sandwiched between two skyscrapers or a puppy in a row of stuffed animals would add surprise and whimsy.

TEXTURE

Capturing the texture of your subject or the backdrop against which it has been placed can create a tactile sensation in your photograph. When you show the roughness of a brick wall or the tickle of grass beneath your subject's feet, you transport the viewer into the world of the photograph.

Find the Right Exposure

>> Exposure results from a combination of settings that ultimately determine how much light reaches your camera's sensor for a particular photograph. Getting the right exposure depends on being aware of the light available, your desired effect, and a lot of repeat shots. Whether you're shooting the stars at night or a soccer game at noon, knowing how to expose a scene will lead to better photos.

• ISO

In digital photography, ISO refers to your camera's sensitivity to light, or how receptive its sensor is to the light source. To set the right ISO, assess the available light in your scene. There is a wide range of ISO settings, but here are some common options:

LOW/SLOW ISO (100) works best for sunny outdoor scenes.

MID-LEVEL ISO (400, 800) is ideal for shooting on cloudy days or taking indoor shots.

HIGH/FAST ISO (1600) maximizes light in a dim setting, whether you are snapping a photo of your favorite singer at a concert or watching the birthday girl blow out the candles on her cake.

Many digital cameras can automatically detect the light level and adjust the ISO for you, but manual adjustment allows you to get exactly the effect you are looking for.

• SHUTTER SPEED

Shutter speed determines how long your camera's shutter stays open during a shot, thus controlling the amount of light that reaches the sensor. The best shutter speed for a picture depends on what you are trying to capture. When shooting still objects, your shutter speed should be determined by the available light. In a dim scene, you will want a slow shutter speed to capture as much light as possible—and a tripod or steady surface to keep your camera stable while the shutter is open. Night photography requires a much longer opening period for your camera to

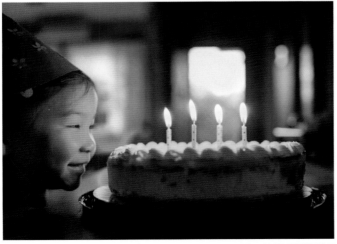

DAVID TAO / A HIGH ISO HELPS CAPTURE THE GLOW OF BIRTHDAY CANDLES — QUEANBEYAN, NEW SOUTH WALES, AUSTRALIA

sense the light coming from the moon and the stars (see next page).

For action scenes, such as a speeding motorcycle or a sports game, a fast shutter speed paired with a good flash can freeze the action in place. Shooting movement with a slower shutter speed creates a blurring effect. When done correctly, it can enhance movement and showcase the speed of your subject. It is also particularly effective when shooting a waterfall or a rushing river.

Speed is denoted in seconds or fractions of a second:

- **Slow shutter speeds: 1/4, 1/8, 1/15, 1/30, or multiple seconds**
- **Average shutter speeds: 1/60, 1/125, 1/250**
- **Fast shutter speeds: 1/1000, 1/2000, 1/5000**

● LONG EXPOSURE

Long-exposure photography refers to using a *very* slow shutter speed—multiple seconds, or even minutes or hours—to capture faraway light or the movement of a light source over time. When shooting the night sky, your camera often requires up to an hour to take in all the light from a source that your eye can see immediately.

Other effects, such as capturing the flow of traffic or "painting" with light (when someone moves a light source, often a flashlight, to draw or write something) require that your shutter stays open for as long as the light source is moving. For these shots it's important to be prepared with a tripod or other steady surface to prevent your camera from moving while the shutter is open. Take along lots of patience as well.

LARRY BEARD / FAST SHUTTER SPEED CAPTURES A CRASHING WAVE — NEWPORT BEACH, CALIFORNIA

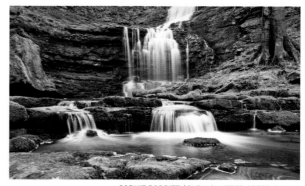

SOPHIE PORRITT / SLOW SHUTTER SPEED SHOWS FALLING WATER — AIRTON, ENGLAND, U.K.

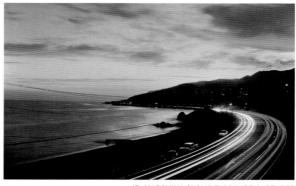

JR. MARQUINA / LONG EXPOSURE CAPTURES TRAFFIC MOVING — MALIBU, CALIFORNIA

Play With the Light

>> Light is what makes photography possible. Different qualities and colors of light can add depth and complexity to your photos. Try experimenting with light in a range of settings and at different times of day. You'll be amazed at the beautiful images you can take of a campfire, a cloudy day, or sunlight streaming through a kitchen window.

• THE QUALITY OF LIGHT

Hard lighting comes from a single light source: a lightbulb, a camera flash, or the sun. This bright, direct light has an easily identifiable direction and casts the scene into harsh contrast (below, left). Shadows are clearly defined. Shooting against hard light, like the midday sun, can produce strong silhouettes, but beware of lens flare—light that bounces around your lens before reaching the sensor, thus causing streaks of light in your photo.

Soft light, on the other hand, lacks direction and instead fills the scene with a dull glow. It produces a more subtle color palette. Soft light often results from cloud, fog, smoke, or some other diffusing agent (below, right). It creates a tranquil, sometimes mysterious effect. Take advantage of the reduced contrast

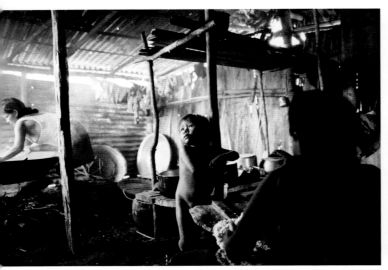

EMILIANO CAPOZOLI / A BEAM OF SUNLIGHT DRAWS THE VIEWER'S EYE TO THE BOY. — SÃO GABRIEL DA CACHOEIRA, AMAZONAS, BRAZIL

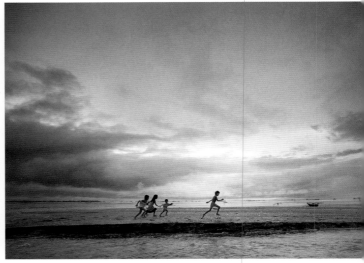

B. YEN / A CLOUDY DAY AT THE BEACH CREATES SOFT LIGHT — BACOLOD CITY, WESTERN VISAYAS, PHILIPPINES

to create a romantic, almost painterly effect in your photo. Soft lighting can create beautiful landscapes, but it's important to take your shot at several different levels of exposure to make sure you're capturing the details and the feeling that you want.

• NATURAL LIGHT

The color and temperature of light change throughout the day. At midday, natural light is relatively colorless. At dawn and dusk, it creates a golden hue that many photographers call the "magic hour" or the "golden hour." You may see the sky change from red to pink to orange, but the camera can't always read these subtle changes in color the way the human eye can. Your camera's digital sensor adjusts based on the temperature of the light that reaches it. The cool colors (purples, blues, and greens) have some of the highest temperatures, and the warm colors (reds, oranges, and yellows) have some of the lowest.

If the camera is set to auto color, it may neutralize the most beautiful and interesting colors in your scene. Knowing when to turn off automatic color settings is an important creative skill. Also try starting with a fast shutter speed, and then slow it down to see how your image changes.

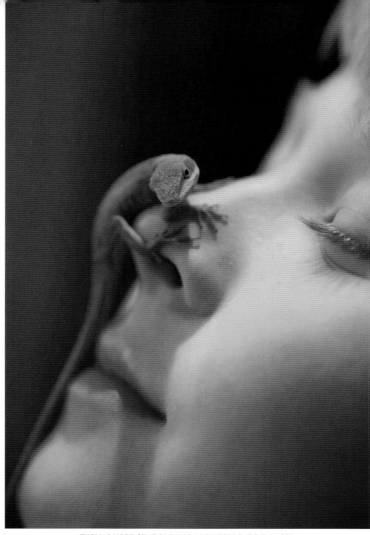

THOMAS NORD / THE GLOW OF A LIGHTBULB IS BALANCED SO IT FEELS WARM AND INVITING. — BIRMINGHAM, ALABAMA

• ARTIFICIAL LIGHT

The camera and the human eye read artificial light sources differently. This is another scenario in which your brain can "autocorrect" what your camera can't. Different light sources bring different tones to a photograph. Standard household lightbulbs emit low-temperature light that can give your photographs an orange-yellow tone. Fluorescent and halogen lights are hotter, but they still cast an off-color tone (toward the blue end of the spectrum) compared to sunlight. To counteract any undesirable tones in artificial lighting, try adding a colored filter or adjusting the exposure and the white balance.

Postproduction Pointers

For many photographers, a photo is only half done after the shutter closes. Photo-editing software has become an indispensable tool of the trade, making it possible to edit and refine digital photos. Here we introduce some of the most common file formats and editing tools, but the best way to learn is to experiment. Just be sure to save your original image before you start editing it.

• FILE FORMATS

The file format you use dictates how many photos you can fit on a memory card. A compressed file format, such as a JPEG, takes the best reading of your photo and saves it, leaving room for many more pictures. A raw file format saves unprocessed photos but takes two to three times more memory space than compressed files do.

Raw files can be worth the extra space because they retain information about your photo, including shutter speed, aperture settings, ISO, color temperature, file size, and more. In addition, working with the raw file allows you to make precise adjustments to the photo's colors, highlights, shadows, and other features.

Other file formats, such as PNG and TIFF, are best for specific purposes. TIFF is best for maintaining quality in printed photos, while PNG works well for posting photos to the Internet.

• PHOTO EDITING

Photoshop, iPhoto, and other photo-editing programs give you many tools to improve your digital images. The following common tools are just a few of the options at your fingertips:

CROP lets you adjust the frame to improve the composition.

ROTATION allows you to rotate your photo in small increments or to flip a photo upside down or sideways.

RED-EYE REMOVAL takes the red-eye out of your portraits. (Red-eye can happen when you use a flash in low-light settings.)

• BALANCING COLOR

Many editing programs have auto-enhance options, which apply a standard set of color filters to photos. You can also adjust the color manually using the tools below (and others). The terminology for these tools can vary depending on which program you use, but all photo-editing programs come with similar functions.

EXPOSURE allows you to adjust the overall brightness of an image. Adjustments correspond to f-stop values: A +1 exposure in editing is equivalent to widening your aperture by a single stop, making the photo slightly brighter.

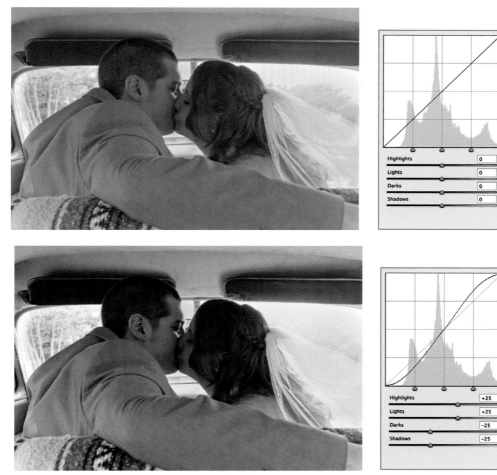

PATRICK BAGLEY — BALTIMORE, MARYLAND

LEVELS lets you alter shadows, mid-tones, and highlights in relation to each other. A slider tool allows you to change the intensity of different tones, based on how prominent they are in the image.

CURVES offers the most precision by letting you adjust bright and dark tones independently of each other in an image.

GRAY SCALE converts color images to black and white. Playing with the saturation and contrast after a photo is in gray scale helps find the right balance.

TRACEY BUYCE — LA PAZ, BOLIVIA

The Assignments

Get out in the field with help from the pros

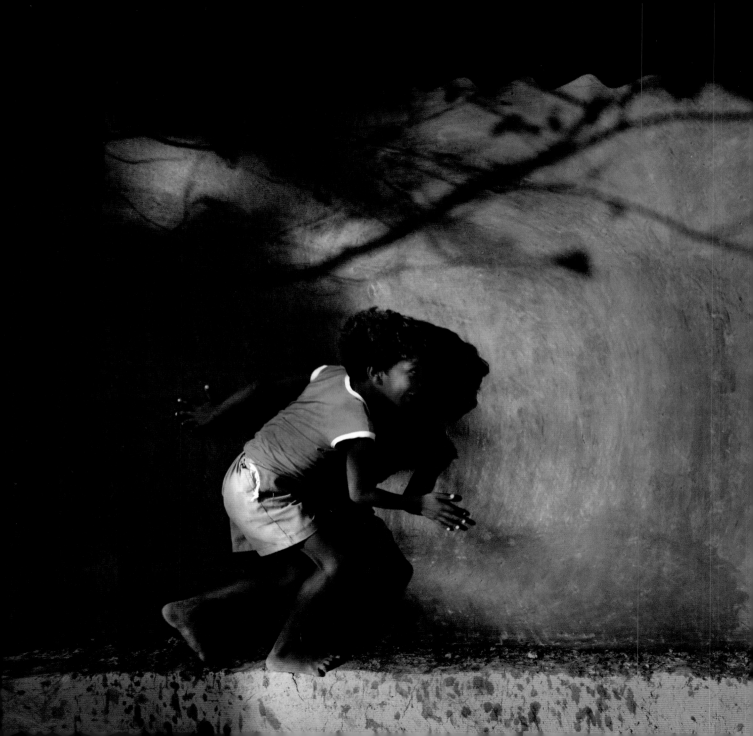

CATCH
THE LIGHT

SAMRAT GOSWAMI — BISHNUPUR, WEST BENGAL, INDIA

BY ALEXA KEEFE

ILLUMINATING IDEAS

Fleeting or steady, capricious or intentional, light is the fundamental element of photography. It transforms a scene from mundane to magical. Illuminated edges reveal shapes and textures. Shadows and reflections create impressions that may exist only for a moment. The ordinary becomes extraordinary, infused with mystery and mood.

I invite you to speak the language of light. Spend time in one place and take note of how the changing light affects the mood and tone of what you're seeing. Observe the way light might fall on someone's face, cast a shadow across a surface, or play with color in a scene. Experiment with light sources in interior spaces, or get creative with light painting.

To catch the light, photographers must be watchful, still enough to notice our surroundings yet ready to press the shutter when something unexpected comes into view. We can even use our cameras to catch light beyond what our eyes see, like the frenzy of hovering fireflies frozen in flight or the light of distant stars.

As you look at the frames you have made for this assignment, ask these questions: Is the light you have captured what makes your photograph sing? Is light the element that binds moment, composition, and technique? Does it make you want to say, "Nice light"?

To be a photographer is to be a master of light—to be fluent in the interplay of composition, shape, and color exactly as it exists in any given moment. The story told by a particular scene transforms depending on time of day, weather, angle of light, or position of your subject. A quiet forest floor may hum with life in the twilight, or a brief ray of light may illuminate grains of sand blown by the wind. You are there, watchful and ready, to catch the light.

ABOUT THE ASSIGNMENT EDITOR

Alexa Keefe, NATIONAL GEOGRAPHIC DIGITAL

As photography editor and producer for nationalgeographic.com and editor of National Geographic's "Photo of the Day," Keefe uses her artful eye to bring the beauty of National Geographic photography to the digital medium. Check out some of her favorites here: *photography.nationalgeographic.com/ photography/photo-of-the-day*

HIMAL REECE — BRIDGETOWN, SAINT MICHAEL, BARBADOS

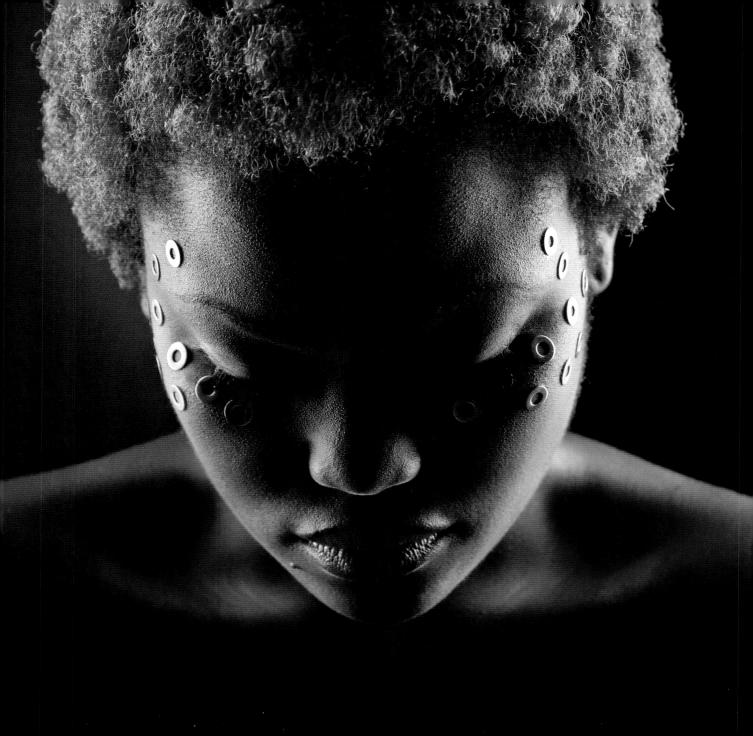

»SAND DUNE

light is the star of this photograph. It animates the blowing sand and gives dimension to the dunes. With no horizon line or other objects to provide a sense of scale, the drama of this fleeting moment takes center stage. The color of the sand creates a feeling of warmth that is almost palpable. Don't be afraid to try out your camera's manual mode to get the most out of extreme light situations like these. Underexposing the scene will allow you to capture the color of the surrounding elements and enhance the contrast of the light ray without blowing it out. You might get lucky shooting in automatic mode, but your camera might not pick up on all of the nuances you see with the naked eye.

THE PHOTOGRAPHER'S STORY

"The Namib Desert must be one of the most fascinating places on Earth. Walking into the low light, you can see the shadows and the shapes of the dunes changing every minute. This is a simple shot of the light highlighting the windblown sand between two large dunes. It all vanished in mere seconds." —Ken Dyball

WALVIS BAY, ERONGO, NAMIBIA

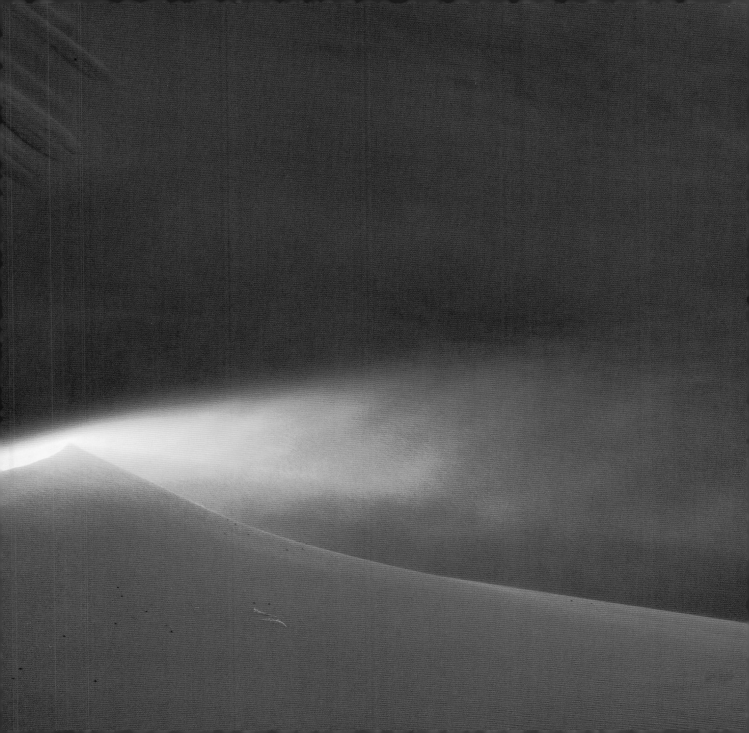

»INTO THE SUN

Bright light can sometimes be exactly what you don't want. It can create harsh shadows and obliterate details. In this case, however, bright light is precisely what transforms a humble geranium into a work of art. Photographing the soft purple petals so they are backlit by the sun creates a luminous gem and accents the fragile veins of the flower. The flower is also a surface unto itself, catching the curled shadow of the flower stamen. You need not travel to a far-off locale to find something special. If you look around you, everyday objects can be just as rich.

HOW TO WORK WITH BRIGHT LIGHT

- **You can't control the sun,** but you can make it work for you. Harsh sunshine helps illuminate the pattern on the flower petals in a way that diffused light does not.

- **Bright light can lead to harsh shadows.** Using a flash in a bright environment can help fill in those shadows so you don't lose the details.

- **Take your time.** This flower is not in a rush to get anywhere. Spend some time with your subject, and experiment with shooting from different angles.

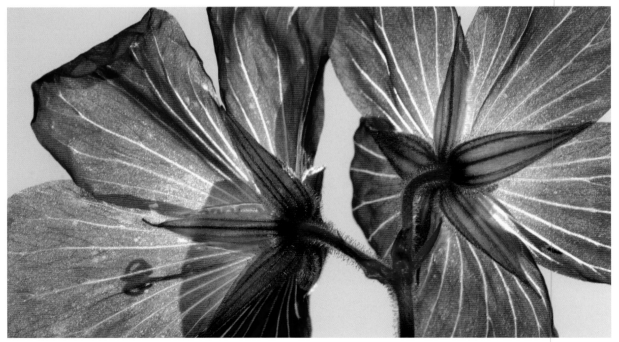

CAROL WORRELL — MOUNT VERNON, WASHINGTON

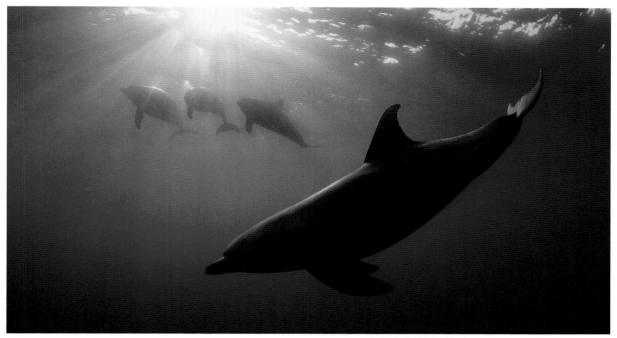

NATALIA PRYANISHNIKOVA — AL GHARDAQAH, AL BAHR AL AHMAR, EGYPT

»TAKE THE PLUNGE

The interplay between the light and layered composition takes this photograph beyond others of its kind. The eye travels first to the light gilding the outline of the dolphin in the foreground, and then to the rays beaming down from the surface. Illumination gives this underwater scene dimension and depth, and invites the viewer to linger a moment. I love the trio in the background, swimming up and out of the frame as they continue their journey. Captured minutes later, this photograph would have looked completely different.

HOW TO CAPTURE LIGHT UNDERWATER

• **Light can't penetrate deep underwater.** To maximize sunlight, shoot when the sun is brightest and stay relatively close to the surface.

• **Water reduces light.** Using a higher ISO will increase your shutter speed, so you won't miss the amazing creature that swims by in a flash.

• **Shooting with your subject between you and the sun** can create a dramatic effect. Here, the backlighting emphasizes the natural curves of the dolphin in the foreground.

• **Avoid using auto white balance,** which will neutralize the blue of the water.

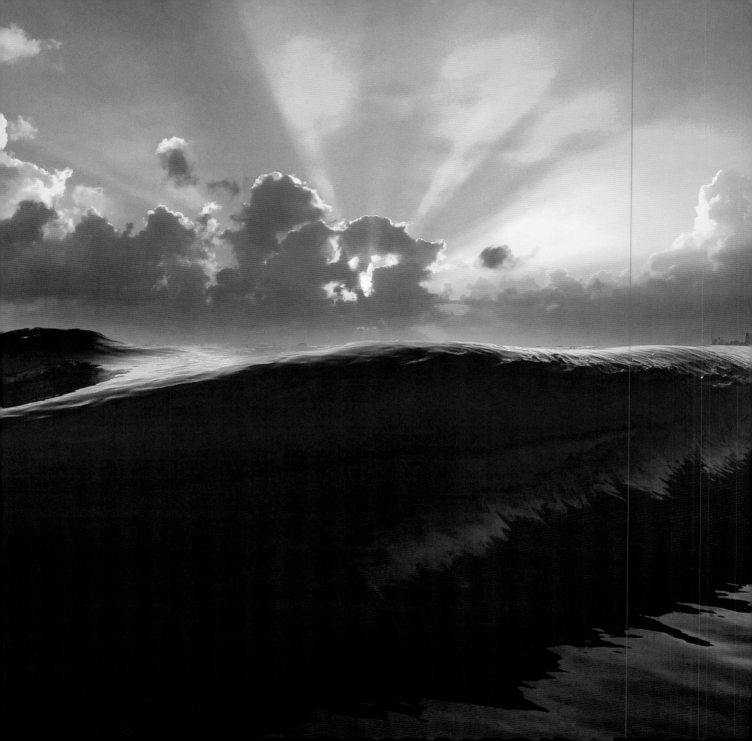

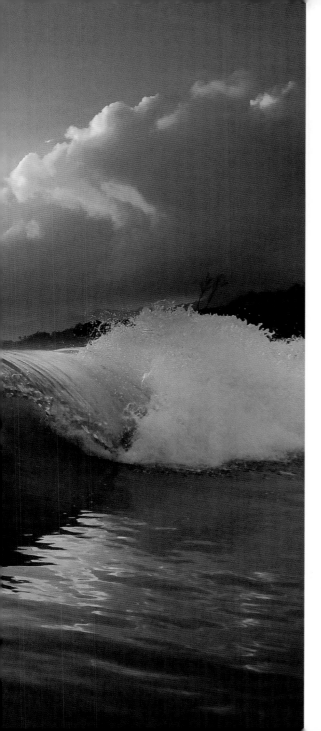

»SUNRISE, **SUNSET**

Perhaps you already have an idea of the kind of shot you want—just the wave curling across the horizon and the sun bursting out of the clouds above. Simple. Except you can't get that from standing on the beach. Sometimes you have to immerse yourself in the scene, literally, to get the shot you want. Beyond finding the right perspective, photographing at sunrise and sunset poses unique challenges. The light changes from one minute to the next and reveals patterns, shapes, and reflections that you can't anticipate. Be aware of elements you want to highlight, and let that dictate your exposure. Timeliness is of the essence, as is a ready finger on the shutter. Start shooting before you think you should, and keep going.

THE PHOTOGRAPHER'S STORY

"I'm standing in knee-deep water, trying to get my camera just above the lip line to catch the sunrise. The light is stunning. I'm taller than the wave, so I basically got chopped in the chest while capturing this. This image taught me that my ego is not my amigo, and I should never pass up the little things in life." —Freddy Booth

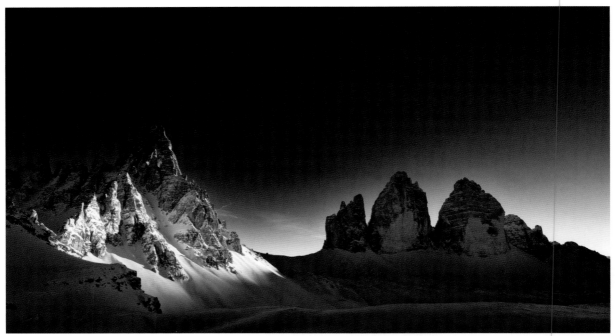

KARIN EIBENBERGER — THE DOLOMITE MOUNTAINS, DOBBIACO, TRENTINO-ALTO ADIGE, ITALY

»SHADES **OF GRAY**

Black and white is a timeless choice for landscape photography, for good reason. Without the distraction of color, the eye is free to focus on the basics of light and composition, form and texture. In this dramatic scene, hard light illuminates the craggy rock face, casting the valley in dramatic shadow. A cloudless sky makes the mountains pop. The photographer made an artful decision to focus on the peaks rather than trying to fit the whole landscape into the frame. Here, showing less is clearly more.

HOW TO CREATE CONTRAST

- **Try to visualize** the landscapes in black and white before you start shooting. Which elements do you want to appear in light and shadow?

- **Expose for the highlights** to create deeper shadows. In situations with a lot of natural contrast, the challenges are maintaining detail in both the light and the shadows, and capturing the shades of gray in between.

- **Go back to the same spot** at different times of day to see how the light changes.

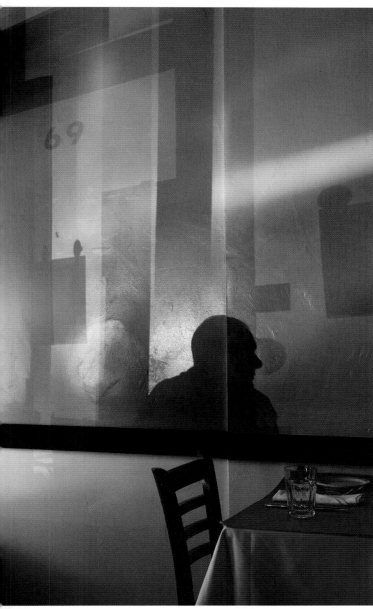

»MIRROR IMAGE

What are we looking at in this geometric interplay of shadows and reflections? When presented with clues, the mind naturally wants to fill in the blanks, which is what makes this photograph so intriguing. The empty table and chair set the scene, but the real subjects are the shadows—subversive elements that suggest rather than reveal. They are sharp enough that we can make out the number on the door and the curve of the man's head, but where is the man exactly? All of this comes together to create a photograph that resembles a photo-realist painting, artfully and meticulously composed.

HOW TO SHOOT SHADOWS

- **If you photograph your own shadow,** be intentional about using it as a creative element.

- **Don't shy away** from a shadowy scene. A shadow can actually become the focal point of your photo.

- **If an object creates an interesting reflection** capture the reflection rather than the object.

- **When photographing** highly reflective surfaces, make sure that flares from your flash or the sun do not appear in the frame.

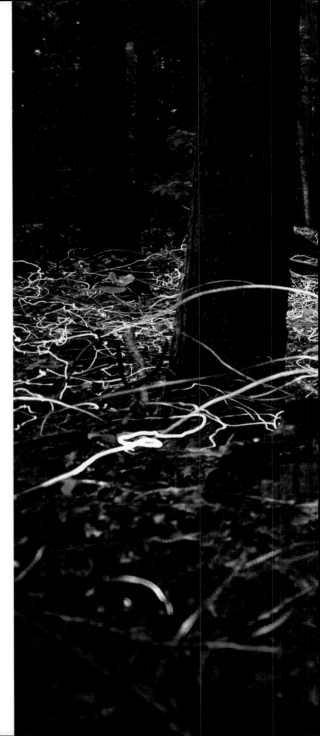

»A FIREFLY SUPERHIGHWAY

The woods are alive! Fireflies are magic in and of themselves, but a view of them en masse, emerging from the blue of the twilit trees, makes this photograph sing. The photographer takes creative advantage of the fact that fireflies are the only light source here. A long exposure time transforms the flies' blinking into zigzagging light trails, heightening the sense of energy. With the contrast of the forest, this scene is a study in movement and stillness. The eye-level perspective brings immediacy to the experience, as if the viewer were about to be overrun by this swarm of sprites.

HOW TO CONTROL LIGHT

- **Creating a scene** like this requires a long exposure time to coax ambient light from the dark forest.

- **A steady camera is paramount** to capturing this scene without blurring, so a tripod or other means of stabilization is a must.

- **When framing your scene,** be aware of extraneous elements that take the magic out of the moment. Imagine if there had been another source of light, such as a streetlight, in this photograph.

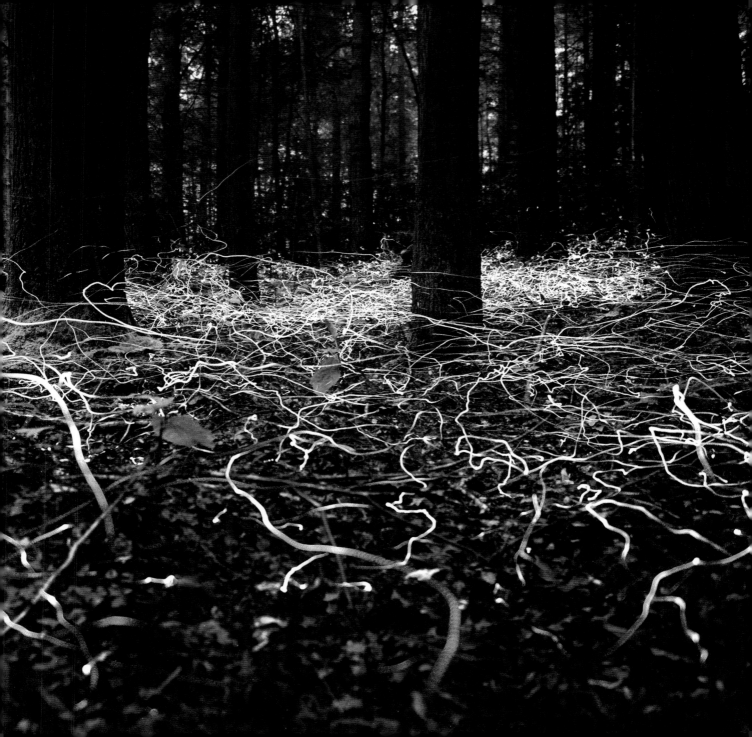

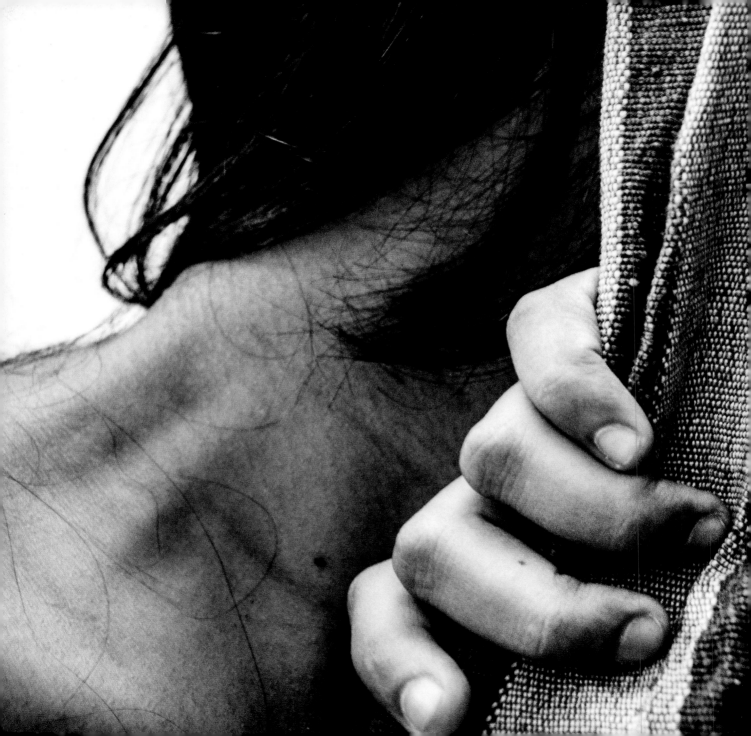

SELF-PORTRAIT

MRITTIKA PURBA — DHAKA, BANGLADESH

BY BECKY HALE AND MARK THIESSEN

EXPRESS YOUR SELF

We all have a self-identity that includes how we see ourselves and how we want others to see us. Here's your chance to show the world something about yourself.

As photographers, we are accustomed to using other people as our subjects. Turning the camera on yourself can be uncomfortable and counterintuitive. But self-portraits do have benefits. When you are your own subject, you control the strings. There's no subject impatiently looking at her watch while you set up the shot. Take as much time as you want to explore the possibilities. You are literally crafting your own image.

Think creatively, and push yourself beyond the traditional selfie, shot at arm's reach. Start by shooting your reflection in a mirror or window. (Remember to avoid covering your face with the camera or getting the camera in the shot.)

Once you feel more comfortable, think about what story you want to tell. Maybe you want to portray your joy for life or express your feelings. You don't have to include your entire form; perhaps just a portion of you or your shadow is enough. Some self-portraits draw on symbolism to emphasize poignant aspects of the photographer's life. You can also play with the lighting to create different moods, or try to compose an environmental portrait that provides more context.

If you get stuck, it can help to previsualize your self-portrait by writing the caption first. What words would you use to describe yourself? How will the viewer know what matters to you? An image may grow out of the caption you craft. Most important, keep experimenting, and don't stop shooting.

ABOUT THE ASSIGNMENT EDITORS

Becky Hale and Mark Thiessen, NATIONAL GEOGRAPHIC PHOTOGRAPHERS

Hale (left) is a studio photographer with *National Geographic* magazine. Her work includes portraiture and images illustrating complex scientific and cultural stories. Fieldwork has taken her to Istanbul, Rome, and Cairo. She has shot Stonehenge at daybreak and aerials of whooping cranes from an ultralight.

Thiessen (right) is a staff photographer with National Geographic and is recognized for his work on science stories and wildfires. He was also the expedition photographer chronicling filmmaker James Cameron's dive to the bottom of the Mariana Trench in *Deepsea Challenge*.

ESTEFANÍA HERNÁNDEZ — PUERTO VALLARTA, MEXICO

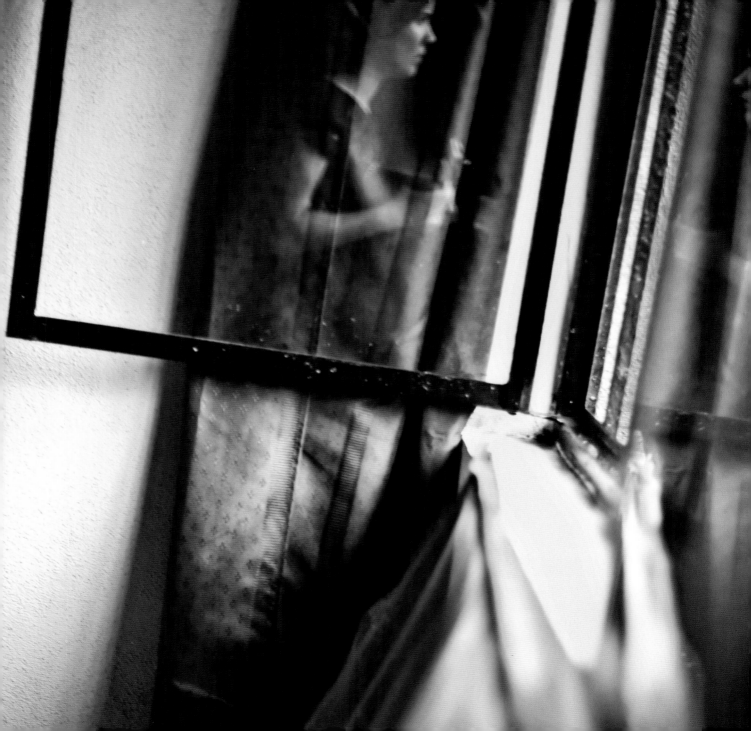

»SLEEPLESS **IN CHINA**

We love images that at first glance look like something else and then require a second look to figure them out. The broken mirror crops the photographer's face so his expression becomes even more intense. We see no forehead, hair, or other distractions. His eyes draw you in. This is a tricky shot because you have to balance the exposure of the foreground with the background. The different qualities of light falling on the mirror and the background play a key role in creating this striking image. The photographer lit his face while ensuring that the background didn't become too light or too dark.

THE PHOTOGRAPHER'S STORY

"Insomnia, I can't sleep. Tossing, turning. Finally a lightbulb. This photo is inspired by the cover of Joe McNally's book The Moment It Clicks *(gotta give credit for the idea). Hey, I just wanted to see if I could light it."*
—Kevin Prodin

YANGJIA, SHANGHAI SHI, CHINA

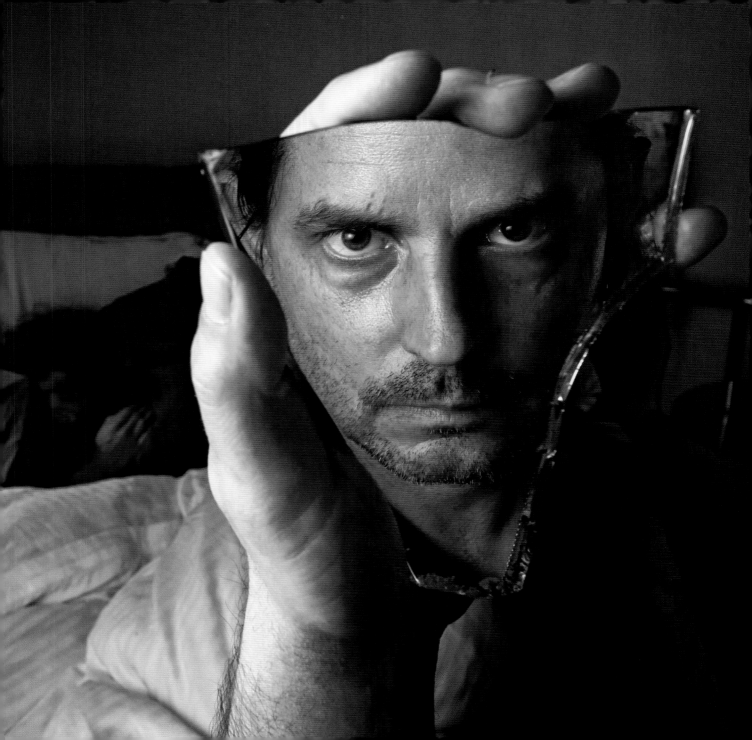

»BEHIND THE GLASS

This is such a mysterious and abstract self-portrait. The out-of-focus face, the hair that seems to defy gravity, and the moody light make this a strong image. We love the soft swirl of hair obscuring her face against the aquamarine background. The hair is interesting in and of itself. In this image, the photographer placed her nose on a flatbed scanner. This technique makes an image with a unique look you can't get any other way. The light on her face falls off so quickly. A scanner has a sensor with an attached light that moves along under the glass. The light is so close to the glass that anything on the glass is properly exposed and anything farther away gets darker.

HOW TO TAKE UNCONVENTIONAL PHOTOS

• **Experiment by pointing your camera** through anything that might make an interesting distorted image.

• **Leverage digital photography's immediacy** by reviewing your image, making adjustments, and shooting again. Rinse and repeat.

• **Try this technique to magnify an image:** Remove your camera lens and hold a loupe (from the film days) against your camera in place of the lens.

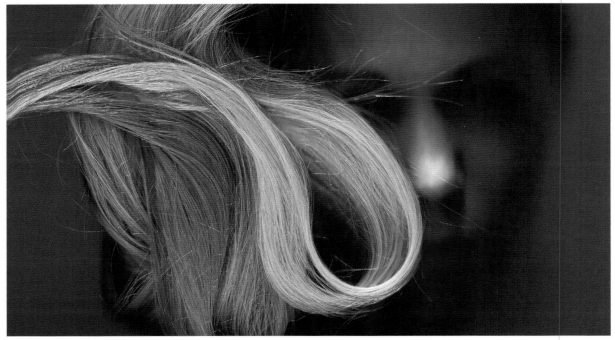

HELENE BARBE — JAN JUC, VICTORIA, AUSTRALIA

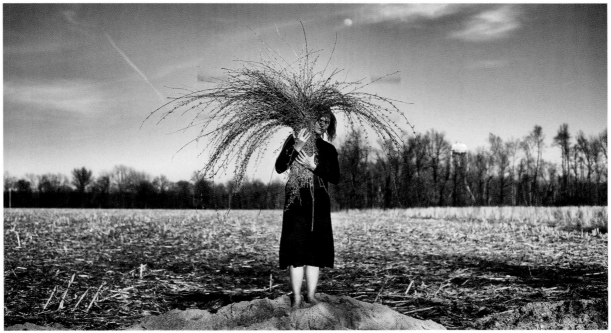

TYTIA HABING — WATSON, ILLINOIS

»FIELD **OF DREAMS**

This intriguing self-portrait made me stop and linger. It feels jarring yet familiar, vintage yet contemporary. The long tendrils of weeping willow seem to be the subject of the photo, yet they simultaneously obscure the human subject. Who is the woman hidden by the branches? By choosing to make this image black and white, the photographer creates a strong distinction between the field and the distant tree line. The photographer's white shins and bare feet contrast sharply with her black dress and guide the viewer's eye to the center of the frame. Quietly present in the background, the moon adds further mystery to this enchanting scene.

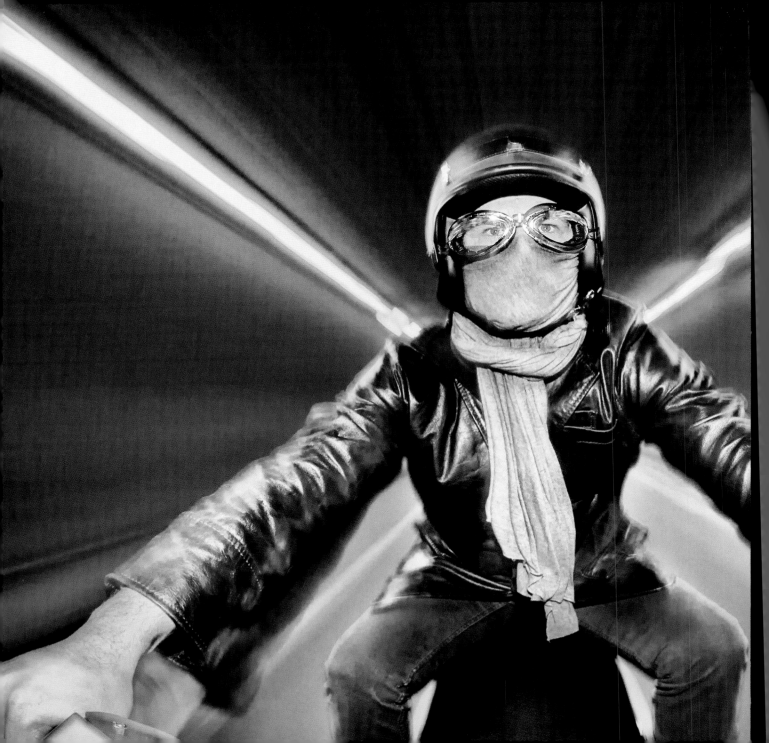

»THE NEED **FOR SPEED**

There's no ambiguity about this self-portrait, as the photographer puts himself smack in the middle of the frame. The bright tunnel lights create bold leading lines and a strong composition. The photographer uses a slow shutter speed to capture the streaming overhead lights, while an on-camera flash freezes his shape and keeps it crisp. He does a great job of incorporating lights that he can control (the flash) and those he cannot control (the tunnel lights). The camera is mounted on the scooter itself, which is an innovative way to capture a clean image at this speed. Clamping your camera down and playing with light and motion can be a great way to turn an ordinary moment into a dynamic photo.

THE PHOTOGRAPHER'S STORY

"I use my scooter for the commute to and from my work. It allows me to stop everywhere I want to take a picture. So a self-portrait should include my scooter. I taped a tripod to the front and mounted my Nikon D7000 with a Samyang 8mm fish-eye. I used the flash on manual to freeze my face and a long exposure to create the speed. This picture was taken in a small tunnel so I could use the tunnel lights to create these lines." —Lex Schulte

EWINKEL, NORTH BRABANT, NETHERLANDS

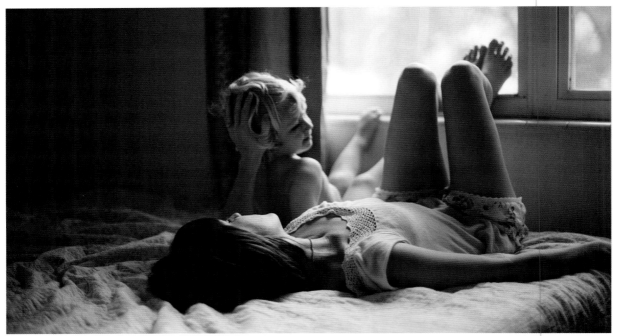

AMANDA DAWN O'DONOUGHUE — GAINESVILLE, FLORIDA

»MOTHER **AND CHILD**

This is such a lovely, simple image. I saw this frame and felt like I was witnessing an ordinary and poignant moment between a mother and her child. Many details make this shot compelling: the soft quality of the light, her hand on his head, his toes on the edge of the windowsill as he tries to mimic her pose. The photographer chose a very shallow depth of field, giving this image a gauzy, dreamlike feel. Very few elements of the frame are actually in focus, except for part of the photographer herself. Sometimes nothing is more resonant than a real moment.

HOW TO CAPTURE A QUIET MOMENT

- **Turn your camera's** sound effects off (or way down) to minimize the distracting shutter sound.

- **Shoot a lot of photos** as you let the moment play out. Keep shooting past the point when you think you've "got it."

- **Make sure you have** lots of room on your memory card for hundreds of images. There's nothing worse than missing a moment because your card is full.

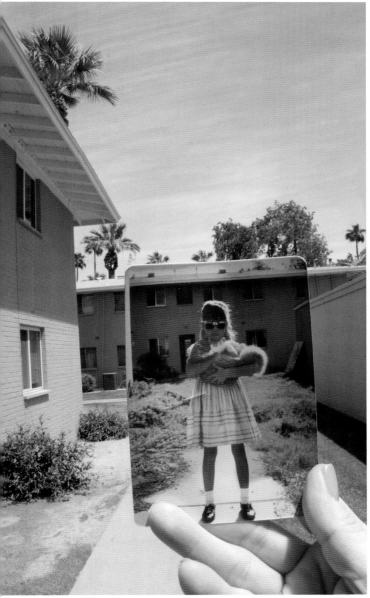

DARCIE NAYLOR / THE PHOTOGRAPHER AS A YOUNG GIRL OUTSIDE HER HOME — PHOENIX, ARIZONA

»LOST IN TIME

This picture is like a time machine. I love the idea of bridging two periods of time to make a self-portrait that tells a story. The present-day background has a timeless look, which adds to the sense of disorientation. The photographer uses a frame within a frame to draw attention to what matters. She stopped down to an exposure of f/22, adding to the depth of field and bringing both the snapshot and the background into focus.

To shoot this kind of photo, try to achieve the same time of day and weather conditions in both the past and the present-day scenes. Shoot lots of pictures to make sure your alignment is dead-on. The final result will be worth the extra effort.

HOW TO CREATE A FRAME WITHIN A FRAME

- **Windows, doorways, and even tree branches** can be used to create a frame within a photo.

- **This framing technique** adds context to your image, because you are looking through the frame into something else.

- **Keep an eye out for frames** in different settings. Once you start looking for them, you will see them all around you.

»THE SELF **REFLECTED**

Cameras are central to a photographer's identity. But using one as a prop in a self-portrait can be a heavy-handed, dated cliché. This photographer avoids the usual traps in an inventive self-portrait that puts her camera front and center. My eye goes immediately to her shape reflected in the lens. Rather than focusing on herself, the photographer chose to make her lens as sharp as a tack and to let everything else go soft. As a result, the repeating silhouettes complement each other rather than competing for attention. The clean background behind the photographer also simplifies an image that could otherwise be overly busy. By letting her "self" take a backseat, the photographer creates a more powerful and surprising image.

HOW TO SET UP A SELF-PORTRAIT

- **Set your exposure first** so your settings are locked down and you can focus on making the image.

- **Use your tripod** and carefully frame the shot before inserting yourself.

- **To release the shutter,** use a long cable release that can be hidden from view easily.

- **Use the self-timer** on your camera to shoot automatically in time increments of your choosing.

MARGARET SMITH — ENGLAND, U.K.

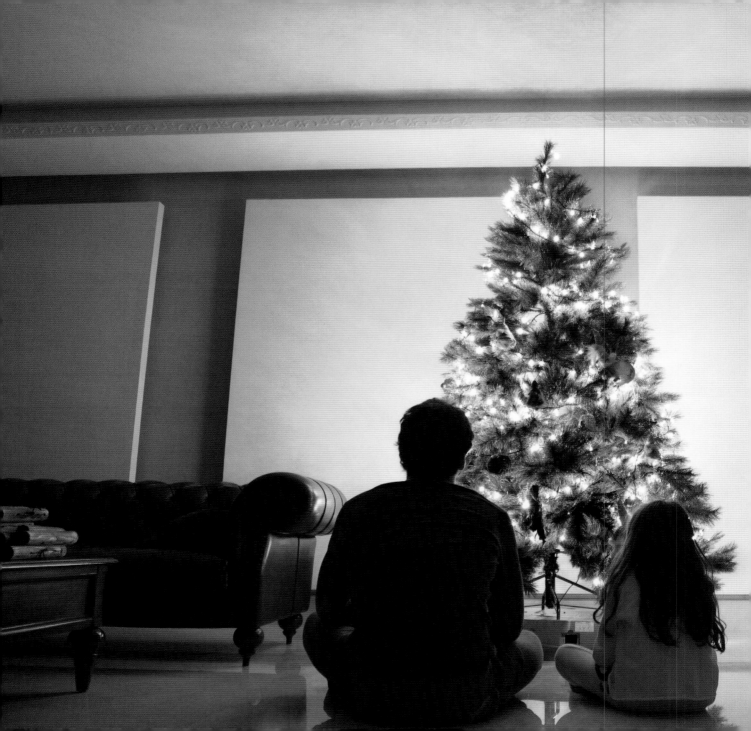

HOM

BY SUSAN WELCHMAN

WHERE THE HEART IS

'I've called many places home, and I continue to establish new homes. Not all of them are places I have stayed for a long time, and some of them don't even have roofs. When you set out to create your individual expression of home, think broadly and creatively. Home can be anything from a small room to the entire universe. It can include moments of sheer joy or desperation. It can be an extremely intimate place or a public space.

Often what constitutes a home is not where you are, but whom you are with. You could photograph the home you currently have or the home you hope to have someday. You can also shoot the home of someone or something else.

Strive not only to document but also to reveal. Your images can be abstract or realistic, but ideally they will convey a thought or emotion. Try to avoid shooting the obvious. Instead, search for the meaning of this assignment with your heart as well as with your camera. As always, there is no specific formula for success, except that all great photos need a little luck or magic.

ABOUT THE ASSIGNMENT EDITOR

Susan Welchman, *NATIONAL GEOGRAPHIC* MAGAZINE

An award-winning photographer and photo editor, Welchman retired as a senior photo editor for *National Geographic* magazine after 35 years. Earlier in her career, she worked as a photographer at the *Philadelphia Daily News* and a photo editor at the *New York Post.*

LARRY DEEMER — CHÉTICAMP, NOVA SCOTIA, CANADA

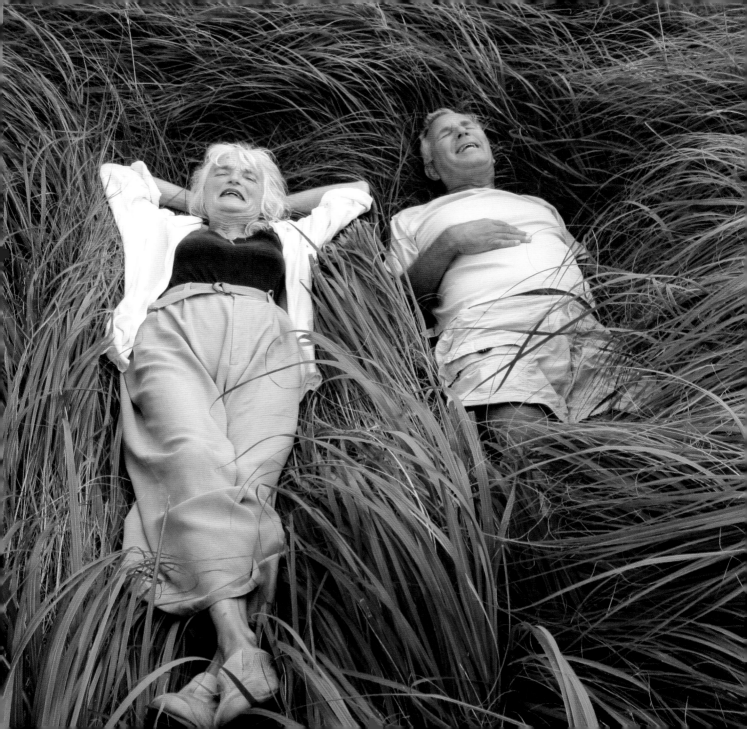

»THE BEDROOM **WINDOW**

My favorite thing about this image is that there's nothing extra in the frame at all. The curtain blows in the breeze in contrast to the strong geometric lines of the house. The photographer snapped this shot at the very moment the wind lifted the curtain at just the right angle. While the scene is somewhat stark, the curtain hints at the warmth and humanity inside. This image could have been shot in color, but it never would have given us the same delight as this black-and-white, perfectly framed image. The window on the right balances perfectly with the chimney on the left. And the asymmetry in the negative space—created by the lines of the house against the sky—adds visual interest. This image is minimalism at its finest.

HOW TO MAKE A LITTLE SAY A LOT

- **Show movement** in your photos to bring them to life.
- **To convey weather conditions** in your photo, look for a curtain blowing in the breeze, condensation on a window, a trickle of sweat, or another visual cue.
- **Stay very still.** It will help you concentrate on capturing movement in the subject.

RUI CARIA — PRAIA DA VITÓRIA, AZORES, PORTUGAL

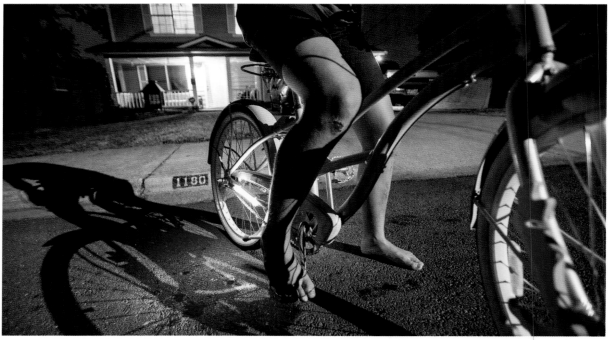

ANNEKE PATERSON — AUSTIN, TEXAS

»A CHILDHOOD **MEMORY**

Bike, shadow, purple light, and home—a flashback to childhood and summer nights riding through the neighborhood in bare feet. The house number connects the rider to the home, yet the rider is anonymous. You connect with the freshly injured knee, the shadow, and the activity, but not to the type of person.

The image is direct in its simplicity. The roofline of the house is cropped, and your head is locked in position with no options. The unexplained green line seen through the bars of the bike makes you wonder what it could be. All of the ingredients in the photo surround the knee wound. You can almost hear the rider saying, "It was worth it."

HOW TO DISCOVER YOUR ANGLE

- **If subjects initially turn you down,** tell them you can make them anonymous by disguising their identity. Show them the image, and gain their permission to keep it.

- **Take photos from all perspectives.** Get down on the ground or on top of something high.

- **Shoot on the edge** of the light. Even if you can't see, make your camera do the work by using a higher ISO in the dark.

»THE WAR **AT HOME**

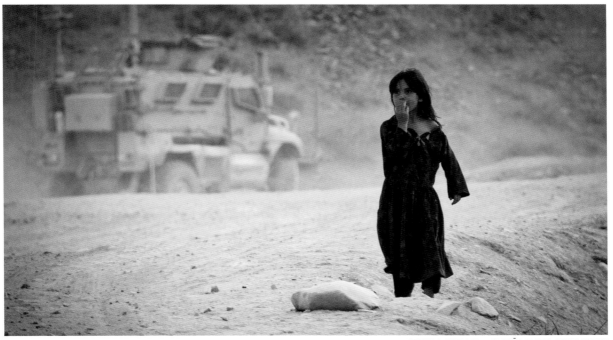

Seeing a child alone in these surroundings reminds us how precious and fleeting safety can be. She, with henna in her hair, fingers in her mouth, and a dress that is far too big for her—she is at home. This girl lives in a small Afghan village close to where the picture was taken. She has spent her whole childhood living among the trappings of war. So small and vulnerable juxtaposed against the massive military truck, she is the only burst of color and humanity in a harsh and unforgiving terrain. This is not a picture of comfort. This image makes us feel desperate to do something.

HOW TO WORK PEOPLE INTO LANDSCAPES

- **Explore depth of field.** Opening your aperture will help fuzz out your background so it doesn't compete with your foreground.

- **Shoot in all kinds of weather and light** just to explore the effects of wind, dust, and rain. Be careful to keep your lens clean and dry.

- **Don't hesitate.** Shoot first, and ask your subject for permission later.

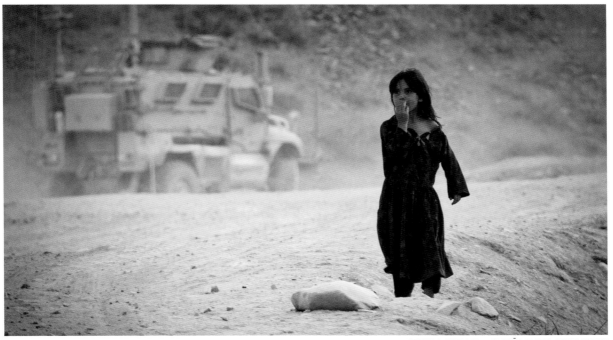

JUSTIN A. MOELLER — GARDĒZ, PAKTIA, AFGHANISTAN

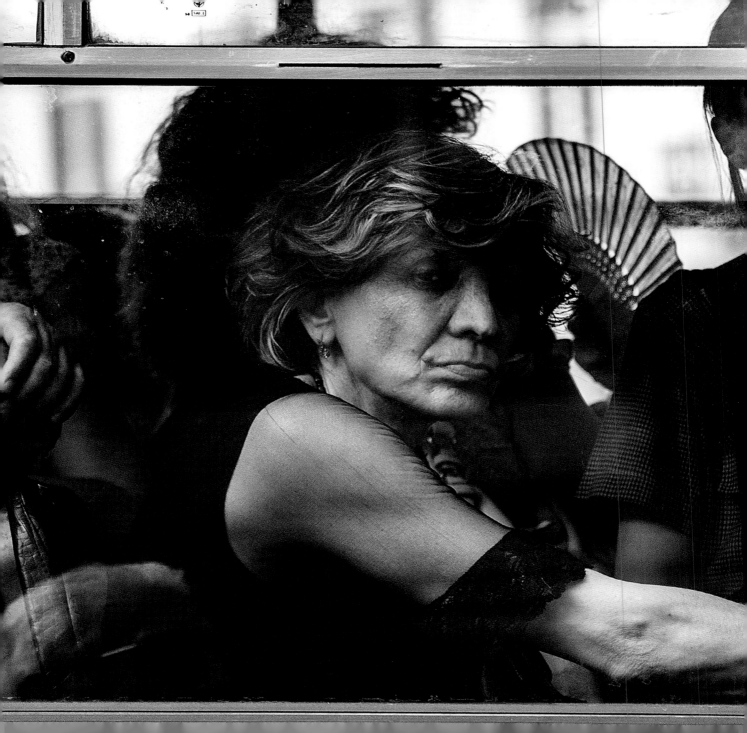

»A FACE IN THE CROWD

Riders on a city bus might not make you think of home, but the riders are often in the familiar surroundings of their hometown. Every inch of this frame is worthy of our attention. The lead character gazes unflinchingly at the photographer. Her confident, disdainful expression and unlikely daytime attire make her look at once defiant and defeated. The woman's hand pushes into the corner of the window while the waves of her hair flow in the opposite direction. At the lower left, the reflection of a face with sunglasses contrasts with the unhappily contorted face at the upper right. The fan is almost playful amid so much disillusionment. You can only wonder what the fanning woman looks like.

THE PHOTOGRAPHER'S STORY

"When I was waiting for my bus, I noticed this woman! I had the impression that she was gazing at me, but I could tell she essentially belonged to a different reality. I don't know what time or space she was in at that moment, but the view was beautiful and, at the same time, dolorous."
—Levan Adikashvili

TBILISI, REPUBLIC OF GEORGIA

»A MINIATURE **WORLD**

This image poses as many questions as it answers. The dollhouse is displayed next to life-size lamps, yet the lamps appear to be the same vintage as the house. If only the lamps could fit inside. Similarly, it looks as if the occupants of the house could drive away the cars at any moment. Is the gold curtain backdrop hiding the real-life home of someone behind it? The doors and tiles provide extra framing around the image and help us understand the reality of the picture—that it's on a street. This scene is likely meant to delight viewers, and it succeeds.

HOW TO SHOOT A WINDOW DISPLAY

- **Still lifes won't run away.** Take your time and make a good exposure. Go back if the subject is right; the light could change in your favor.

- **Captions can illuminate.** Try to gather information before leaving a scene. It might change the whole meaning of your image.

- **Avoid reflections** unless you can give them an unusual spin. They tend to be cliché.

»WAITING TO LEAVE

The photographer's vantage point for this image makes the child look insignificant. The scene is unpleasant. She and we are waiting and wanting to get out of it. The disorganization and decrepitude remind us that homes vary greatly from tents to mansions. Small attempts at comfort, such as the curtain and the dangling Christmas lights, only make the scene worse and seemingly more desperate. The child is so relaxed that you wonder about her relationship to the photographer. You want to say or do something! Make it better! The viewer marvels that a shot could be so perfectly composed, seemingly on the fly.

HOW TO SHOOT REAL LIFE

- **If you want to document truth,** then change nothing in the scene.

- **Listen to your subjects** while you are shooting. They might be on the verge of doing something greater than they are doing now.

- **Scenes evolve.** Follow your subject until you are out of time or your subject is out of patience. Then go one step more.

URDOI CATALIN — ROMANIA

»THE WELL-DRESSED MAN

This photo is a beauty. At first I thought it was a vintage image, but the gas price, modern cars, and 2014 newspaper headline take us right back to today. When this paper-selling man stops for a moment with his hand on the car's roof, he displays the checks of his perfectly pressed suit jacket and gives everything else a supporting role. The newspapers, the BP gas sign, and the smiling woman in the white truck divide up the sky's negative spaces. The man's arm is bent back, creating movement in the frame. You know there's no posing going on here. The photographer has succeeded in documenting a true moment in life.

THE PHOTOGRAPHER'S STORY

"Detroit is a city of flash and panache. I feel at home when I see a sharp-dressed man at a stoplight in the middle of the street with a bag of lollipops and a stack of newspapers. I roll down my window: 'May I take a picture?' There's something very old-school about this image, and about many of the photos I've taken in Detroit. It's a forgotten culture—that's what I love about it." —Amy Sacka

DETROIT, MICHIGAN

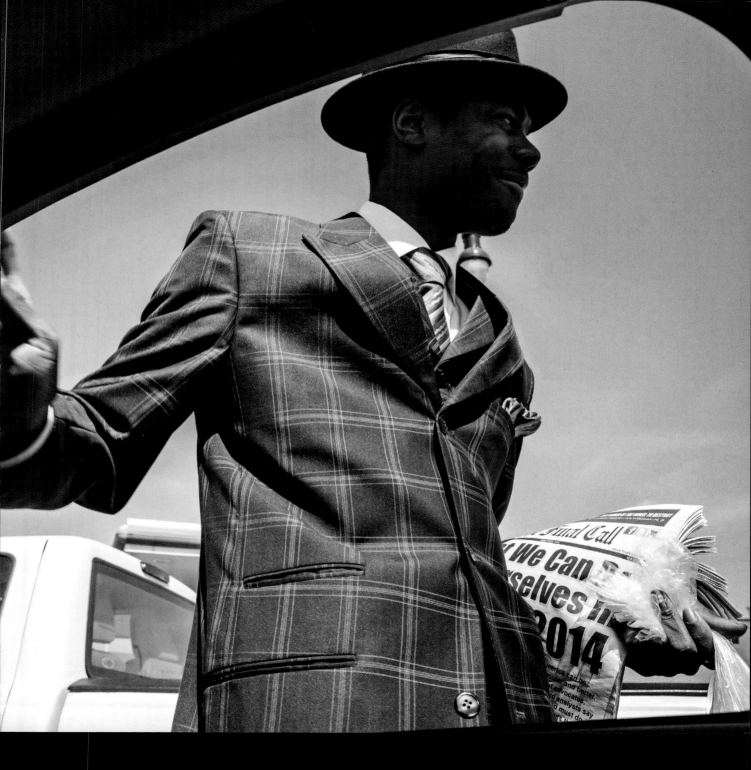

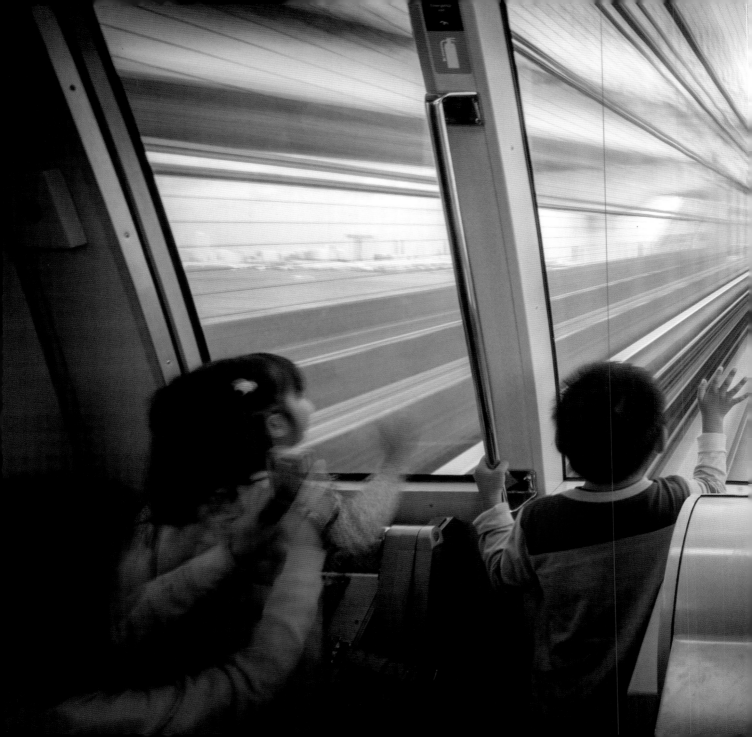

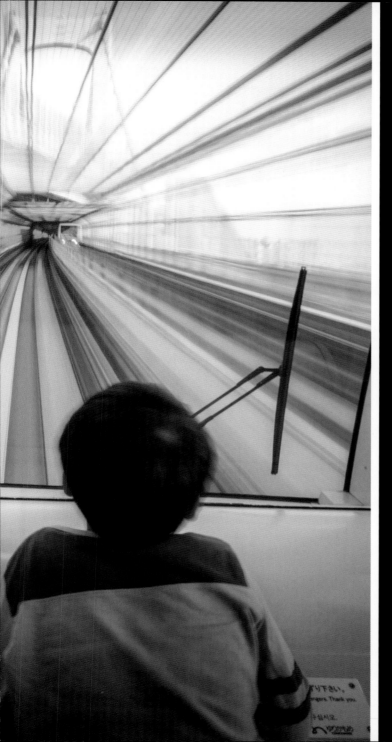

SPONTANEOUS ADVENTURE

DANILO DUNGO — RAINBOW BRIDGE, TOKYO, JAPAN

BY JOHN BURCHAM

GET UP AND GO!

Has it been way too long since you went on an unplanned adventure? If so, I invite you to forget your cell phone and email, to turn off your reminders, and to throw out your itinerary. This assignment is all about spontaneity.

For me, the unplanned adventure always turns out to be the most memorable. You don't have to go far to have a spontaneous adventure; you just have to go. So the next time you get an impulse to go out and do something, follow that impulse right out the door—and take your camera with you!

Your assignment is to take photos that showcase unexpected and exciting imagery from an unplanned escape. Shoot an idea you have had for a while, take a fresh look at a place you have been before, or go somewhere you have always been meaning to visit.

Don't forget that emotion can create some of the most dramatic action shots. An image can have solid composition and beautiful scenery but still lack connection with the viewer. Instead of just photographing the places you go on your road trip or the mountain you just climbed, capture the experience of *being* there.

Being spontaneous is not the same as being unprepared. You don't want to miss the perfect shot because you forgot your favorite lens or that extra battery. Create a checklist of items you might need for your adventure. Keep a packed bag in your car or closet for easy access when you need it.

If you keep up the philosophy of spontaneity, you will never stop growing and learning as a photographer. Continue to go out there on your own personal assignments, take those risks, and force yourself out of your comfort zone. It's worth it in the end.

ABOUT THE ASSIGNMENT EDITOR

John Burcham, NATIONAL GEOGRAPHIC PHOTOGRAPHER

Burcham feels most at home when climbing up the sandstone spires of Sedona, Arizona. He has been adventuring and photographing since college. His work has appeared in *National Geographic* magazine and the *New York Times*, as well as on the History Channel.

　　　　　　　　　　DOUGLAS GIMESY — TORRES DEL PAINE NATIONAL PARK, MAGALLANES, CHILE

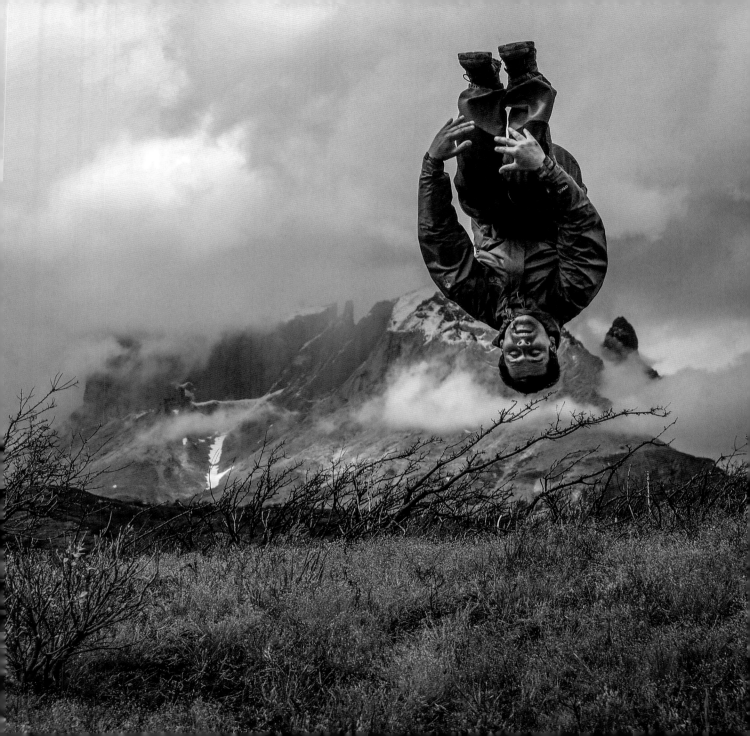

»LOVE **IN THE WILD**

ometimes one small gesture is all you need to transform an image from good to amazing. The composition of this photo is perfect. Your eye goes directly to the young elephant in the center of the frame. You see the other elephants, but there is only one face in the crowd. The connection is instantaneous. The way the elephant drapes its trunk gently over the other elephant, presumably its mother, creates a powerful and touching image. You can sense the young elephant's need to hold on and desire for security. By capturing this moment, the photographer has created an affectionate story as well as a great photo.

● **To capture this tight view,** the photographer shot at a focal length of 80mm. Telephoto lenses can help you get that close-up when you are far away from the action.

● **Shooting wildlife is unpredictable.** Stay in position to shoot, because you never know when the action is going to happen.

● **Don't be afraid** to crop an image to improve its composition.

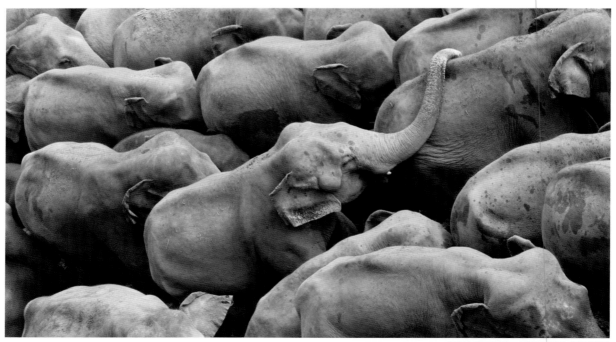

YASHA SHANTHA — PINNAWALA, SRI LANKA

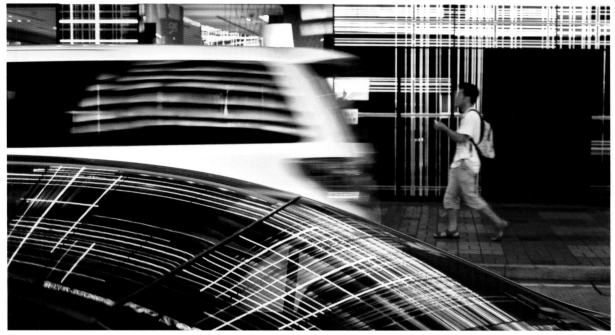

»BRIGHT LIGHTS, BIG CITY

This image is graphically stunning. Its many shapes and colors could overwhelm us, but a perfect composition ties all of the elements together. The photo has a symmetrical, balanced feel. The bisecting lines in the background and the reflecting lines in the foreground echo each other and draw us in. All of the components are in just the right position, and the pedestrian fills the space exactly where he is needed. It's amazing how the photographer was able to make all of these moving parts work together in one frame. This is a truly spontaneous moment.

HOW TO FIND BEAUTY IN BUSY SCENES

- **At night cities come alive** with contrasting colors. Look for bright colors as a focal point, and let them draw you into the photo.

- **Sometimes a scene** may seem too busy, but you see a way that it might work. Take the photo anyway. You never know when something exciting and unexpected will enter your frame.

- **You don't have to go far** to get a great photo. Keep an eye out for graphic elements that surround you every day.

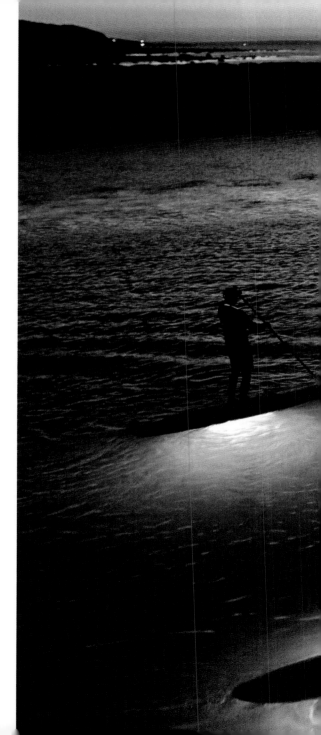

» ADRIFT **AT SEA**

What an adventure it would be to go out on the ocean at night with an illuminated paddleboard. Imagine the thrill of gazing down and looking into that dark unknown below your feet. These nighttime explorers are setting out on their ocean adventure, and we want to partake of this journey with them.

Each board is illuminated so perfectly, giving off just enough light to silhouette the paddlers as they drift with the soft current. The lighting from the background warms everything up, but not too much.

The most magical photos often happen after sunset. Twilight can illuminate clouds beautifully and give off different intensities of light and subtle colors. If this shot had been taken any earlier in the evening, the boards may not have been lit up in the same way. The natural light on the horizon and the unnatural light under the boards complement each other and make this photo a beautiful, spontaneous adventure into the unknown.

THE PHOTOGRAPHER'S STORY

"What I love so much about stand-up paddleboarding is its ability to transport me, surrounded by nature, to a quiet, meditative state. On a perfect late-September evening, with no wind and a full moon, I got to photograph the nighttime version of this experience. Waterproof LED lights are attached to the bottom of the boards, illuminating the water below, which meant the paddlers could see fish passing by. I photographed this from a jetty at a harbor near my house and was stunned by the beauty of it all."
—Julia Cumes

DENNIS, MASSACHUSETTS

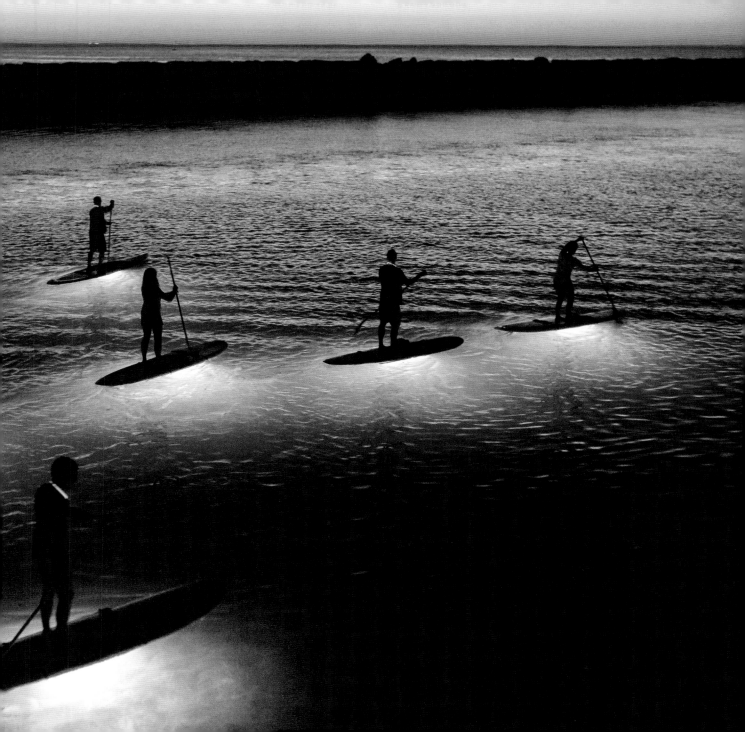

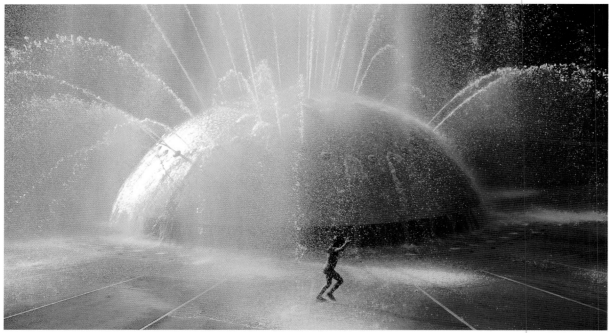

STEVE DEMERANVILLE — SEATTLE, WASHINGTON

»FOUNTAIN OF YOUTH

The dreamlike quality of this image stirs up memories of those summer days of childhood, when we ran gleefully through backyard sprinklers. The photo has a futuristic feel, but it also makes the viewer wish to be young again. The water fountain, with its soft, luminous shades of blue, would have made a spectacular photo on its own. But with the little girl frolicking in the spray, the photo is no longer about the fountain or the girl; it's about a feeling. It becomes a beautiful representation of nostalgia.

HOW TO SHOOT A MOMENT

• **If you want to "freeze"** moving water, prevent blurring by keeping your camera on the highest possible shutter speed.

• **Don't stop shooting.** Ironically, it often takes a long time to capture a spontaneous moment like this one. Waiting for that perfect moment takes patience.

• **Set your image quality** to raw rather than JPEG, if you have the option. This will give you more control in post-processing. You can warm up the color or, in this case, cool it down.

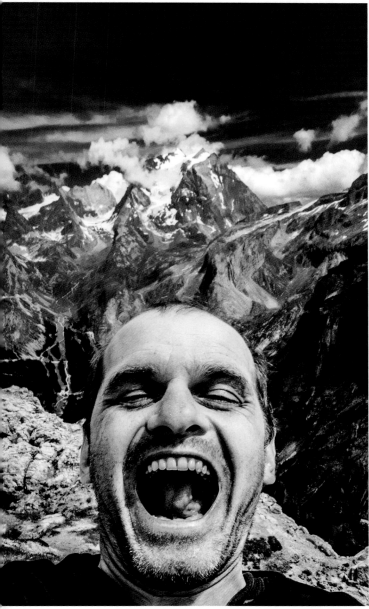

SERGE BOUVET — PRALOGNAN-LA-VANOISE, RHÔNE-ALPES, FRANCE

»A NATURAL HIGH

Spontaneous adventure is about getting out, experiencing an amazing place, and having fun with it. This ultimate selfie expresses the joy of adventure. The mountain range in the back is awe inspiring and massive, and the photographer puts himself right smack in the middle of it all. It can be difficult to capture the feelings that you are experiencing at a given moment, but the photographer does this quite well. The look on his face says that he's enjoying this moment to the fullest. What makes this image so much fun is that he is a part of his own photographic journey.

HOW TO ADD LIFE TO A LANDSCAPE

• **Try using a wide-angle lens** to capture the surroundings. But be careful not to go too wide, or the photo could get distorted.

• **Be daring.** A beautiful landscape makes a pleasant photo, but don't be afraid to try something different and have a little fun.

• **Human emotion** goes a long way in spicing up a photo.

93

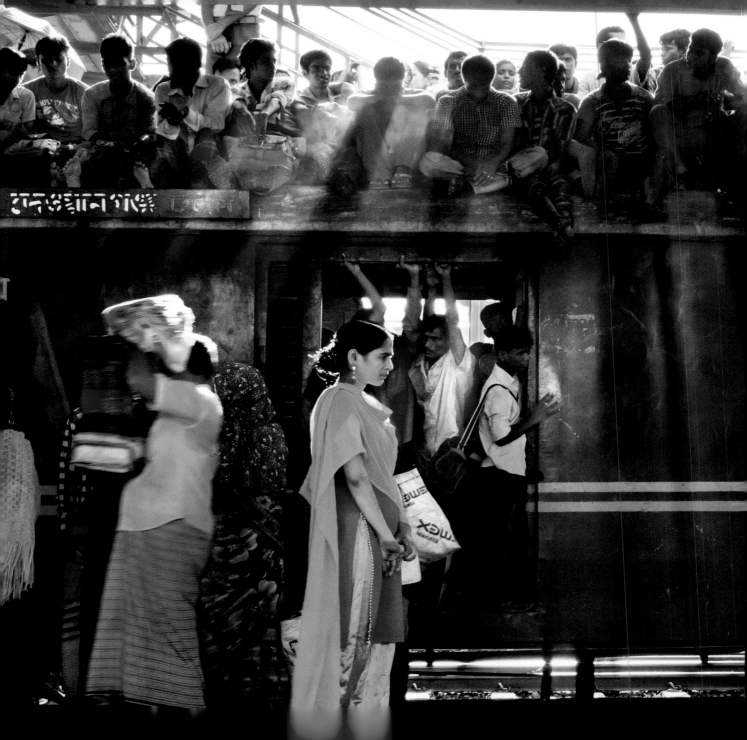

»ALONE **IN A CROWD**

This stunning photograph creates a mystery. Who is this woman? Is she lost in thought or just waiting for someone? The woman and the direction of her gaze become the focal points of this photo. We follow her gaze and wonder.

You can feel the thickness of the air. The crowds on top of the train add to the story by creating a feeling of chaos and crowding in the background. Despite the hustle and bustle, the woman in the foreground remains as still as the eye of a hurricane.

The contrasting colors and subject matter give this image an almost palpable strength. The photographer shot into the sun, which backlights everything beautifully and creates mellowness and tranquility. The photographer saw this moment and captured it perfectly.

THE PHOTOGRAPHER'S STORY

"A newlywed bride waits for her husband to board the special train in Kamalapur Railway Station in Dhaka, Bangladesh. The mehendi *(henna) on her hand is still showing as the light seeps through the roof and onto the people 'seated' on top for the journey. This is a pilgrimage home to enjoy the Eid festival with family." —Shahnewaz Karim*

DHAKA, BANGLADESH

»JOURNEY **INTO SPACE**

The universe is vast and endless. Our planet makes up only a tiny portion of the cosmos. Looking at this image, you grasp the reality that humanity is just a tiny blip in time and space. Paradoxically, the photo is also a testament to human ingenuity. To get this shot, a couple of guys sent a GoPro camera into space on a weather balloon. Their crazy idea worked! The results were amazing images of Earth.

This photo is embedded with so many contrasts. Humans are big yet small, helpless yet powerful. Our planet sometimes seems chaotic, but it is beautiful and peaceful from a distance. Mostly, we see how far we can go with very little.

HOW TO TAKE YOUR DREAM SHOT

- **Follow through.** We all have ideas, but they don't mean anything until you put them into action. If you think a project is worth doing, write down step-by-step what it would take to get from point A to point B. Set a date and make it happen.

- **GoPros can inspire creativity.** You can attach these small, lightweight video cameras to just about anything, so they can go places where you and your DSLR cannot.

- **Don't be afraid of failure.** Crazy ideas work sometimes.

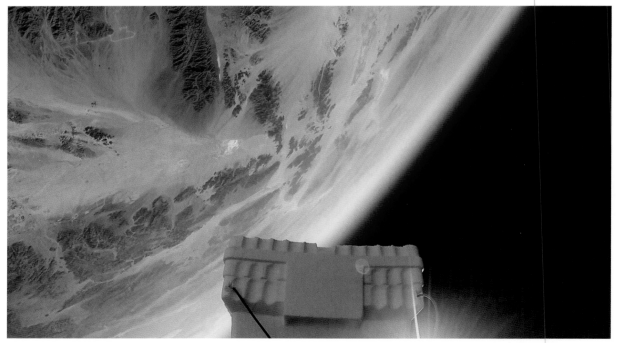

JAY MANTRI — EARTH'S STRATOSPHERE (ABOVE SOUTHERN CALIFORNIA)

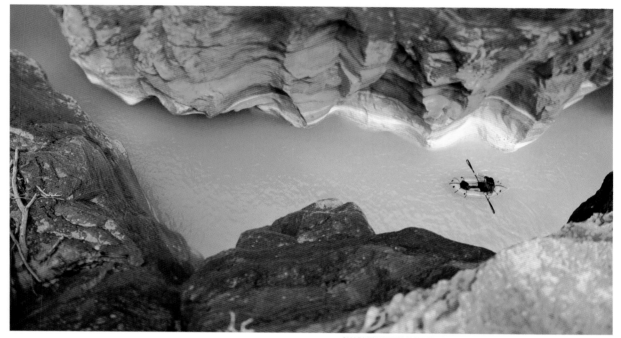

CHARLIE NUTTELMAN / RAFTING THE HAVASU CANYON — SUPAI, ARIZONA

»ROLLING ON THE RIVER

The rich colors in this scene appear to bleed into each other like those of an oil painting. The orange hues of the rock contrast nicely with the aqua blue river. The small yellow raft provides perspective on the incredible steepness of the canyon walls. The rafters create a sense of direction as they paddle into the scene from the right. Although the environment is harsh, the soft, even lighting brings out the beauty of the landscape. This place feels isolated, but the bright colors and lighting evoke the pure joy of adventure.

HOW TO SHOOT IN ROUGH TERRAIN

- **Look for the perspective** that best tells the story. Sometimes getting lower or higher can change the whole photo.

- **Cloudy days** often make for better shooting conditions than sunny days, which can create harsh lighting.

- **When shooting in extreme or vertical conditions,** make sure you have a high-quality camera strap. It could be worth every penny. A reliable strap is much cheaper than a replacement for a dropped camera.

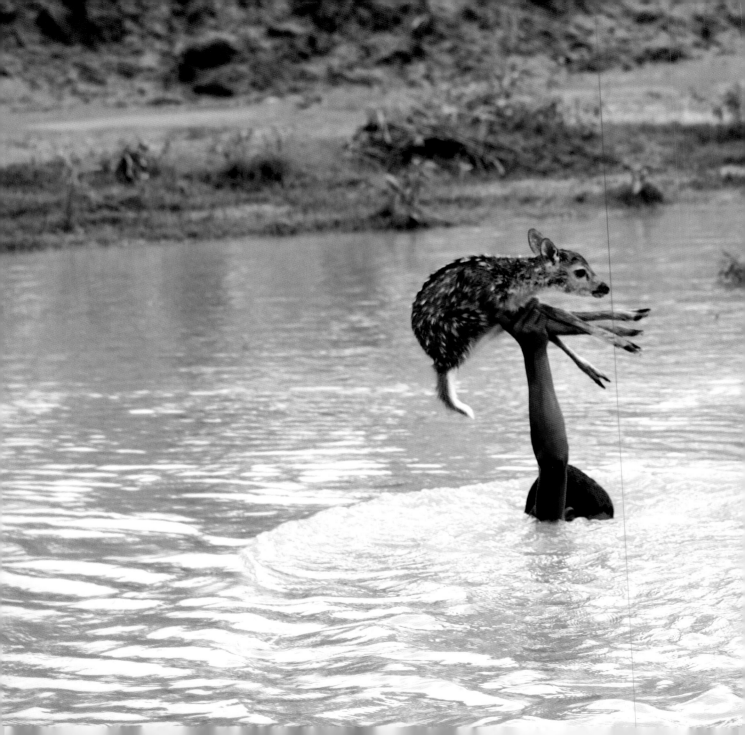

THE ANIMALS WE LOVE

BY ROBIN SCHWARTZ

A WALK ON THE WILD SIDE

Animals have been my passion for my entire life. They are my joy and my family. They give me support and make my life better. If you identify with any of these statements, then this assignment is for you. I challenge you to follow your passion for animals and photograph from the heart.

You might create an intimate portrait that communicates an animal's distinct personality, or you may decide to photograph an animal within a landscape, on the street, or in a park or zoo. Just remember to be respectful and safe at all times. Be aware of cultural mores and institutional rules. Asking permission to take pictures of someone's pet may open up a dialogue and allow you to create a more intimate photograph.

There is no formula for shooting the perfect animal photograph, but the most powerful images strike a universal chord. Some generate poignancy and empathy; others capture similar qualities in humans and animals. Finally, including context, such as an informative background, can help tell the animal's story and make it relatable.

As you shoot, keep an eye out for any arms or legs that are awkwardly chopped off in the frame. And when you are editing your photos, be aware that there is a fine line between poignant and cloyingly cute.

That said, photograph what you care about and don't worry about making a perfect composition. Get the shot first and edit yourself later. Some of the photos in this chapter are not technically perfect, but they get to our hearts and minds—and that is a successful photograph. Trust that the value you place on a photograph might come through in your capture.

If you truly love animals, and if photographing animals gives you pleasure, then do not let any criticism impede your photographic pursuits—unless it involves safety or stalking! Follow your instincts, and photograph what you love.

ABOUT THE ASSIGNMENT EDITOR
..

Robin Schwartz, FINE ART/EDITORIAL PHOTOGRAPHER

With photographs in collections at the Metropolitan Museum of Art, the Museum of Modern Art, and the Smithsonian, Schwartz has also been published in four monographs, as well as the *New York Times, TIME LightBox,* and *Aperture* and *O, the Oprah* magazine. She teaches at William Paterson University in New Jersey.

JUAN TORRES — GUAYAVILLA, PUERTO RICO

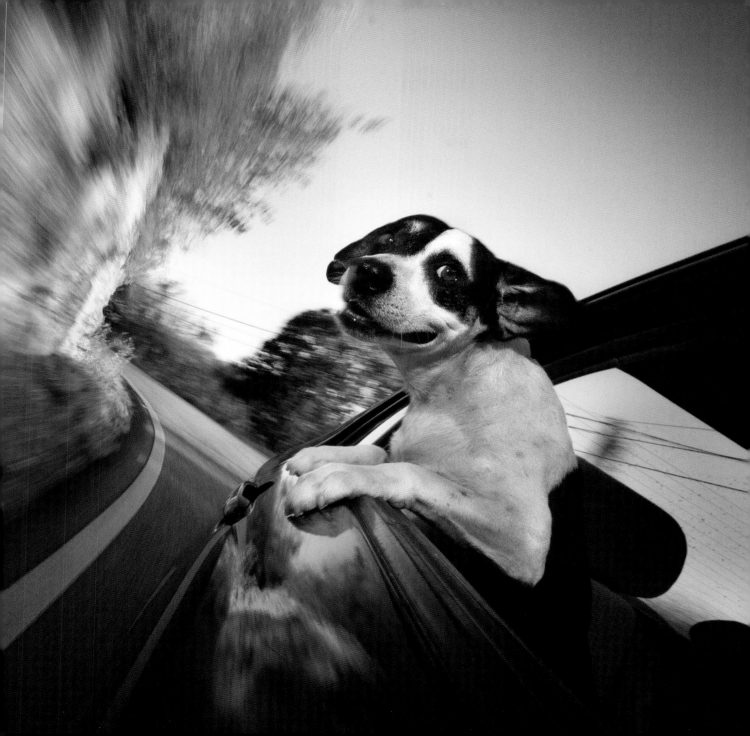

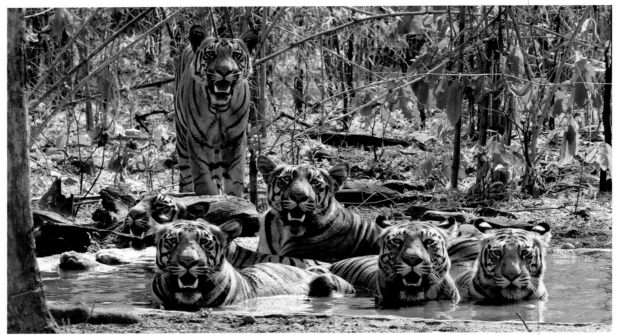

»LAND **OF THE TIGER**

This is the shot of a lifetime. A photograph of six large tigers immersed in a small stream, as if they were at a spa, is almost unfathomable. Remarkably, five out of six animals are looking directly at the camera. I relate to this photo as a universal family portrait of the almost-adult kids and parents together before everyone grows up and leaves home.

The photographer, Nirmalya Chakraborty, knows these tigers as a family of parents and four subadults. Chakraborty writes: "This is a rare capture after much patience that at last bore sweet fruit."

HOW TO PHOTOGRAPH WILDLIFE

• **Know your subject's behavior,** both for your own protection and to help you get better shots.

• **This photograph requires** a long lens to capture the image without getting too close.

• **When photographing animals,** extreme patience is required. Attempt to take the photograph you want many, many times.

• **If photographing animals is your passion,** connect with people or organizations that can help you learn. Contribute financially, invest your time, and volunteer. This may give you the opportunity to access the animals you are passionate about.

»IMAGINARY FRIEND

I laughed out loud when I saw this sheep head-butting a screen door. This photograph speaks the universal language of humor. Let's face it, we have all walked into a sliding door at some point in our lives. The mirrored reflection reads as a metaphor of the sheep knocking her head against the wall and getting nowhere—definitely not inside.

Showing a sense of humor in your photographs is a wonderful way to engage the viewer. Your approach can be intentional or serendipitous. It is a gift to make people smile or laugh. Some of the funniest shots highlight behavior that humans and animals have in common.

HOW TO CAPTURE ANIMALS IN ACTION

- **Shooting animals at eye level** often makes for stronger photos. If this photograph had been taken from above, the sheep would look distorted.

- **Prefocus your camera,** and be prepared to shoot. Photographs like this require a quick capture, a fast shutter speed, and are often serendipitous.

- **Think through the composition** of the entire frame. This photo includes the sheep's reflection, and this took a plan.

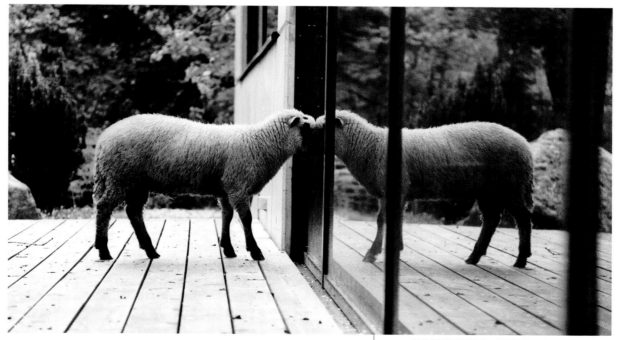

KRISTOFFER VAIKLA — SUURUPI, HARJUMAA, ESTONIA

»SHELTER **IN THE STORM**

Photographers have taken many wonderful shots of snow macaques in Japan's hot springs. But this image is particularly poignant in that it creates a universal portrait of a mother-child relationship. The mother's expression of awe and awareness of the weather, as evidenced by her open mouth and upward gaze toward the falling snow, are entirely unexpected. Secure in her embrace and perhaps ready to drift off to sleep, the baby looks off into the distance. An animal's surroundings can be a powerful factor in a photograph, as context helps the viewer understand the story about the animal's life.

HOW TO CONVEY A MOOD

- **Be careful of shooting *too* much** and missing the moment. The downside of using a digital camera is that you might click so much you miss the "decisive moment."

- **Be empathic and sensitive** to your subject—in this case, universal mother-baby love.

- **Choose your depth of field carefully.** This long lens set at f/5.6 rendered the lovely, soft focus around the monkeys.

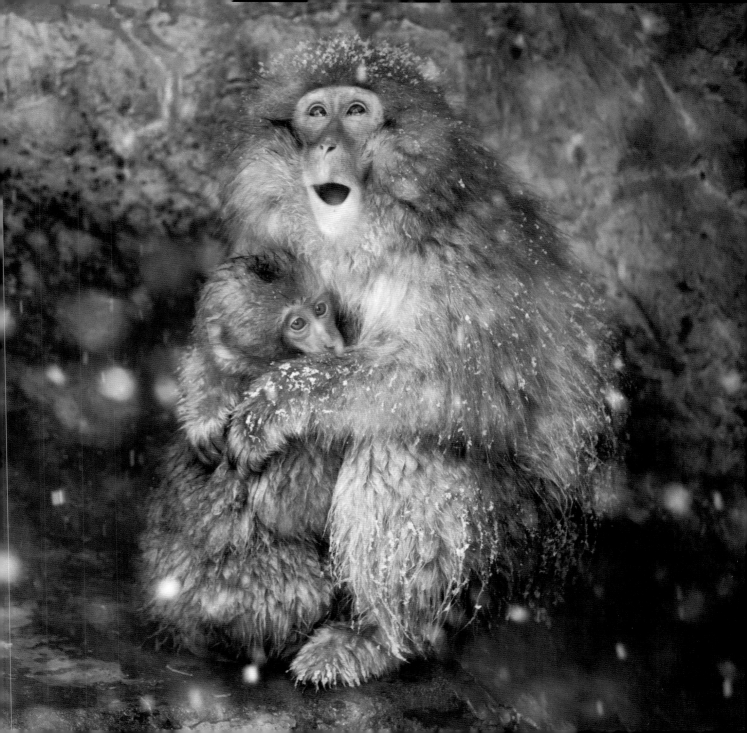

»FEEDING **FRENZY**

This image captures a popular attraction in Thailand, but it transcends any generic, touristy photo. A bright orange koi stretches its head out of the water to suck on a baby bottle held by a human hand. A cluster of open-mouthed fish desperately want to latch on to the bottle. Motion is everywhere, and the slow shutter speed amplifies the frenzy. The overexcited fish create a chaotic rippling in the water. Meanwhile, the oddly colored pink-and-brown bottle clashes with the orange fish. Weird! But weird is good. The surreal quality of the scene makes it that much more intriguing.

HOW TO KEEP AN OPEN MIND

● **Take a chance and shoot.** You have nothing to lose.

● **Consider the happy accident** when reviewing your photos. Photos may have technical glitches but still create an interesting or quirky scene like this one does.

● **Show your images to others** to see their reactions. Listen first. They may love an image that you have overlooked. But after considering all feedback, go with your gut.

HANNAH HARVEY — MASSACHUSETTS

»A PERFECT **PAIR**

The photograph is a staged self-portrait taken with a smartphone, but the photographer managed to compose a successful shot, even with minimal control over the camera's settings. The approach is deliberate, confrontational, and challenging. This composition is edgy, with an extreme crop of the face that begins at the corner of an eye staring directly into the camera. The eye, dramatically accentuated with makeup, is juxtaposed against the eyeless cat. The two are linked visually by the similar colors of the woman's hair and the cat's fur. Dillon is a blind rescue cat, but the photographer says that Dillon rescued her right back.

HOW TO BE CREATIVE WITH A SMARTPHONE

- **Do not put off photographing** because you think you do not have the right equipment. As this photo shows, it's possible to create a powerful photo with the most basic of cameras.

- **Photograph** the people and things you love.

- **Consider using your camera** to create a visual diary.

- **Plan your color palette.** The harmonious colors in this photo greatly increase its impact.

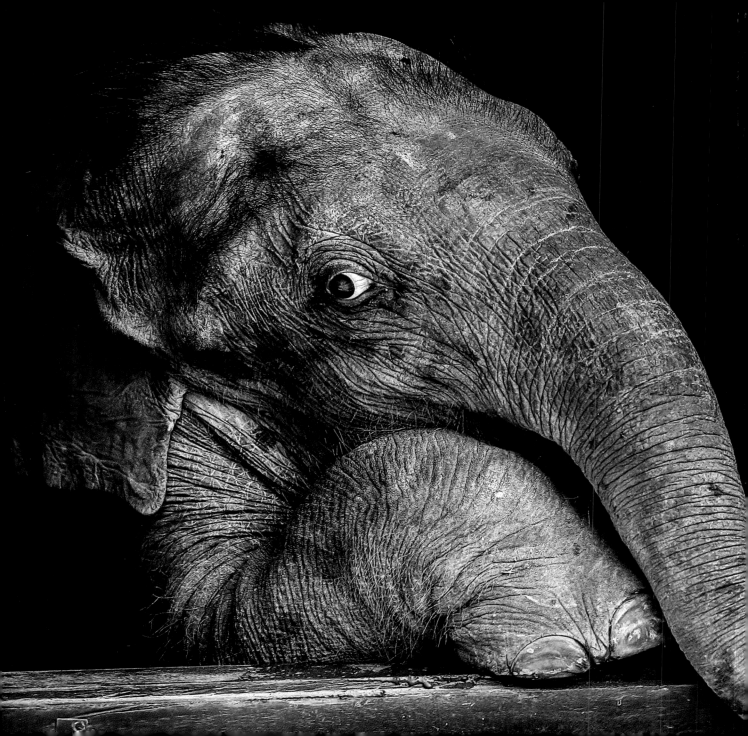

»ORPHAN **ELEPHANT**

This photograph is a strikingly compelling portrait with uncomplicated but dramatically effective composition. Structurally the baby elephant is literally in the window frame, which functions as a frame within a frame. The elephant has surprisingly negotiated this barrier to see the photographer one last time. As viewers, we first make eye contact with the elephant and then follow his trunk to his front foot, which lightly circles the bar of the window frame and connects to his other foot. His wide-eyed, beseeching look is so compelling, especially because we see the whites of his eyes—an interesting element in photographs of animals. This image is at once endearing and haunting.

THE PHOTOGRAPHER'S STORY

"I met this baby elephant while documenting an elephant rehabilitation and release program. He had lost his mother in a flood. I spent a lot of time with him and became quite attached. When I finally had to leave, I turned around one more time to look at the building that housed him and saw that he had gotten up on his hind legs and was looking out the window at me. His expression was so strikingly human in that moment, and I saw in his eyes something universal and profoundly expressive." —Julia Cumes

KĀZIRANGA, ASSAM, INDIA

»ONE MINUTE OLD

This newborn piglet, with its umbilical cord still attached, seems to smile right at the camera. The arms create a frame around the piglet and tell the story of passing along this sweet bundle. The color palette is mellow, and the pale pink color of the pig pops against the blue background. The focus and drama of the photo lie in the piglet's black markings and its eye, which looks directly at the camera. This adorable piglet's eyes and expression create a humanlike quality, which is one of the most tried-and-true ways of creating connection in a photo of an animal.

HOW TO SPOT A SHOT

- **Eye contact** can draw a viewer in, but it is not a foolproof formula. Experiment with shooting portraits that do and do not include direct eye contact with the animal.

- **When photographing animals,** look for the same qualities you would want to capture in a photograph of a person—in this case, the eye contact and the smile of the new baby.

- **Choose your subject deliberately.** This piglet may have stood out because of her eye markings.

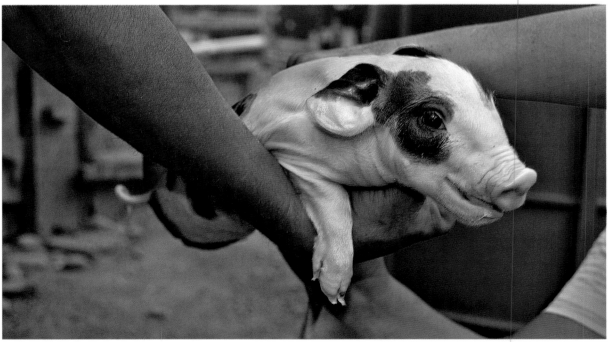

JOSE A. SAN LUIS — KALINGA, CAGAYAN VALLEY, PHILIPPINES

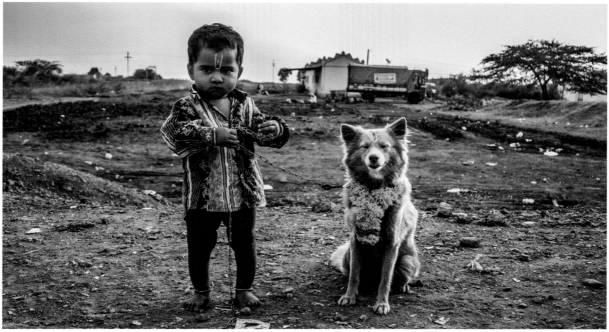

ASLAM SAIYAD — PANDHARPUR, MAHARASHTRA, INDIA

»CHAINED LOVE

A sense of equality emanates from this boy-dog pair. They are close in size, as the child is young and the dog is petite. They are linked companions, literally, as the child holds the dog's chain-link leash with two hands. The dog's eyes are closed, as if in a gesture of supreme patience with his too-young master. The foreheads of both the child and the dog are adorned with religious symbols. The dog is clearly identified as a participating family member with festive marigold flowers, which add to the charm of this unusual capture.

HOW TO TELL AN ANIMAL'S STORY

- **Show the relationships** between the animals and the people in your photographs by looking for expressions of love, interdependence, and gratitude. Capture the connection.

- **Seize opportunities** to create context for your photos. The background of this photo speaks volumes about the boy-dog pair.

- **Be aware** of cultural or religious symbols displayed by the subjects of your photos. They can help tell a more complete story.

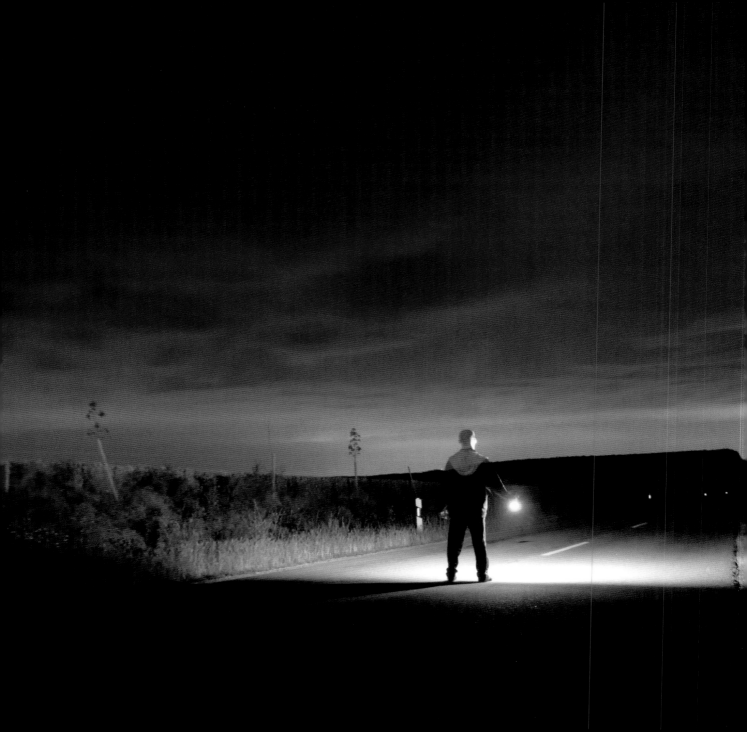

AFTER MIDNIGHT

BY DIANE COOK AND LEN JENSHEL

A SHOT IN THE DARK

As inspiration for this assignment, we are using the lyrics from J. J. Cale's song "After Midnight,"—famously covered by Eric Clapton in the 1970s. The lyrics begin, "After midnight, we're gonna let it all hang out."

So how are you gonna let it all hang out? We've spent many a midnight hour making pictures. In fact, the night is an amazing time to photograph: It's magical, mysterious, and metaphorical, whether by moonlight, ambient city light, or any light you find yourself in after the clock strikes midnight.

Those of you way up in the Northern Hemisphere may have the midnight sun to work with. And for those of you way down south, who knows, maybe an amazing display of the aurora australis? For everyone else, use your imagination to show what "after midnight" means to you.

What do we love most about photographing after midnight? We've learned to embrace the unknown, the darkness, and the strangeness. The night is mysterious, magical, and often surreal, but mostly dark. You simply can't see everything out there, and you have to take a leap of faith and to trust your intuition and instinct. Especially in the dark, the camera can "see" what the human eye cannot.

When we shoot for *National Geographic* magazine, the conditions aren't always ideal, the weather doesn't always cooperate, and the light is never what we envisioned—but on a professional assignment, we still need to come home with the goods. Wherever you find yourself—even if you are inside—you'll have lots of interesting nocturnal potential.

Pay careful attention to your exposure, and beware of overprocessing. You don't want your nighttime shots to look as if they were taken during the day. The last question you need to ask after you have made your best frame is this: "Now, how can I make this picture even better?"

ABOUT THE ASSIGNMENT EDITORS

Diane Cook and Len Jenshel, NATIONAL GEOGRAPHIC PHOTOGRAPHERS

Two of the foremost landscape photographers in the United States, Cook and Jenshel make award-winning images that explore issues of beauty, boundary, culture, and control over nature. Their work has been published in many books and magazines, including *National Geographic*.

JUAN OSORIO — NEW YORK, NEW YORK

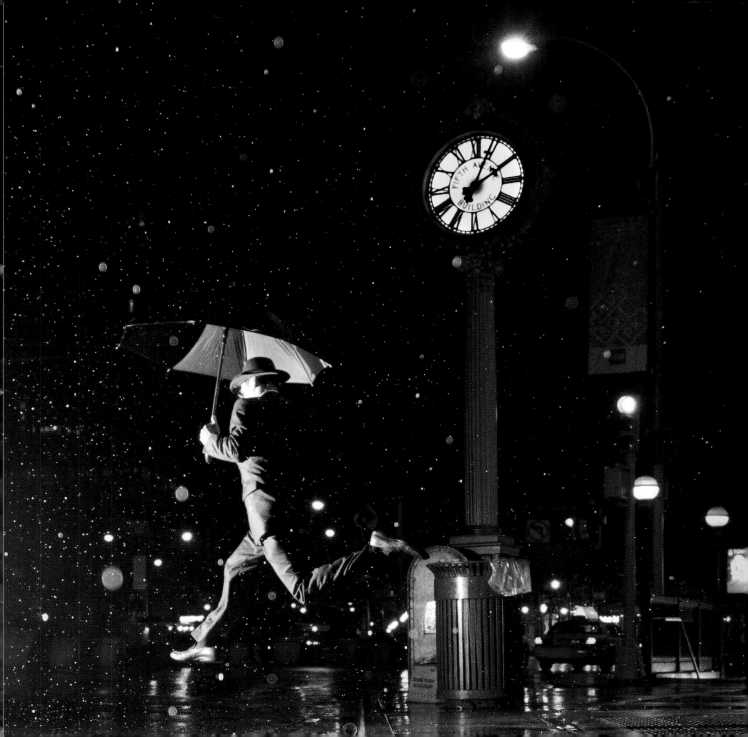

»NIGHT ON THE RIVER

There is something magical about this nocturnal landscape. The incredible sweep of stars and sky pulls us into the image and rushes alongside the wonderful blur of the fast-moving river. The still forest, a perfect counterpoint to this motion, makes for an arresting image.

Capturing a nighttime scene like this, with little or no illumination, requires one of two methods. You can bump up your ISO to 3200 or higher, in order to get enough exposure for the image. Or you can opt for a longer exposure, which results in a blurring of elements in motion.

This photograph was created with a technique called light painting, in which the photographer uses light to illuminate or "color" the scene. The exposure for this image was approximately five minutes, which gave the photographer time to use a high-powered flashlight to light up the trees and the river. The result? The dazzling effect of simulated moonlight.

HOW TO "PAINT" WITH LIGHT

- **To create an image using light painting,** shine a light source onto various sections of the scene for different amounts of time.

- **Flashlights and headlamps** are essential for working in the dark.

- **Be sure to move** the light source around to achieve a softer edge. Holding the light in just one area will create hot spots.

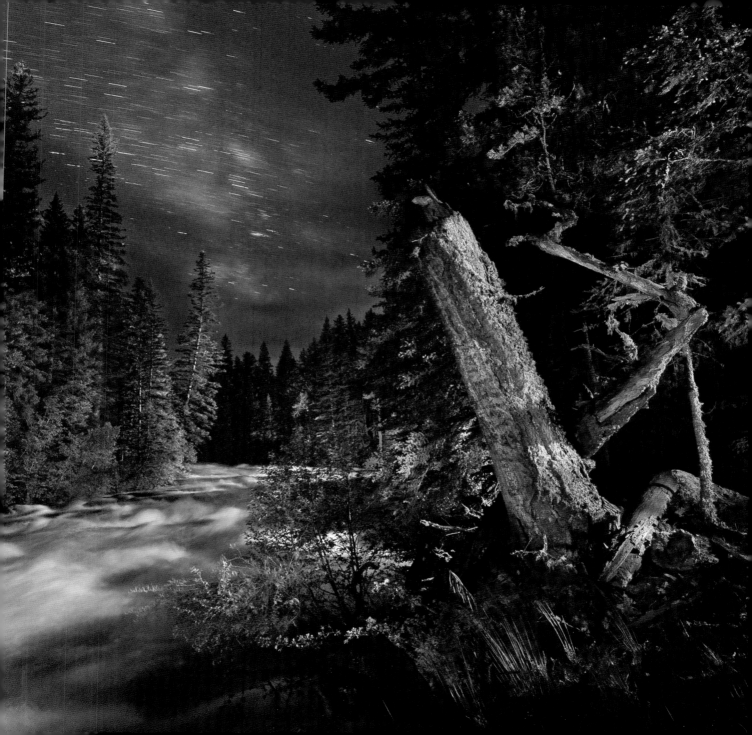

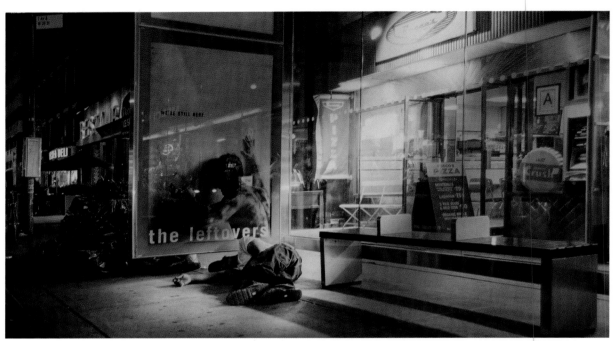

»STREETS **OF NEW YORK**

n this photograph, many layers add up to a complex nocturnal narrative. The homeless man with his arm sprawled out is beautifully juxtaposed against the bus shelter's poster, in which the man's arm is also outstretched. The words in the poster—"We're still here" and "the leftovers"— add another poignant layer of meaning to this image. In addition, the homeless man is bathed in an ethereal light while sleeping next to a pile of garbage bags—a contrast that completes the irony and the narrative beautifully.

The photographer paid close attention to framing, vantage point, details, and lighting. This is a complicated and meaningful photograph.

HOW TO LIGHT THE NIGHT

- **A lens hood is helpful** at night (especially in urban settings), as it will prevent unnecessary light from entering the lens and creating unwanted lens flare.

- **Mixed lighting—** whether flashlight, flash, or ambient light—vastly improves the final image.

- **If you find yourself uncertain** about whether to use color or black and white, shoot the image in color and convert to black and white in postproduction.

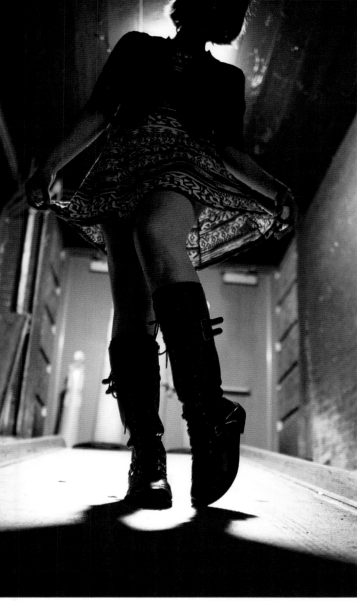

»A FLIRTY SKIRT

The conventional way to photograph a person would be to avoid cutting off the subject's head. This image throws convention aside and takes a more lyrical and whimsical approach to photographing people. The low vantage point is unusual and daring. The figure blocking the main light source creates an intriguing shadow, an interesting silhouette effect, and a beautiful backlighting effect on the skirt.

From this photograph we may not know this woman's exact identity, but the details of how this image is captured reveal an aspect of her personality. In photography, ambiguity is an asset—less is often more. The strong complementary colors of orange and blue create a dramatic backdrop to this unconventional and charming portrait.

HOW TO WORK WITH YOUR LOCATION

- **If you are taking pictures** that cannot be repeated, scout out the location beforehand, and be prepared for anything.

- **At night, and especially indoors,** check your white balance setting. "Auto" doesn't always get it right, so tweak the settings to get the effect you are after for each picture.

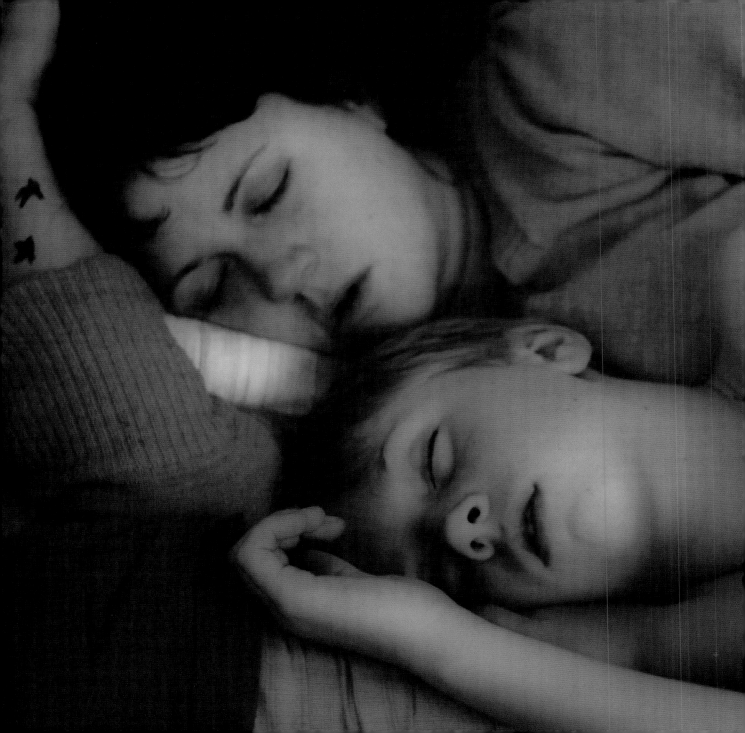

»SLEEPING BEAUTIES

You don't have to travel far from home to find suitable or intriguing subject matter. Photographing someone you know well often leads to new discoveries—and successful pictures. This image reminds us of the work of Gertrude Käsebier, a pioneer of photography who often shot personal themes, such as motherhood, in the late 1800s. The composition and lighting are excellent, but what stands out is the idea of photographing people asleep. This picture is soft, peaceful, dreamy, and suffused with tenderness and love. The sepia tone not only lends itself to a look of antiquity, but also contributes to the romantic quality of the image.

THE PHOTOGRAPHER'S STORY

"It's a Friday night, and we don't really go out with kids at home. While watching a movie these two fell asleep on the couch. My older son laughed as I set up the tripod and started taking photos of them. It's 2 a.m., and I'm trying out black and white with a sepia tone. You'll notice the bird tattoos on her arm. Two years ago we decided we needed more excitement in our lives, so I bought a Harley and she got tattoos. Life is for living." —Adrian Miller

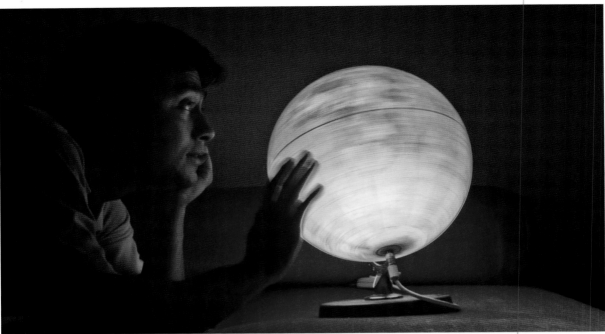

JOYDEEP DAM — DARMSTADT, HESSE, GERMANY

»AS THE **WORLD TURNS**

Photography can be literal, documenting a scene as it exists, or conceptual, which involves communicating a preconceived idea. This spinning, illuminated globe is a journey of the mind, with the spirit of discovery on the next horizon. We love that "dreaming" becomes the subject of a photograph. Our eyes go first to the spinning globe and its twirl of seductive colors. Next, we discover the warm glow that brings the man out of all that darkness. He has a dreamy glint in his eye, and his mind spins with thoughts of future travels and adventures. This photograph contains a well-executed conceptual narrative.

HOW TO CONTROL YOUR EXPOSURE

- **Your eyes adjust to darkness,** so what appears to be a good exposure on your LCD screen will actually be underexposed. If you have a DSLR camera, adjust your LCD brightness to the "–1" setting.

- **Learn to use the histogram feature** on your DSLR camera to check exposure.

- **A combination of stillness and blur** in the same frame can be an effective tool. Experiment with different shutter speeds and ISO settings in order to get the desired effect.

»SOLSTICE **SUNSET**

One of the first things we learn in photography is to keep the light source behind the camera. This photographer, however, bucked the rules and created a beautiful image. By shooting into the setting midnight sun, he creates a starburst effect and makes the glowing rays on the horizon even more dramatic.

He cleverly used a secondary light source on the woman and dog. Had he not done so, shooting into the sun would have rendered them as dark silhouettes with no detail at all. In the end, he created a powerful photograph that transports the viewer into this private yet majestic scene.

HOW TO SHOOT FOR THE STARS

- **Know the sunrise,** sunset, moonrise, and moonset times, along with the phases of the moon, before you go out to shoot.

- **Use apps to learn** about the positions of stars, such as when a galaxy will be in the correct part of your frame.

- **Use fill flash** to light people against a bright sky. Just a hint of light will make your picture look realistic and natural.

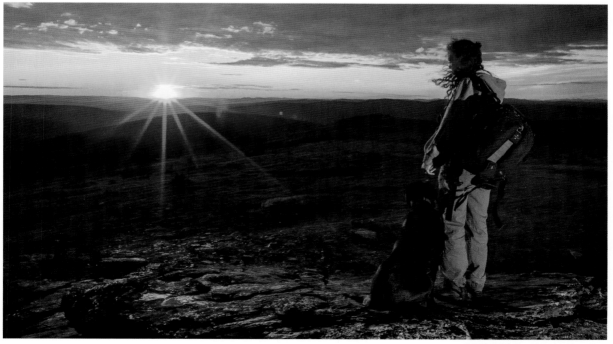

RONN MURRAY — FAIRBANKS, ALASKA

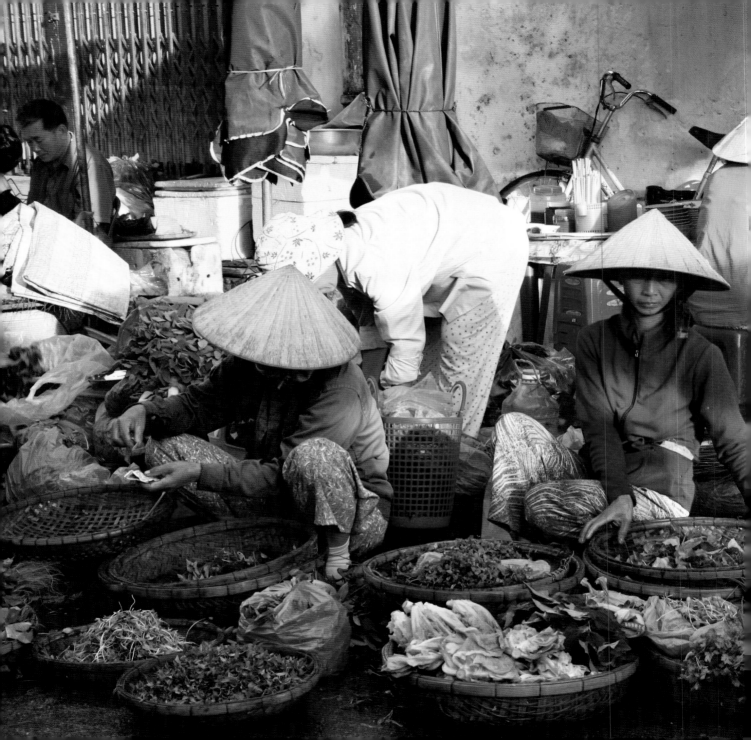

FOODSCAPES

BY PENNY DE LOS SANTOS

AN INVITATION TO DINNER

Photography has always been my way into the lives of people, whether they are a family sharing a meal in the Mediterranean, a group of farmers harvesting grapes in northern California, or the elder ladies of a Sicilian village drinking wine and cooking. Food and the moments that surround it are incredible ways to dive into a community and to discover stories and real human moments.

In this assignment, try to capture what you see at the crossroads of food and culture. Foodscapes are about so much more than showing what's on the plate. They tell the story of the landscape of food from table to farm and beyond. They are about everything that surrounds food, especially the connections that happen before, during, and after a meal.

Two things come to mind when I think about shooting great foodscapes. First, I want to be where the action is. I want to stand wherever the energy in a scene is most intense. And when I'm there, I wait with my camera to my eye. I am waiting for a moment. Maybe it's fast-moving cooks, slinging pans and yelling out orders in the kitchen. Or maybe I'm on a step stool so I can hover above a crowded table and capture hands grabbing for bowls and plates. My point is, put yourself where the action is—not ten feet away from it, but right in front of it.

The second thing I think about is how the scene feels. Is it chaotic, empty, lonely, or happy? As a photographer you should aim to capture that feeling. Think about the creative devices you can use to create mood in a photograph: lighting, motion, details, and so on.

What I love most about photographing food culture is its powerful storytelling ability. Food can tell us so much about history, culture, and ourselves. Next time you sit at a table in another culture or community, think about the story behind what is on your plate—who made it, who grew it, why it matters. Think about those moments, then grab your camera, and go.

ABOUT THE ASSIGNMENT EDITOR

Penny De Los Santos, FOOD AND TRAVEL PHOTOGRAPHER

An American born in Europe, with a family history tied to the Texas-Mexico border, De Los Santos began photographing as a way to explore her diverse cultural background. She has traveled on assignment to over 30 countries.

SOMA CHAKRABORTY DEBNATH — WEST BENGAL, INDIA

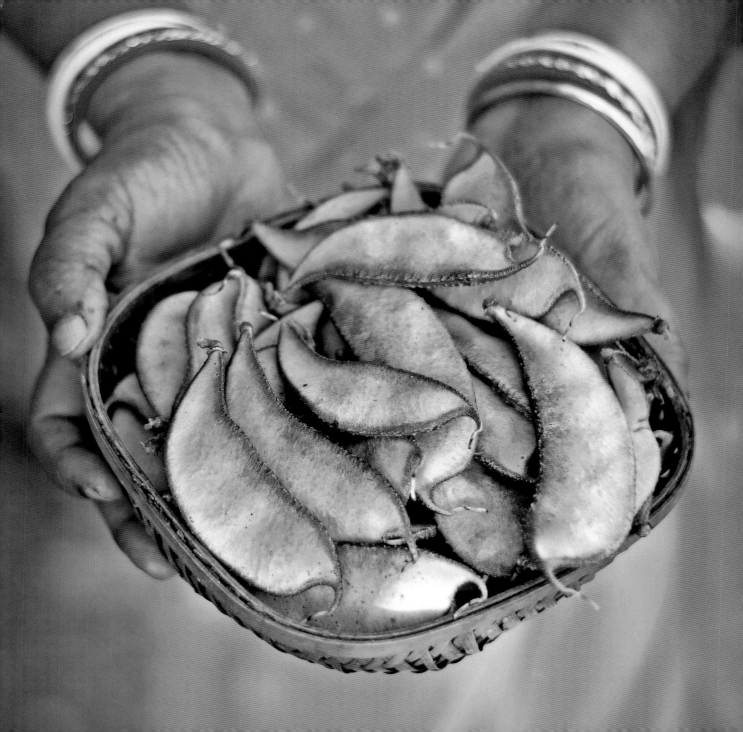

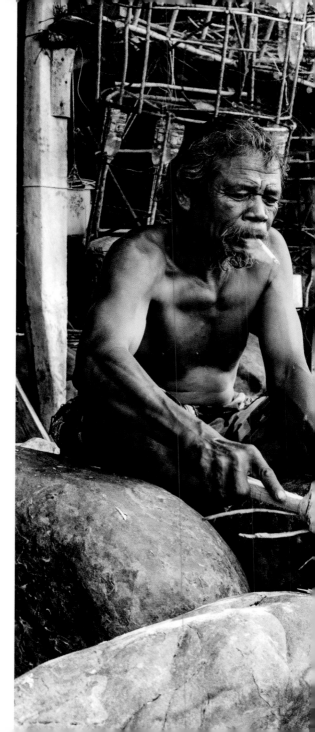

»SEA **GYPSIES**

When I am shooting a story about food in a foreign country, or even in my own backyard, I love to head straight to where the cooking is happening. That's what is so great about this image: It takes me immediately into these men's world. The fishermen are shirtless as they cook their meal. They are surrounded by boulders and hanging fishing cages. The exposure allows the viewer to see everything, from the veins in the men's bare arms to the smoke rising from the obscured fire. This image grabbed my attention and made me want to know more. It tells a story, informs the viewer, and beckons us to ask questions.

HOW TO CAPTURE FOOD AS CULTURE

- **Look for unusual people** or interesting jobs. Then spend time cultivating trust so you can gain the access you need.

- **Follow your subjects** throughout their day and search for unique moments.

- **Where there's smoke** there's fire, and a great shot. Follow the flames to find the action.

KÁRI JÓHANNSSON — KRABI, THAILAND

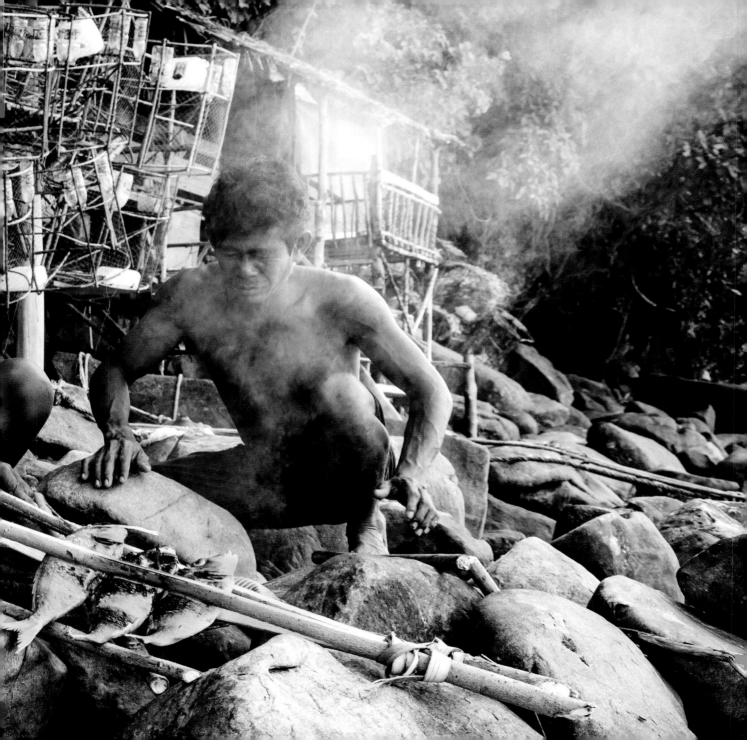

»FEAST **FOR THE EYES**

From any other angle this moment would be straight-forward and expected, but shooting from overhead created a graphic composition that celebrates the background and the bright colors of the food. As observers, we feel privileged to be allowed inside a scene we might not normally experience. This image feels almost voyeuristic. From above you can also appreciate the texture of the ground and the beautiful arrangement on the platter. The person wears colorful and uniquely formal attire, which serves as a backdrop to the food. This is a photograph of ingredients, but the unusual perspective in this image heightens the experience.

HOW TO CAPTURE A UNIQUE VIEW

- **Walk around** the food subject 360 degrees before shooting.

- **Look at the food from overhead,** from a three-quarter view, and from a side view and decide which way the food looks the most appealing.

- **Capture unusual details** around food, such as: condensation, color, textures, weathered hands, beaten-up knives, old cutting boards with dark patinas, etc.

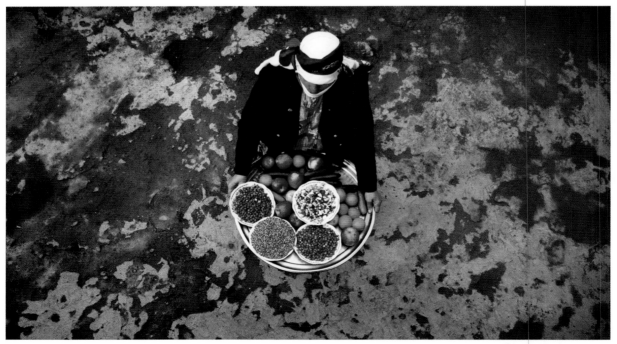

ALI HAMED HAGHDOUST — LEQALÃN, EAST AZERBAIJAN, IRAN

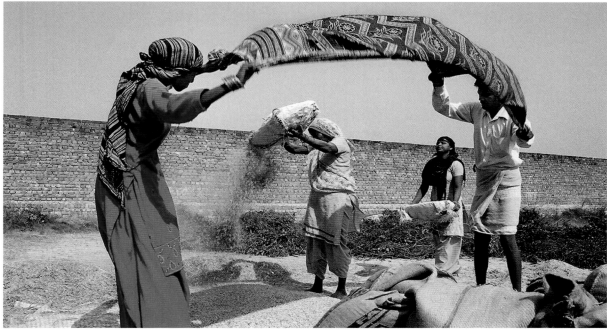

»IT TAKES **A VILLAGE**

ooking at this photo is like watching a dance with every character in place and helping to tell the story. There is so much movement and energy in this frame. The bright red color of the woman's dress draws us in to the action.

To make a great storytelling photograph, look for a rare scene, and then elevate the moment by anticipating and thinking about your composition. Try to include elements that create a backstory for the action. In this case, the photographer used framing and layering to create context and visual interest.

HOW TO TELL A VISUAL STORY

- **Try to think ten steps ahead** of where the subject might go at all times.

- **Capture the food** before it's on the plate. Show the harvest, the cooking, and the preparation.

- **If possible, layer images** with movement in the background. This will add weight and interest to your composition.

- **Get down low** to convey intimacy and perspective.

- **Use your subjects** as a way to frame the action.

»FISH FOR SALE

The power of this image lies in its details: the thin white fish, the wet surface, the dark arms, the hands in motion, the primitive scale, and the bare dirt floor as a backdrop. These elements give tremendous emotion and tension to the frame. The photographer's use of perspective—photographing the image from overhead—makes for a graphic and clean image. The black-and-white palette strengthens the image by allowing the shapes and tones to set the mood.

Shooting in black and white can transform a so-so image into something entirely different. Black-and-white photography is much more forgiving than color and allows the photographer to focus on composition, light, and tone—a liberating practice.

THE PHOTOGRAPHER'S STORY

"Among the shouting of the fish and vegetable sellers, in this chaotic riverside market, I found solitude and beauty in these simple circles. A few tiny fish provide an affordable protein. This is likely this family's one daily meal of fish curry, spooned over a hearty portion of rice."
—Joshua Van Lare

YANGON, MYANMAR

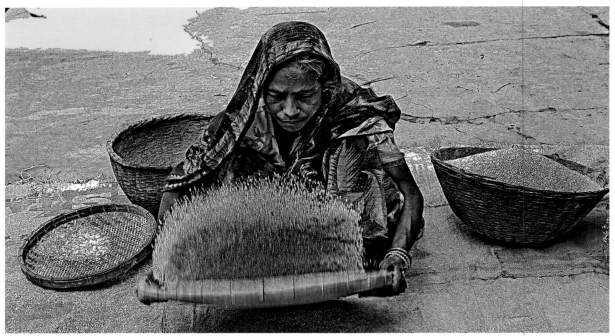

SRIMANTA RAY / A TRADITIONAL METHOD OF CLEANING RICE — KAILĀSHAHAR, TRIPURA, INDIA

»THE RITUAL **OF RICE**

E very image has a decisive moment. Some, like this one, are more obvious—the photographer captured the exact millisecond when grains of rice were perfectly suspended in midair. Other moments are harder to anticipate. When you come across a scene, step back and really think about when the decisive moment will happen. Remember that the moment can be quiet and soft, or it may hit you over the head. The image can have several layers and a complicated composition, or, in this case, it can be quite simple. The idea is to hone your ability to know when to wait for it and when to try a different approach.

HOW TO MAKE SIMPLE PHOTOS SAY A LOT

- **Think about** what you are trying to say in a photograph. What is your point of view?

- **If your subject is doing something** while preparing food, stick with it and look for pauses or breaks in the routine. Try to anticipate the photograph.

- **Don't be afraid** to shoot simple, quiet photographs. Sometimes they speak the loudest.

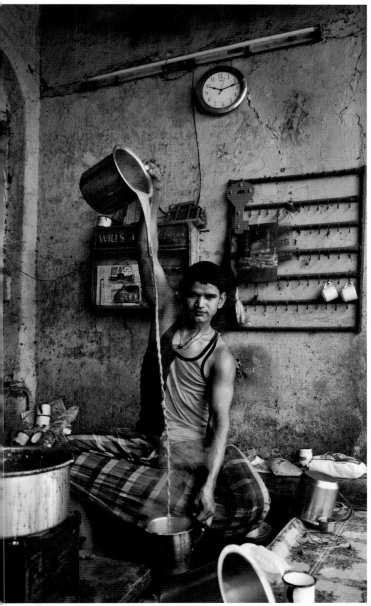

MITUL SHAH — AHMEDABAD, GUJARAT, INDIA

»THE TEA **MAKER**

The colors and details in this scene tell such a compelling story. I love how the teal background, the yellow shirt, and the hints of red make this image jump. This *chai wallah,* or tea maker, is in his own environment, and you can feel it in all the details—the cups on the table, the turned-over kettle, and the clutter of his work surrounding him. The photographer has captured the subject's mood so well. Even if the wall weren't such a vivid color, the subject would still stand out because of the intense expression on his face. This young man clearly takes great pride in his ability to perform this feat and to do his job well.

HOW TO MASTER FOOD PORTRAITS

- **Identify someone** who is interacting with the food and has striking features or an interesting expression.

- **Take time to study the person.** Contemplate how you will make a portrait of your chosen subject and what role the food will play in the photo.

- **Try to use all the elements** of composition, color, light, and moment to make a portrait that is expressive, moving, and evocative. Portraiture is a hard skill to master, but with practice you can get there.

135

»HOT FOOD ON A COLD DAY

This image invites me to travel to a different place, to learn something new, and to see something in a unique way. It is evocative and thought provoking, and it makes me ask so many questions. This portrait captures a true moment in a market scene where visual elements are constantly shifting. In this case, the setup of the food, the steam, and the woman's clothing and gear come together to tell this woman's story. The woman's body language is non-emotive, but the intensity in her eyes speaks volumes. The use of color and light create mood for this image. It takes time and hard work to recognize moments like this, but when you find them, it is worth all the waiting and searching.

THE PHOTOGRAPHER'S STORY

"Even in the below-freezing temperatures of wintertime, there are always food vendors doing business outside in Harbin, China. That's because Chinese people take meals and eating very seriously. No one misses a meal no matter where they are—or, for that matter, how cold it is."
—Wesley Thomas Wong

HARBIN, HEILONGJIANG, CHINA

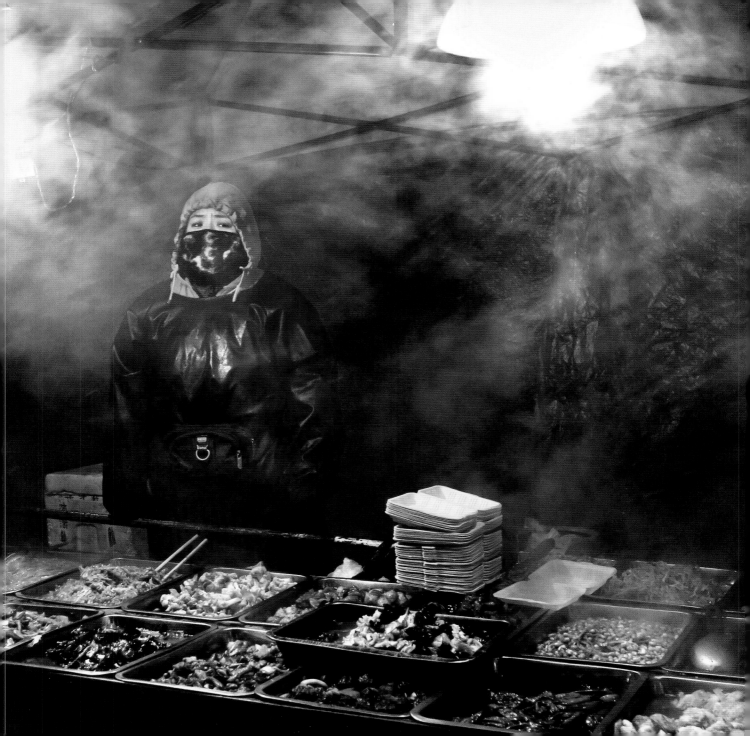

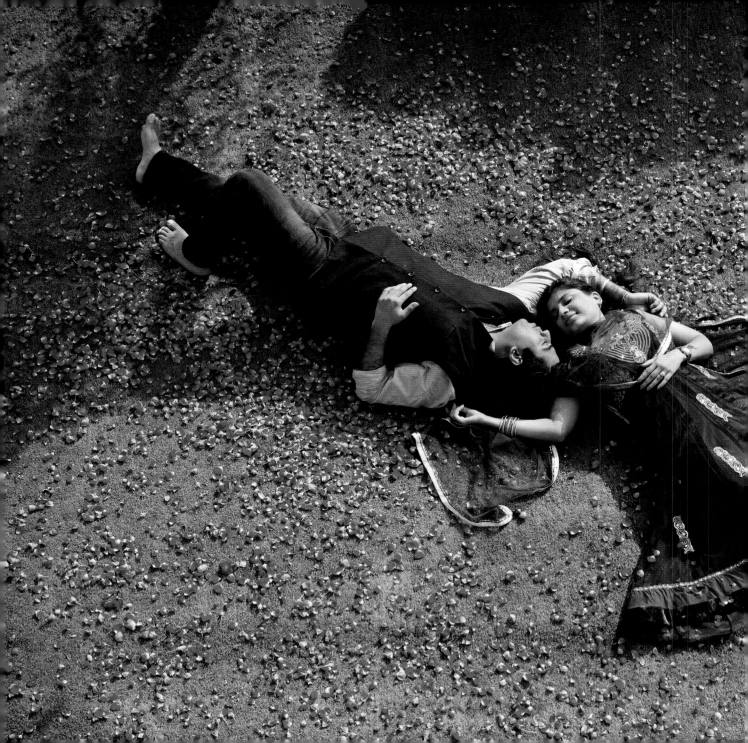

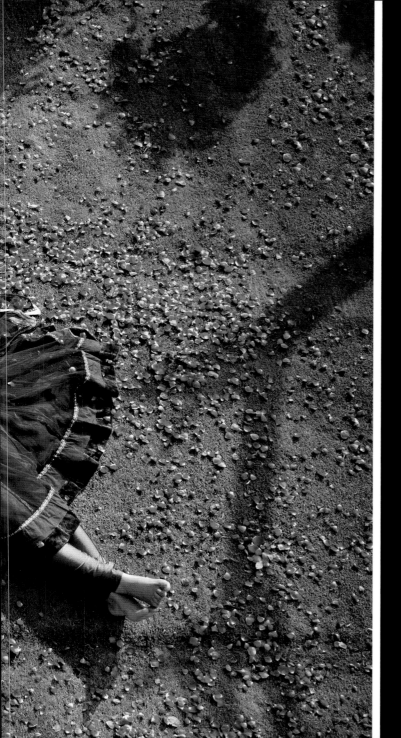

LOVE SNAP

BY LYNN JOHNSON, ELIZABETH KRIST & MAGGIE STEBER

SHOT THROUGH THE HEART

ove. We often use this powerful word so casually. Stop for a moment and consider what love actually means to you. Now is the time to turn words into images. Who or what makes your heart sing?

Photography is a powerful voice for all things, physical and metaphorical. How can the people and things you love be expressed with light, movement, and color? Stop and close your eyes. Conjure up the situations that bring out your deepest feelings for your chosen subject. Is it when your husband cooks you breakfast or your wife tucks your daughter into bed? When your mother practices the cello? Or when your dog runs through the woods? What time of day is it? What is the light like?

We live in a Hallmark world, filled with candy-coated images of love. These are not the images that make great photographs. A great photograph is timeless, purposeful, balanced, energized.

Pretend you need to make one new frame of someone you love, to bring with you on a long journey. But you are absolutely forbidden from making the classic snapshot—no standing at eye level and shooting a head-and-shoulders frame straight on. Try catching your beloved in motion, or shoot from different angles.

We want to goad you into a deeper originality, a raw authenticity going beyond the slick, idealized ads promising love in impossible ways. Don't settle for anyone else's ideas. Only you can create your own true vision of love.

ABOUT THE ASSIGNMENT EDITORS

Lynn Johnson, NATIONAL GEOGRAPHIC PHOTOGRAPHER, **Elizabeth Krist,** *NATIONAL GEOGRAPHIC* MAGAZINE, **Maggie Steber,** NATIONAL GEOGRAPHIC PHOTOGRAPHER

Featured in the introduction to this book, Johnson (left) has been photographing the human condition for 35 years. A National Geographic photography fellow and a "Woman of Vision," she is a regular contributor to the magazine.

A senior photo editor, Krist (right) curated Women of Vision, a traveling exhibition at National Geographic. She also judges competitions, teaches workshops, and reviews portfolios at photography festivals.

Also named a Woman of Vision by National Geographic, Steber (left) is an award-winning documentary photographer who has worked in 65 countries and has been a contributor to *National Geographic* magazine since 1988.

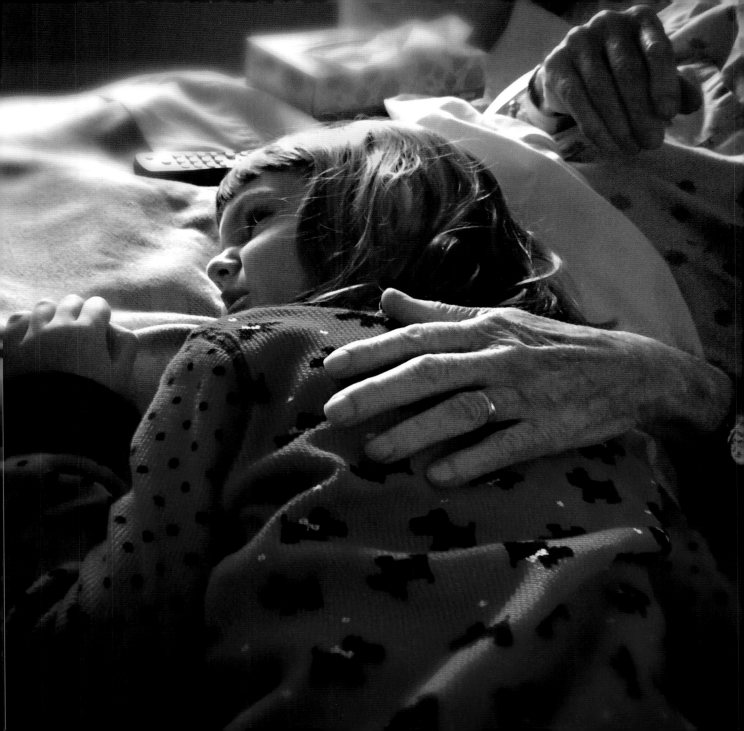

»ARTISAN'S BALL

On fields and patches of grass all over the world, children play soccer for the love of the game. It is a completely democratic sport, open to everyone. Economics has nothing to do with it. Children who can't afford real soccer balls make them from anything they have—a rag, a sock, or a tire. Sometimes they are made of plastic or even bark, which can be weaved into a ball. As long as the ball rolls, it's perfect.

You can feel the love and care the boy has put into this ball. It represents initiative, planning, pride, and problem-solving skills. Each ball is a unique signature of the person who made it. This simple photograph tells a big story.

THE PHOTOGRAPHER'S STORY

"Timamo, my 15-year-old neighbor, rushes home, completes his chores as quickly as possible, then begins constructing his soccer ball. Every child has his or her theory/process on making the best ball possible. This is Timamo's." —Rafael Hernandez

PEMBA, CABO DELGADO, MOZAMBIQUE

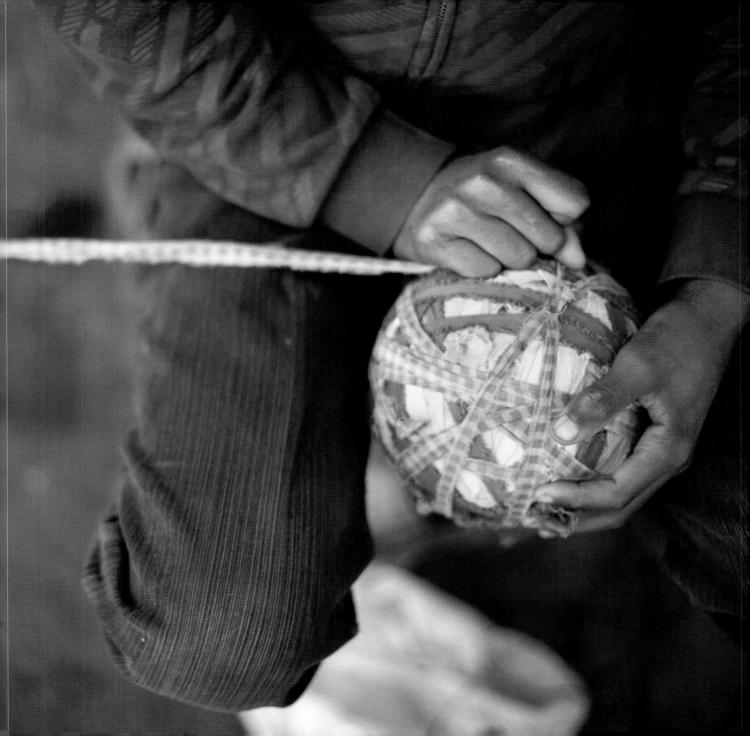

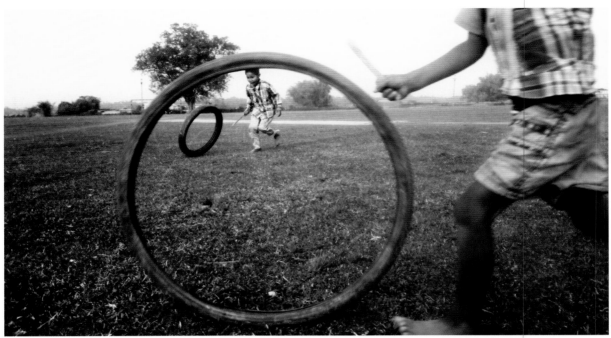

»PLAYING **HOOPS**

Children love their toys, even if the toys don't always cooperate. These boys skillfully guide old bike tires as hoops. It's a joyful battle for control over the tire. This photo has so many things going for it: the composition, the frozen action, and, most important, the story. Children in developing nations play with whatever is available. Running hoops down the road is a common game in many cultures—one of those universal experiences that transcends borders and cultural boundaries. These kids may have limited choices, but the joy they feel while playing is limitless.

HOW TO EVOKE FEELING

- **Create mood** by using different tonal ranges with digital files—from saturated color to sepia—as this photographer did. The sepia tone alludes to a memory and evokes a feeling of nostalgia.

- **Look for interesting ways** to frame your shots. This photographer captured the exact moment when one boy was framed by the other's hoop.

LORI COUPEZ — CHICO, CALIFORNIA

»A CUB **IN HIS DEN**

Which is more popular, pictures of cute animals or pictures of cute kids dressed up as animals? I chuckle each time I see this photograph. This little baby, all dressed up in his bear outfit, is smiling at his mother, who is out of the frame. He is joyful at seeing her, and she is, no doubt, smiling back at him. The warm lighting sets the mood for this photograph. We can see by the baby's face that he and his mother love each other deeply. We dress up babies because it piques our own imaginations and our hopes for our children. This little bear sitting in his pen, with the world on the wall at his back, is a story in the making.

HOW TO CREATE EVEN LIGHT

- **The lighting** in this scene is called high-key lighting, which creates a joyful or playful mood. One way to achieve this effect is to raise the ISO so you can hold the camera by hand.

- **Choose your frame and compose it.** The composition and framing in this photo makes the photo informative and even funnier.

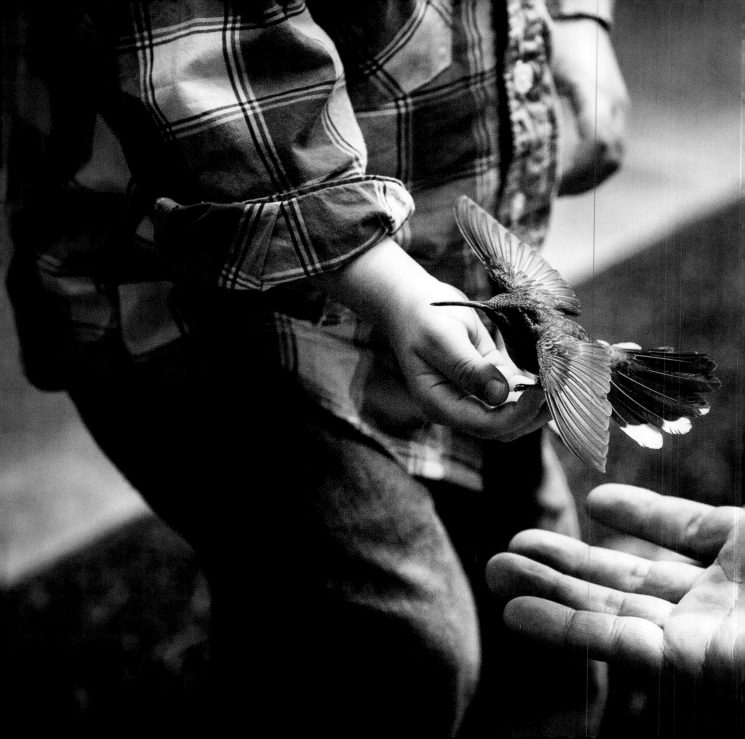

»LEAVING THE NEST

've liberated or tended to small birds and baby owls in various places. Once I bought a sea turtle and returned it to the sea. Releasing these animals gave me the most indescribable feeling. I had freed something to go back to its happy life in the sky or sea. This photograph of a father and son helping an injured hummingbird is about the love of freedom and the honor of holding something wild for a fleeting moment. It also shows a tender, unforgettable moment between a boy and his father.

THE PHOTOGRAPHER'S STORY

"This picture was taken on a picnic day. We found a wounded hummingbird that flew and crashed on a window, and my husband picked it up and I started taking pictures. When my husband was showing it to our son, the bird opened its wings and the moment was captured."
—Karla Maria Sotelo

ARTEAGA, COAHUILA, MEXICO

»A SPIRIT SONG

This young man is singing his heart out and seems to be transported to a more spiritual place. Love appears to pour out of him, with his voice and body dedicated to the power of his emotion. In the shadows we see the rest of the choir, creating a backdrop that makes the image even stronger. Shot at the peak of the boy's song, the photograph's tone is moody and serious, yet joyful. The composition also works to isolate the subject while keeping important information (the choir) in view. This photograph tells a deep story that's as old and universal as time.

HOW TO SPOTLIGHT YOUR SUBJECT

- **A telephoto lens** gets you closer to the action and stacks up things in the frame for a layering affect.

- **Expose for the light** hitting your subject while being mindful of the background.

- **Try bracketing your shot**—testing several different exposures to capture the desired lighting and the elements you wish to include in the frame.

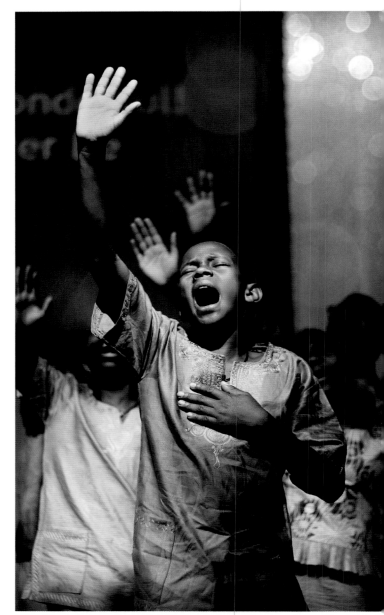

BRANDY METZGER — SHREVEPORT, LOUISIANA

»ON THE **LOOKOUT**

We are witnessing a memory in the making in this photo. This image reminds me of being young more than any other photograph in this collection. It is about youthful curiosity and the love of new experiences. Lyrical and soft, the young woman in this image seems to be longing for something or someone. Or perhaps she is seeing a new view of the world for the first time. The power of the image lies in its simplicity. The lighting and composition tell the whole story without ever showing the subject's face. It's all in her body language—a spontaneous, happy, carefree moment of discovery.

HOW TO CREATE DREAMY PHOTOS

- **Not everything has to be sharp.** Shooting with a wider aperture allows for creamy light and a dreamy background. Meter for the subject, and let any other light blow out to create a moody seascape.

- **Where you focus** determines the subject of the photograph. The focus is on the girl, not what's outside the window.

»THE FIRST **KISS**

There is only one first kiss after a couple marries. We fall in love if we are lucky. Many of us see ourselves walking hand in hand toward our lives together, on a road laid out before us. Sometimes it works out, sometimes not, but there are always love and hope at the beginning. For this couple, it is an intimate moment, shielded by her veil and made dreamy by light coming from behind. We see their faces and enjoy both the shelter and the mystery behind that veil. The toning colors are both warm and cool, and the soft focus on the couple adds to the mood of the photograph. This photograph is a great example of the wedding fantasy because it's about love and romance and the sense of possibility.

HOW TO GET GREAT WEDDING PHOTOS

- **Avoid posed photos** of the guests at the reception. Take candid shots that make the viewer feel like part of the action.

- **Take some risks.** This photo is backlit and shot through the veil, but it's very moody and romantic. These are the photos that you and the couple will cherish.

- **Weddings are fun and joyful.** Stretch beyond portraits and capture the mood with lighthearted or zany photos.

PETER FRANK

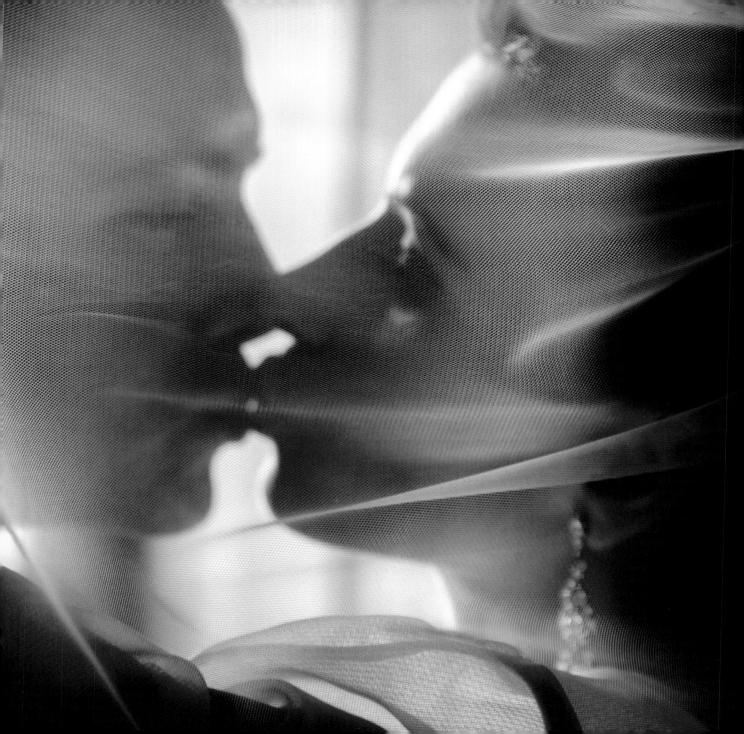

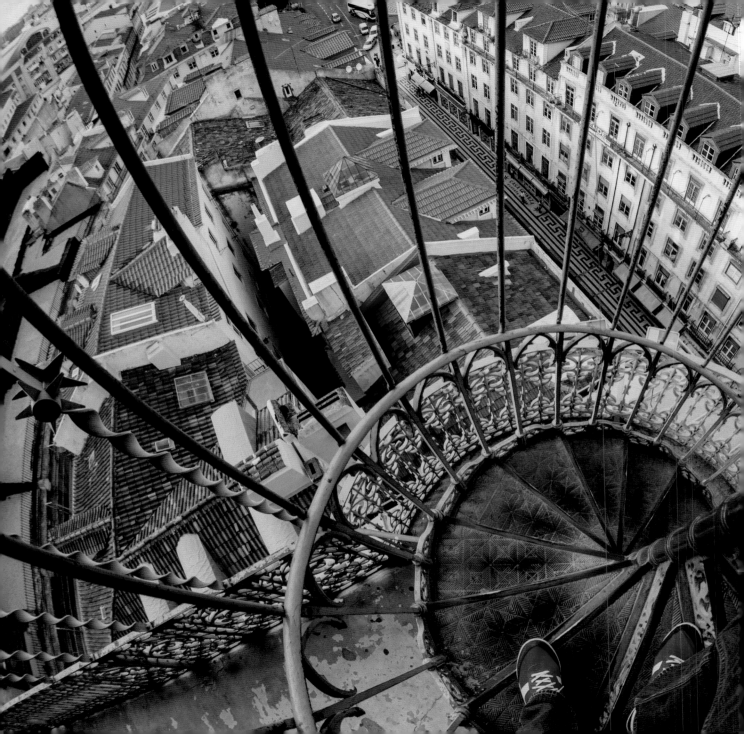

I HEART MY CITY

ANDER AGUIRRE — LISBON, PORTUGAL

BY SARAH POLGER

AN URBAN LOVE AFFAIR

"**Y**ou're going where? Don't even think about leaving without seeing . . ."

In our favorite cities, we all have cherished corners, hidden gems, and secret standbys. Whether it's your hometown or your home away from home, there's a place in the world that comforts, challenges, and excites you.

But how do you capture the essence of your city? What makes it different from any other place in the world? How do you show those moments when the day slips away and, for a second, the soul of the city seems alive in the scene before you? The way the light falls on the buildings just so, the way locals greet each other in the street, the aromas carried on the breeze . . .

At National Geographic we like to explore new destinations and to rediscover the classics. And with hundreds of thousands of cities in the world, there's always something new to learn. That's why we started the feature I Heart My City on our travel website *(travel.nationalgeographic.com)*, where locals share insider intelligence about the places they know and love best.

Cities are, in many ways, living organisms. Stunning architecture, breathtaking gardens, busy traffic, and bright lights make for strong photographs of cities, but the people are the true life force. Without people, cities would sit still, glistening with the promise of adventure never fully achieved. Take photographs that highlight the personalities and people that make the city come alive.

The experience of visiting a city can be difficult to capture. So bypass the standard tourist photos and take your camera down that narrow cobblestone alley or to the best restaurant in town. Show your city how you see it, whether you're shooting the well-worn path, the local haunts, or the coolest music festival in town. When you show your photos to friends and family members back home, you want them see what made you fall in love with this city and why it still makes your heart skip a beat.

ABOUT THE ASSIGNMENT EDITOR

Sarah Polger, NATIONAL GEOGRAPHIC TRAVEL

With more than 12 years of experience in visual storytelling, focusing on multimedia and digital platforms, Polger has a passion for crafting engaging stories in real time and helping us explore and understand our world.

KARL DUNCAN — AMSTERDAM, NETHERLANDS

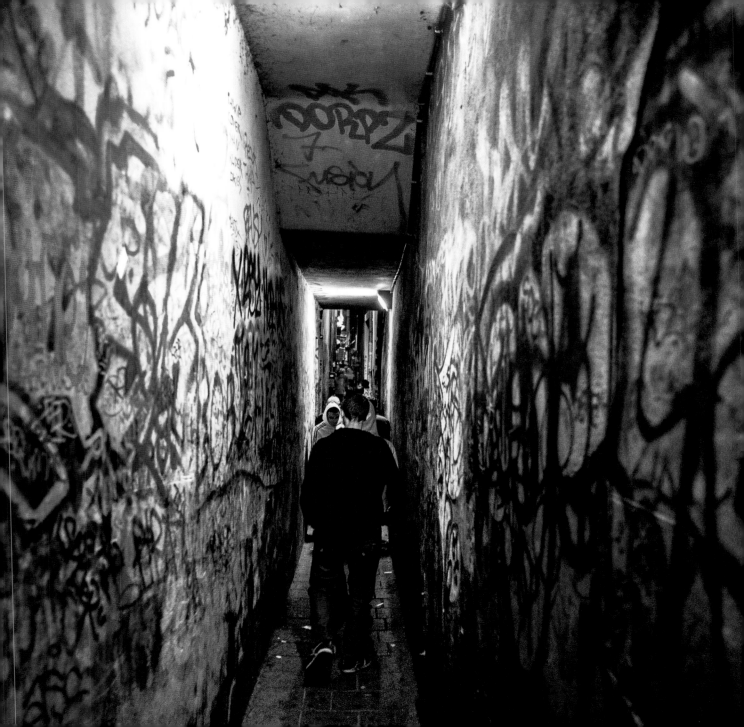

»TURKISH **COFFEE**

No one is looking at the camera in this scene. All of the patrons and workers are in their own worlds, and the viewer feels a bit like an interloper, or perhaps a tourist, in a coffee shop in a foreign city. The shop's geographic location emerges from the details—the design of the tile floor, the server, and the style of the coffee being served. The viewer may guess that this photo was taken in Istanbul. The angle and height—created by the vantage point of a staircase—allow us to see more of the environment and the patron interactions than if the image had been shot on the main floor. The resulting shot captures an authentic moment in this East European city.

THE PHOTOGRAPHER'S STORY

"This is a tiny hole-in-the-wall coffee shop on the Asian side of Istanbul. It has existed for years. I am passionate about their product, their service, and their history. Does it get better than this? It's real. It's nongeneric. It's nonhipster. The coffeehouse was a gem of a discovery, and the photo even more so. I discovered this angle for the shot when heading up the tiny stairs to the restroom!"
—Philippa Dresner

ISTANBUL, TURKEY

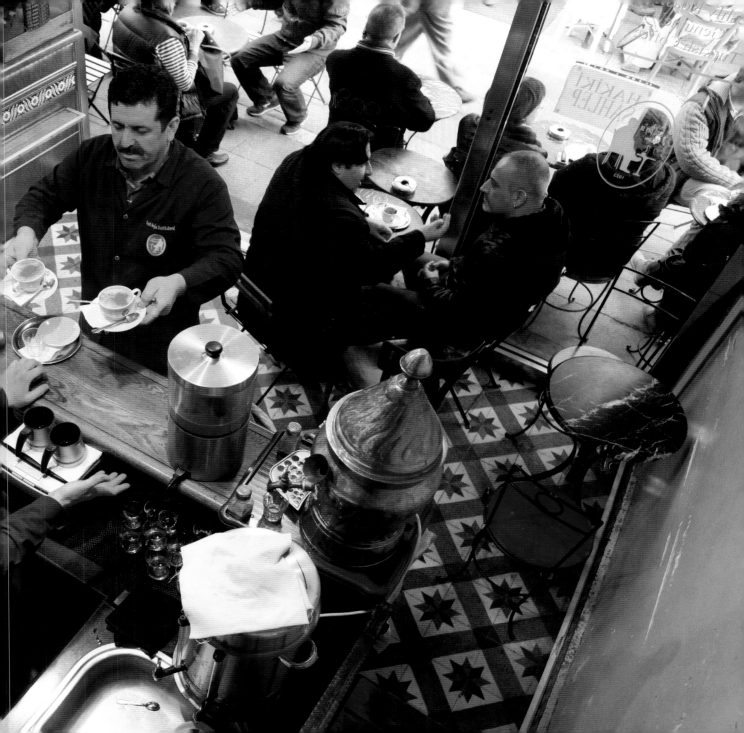

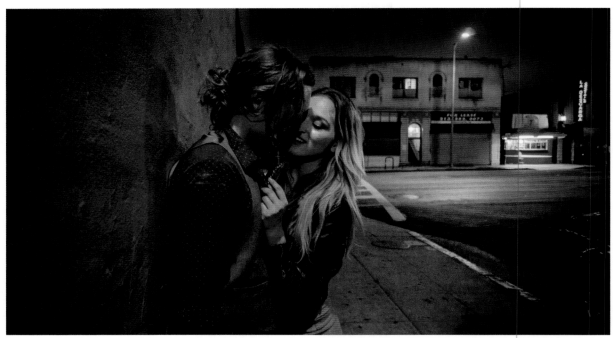

ANDREA JAKO GIACOMINI — LOS ANGELES, CALIFORNIA

»LOVERS' LANE

You can feel the grit of the street, the sweat of the night, and the sensuality of this couple. The way that the pair is framed against the barren street and the lone street lamp creates a sense of time—likely very late at night—and immerses viewers in the intimacy of the moment. Brash, contrasting colors dance throughout the picture. The couple is bathed in green light, suggesting both envy and lust. And the woman's lipstick red skirt pops from the bottom of the picture. Hair hides the man's face and creates a space for a private kiss soon to come. The viewer is left to guess how the night began and how it might end.

HOW TO SHOOT WIDE

- **This is a scene** where you crank up your ISO, open your aperture, and keep your hands very, very steady.

- **The photographer** used a wide-angle lens. The wide aperture helped achieve the necessary exposure and allowed for the wall on the left and the street lamp on the right to fit into one picture.

- **Think about color,** texture, and mood. These elements are not arbitrary in a well-thought-out image.

»SHANGHAI **NIGHT**

Using a long exposure to capture cars rushing by on the highway is a common photographic technique, but the photographer elevated this city scene, literally and figuratively. The headlights draw the viewer into the scene and create an alluring blood flow through the raised highway. The warm magenta hues, which seem to seep into the roadway, create an electric and vibrant mood. We can almost feel the thump of the city's heart, the whir of cars racing by, and the excitement of people dashing to their nights out. The photographer actually had to shoot this scene from a distant perch, but he puts the viewer right inside the action.

HOW TO MAKE A RIVER OF LIGHTS

- **Night photography** almost always requires longer exposures. Here the photographer left the shutter open, allowing the city's ambient lights to bleed into the night sky.

- **Use the graphic elements** in your frame to lead the viewer's eye. Here the roadway and lights weave into the night and create the sense of being drawn into the scene.

- **Do you want your scene** to be bright? Dark and moody? Adjust your aperture and ISO to meet your goals. To ensure streaming lights, use a shutter speed of 1/15th of a second or slower.

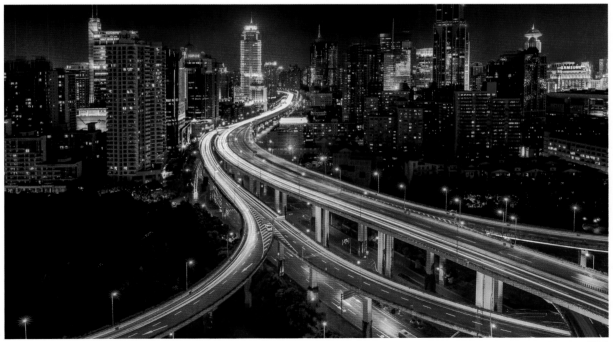

BIN YU — LUWAN, SHANGHAI SHI, CHINA

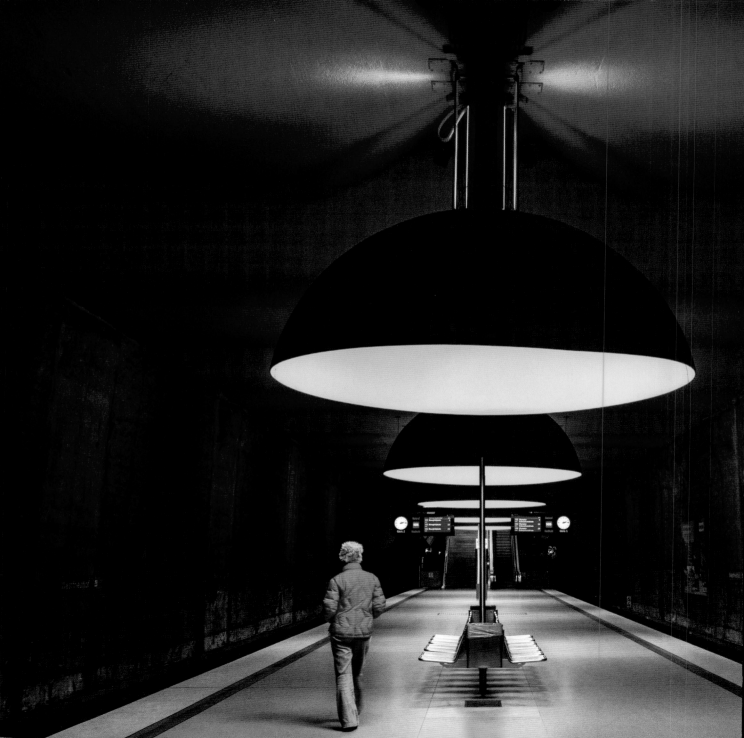

»SURREAL **SUBWAY**

Munich's subway system is full of uniquely designed elements, creating a vibrant and photo-ready transit system. The subway is a popular subject for tourist photographs, but this photographer spied a unique scene and made it entirely his own. He waited for a lone figure to hover, waiting on the platform for the next train. The giant orbital lights cast a yellow haze over the person and create a scene that is at once lonely and playful. Is this person alone, or is she a character in a sci-fi movie with a UFO ready to beam her up?

HOW TO GET GREAT TRAVEL SHOTS

- **Don't be afraid** to open a tripod in public. Set up where you need to, and take your time until your moment arrives.

- **Tourists often** take photos they are "supposed to" take but forget to document the real-life elements of their visit. When you travel, immerse yourself in the city and capture mundane moments—such as subway rides—and you'll have more honest pictures when you return home.

TONY RAMOS — MUNICH, BAVARIA, GERMANY

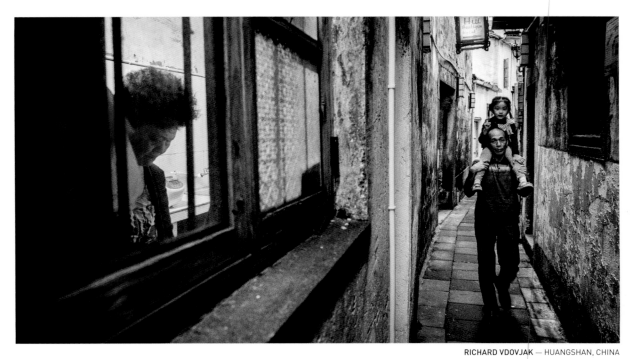

»WHEN PATHS CROSS

When exploring a city, wander off the main street and you'll often find the city's most authentic parts. That's what this photographer did before stumbling into this scene. He relied on a wide-angle lens to capture both the woman in the window and the man walking with the girl on his shoulders. While the man and girl stare directly at the photographer, the viewer is left to wonder what the woman in the window is doing. Two separate worlds collide in one photograph in a narrow alley. Are the people connected, or are they strangers?

HOW TO CAPTURE A SLICE OF LIFE

- **Daily-life scenes** make some of the best travel photos because they are relatable and authentic.

- **Stay aware** and scout your location. You never know where a great photo might pop up.

- **Use wide-angle lenses with caution.** They are both a blessing and a curse. The exaggerated angle can capture extra elements in tight scenes, but it can also cause subjects to appear stretched and abnormal.

»FOGGY AUTUMN

Fall is a season that beckons us to take beautiful pictures. When the feeling strikes, heed the call. This picture is a reminder that cities and nature can exist in equilibrium. The urban environment suddenly becomes a charming nature scene, as the morning mist blends with the yellow and auburn hues. The fence and street remind us that we are in a city, where the monotone color palette wraps itself around the lone pedestrian. The photo seems to invite us to stroll alongside the woman, who adds a needed human element to the frame. The light is key to making this photo work. Get up early, wander in the city, and you'll likely find a picture waiting to be taken.

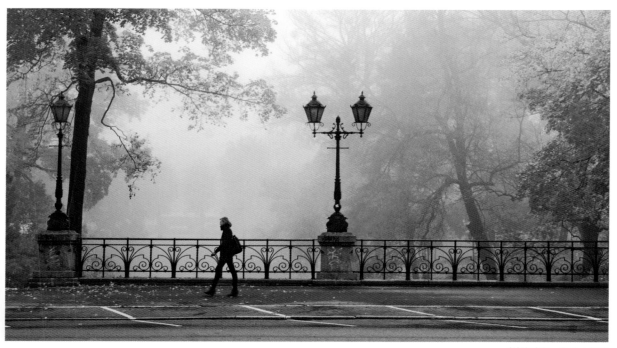

SIGITA SICA — RIGA, LATVIA

» COCKTAILS, ANYONE?

One of my favorite ways to get to know a new city is to eat. Food reveals the underbelly of the city. Lately, everyone is taking snapshots of dinner plates. So mix it up and try taking pictures of the restaurant experience instead. The servers, the architecture, and the bartender are often more interesting than what's on your plate. While dinner may seem like the most interesting photo op, light is actually best during the day. So go to lunch or get a mid-afternoon cocktail. You'll get good light, and the restaurant will likely be less busy than it would be at dinnertime, so the waitstaff won't mind if you hang out for a while to get a great picture.

THE PHOTOGRAPHER'S STORY

"One of the best parts of my city of San Francisco is the way the city has allowed for so many artists to follow their passions—whether it is photography or making fancy cocktails. I love popping into the studios, restaurants, and bars to see what new creative juices are flowing."
—Mat Rick

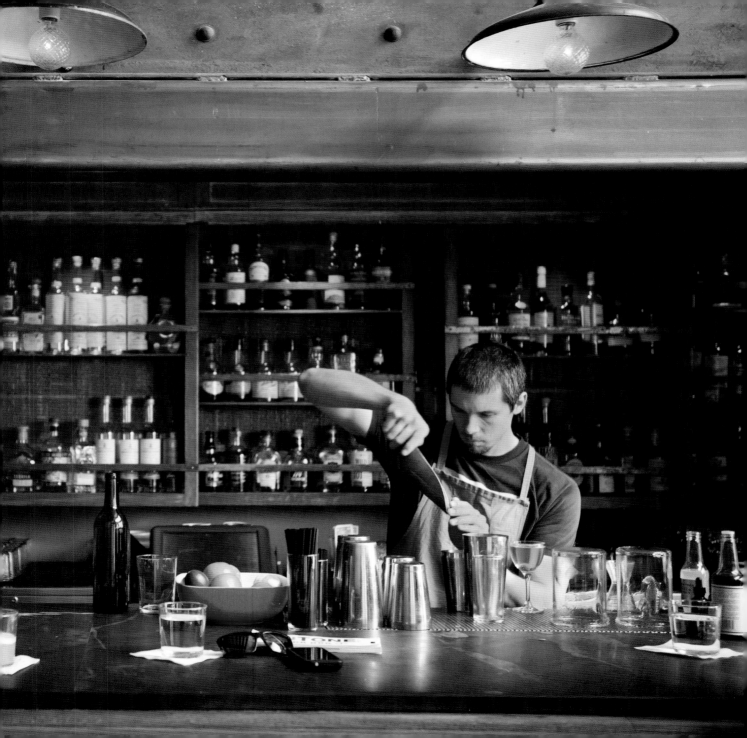

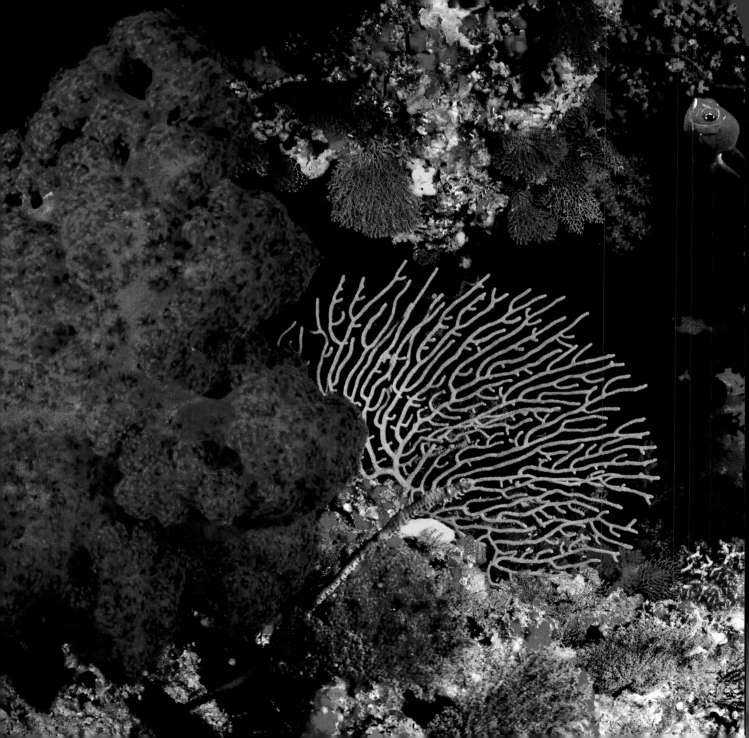

BIODIVERSITY

BY DAVID LIITTSCHWAGER

BEAUTIFUL LIFE

've always wanted to take pictures that mattered. I want to capture images that the world has a use for. Somewhere along my journey, I discovered that beauty is a tool that draws people in. And it can be used to attract attention to and illuminate important issues, such as the impact of biodiversity on the future of our planet.

We need to present the world the way it is. It is full of death and destruction for sure. But we also need photographs that celebrate our planet's natural beauty and inspire people to protect it. This assignment is about capturing biodiversity—the millions of plant and animal species that inhabit different environments. Where do you see nature teeming with life? Your sample size can be as large as a forest or as small as a garden. It can even be a handful of earth. You can focus on a single group of creatures, a defined window of observation, or animals of a certain size. Take a picture of what biodiversity looks like to you.

Nature loves to hide. So shooting biodiversity is often easier said than done. You may need to keep working on some pictures. On an assignment for *National Geographic* magazine, I spent weeks photographing only one cubic foot. Try using different tools to see your subjects, from DSLR cameras to microscopes. Explore what happens to the number of creatures and species you see when you change the scale.

I'll leave you with a quote from biologist Edward O. Wilson, who is possibly the greatest naturalist of our time. I hope you find it as inspirational as I do.

"A small world awaits exploration. As the floras and faunas of the surface are examined more closely, the interlocking mechanisms of life are emerging in ever greater and more surprising detail. In time we will come fully to appreciate the magnificent little ecosystems that have fallen under our stewardship."

ABOUT THE ASSIGNMENT EDITOR

David Liittschwager, NATIONAL GEOGRAPHIC PHOTOGRAPHER

After working with superstar photographer Richard Avedon in New York in the 1980s, Liittschwager left advertising to focus on portraiture and natural history. A World Press Photo Award winner, he is a regular contributor to *National Geographic* and has created several books of his photography.

»MAGIC **MUSHROOM**

This idyllic scene is all about reproduction. The mushrooms are the fruiting bodies of fungus. The little reproductive pieces that sprout out of moss are called sporophytes. The soft light creates just enough contrast to throw shadows that create depth and shape. In macro photography—shooting small images extremely close up—the narrow range of focus often makes the background blurry. The photographer uses this limited depth of field to maximum effect, separating the mushroom and sporophytes in the foreground from similar plant life in the background. We see the relationship between species in a frame that is only a few inches tall. This is the scale at which we begin to see the greatest biological diversity.

THE PHOTOGRAPHER'S STORY

"This is a close-up of some mushrooms I saw on a tree trunk. I found the light and setting a bit magical . . ."
—Sebastian-Alexander Stamatis

DENMARK

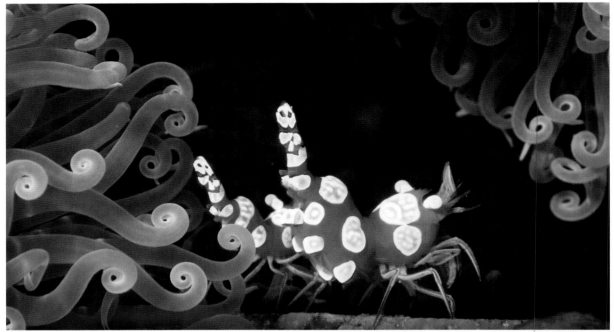

»SEDUCTIVE **SHRIMP**

Dubbed "sexy shrimp," these elegant creatures are named for their flashy markings and the way their hips waggle when they walk. Safe in their lair, the male and female shrimp hide among the stinging tentacles of anemones, which keep shrimp-eating predators at bay. This image is an excellent example of biodiversity and a remarkable photograph. The focused, shapely light shows off the almost mathematical precision of the anemone's curled tentacles. And the whiter-than-white spots on the shrimp pop off the soft, dark background. It's an intimate view of sexy shrimp domesticity.

HOW TO PHOTOGRAPH SMALL CREATURES

- **Be patient** and wait for a creature to show itself.

- **Avoid overexposing** the shot. You want to capture the details and textures on the animal's skin or scales.

- **In this picture,** the photographer kept the light focused on the subject, which prevented light from spilling over and creating distractions in the background.

- **Try to use one light source.** If you really need two lights, avoid confusing crossed shadows.

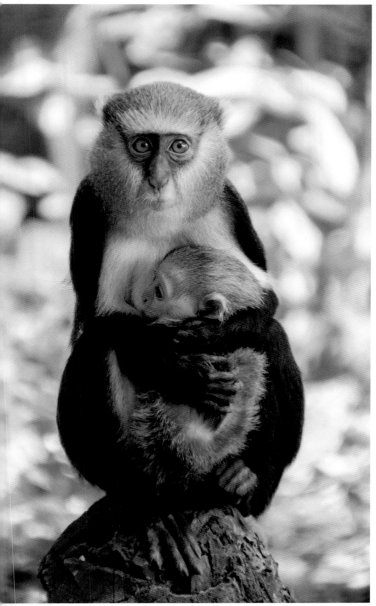

»MOTHER **AND CHILD**

This image of motherhood makes us question how different we are from our primate relatives. The monkeys sit on a pedestal, as if posed for a formal portrait. The photographer captures the mother's direct gaze and her arms in a protective clutch around the baby. With lovely, soft light and a background relatively free from distraction, this image could have been taken in a studio. In reality, it was taken at a wildlife refuge. I wonder how the photographer perceives the monkey and how the monkey perceives the photographer.

HOW TO SHOOT AN ANIMAL PORTRAIT

- **First, find a really good-looking animal.** Seriously, not all individuals of a given species are equally beautiful. Choose the best specimen.

- **A glint or engaging expression** in the eyes makes the animal more relatable.

- **Separate the animal** from its background. The soft shade on this monkey helps it stand out from the blurry, overexposed greenery behind it, thus adding to the sense of formalness in this portrait.

»A RESTING **PLACE**

What a lush and serene place to sit. Peeking through the tree canopy, highlights create a sense of isolation. There is surely another bright and busy world just beyond, but this place cannot be bothered by it. This bench has a story, or lots of them. In time, the surrounding forest will consume the bench and reaffirm humankind's place in the world. Our existence is but a passing moment—a blip on the grander time scale of a forest. I find the message in this picture hopeful and comforting. The shot expresses the natural world's ability to carry on, even with our sometimes heavy-footed presence. What an excellent place for pondering matters such as these.

HOW TO SHOOT IN THE WOODS

- **There is beauty in simplicity.** You can take exceptional photographs of something as commonplace as a park bench.

- **If a scene is dark and shady,** you will need to compensate by decreasing the exposure. Don't rely on exposure meters. They make the overall average of the scene a mid-tone.

- **If you are holding the camera** in your hands, plant your body and keep as still as possible. Photography is more physical than many people think.

VITOR HUGO MOURA — LAUSANNE, VAUD, SWITZERLAND

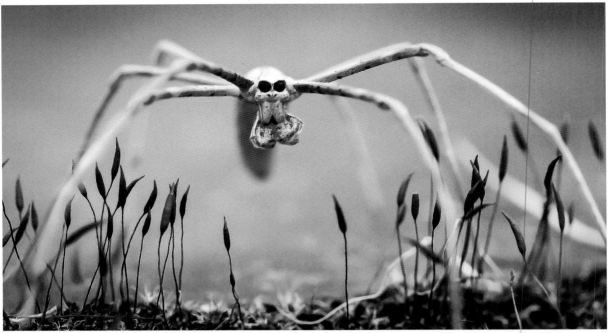

»ANGRY **ARACHNID?**

The shallow focus in this macro photograph shows just how impressive this beast is. With its long legs softening as they leave the frame, the spider's body towers over the sporophytes below. It's larger-than-life—a real-world Godzilla that is terrifying at this scale. This male spider, with his dark predator's eyes and prominent pedipalps (the appendages below the mouth), would make me worry if I were smaller or he were bigger. The pedipalps look fierce, but they are used for sexual reproduction and are probably quite titillating for the female of the species: "My, what large pedipalps you have!"

HOW TO MAKE MACRO ANIMAL PHOTOS

- **Remember,** most of the world's biological diversity occurs among small organisms. The entire scene might be only one inch across.

- **Consider investing in** a macro camera lens. (See "Choose the Correct Lens," p. 22.)

- **Get down on the same level** as your subject, and keep the eyes of the animal—or at least one of the animals—in focus.

- **Keep the background simple** to avoid visual distractions.

- **Be mindful** of your footprint. You don't want to step on potential subjects.

»WHITE WONDER

From the poufs of cotton grass in the foreground to the glacier-capped mountain in the distance, this image maintains focus across an impressive panorama. The whimsical cotton balls seem to brush up against the severe, rocky texture of the mountain. And the soft clouds above the horizon match the gentle softness of the cotton below. This photo was taken during one of Norway's long summer days, but I can imagine this scene six months later, when the sun spends little time above the horizon and the cotton grass lies dormant beneath the snow. How will this habitat and its diversity adapt to climate change?

HOW TO MAKE THE MOST OF THE SKY

- **Watch out for overexposure** in the sky. You don't want to miss the details and rich colors above the horizon.

- **Make sure** the edges of the frame will show. If you plan to display the photo on a white background (on a page or a screen), be sure to darken the white at the edges of the frame.

- **Try changing your aperture** to find a depth of field that fits your scene.

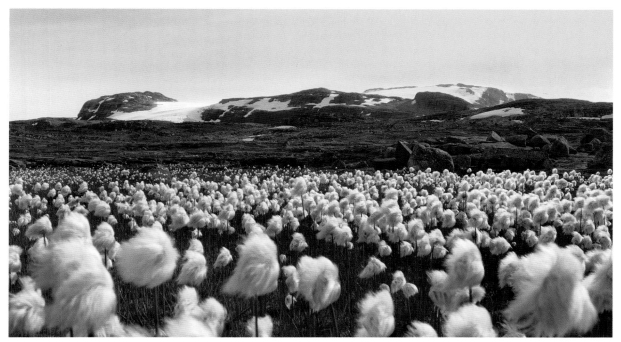

DAIGA ROBINSON — FINSE, NORWAY

»ISLAND **IN THE SKY**

This magical little island looks at once peaceful and lonely as it hovers between the sky and the water. It is separate but connected. What small creatures have found refuge here? What creatures are in the nearby surrounding water, and which ones pass through the air above? It is likely a microcosm—a cast of tens of thousands representing hundreds of species, maybe more. The photographer's point of view creates a magic-carpet effect, as if we are floating above this serene scene. To get this shot, the photographer would have to get up high by climbing a hill or a tree, or snap the scene from a helicopter, an airplane, or even a drone.

THE PHOTOGRAPHER'S STORY

"There is an ethereal, otherworldly feeling to this photograph. This little island, in the middle of remote and wild Tumuch Lake in northern British Columbia, appears as if it's floating in the clouds. To bring us back to Earth, a fish has left a ripple in the water on the left-hand side of the shot . . ." —Shane Kalyn

PRINCE GEORGE, BRITISH COLUMBIA, CANADA

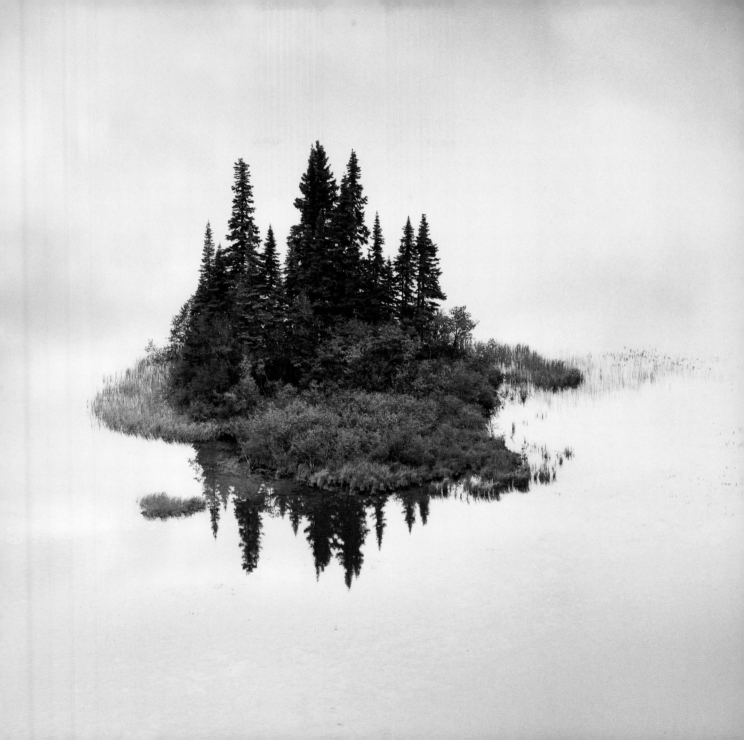

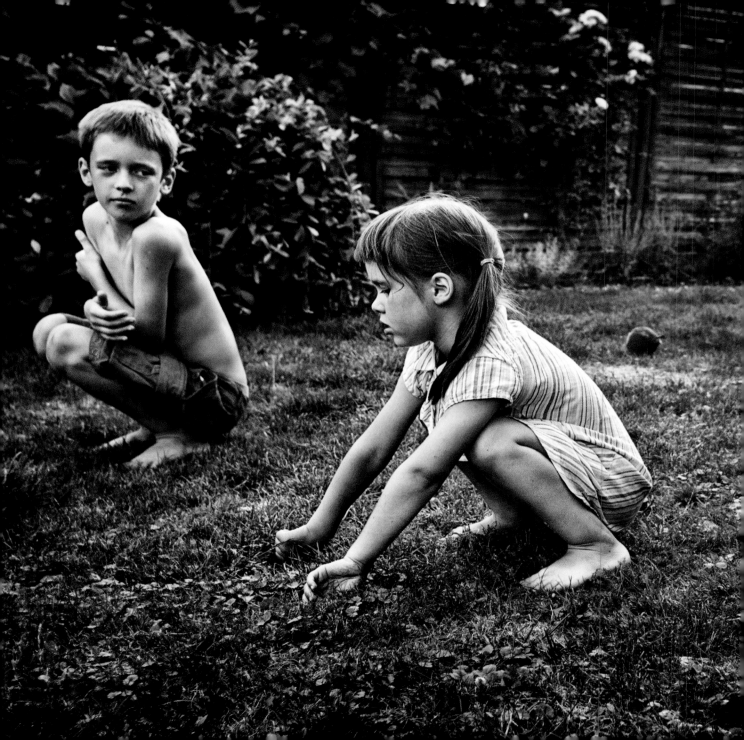

FAMILY
PORTRAIT

BY BEN FITCH

A TIME TO REMEMBER

I love visiting my grandmother's house in Vermont. The Yellow House, as we call it, has been in my family for nearly 60 years. My great-grandparents, cousins, and others from different branches and generations have all lived there or visited over the years.

Tucked away in old bookshelves and cabinets throughout the house are faded envelopes filled with old pictures, left behind by various family members and dating back decades. Whenever my family visits the Yellow House, we find ourselves looking through these old pictures. We handle each one with great care, as we treasure the images that provide glimpses into the everyday lives of our relatives, some of whom we never knew.

My favorite thing about family pictures is how well they can pass down stories through a series of often informal and personal moments. Part of what makes photographing members of your own family so interesting is the close relationship you have with them. This assignment is an opportunity to show the intimate and meaningful connection between you (the photographer) and your subject matter.

Families come in all shapes and sizes, and the term has never been more all-inclusive or had so many different meanings as it does today. Your family might include your brothers and sisters, your sports team, your classmates, your pet, and even your larger community. No matter how you define the word *family,* show how yours is unique. Think about what you'd like others to learn about your family story by looking at your pictures. Both posed and candid portraits are a great place to start, but also think about illustrating the important traditions, places, and personal qualities that make your family story special. After all, if you as a photographer don't record your family's story, who will?

ABOUT THE ASSIGNMENT EDITOR

Ben Fitch, *NATIONAL GEOGRAPHIC TRAVELER*

A photo editor for the magazine, Fitch finds inspiration in all forms of visual art, with a special affinity for the French and Spanish Romantic painters of the 18th century. He loves hiking, a good diner, and making portraits.

MARC MANABAT — NORTH HOLLYWOOD, CALIFORNIA

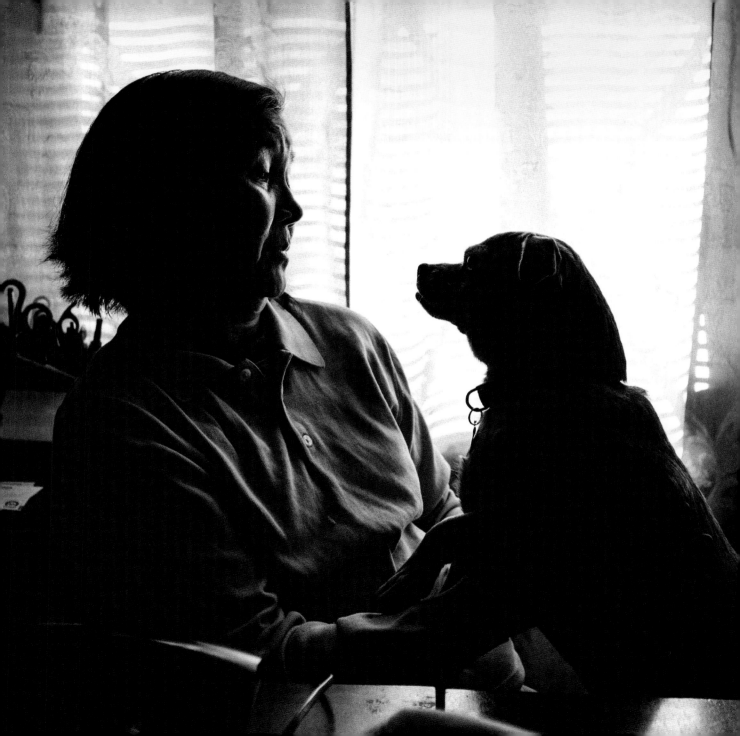

»A CLOSE **SHAVE**

All great photographs have emotion. A picture can be perfectly executed from a technical standpoint, but if it doesn't make the viewer feel something, it likely won't be memorable. Here the photographer captured emotion in a very literal way by shooting the dramatic expressions of a groom, who is being shaved in preparation for his wedding, and his daughter, who is in tears. My eyes travel back and forth between the girl and the groom, who are equally expressive but overcome with completely different emotions. The girl, with the skinned knees typical of an adventurous child her age, looks in horror at the man who has taken a razor to her father, who laughs back at his daughter's innocent misunderstanding. It's an entirely authentic moment—and a great illustration of family dynamics.

THE PHOTOGRAPHER'S STORY

"According to tradition, the man in front, the groom, is shaved by the godfather with a knife. His daughter is crying because she's scared." —Vasile Tomoiaga

BUCHAREST, ROMANIA

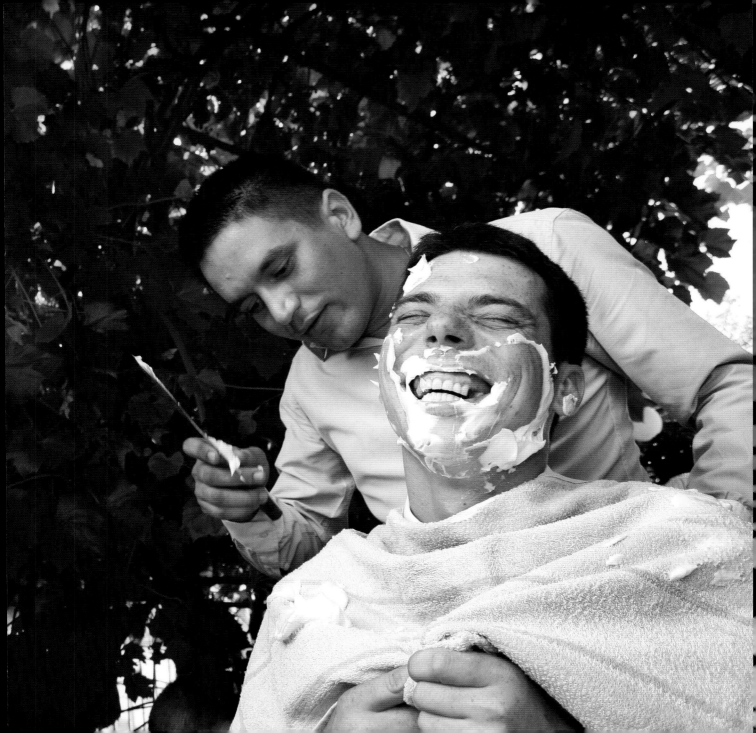

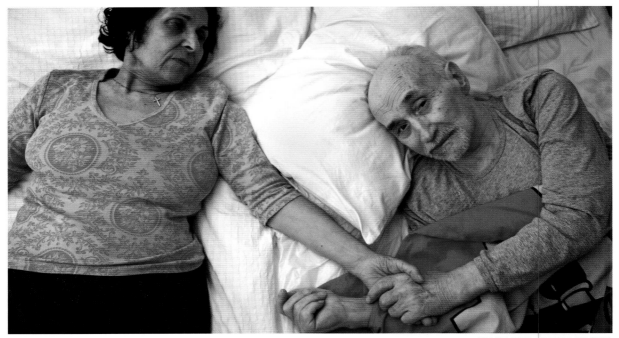

»LOVE **OF A LIFETIME**

The arresting gaze of the male subject looking directly into the camera immediately pulls viewers into this photograph. The man died shortly after the picture was made, which means this was one of the last portraits of the aging couple together. Even without the caption, we are able to grasp the solemnity of the moment through the image itself, especially from the way the woman looks longingly at her husband and the tight clasp of their hands. This frame is an example of how shooting from a unique perspective—here, from above the bed—can add an unexpected level of meaning and dimension to a picture.

HOW TO HOW TO GAIN PERSPECTIVE

• **Try photographing one subject** in three different ways as an exercise in shifting perspective. For example, photograph an object from a low angle, straight on, and from above to see how your perspective changes the image.

• **Take pictures** of the everyday moments in your life. These images end up being some of the most personal and powerful because we approach them with such intimacy.

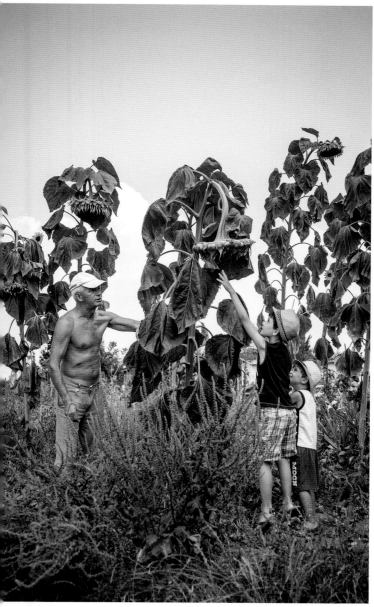

ADRIAN CRAPCIU

»GROWING TALL

The boys look curious about and intrigued by the towering sunflowers. For me this image is about the grandfather passing his respect and love for the land on to his young grandsons. The photographer was smart to shoot this image from a distance, allowing us to appreciate the scale of the flowers against the height of the figures. Had this image been shot closer in, the flowers wouldn't have dominated the scene in the same way. Depending on your subject, you may benefit from more or less environment in your photograph. Think about which elements are important to include in your composition when constructing your visual narrative.

HOW TO COMPOSE YOUR SHOT

- **With your eye** in the viewfinder, take a minute to look around at what you're including in your composition before hitting the shutter. Take out what's distracting or unnecessary in the image.

- **In this image** the verticality of the frame helps accentuate the tall sunflowers. Make sure you choose the orientation that best fits your subject.

- **Once you've framed** up your perfect shot, take a lot of pictures so you don't miss anything.

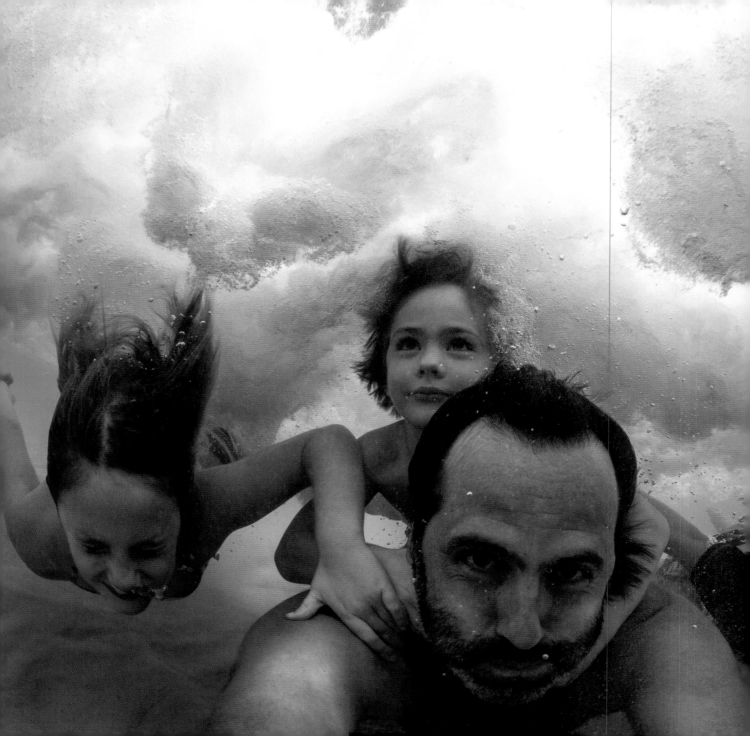

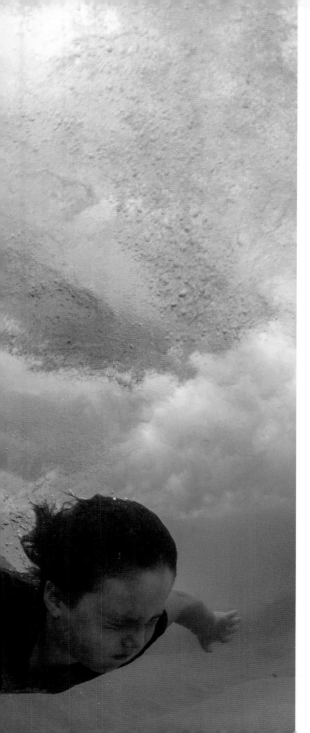

»TAKING THE PLUNGE

n a time of ubiquitous selfies, this self-portrait of a father and his children is unique and compelling. I was originally drawn to the image by the dynamic composition. The image was taken at just the right moment, seconds after the family dived into the water, causing a cloud of bubbles to fill the top half of the frame. The bubbles intensify the sense of movement in the image. The tight focus emphasizes each person's expression as the family swims out from the bottom of the photograph. This image so clearly illustrates the notion of family. The patriarch leads his kids forward with utmost confidence as they follow with looks of excitement and wonder.

THE PHOTOGRAPHER'S STORY

"This photo really shows the trust and love of a father and his children. This self-portrait shows all the children following their father through the turbulent waters of a breaking wave. Each child has one hand on the father for support. But their faces do not show fear; instead their expressions show the trust they have for their father." —Sean Scott

»BLOOD **BROTHERS**

This portrait is powerful in its simplicity. The photographer's choice to center his subjects is especially meaningful, as the symmetry of the image highlights the twins' similarities. The bright towel not only provides a welcome pop of color against a muted palette, but also reinforces the brothers' physical and emotional connection. When shooting portraits, think about what makes your subject unique. Look for ways to highlight these special qualities, perhaps by inserting into the frame other elements that accentuate those characteristics.

HOW TO MAKE A PORTRAIT

- **Get to know your subject** before taking his or her picture. You'll find that the comfort level between you grows, and that translates to a more natural-looking and personal portrait.

- **Find ways** to highlight your subject's unique qualities through composition and framing.

- **Think about** how the subject's environment can add context to the person's story.

ANDREW LEVER — BOURNEMOUTH, ENGLAND, U.K.

KARINE PURET — PARIS, FRANCE

»CHILDHOOD **INHIBITION**

When I think about family, I inevitably think about the home I grew up in. This image strikes me because of how well it illustrates the comfort of the domestic setting, which goes hand in hand with family. Small details in the frame add to this timeless depiction of home—the checkered tablecloth, the worn wooden cabinets, and the warm light streaming through the window. The kids, playing in the safety of their kitchen, seem lost in a make-believe world. It was crucial for the photographer not to disrupt the magic of the scene taking place. Had the kids been aware of the camera, the photo wouldn't be nearly as authentic and compelling.

HOW TO MAKE AUTHENTIC PHOTOS

- **Sometimes the best shots** happen when the subject is unaware of the camera. Be sure to ask permission to keep the photo after you shoot it.

- **The longer you stay** in a place, the more the comfortable the people around you will become, and the greater the potential for capturing a one-of-a-kind moment.

- **Use a wider lens** and get close to your subject. Many great moments are subtle ones, made special by the slightest expression or gesture.

»FAMILY CIRCLE

This portrait shows the child within the context of his greater family and community. Although we can see only the child's face, the anonymous figures around him symbolize the circle of those who support him. I particularly like the soft gestures of the outstretched hands reaching into the center of the frame and the range of patterns in the various white fabrics. This photograph is a lovely example of how to distill a busy scene into one strong, isolated moment. If the photographer had pulled back and included more of the surrounding figures in his picture, the scene could have been too chaotic to digest. Instead the photographer focused on a small piece of the scene that was just enough to tell the whole story.

HOW TO ISOLATE THE MOMENT

- **A good place to start** when taking pictures is to determine where the best light is in the scene. Then stick around to see what happens in that spot.

- **When shooting a busy scene,** start wide and then go tight. If you are looking everywhere, you are less likely to miss a great moment.

- **Don't plan** all of your pictures. Take time to roam around a location and look for images in places you wouldn't expect to find them.

ABIR CHOUDHURY — CALCUTTA, WEST BENGAL, INDIA

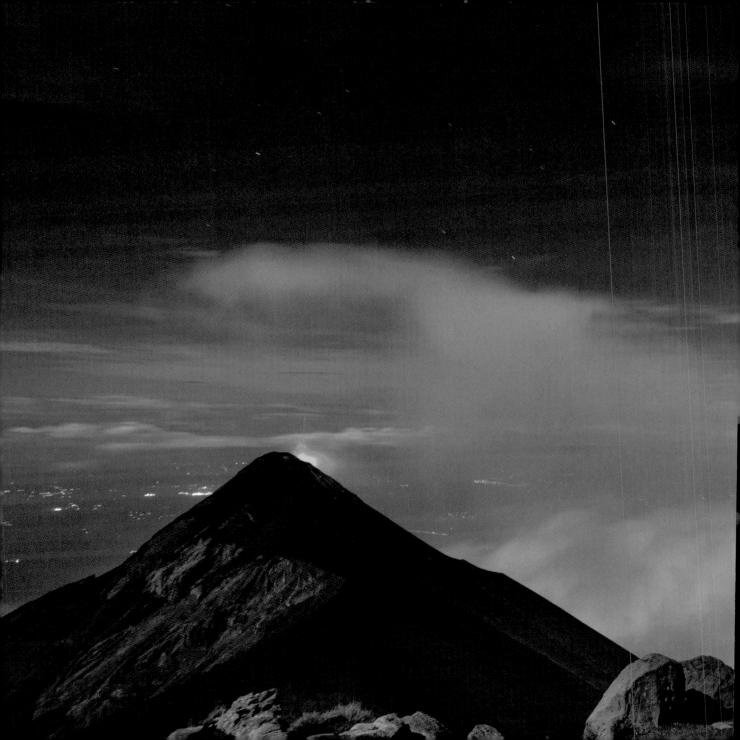

THE MOMENT

DIEGO FABRICCIO DIAZ PALOMO — ACATENANGO VOLCANO, GUATEMALA

BY JAY DICKMAN

GETTING IN ON THE ACTION

Photography is all about moment. It's the big, loud moment of the wide receiver going up for the football with eyes popping out, sweat flinging out from his helmet, fingers stretching to grasp the ball. Or it's the quiet moment of two friends meeting on the street, one throwing her head back in laughter or gesturing in response to something the other has said. Each of these situations, and everything in between, has a moment that is the job of the photographer to capture.

Moments bring power and impact into the photograph. They resonate with viewers and engage them with the photo. The moment image can be the central image in a larger story, or it can stand alone as a powerful testament to an event, a way of bringing everything to a visual fruition.

For this assignment, I'd strongly suggest that photographers work on staying with the scene and watching it build up to—and beyond—the moment. Thinking you've reached the height of a moment is similar to a mountain climber reaching a false summit, only to discover the real summit off in the distance. You'll tend to shoot what you think is the peak frame and then lower the camera to admire your photo, only to look up and see the real moment occur. So stay with that scene to make sure that the great photo you just captured isn't only a step up to the climactic moment.

The famous French photojournalist Henri Cartier-Bresson said that every situation has its decisive moment; you watch as something builds and wait for that peak. Applying the idea of a moment to your photography will make you a more observant and connected image maker. The moment trumps everything. The waiting is the hardest part.

ABOUT THE ASSIGNMENT EDITOR

Jay Dickman, NATIONAL GEOGRAPHIC PHOTOGRAPHER

A Pulitzer Prize–winning photographer, Dickman has shot more than 25 assignments for *National Geographic* and has visited every continent as an expert and photo instructor on National Geographic Expeditions travel tours. With his wife, Becky, he founded the acclaimed FirstLight Workshop series.

BETTY CATHARINE HYGRELL — TENGBOCHE MONASTERY, NEPAL

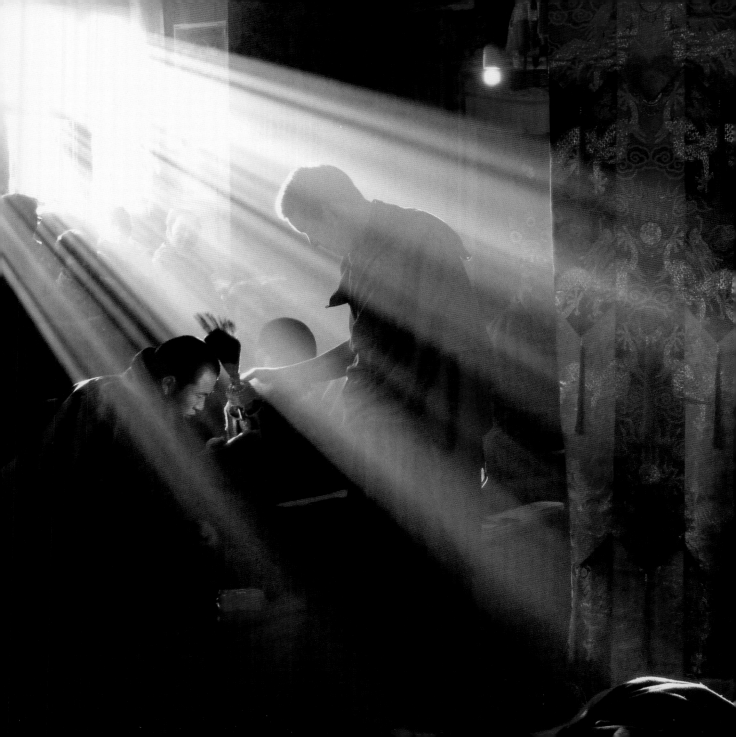

»AIRBORNE

Capturing just the right moment can bring joy and energy to a photo. When we dissect this image, we see what makes it work and why it resonates so strongly with the viewer. The photographer has captured a delightfully happy baby at the peak of motion, as the child is tossed in the air (and hopefully caught!). The baby's face is priceless. He faces the viewer with an expression of pure happiness, adding another layer of energy to this wonderful moment. The beautiful sky and clouds create a beautiful background to this joyful scene.

THE PHOTOGRAPHER'S STORY

"This was the ending of a family portrait session, and a storm was rolling in over the Front Range. I had just finished some father-and-son shots when I looked down at my camera and back up to see him tossing his boy in the air. I was lucky to get this shot and also to have this beautiful dark sky in the background accompanied by the golden light of the late-summer evening. The joy in the boy's face is there because he sees his mom standing behind me. I knew immediately that this shot would be special."
—Christy Dickinson-Davis

DENVER, COLORADO

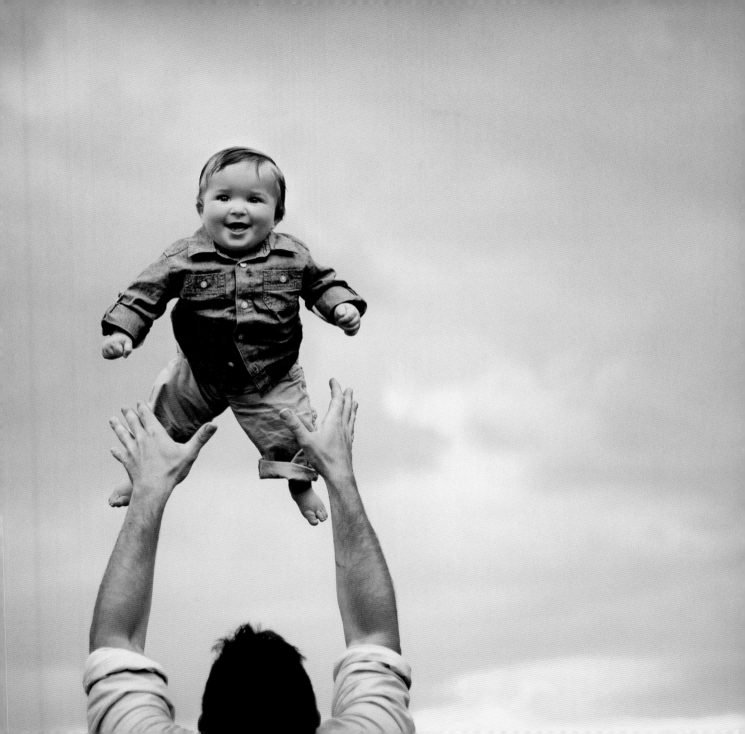

»THE INVISIBLE KITE

The most powerful photographs pull the viewer's attention into the moment that is taking place. In this engaging photo, I feel as if I'm standing there, enjoying the boy's enthralled expression as he pulls the kite string. The child's gesture is at its peak, and its energy fills the white space created by the wall. All components of this shot provide important information. The buildings along the street tell us about the place, and the road curving off to the left reinforces the movement of the subject. As photographers, we're responsible for the entire frame. And everything in this shot is working together to put the audience "in the frame."

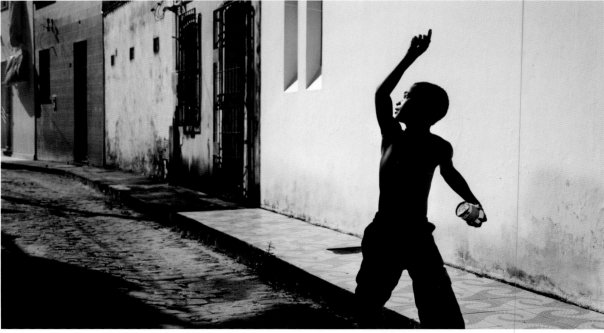

BARBARA BELTRAMELLO — ITAPARICA ISLAND, BAHIA, BRAZIL

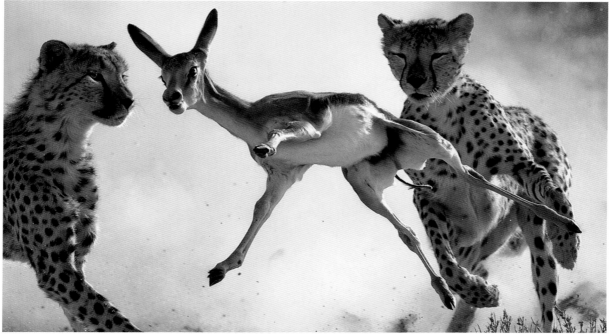

»IN FOR **THE KILL**

This is a stunning wildlife moment. The composition couldn't have been choreographed more perfectly. The airborne gazelle is frozen, mid-leap, and book-ended by the two pursuing cheetahs. The photograph conveys information so efficiently that there is no ambiguity about what is happening. This image also illustrates the amazing power of still photography—how it allows us to study an extremely frozen moment in a frenetic scene. We can't share this intimacy through moving film or video. It takes the still photograph to illustrate that millisecond of finality.

HOW TO SNAP ANIMALS IN ACTION

• **Shoot very early or very late** for the best chance at capturing great wildlife photos. Animal activity—and light—tend to peak at these times of day.

• **To photograph wildlife** in action, you will need a large telephoto lens with maximum speed. Check out lens rental companies if you are not ready to make this pricey purchase.

• **Practice, practice, practice.** Before you go on that big safari, warm up by taking pictures of birds or of dogs chasing Frisbees.

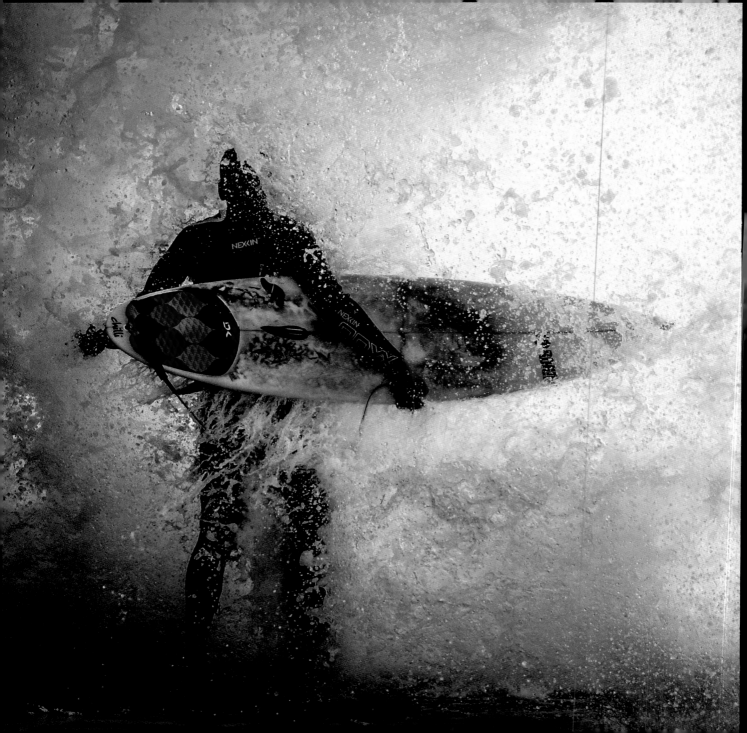

»SPLASHDOWN

f the photographer had pressed the shutter a millisecond earlier or a millisecond later, this image would not have existed. We can feel the blast of the wave as it hits the surfer. The highlights build toward the left side of the frame and allow our perception to fill in the blanks. We can almost hear the water crashing just outside of the frame. The beautiful light on the back of the surfer illuminates the water wrapping around the body and provides that critical detail of texture. What a perfect illustration of a moment in this mesmerizing photo. Surf's way up!

HOW TO SHOOT WATER SCENES

- **When shooting near water,** consider using a waterproof case, and I suggest carrying a chamois to use as a "raincoat" for your camera or to wipe off water from spray and splashes.

- **If you are shooting** above and below the water's surface in a single frame, use a water-sheeting product, which makes the water "sheet off" the front, thus minimizing water beading.

- **High shutter speeds** will "freeze" water in motion and allow the viewer to see the incredible detail in the droplets.

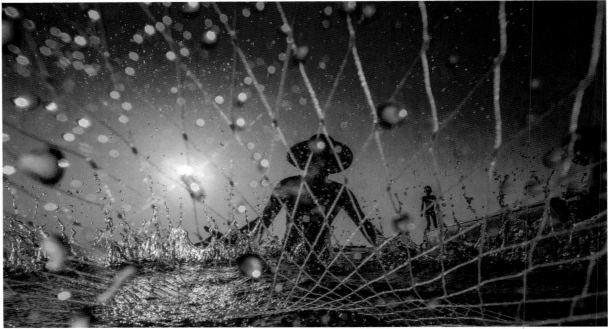

»THROUGH **THE NET**

The viewer doesn't have the luxury of hearing the sounds of the ocean and the fishermen talking, or of smelling the salt spray and the odor of fish. But this photo helps us imagine the sensations that the photographer experienced at that moment. The net, which fills the frame edge to edge, is such a critical component of this beautiful photo. The attire of the person fishing, the warm light, and the water drops help us feel the humidity in the air and the sogginess of the net. The photographer worked this situation so well, bringing together texture, palette, and setting to create a palpable sense of place and immediacy.

HOW TO FILL THE FRAME

- **Get close,** and then get closer. Sometimes your best zoom lens is your feet.

- **Make sure** everything in the picture is relevant to the image.

- **Know your equipment** so well that it doesn't get in the way. If you are not familiar with your camera's menu or ergonomics, it creates a wall of interference between you and the subject. The camera should be invisible in the process.

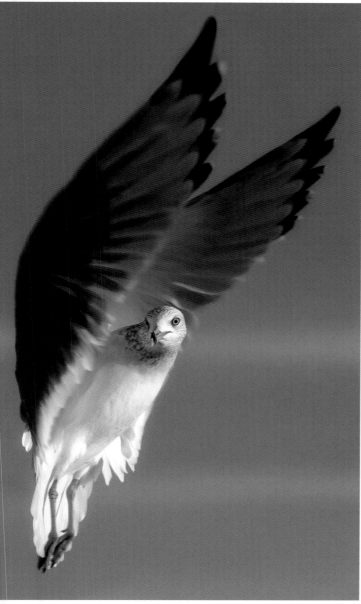

»A WINGED **VICTORY**

When the photographer confirmed this shot in the camera's monitor, there was probably a shriek of joy. This image not only captures the bird in an amazing position, but also achieves that perfect confluence of composition, framing, palette, and moment. The power of this image lies in the animal's eyes. Notice how you look almost immediately and directly at the eyes and then let your gaze sweep across the rest of the image. But you always come back to those eyes. The motion of the bird is vertical, which creates added visual interest in a world where horizontal images are often the default. As a photographer, you shoot and shoot with the hope of capturing that perfect moment. This photographer has achieved that shot.

HOW TO CREATE VISUAL INTEREST

- **Think of shooting vertical,** if it suits your subject. By varying the orientation, you create a more interesting group of images.

- **Eye contact** often makes for more compelling photos of people and animals.

- **Consider carrying** two cameras: one with a wide zoom lens, the other with a telephoto zoom. These two cameras will meet 90 percent of your photographic needs.

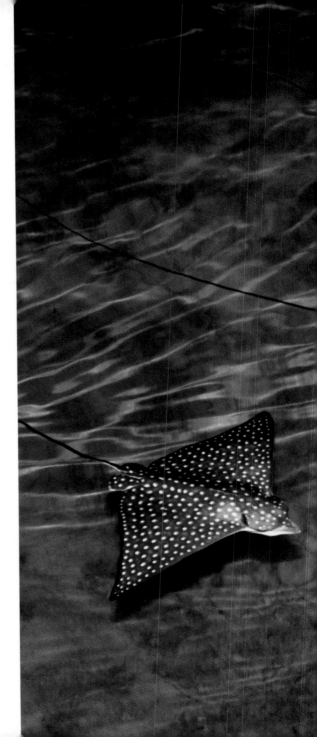

» NIGHT FLIGHT

This serene image weaves a complete story through the simplest details. The color of the water and the spotted pattern on the stingrays tells us that this is likely a tropical location. We are definitely not in Kansas anymore! The photographer introduces us to our lead characters—these incredible rays—and lets our eyes luxuriate on their patterns and the graceful shapes of their bodies. The formation of the stingrays creates a sense of direction and a moment of perfect symmetry. The shadows and grasses on the ocean floor tell us this water is shallow enough to wade in. We feel as if we could just step into the frame and dip in our toes.

THE PHOTOGRAPHER'S STORY

"Young spotted eagle rays feed in a shallow lagoon at night—truly a 'National Geographic moment.' These rays had been feeding individually, then ran into each other and turned together, then split up again immediately after the shutter tripped. I had waited for six hours over two nights, ever prepared to shoot individuals entering the sweet spot. My heart raced as I saw this image coming together right in the spot that I had dialed in to." —Courtney Platt

GEORGE TOWN, CAYMAN ISLANDS

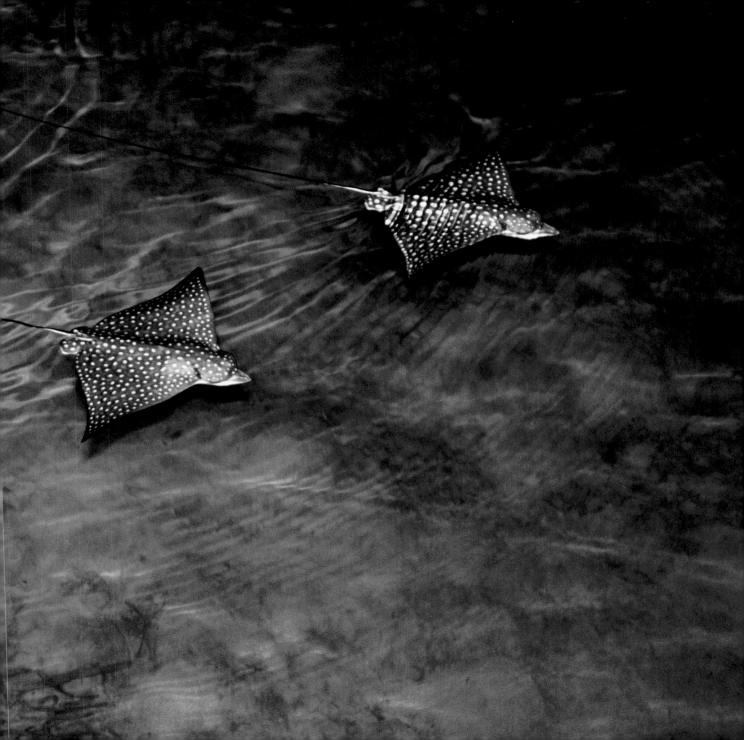

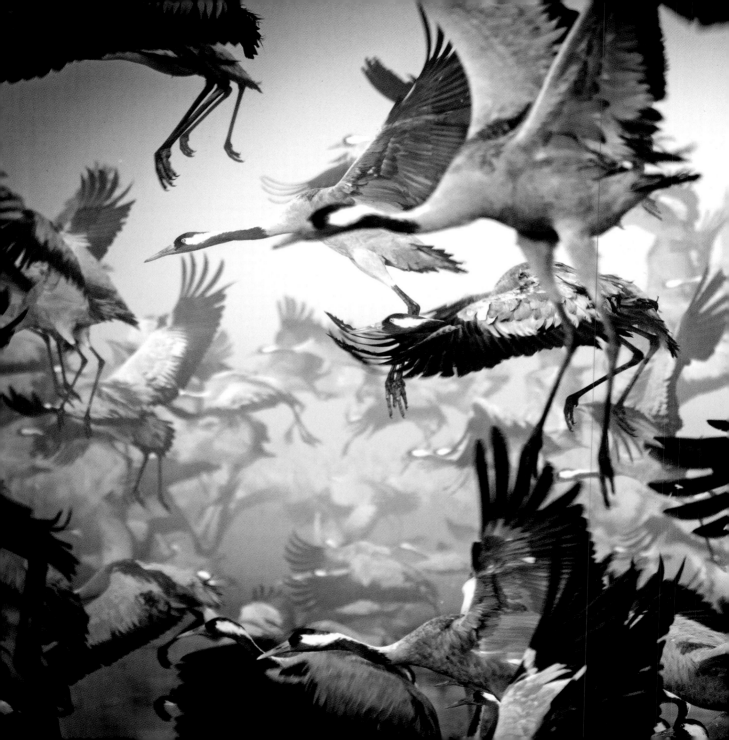

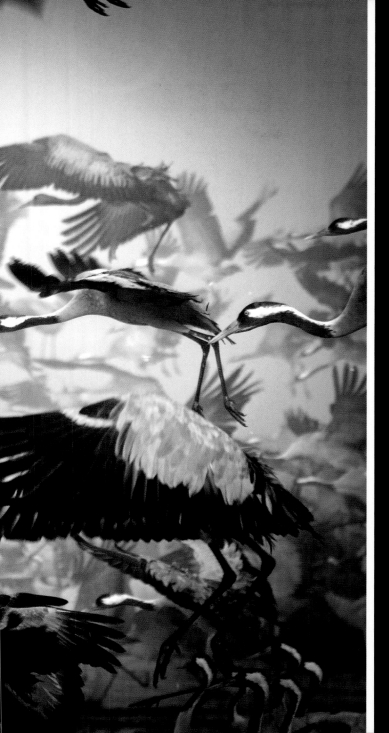

EMBRACE
THE UNTAMED

BY EVELYN HOCKSTEIN

A WALK ON THE WILD SIDE

What does it mean to embrace the untamed? The goal for this assignment is to shoot photos that are a visual celebration of wildness. Everything from the deer in your backyard to elephants on an African savanna is fair game (no pun intended!). Raging rivers and daunting mountain peaks are also a perfect fit for this assignment. Capture nature displaying its untamed majesty. One rule: no pets allowed!

I can't resist a good portrait of an animal—a close-up of a lion, a gorilla, an owl—but the images that blow my socks off are the ones that capture the spirit and context of this wild world we live in. Try to portray an animal's spirit or environment in the shot. Rather than photographing a bird close up, snap a picture of a flying bird that conveys the space, height, freedom, or vastness of the natural world. Including more context in an image can help unleash that untamed feeling.

Zoos are great places to see animals that you might not have a chance to see otherwise, but this assignment is about photographing nature and animals in their natural habitats. You don't have to go to an exotic location to take great photos of animals. You can go to a local park, a nature trail, or a pond or lake. The animals that live there are just as wild as the wildebeests of the Serengeti.

For landscapes, aim for sweeping shots, with dramatic light, weather, or terrain. Look for landscapes that feel untamed—that portray Mother Nature as the wild, awesome force that dwarfs and awes us with her power and beauty.

Keep in mind that with every photograph, you are telling a story. Close-ups can be evocative and compelling, but also try to shoot big and wide—and thoughtfully. Take viewers to the place where you are shooting. Let them experience all the textures, colors, sounds, spaces, movements, smells, and creatures. Keep going wild!

ABOUT THE ASSIGNMENT EDITOR

Evelyn Hockstein, PHOTOJOURNALIST

Hockstein is an award-winning photojournalist who has worked in more than 70 countries for news outlets including the *New York Times*, the *Washington Post, TIME,* and *Newsweek.* She has won two Pictures of the Year International awards, and her work has been exhibited around the world.

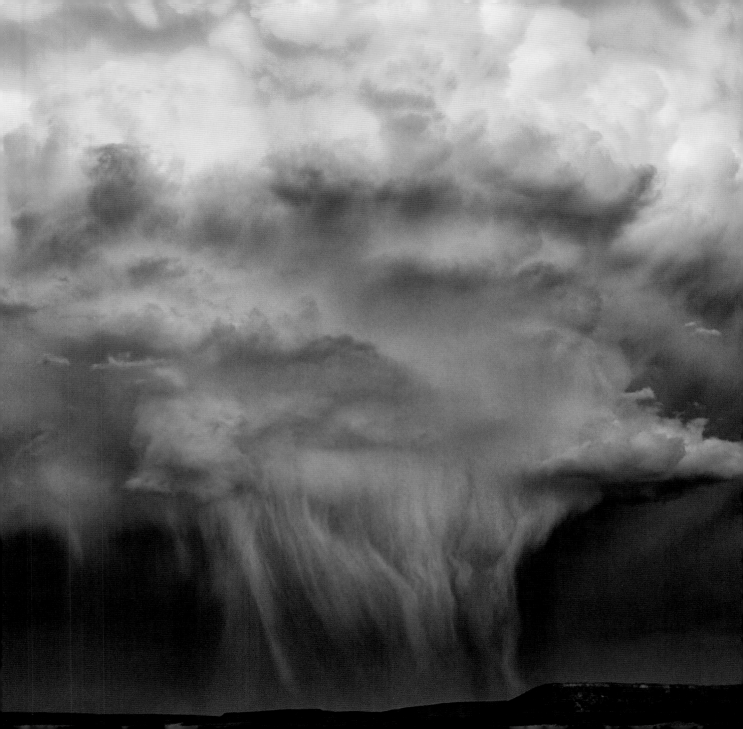

»TRUNK TO TRUNK

Elephants are majestic and highly intelligent animals. Many of their behaviors are humanlike. This photographer deftly captured an affectionate moment between these tremendous mammals as they interact with each other. The sharp white tusks jutting out beneath their trunks create an interesting contrast against the dark skin of the elephants and the gentle act of one elephant wrapping its trunk around the other elephant's head. Strong wildlife photography requires the patience to wait for the perfect moment that will convey the personality of the animal to the viewer.

THE PHOTOGRAPHER'S STORY

"Totally wild and untamed, these amazing animals show humanlike behavior. Etosha National Park in Namibia was the scene of this show of affection by two family members in a herd of over 40 elephants." —Ian Rutherford

ETOSHA NATIONAL PARK, NAMIBIA

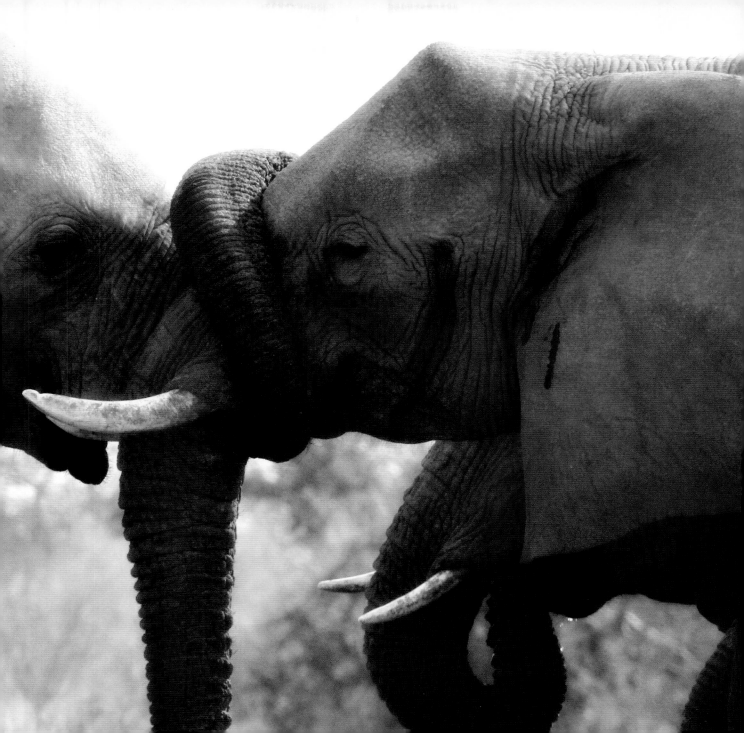

»NIGHT MOVES

So many elements contribute to this exceptional image. The stars twinkle in the rich purple-and-blue sky. Light emanates from behind Oregon's Mount Hood and highlights its snowcapped peak. The flowing white water perfectly complements the white of the mountaintop. The dark hills contrast beautifully with the highlights in the stream and lead the viewer's eye toward the peak, glowing in the distance. Capturing this image was no small feat. In order to get a balanced composition and to use leading lines, the photographer actually had to stand in the middle of the stream. This required a sturdy tripod, a slow shutter speed, and serious dedication.

HOW TO GET THIS SHOT

- **Sometimes** you have to place yourself in an uncomfortable position to get the perfect shot. But be careful. There's a difference between uncomfortable and unsafe.

- **Use a slow shutter speed** to capture the movement of flowing water. Try a shutter-release cable to ensure you don't move the camera when you release the shutter.

- **Want a less expensive alternative?** Use the self-timer setting on your camera instead.

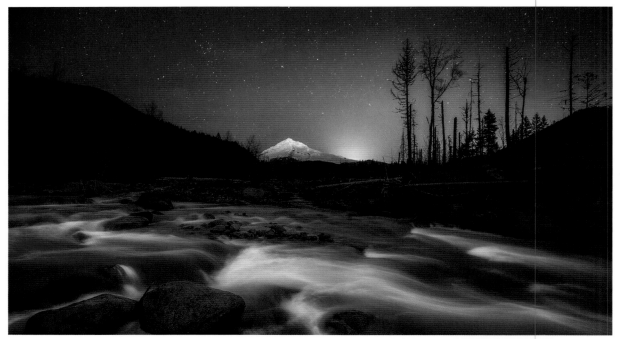

PAUL WEEKS — RHODODENDRON, OREGON

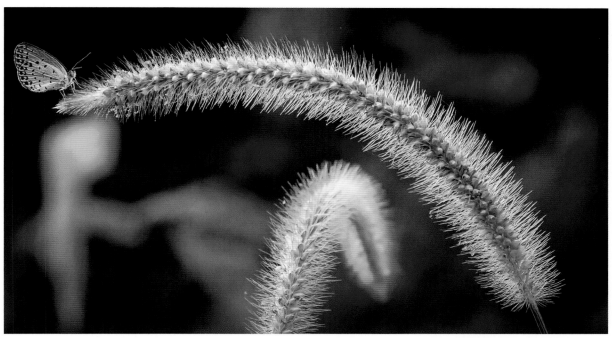

JEREMY AERTS — DAEGU, SOUTH KOREA

≫WINGED **VISITOR**

The beautiful light, soft colors, and texture of this illuminated wheat stalk are absolutely stunning. As the stalk bends, your eye follows its curve to a gentle lavender moth perched on its delicate tip. The lavender complements the green background, and a warm glow emanates from the stalk. This image is a testament to the untamed beauty found right in our own backyards. A field of wheat or tall grass is a common sight, but with great lighting, crisp composition, and a well-timed landing, the photographer created a striking image. And caught on camera, this insect offers more insight into the natural world that we might be able to see with the naked eye.

HOW TO SHOOT WILDFLOWERS

- **You can capture** beautiful light at any time of day. Backlighting and strong shadows can create dramatic effects.

- **When photographing** plants or flowers, an element of interest, such as an insect, can make the picture even more exciting.

- **When shooting** the intricate detail of flora, use a shallow depth of field to remove background distractions and keep the focus on the subject of the photograph.

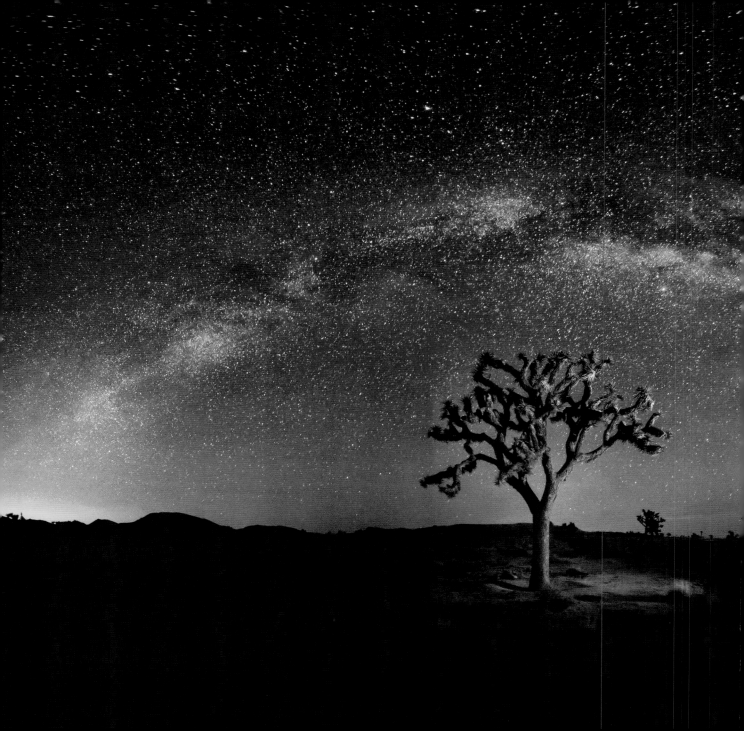

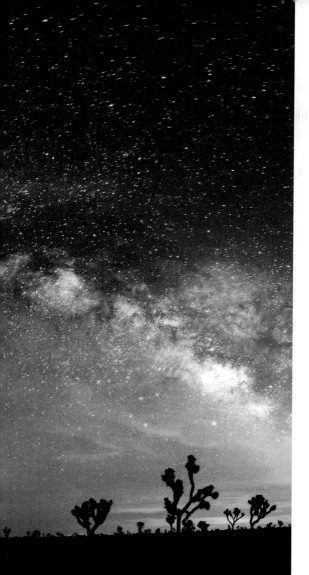

»HEAVENLY LIGHT

The Milky Way is a beautiful sight to behold, and this photographer masterfully captured the myriad of stars that we so often can't see with the naked eye. The lone Joshua tree has an ethereal glow and stands out perfectly against the evening sky. What makes this image even more special is its perfect composition. The subtle arch of the Milky Way gracefully frames the tree and echoes its shape. Rich gold, red, and pink colors emanate from the horizon, contrasting with the deep blue of the star-studded sky. This photograph successfully uses Earth's landscape to make us feel more connected to the greater universe.

HOW TO CAPTURE THE NIGHT SKY

- **When photographing** the night sky, add a compositional element to the foreground to give the image perspective.

- **A slow shutter speed and low ISO** reduces digital noise—speckles in the picture, which detract from the clarity of the image—that might appear in the shadows at a higher ISO.

MANISH MAMTANI — JOSHUA TREE NATIONAL PARK, CALIFORNIA

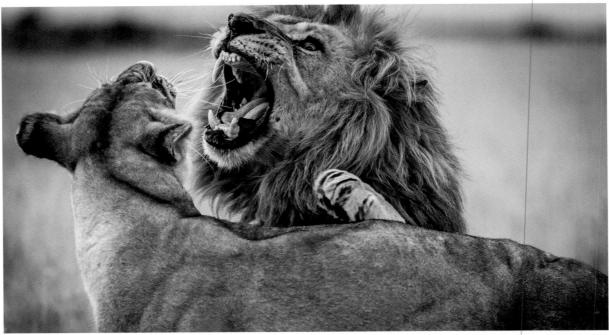

MAJED AL ZA'ABI — NAIROBI, KENYA

»HEAR ME ROAR

This is the moment wildlife photographers wait for. Animals are beautiful when they are still or resting, but a wildlife image is infinitely more interesting when an animal's wild nature comes through. It is important to look beyond the straightforward portrait of a majestic animal. How does the animal behave in its habitat? What is the character of the animal? This image beautifully captures the personality of the lion, its powerful teeth, and its interaction with the lioness. I love the wild look in this lion's eye. I can practically hear this lion roar—a sure sign that the photographer has done his job well.

HOW TO CAPTURE THE "MANE" EVENT

- **Patience is essential** when photographing wildlife, and that applies to a deer in your backyard or a cheetah on the hunt. A wild animal isn't going to pose for the camera or walk into the perfect patch of sunlight on cue.

- **Wait for a moment of action** or a moment when the animal wears an engaging expression.

- **Images of animals** playing, being affectionate, or living in a community evoke a human response and make your pictures more interesting than just portraits.

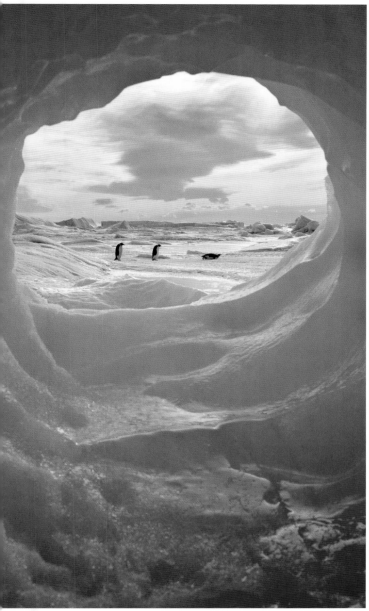

KEITH SZAFRANSKI — SNOW HILL ISLAND, ANTARCTICA

» PENGUIN **PEEPHOLE**

This once-in-a-lifetime photograph creates a wonderful sense of place. A shot of emperor penguins marching along the icy Antarctic landscape would be a winner by itself. But this photographer raises the bar by shooting through an ice tunnel, creating a uniquely stunning composition. We drink in the rich blue of the ice, which perfectly frames the soft purple of the snow and the orange and purple in the sky. Shooting with a wide angle brings the texture of the ice into the image and helps convey the vastness of the Antarctic. Think about a unique feature of the landscape you are shooting, and see how you can incorporate that feature into your photograph.

HOW TO CREATE CONTEXT

• **Bringing the habitat** into your photograph helps tell a story about the animal.

• **Don't be afraid to shoot wide.** A wider angle gives the viewer a sense of what the animal's life is like and the environment in which it must survive.

»SEEING **RED**

This lake's startling red color—caused by algae—pops off the page, but the flamingos dotting the water add an essential element of interest. As your eye travels from top to bottom, the bands of color create a beautiful, clean composition: first the royal blue sky, then the deep blacks in the mountain shadows, then a striking band of white salt, and finally, the deep red. The flamingos in the foreground echo the bands of salt, break up the predominant swath of red, and take this image beyond a straightforward landscape.

HOW TO SNAP A GREAT LANDSCAPE

- **In landscape photography,** use greater depth of field to ensure that as much of your scene as possible is in focus.

- **Horizontal lines** are visually interesting and add stability to your image. Lines often serve as dividing points that let your eye focus on different sections of the photograph almost as individual images within the single frame.

DHARSHANA JAGODA — JUNTACHA, POTOSÍ, BOLIVIA

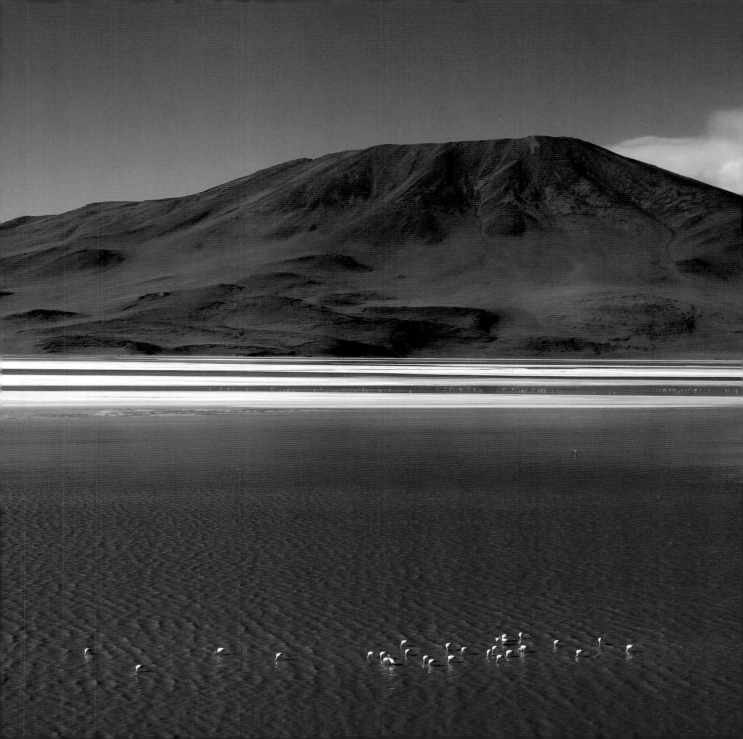

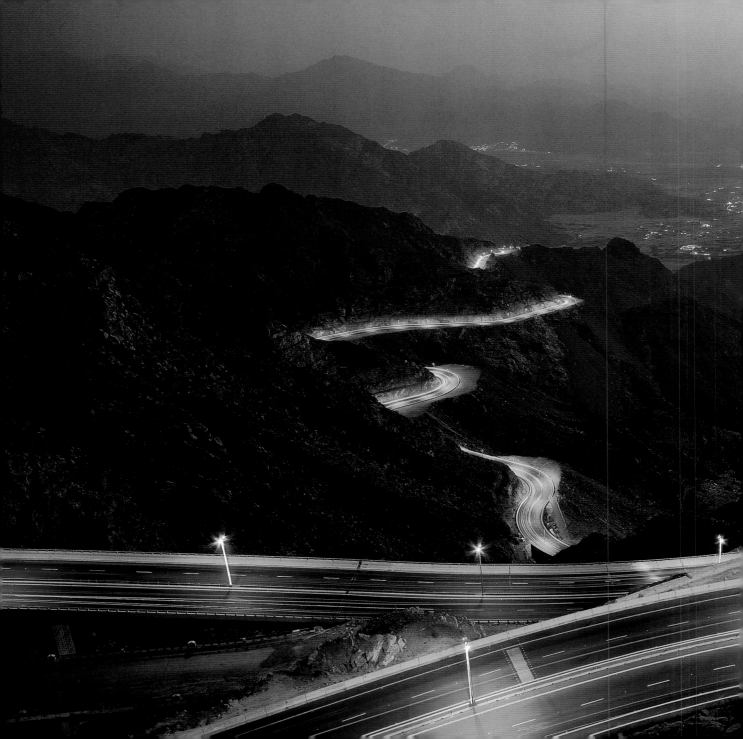

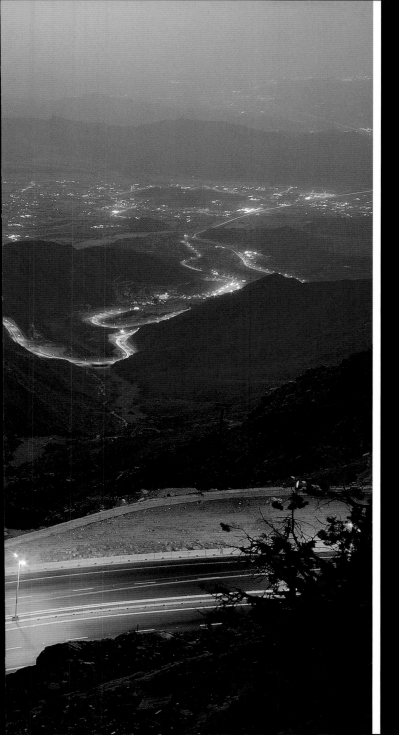

EXPLORE OUR CHANGING WORLD

DIOSDADO BAUTISTA — AL HADA, TA'IF, SAUDI ARABIA

BY CORY RICHARDS AND SADIE QUARRIER

THE POWER OF A PICTURE

Changes in our world are happening at breakneck speed. Great photographs provide us with the opportunity to slow down and see the world in a new way. They can inform, delight, engage, and broaden our worldviews. Evocative images can also direct attention to important issues. That's when the power of photography really emerges. It enables us to document and explore what these changes mean for ourselves and for our communities.

This assignment is about finding examples of change. Your pictures might come from your own community or backyard, or from a place that you are seeing for the first time. Ask yourself what is special, or perhaps disappearing, in your world. The list of ideas is endless. "Our Changing World" can include weather (droughts, floods, storms, or fires), landscapes (pristine areas under threat or aerials showing suburban sprawl), or culture (vanishing traditions or new trends). Pictures that juxtapose old and new also work well to demonstrate change.

Take pictures of what inspires you, and challenge yourself to create thought-provoking examples of change, whether positive or negative. Look for unique vantage points, unexpected moments, and interesting details.

With this assignment, we hope you will embrace the power of photography, which connects us and inspires us to care about our evolving planet. Photography not only captures change, but also creates change. Have fun with this assignment and enjoy seeing in a new way.

ABOUT THE ASSIGNMENT EDITORS

Cory Richards, NATIONAL GEOGRAPHIC PHOTOGRAPHER AND **Sadie Quarrier,** *NATIONAL GEOGRAPHIC* MAGAZINE

One of the world's most acclaimed adventure photographers, Richards (right) has been named a National Geographic Photography Fellow and a National Geographic Adventurer of the Year. His photography has appeared in *National Geographic* and *Outside* magazines, and in the *New York Times*.

 As a senior photo editor, Quarrier (left) specializes in editing adventure stories for the magazine. She has won numerous awards for her work and is a voting member on the National Geographic Society's Expeditions Council.

MICHELE MARTINELLI — RANOHIRA, MADAGASCAR

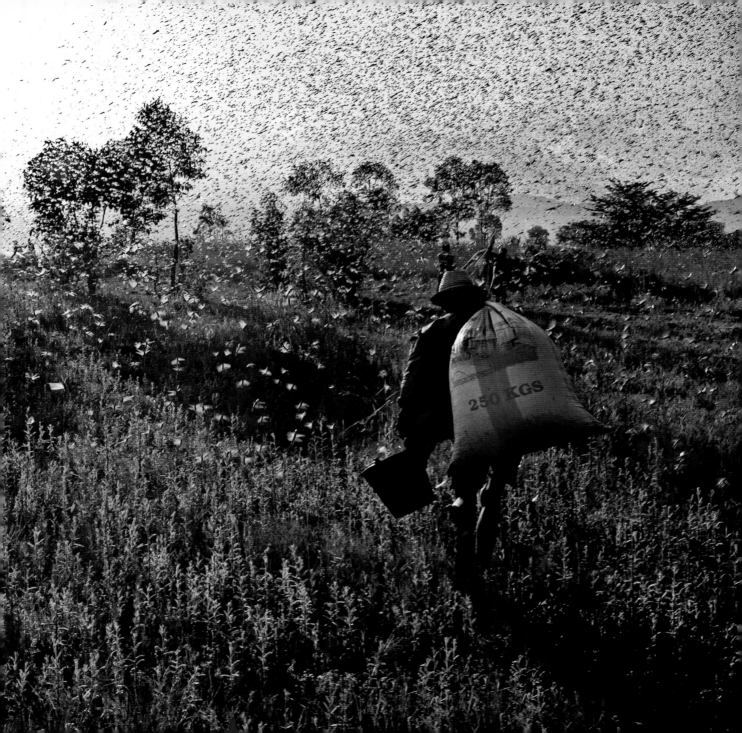

»LIGHT TAKES FLIGHT

At any given time, half of our planet exists under the cover of darkness. In this seeming absence of light, it's easy to set our cameras down. *Don't!* Nighttime is *not* an absence of light, but an opportunity to use it differently. In this image, we see a creative interpretation of form and composition, as well a playful inquiry into how we can bring a world in shadow to life. A wingspan, light trails, headlights, a cityscape, and a figure come together as a story begging to be told. Using techniques like shutter drags, long exposures, flash, and even high ISOs, we can create graphic imagery while much of the world is fast asleep.

HOW TO BALANCE MOTION AND STILLNESS

• **Find your anchors.** If everything moves, your photo becomes one big blur. Make sure to include nonmoving elements to anchor your image.

• **Turn your flash on.** Use a combination of flash and slow shutter speed to freeze some elements, while capturing the movement of others through light paths.

• **Follow the light.** Look for interesting colors or bursts of light to create a busy, but not overwhelming, scene.

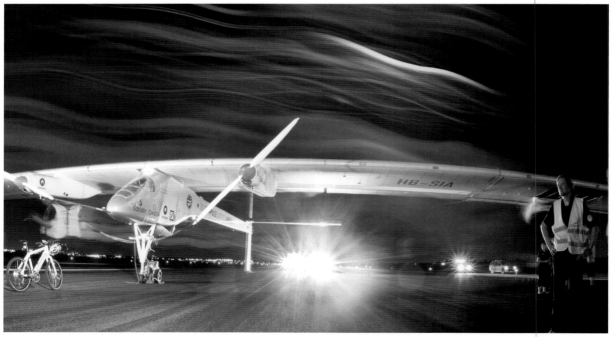

JUAN OSORIO / SOLAR-POWERED PLANE — ROCHDALE VILLAGE, JAMAICA, NEW YORK

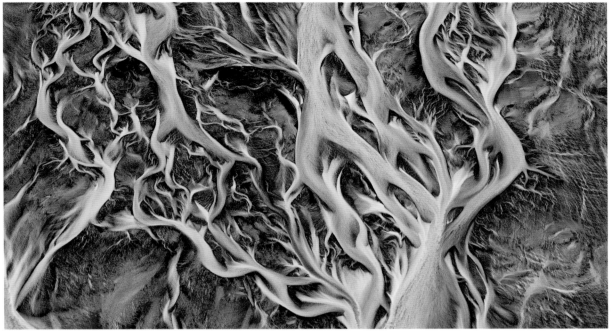

EMMANUEL COUPE / AERIAL VIEW OF RIVERS — ICELAND

»THE RIVER **WILD**

Sometimes the best way to tell a story is to change the way we see it, both mentally and spatially. This image is such a perfect use of that technique. Because we experience Earth from its surface, we overlook so much of our surroundings and mistake the extraordinary for the ordinary. This image offers us a new vantage point. From ground level, all we would see is a simple floodplain. Here it becomes an intricate tapestry and palette that tells the story of gravity, water, and minerals. This photo provides a fresh look at how dynamic and alive our planet is.

HOW TO TAKE AERIAL SHOTS

- **Get up high** in an airplane, in a helicopter, or on a mountaintop for a new look at the landscape below.

- **Aerial shots let you** show huge stretches of scenery at once. Use this perspective to create a sense of the world below.

- **Seek out patterns and shapes** in the landscape. Natural and man-made landscapes can become abstract when you look at them from the right angle.

»ON THE **ROAD**

Sometimes great images are more than what we see at first glance. The beautiful use of dusk light combined with the ambient glow of the lantern gives the foreground subjects contrast and life. The cart and the ox, falling off into the shadows, begin to give us a larger narrative. But what I really love is the contrast between old and new, traditional and modern. The cityscape on the horizon tells us that even among the hustle of contemporary metropolitan life, a simpler and, at times, overlooked way of life persists. Great photography so often depends on finding and illuminating the unexpected, balancing what we know against what we so easily overlook—or simply choose not to see.

ANTIPOLO, CALABARZON, PHILIPPINES

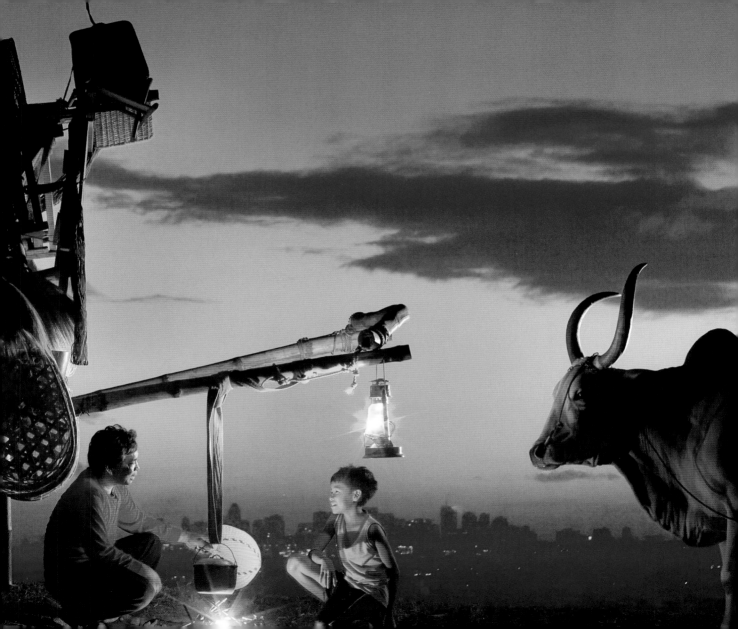

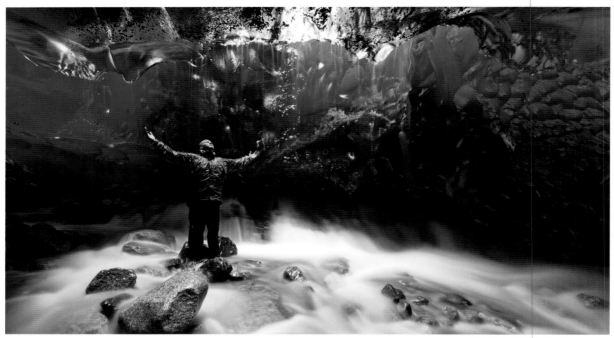

JONATHAN PRINCE TUCKER — ALASKA

»TANGLED UP IN BLUE

O f all the elements that make up our constantly changing planet, I find water to be one of the most captivating. Ice holds a deep fascination, as it signifies both hostile environments and the lifeblood that sustains us. Ice landscapes are at once ferocious and meaningful. This image places a human in an inhuman landscape, using color, texture, light, and form to illustrate both our impact and our reliance on Earth. The low shutter speed shows the ice melting, morphing into water.

HOW TO PHOTOGRAPH A GLACIER

- **To get the full effect** of the intense blues and other colors, turn the automatic white balance on your camera to tungsten.

- **Finding natural light** in a cave is hard, but it can be done. Look for the places where light streams in, and notice its effect on the glacier walls.

- **Bring your walking shoes.** This photographer hiked nearly two and a half hours to get to this cave. Hard-to-access places can make for very special photos.

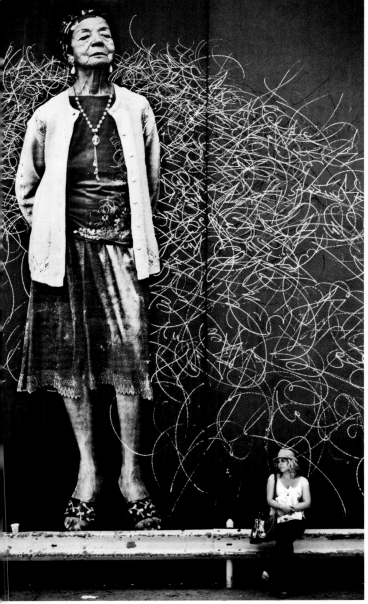

»A GIANT **AMONG US**

've always loved it when a photographer manages to play a trick on me. This image does that every time I look at it. We can often use scale to throw the eye, whether through spatial variance or through actual size differences. When you first look at this image, you see a proud older woman, three-dimensional and alive. But it's only when you see the smaller "real" figure on the bench that the image truly comes to life. The composition of this capture is extremely simple, yet paramount to its success. The black-and-white tonality allows us to experience the creativity and playfulness of the image without the distraction of color.

HOW TO SHOOT STREET ART

- **Contrasts between** art and the real world can create intrigue.

- **Look for clean lines.** A vertical line separates the elements in this frame, while a horizontal baseline keeps things grounded.

- **Show context.** Street art and graffiti come in all different shapes and sizes. Showing the wall, mailbox, or sidewalk where the art lives gives the viewer a sense of scale and context.

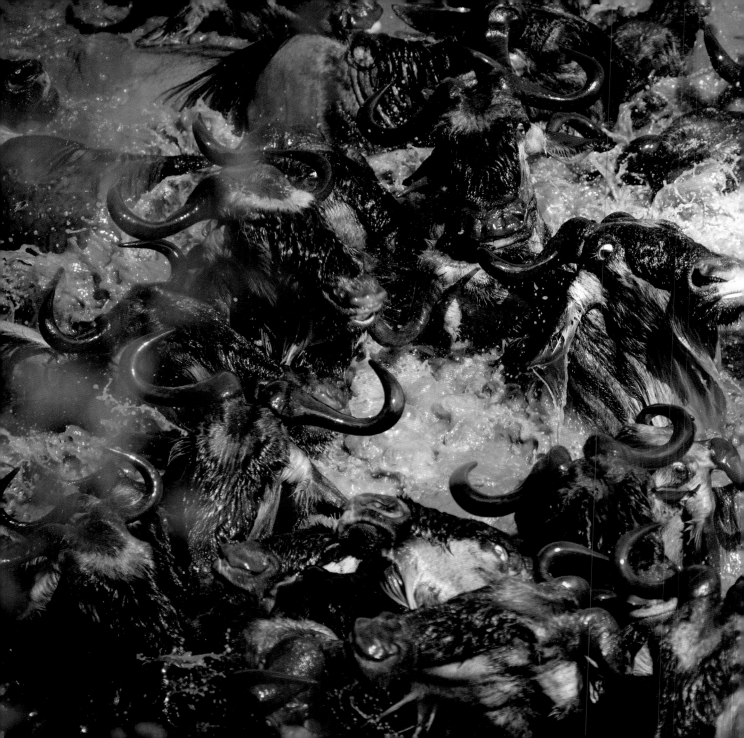

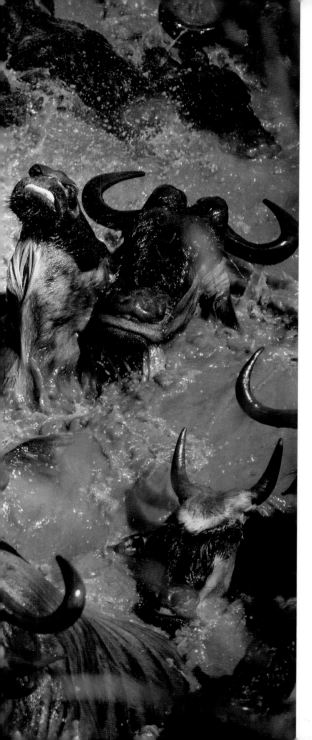

»MASS MIGRATION

The simple magnitude of a scene can be enough to make a good image. But how we choose to capture the energy in that scene can make it truly great. A wildlife migration can be a dramatic and provocative illustration of energy. This image captures chaos, motion, and change. Using a long lens, the photographer isolated a group of animals and created a visual vacuum, suspending us amid the chaos with no escape. We feel the immediacy of the migration frozen in every clashing wave and drop of water. And then there is the eye—a moment of panic and urgency serendipitously captured at center frame. I'm drawn into this image because I know there is no way out.

THE PHOTOGRAPHER'S STORY

"Forced to find new river crossing points in the Serengeti-Mara region of East Africa, the wildebeests descend into individual despair and collective chaos. Fast currents and steep banks all but deny escape onto the tree-covered banks. New arrivals try unsuccessfully to scramble over the lead group, which cannot climb quickly enough onto the available dry ground. Such scenes may become more common as the great migration faces more variable climate and narrower corridors from changing land use."
—Karen Lunney

MAASAI MARA, GREAT RIFT VALLEY, KENYA

»GONE FISHING

This image is all about light. The color of the backlit fishing nets contrasts with the deep shadows of the background. The light coming through the spray of the water creates playful shapes, drawing our eyes through the composition. We are so captivated by the color that it takes a moment to notice the larger cultural narrative. This kind of image takes equal parts skill and timing. In trying to capture powerful cultural illustrations, we need to be aware of all aspects of our surroundings, including when and where we can use light most effectively as a visual hook.

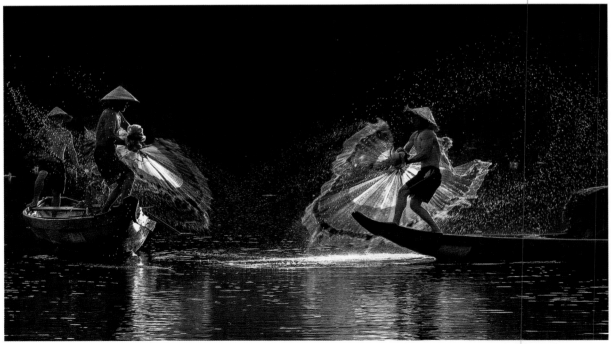

HOANG GIANG HAI / TRADITIONAL THROW FISHING — THUA THIEN-HUE PROVINCE, VIETNAM

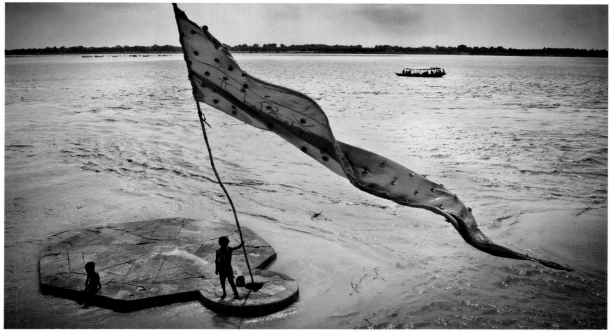

JOY ACHARYYA / GANGES RIVER — VARANASI, UTTAR PRADESH, INDIA

»FLAG **DAY**

We don't always have to be in someone's face to tell an intimate story. The scale of this image—created through the composition—makes it particularly evocative. Look at the vastness of the water and the size of the boat juxtaposed against the small children holding an enormous flag. It's a quiet moment of autonomy that leaves us connected, despite the stark absence of personal information. As we try to tell the story of culture, incorporating landscape can be pivotal to our success. In this case, through the use of negative space and a monochromatic palette, we get a glimpse of a life unknown . . . but with just enough intimacy to invite us in.

HOW TO MAKE A DRAMATIC STATEMENT

- **Give it some room.** Don't crowd your frame. When each element has its own space, it has a greater impact on the viewer.

- **Let a person be a shape.** Silhouettes can be just as interesting as a person in full focus.

- **Put harsh light to work.** The bright midday light can create interesting effects in your photography. See if you can make it work for you instead of compensating for harsh light.

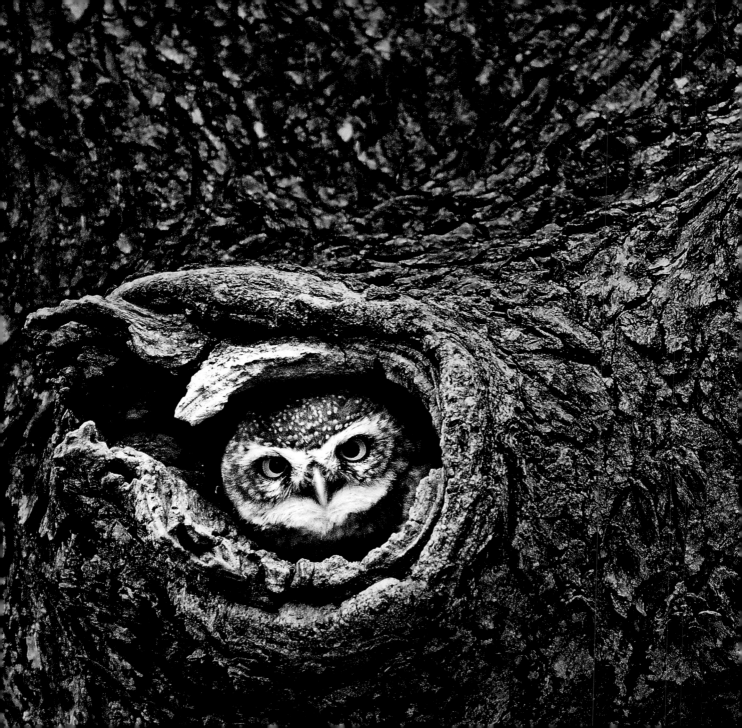

NATURE IN BLACK & WHITE

BY PETER ESSICK

BACK TO THE ELEMENTS

recently discovered Ansel Adams's book *Sierra Nevada: The John Muir Trail,* which showcases the stunning wilderness of California's Sierra Nevada. Adams's photos immediately struck me as simple yet elegant compositions; his straightforward black-and-white approach perfectly complements the purity of the mountains. These images left an indelible impression on me.

This assignment is a chance to channel your inner Ansel Adams by shooting nature in black and white. Many of Adams's photographs of nature elevate form by reducing a scene to its elemental components. Adams described this as "an extract of nature"—a way to turn landscape photography into an avenue for personal expression.

Black-and-white photography strips away the distractions and lets that message ring loud and clear. These photos are a departure from the reality we see every day; they carry the viewer to a different world. Try to capture the sacred spaces you've found in nature.

Seek out nature images that look more dramatic in black and white than in color. Usually this requires subjects for which form, light, and design are the dominant elements. Set your LCD display on your camera to monochrome so that you can see how the photo will look in black and white as you are shooting.

Ansel Adams and other early photographers portrayed nature as a Garden of Eden. Today we have a different view. We now know that all aspects of nature are interconnected and that humans can impact nature in a detrimental way. So, photographing nature can mean shooting a city park or a reclaimed industrial area, both of which are ecologically important and beautiful in their own ways. Nature photography can now include just about anything on Earth—an exciting prospect to discover and to enjoy.

For me, nature is a subject matter with no limits for a photographer with clear eyes and a receptive heart. I hope you feel the same.

ABOUT THE ASSIGNMENT EDITOR

Peter Essick, NATIONAL GEOGRAPHIC PHOTOGRAPHER

One of the world's most influential nature photographers, Essick has spent the past two decades photographing natural places around the world. His work has been featured in some 40 articles in *National Geographic* magazine.

MANISH MAMTANI — YOSEMITE VALLEY, CALIFORNIA

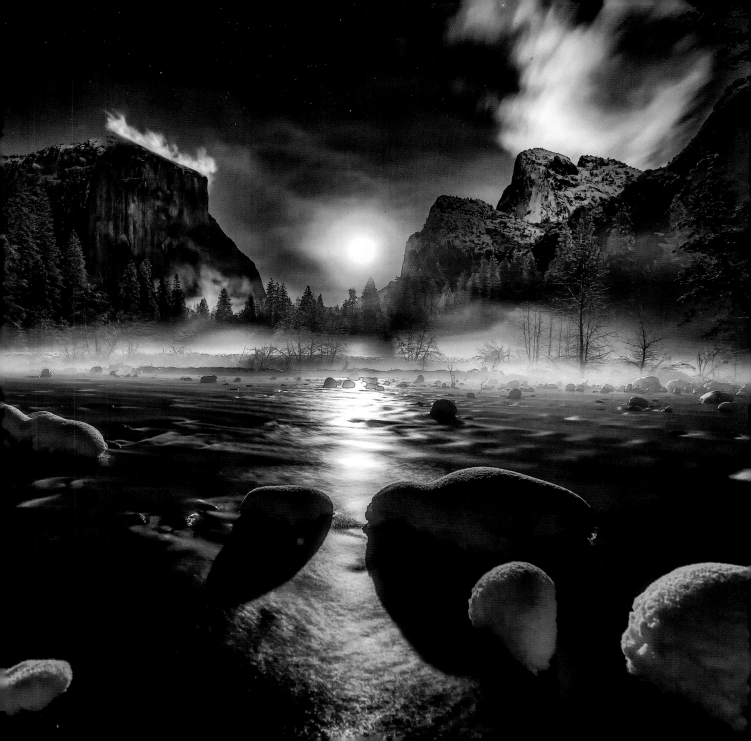

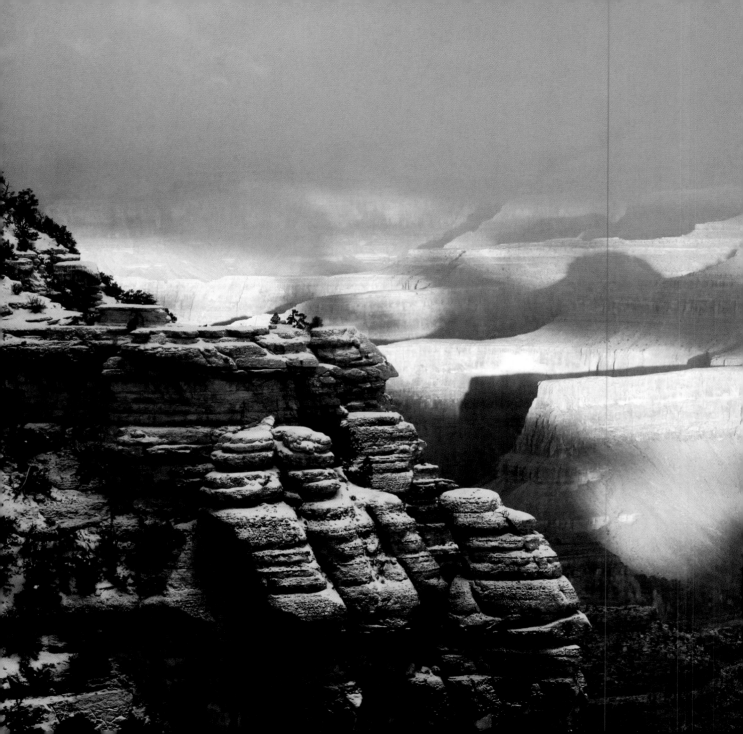

»UP IN THE CLOUDS

Outstanding landscape photography is often a matter of timing. Sometimes luck is on your side, but more often it is a matter of doing your research and making a concerted effort to be in the right place when conditions are optimal. Storms produce some of the most memorable landscape photos. In this case, a storm has passed over the Grand Canyon and has left a dusting of snow on the South Rim. The North Rim is hidden in the clouds, but just enough sunlight pokes though the clouds to light up the rock formations in the canyon. Not every storm produces perfect photographic conditions, but watching the weather and planning trips in off-seasons usually pay dividends. A photographer's definition of a beautiful day often differs from most people's—photographers frequently forgo comfort to experience a spectacular natural display.

THE PHOTOGRAPHER'S STORY

"It's the day after an all-day snowfall. This morning the weather was better already, but changing: clouds coming and going, occasional snow, and the sun peeking in and out. The Grand Canyon is always awe-inspiring, but with all of this light and shadow, with the misty clouds, and with snow-covering the top of cliffs like powdered sugar on a cake, it was just beyond my imagination."
—Veronika Pekkerne Toth

GRAND CANYON, ARIZONA

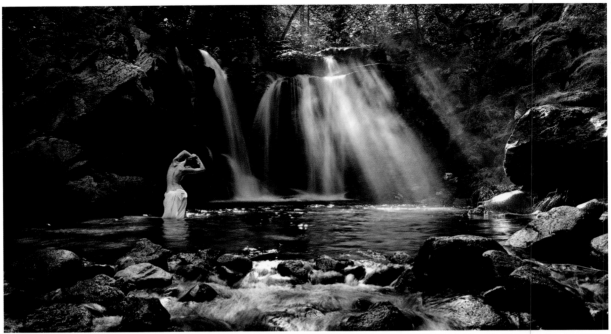

MARYANNE GOBBLE — WHISKEYTOWN, CALIFORNIA

»PARADISE FOUND

Creating a mood in a photograph can sometimes be more difficult than finding a good composition or making the correct exposure. This photograph makes you feel as if you are peering into a secret world. The graceful lines of the woman's figure convey a sense of calm. Soft light rays, filtering through the forest in the background and passing over the waterfall, create the impression of a mystical place. The water in the pool looks refreshing and inviting. The woman is small in the frame but stands out because she is sunlit and against the shadowy rocks. Somehow the photo invites us into an intimate space rather than making us feel like outsiders.

HOW TO CREATE MOOD IN PHOTOGRAPHS

- **Use soft lighting,** or shoot in the early morning or late afternoon.

- **When photographing** moving water or clouds, try a long exposure to capture a soft, dreamlike feeling. Don't forget to use a tripod to steady the camera.

- **Mist or fog** can produce an atmospheric effect in a landscape.

- **Create compositions** that are pleasing to the eye without any jarring elements, especially near the edges of the frame.

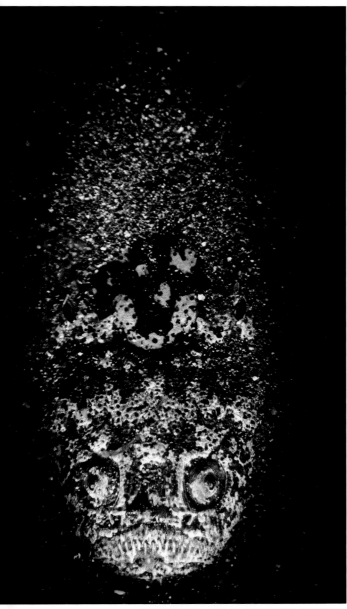

PERI PALERACIO — ANILAO, CALABARZON, PHILIPPINES

»CREATURE **OF THE SEA**

This unusual black-and-white underwater photograph of a stargazer fish uses directional lighting from below to create a feeling of mystery. The overall mood is one of an otherworldly creature lurking in darkness at the ocean bottom. At first we aren't sure what we are looking at. The sand covering the back portion of the fish makes the image resemble a stone statue or carving. Then we see the Frankenstein-like lighting, casting shadows upward on the eyes, and the realization hits us: This is a living organism, with very sharp teeth! In photos like this, the photographer often darkens the sides of the image to make the subject stand out. This technique increases the contrast in what could otherwise be a flat or unevenly lit image—with a captivating result.

HOW TO TO CREATE MYSTERY

- **Light small areas** of the image, and let the rest go into darkness.

- **Use symbolism** in your choice of subject matter. For example, moviemakers often use certain subjects, such as dark forests shrouded in fog, street lamps, moonlight, masks, or curtains, to evoke a mysterious mood.

- **Lighting from below** can create a fantastic, ghoulish effect.

»NATURE'S **FURY**

Lightning is a favorite subject of photographers, and for good reason. These images can be dramatic and beautiful in depicting the raw power of nature. Rendering lightning and storm clouds in black and white only enhances the drama. What makes this lightning photo special is that it captures both the downward bolt striking the ocean and multiple bolts radiating upward. Often lightning in the clouds doesn't photograph well and appears as just a flash of light, but in this case the lightning is spectacular. It is also fortunate that the upward bolts are balanced on the right and left sides of the frame. No one can plan for this, but if you can take many exposures during an intense thunderstorm, your odds of getting a breathtaking shot increase.

HOW TO PHOTOGRAPH LIGHTNING

- **Choose a safe location** that isn't near any tall objects.
- **To increase your chances** of seeing cloud-to-ground strikes, shoot from a location where you can see a great distance.
- **At dusk or at night,** open the lens for up to 30 seconds with an aperture of around f/8. Shoot frequently and hope for a lightning strike.
- **During the day,** use a lightning trigger. It will open your shutter when it senses the bolt of lightning.

RUDI GUNAWAN — TANJUNG LESUNG, WEST JAVA, INDONESIA

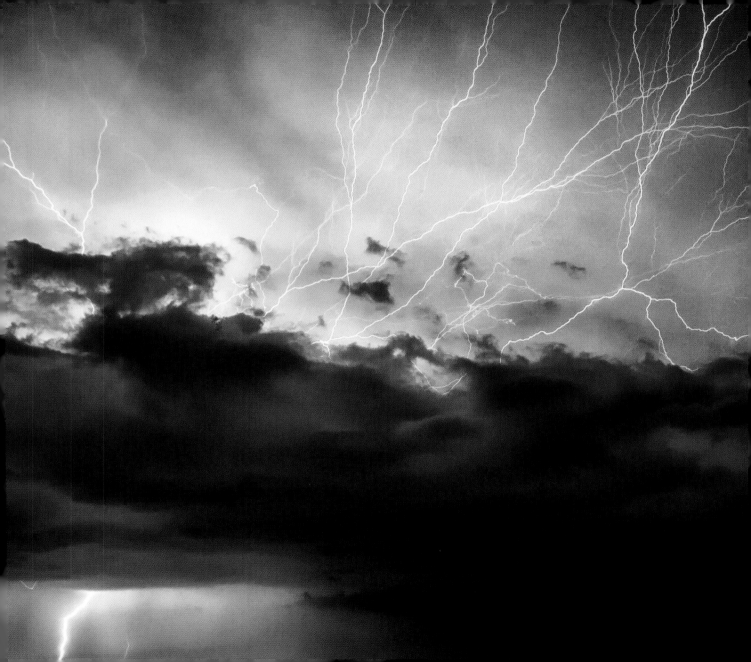

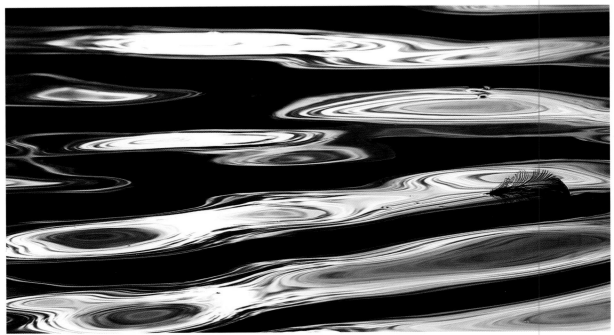

VERONIKA KOLEV

»RIPPLES **OF LIGHT**

Reflections in water offer an infinite variety of patterns for a creative photographer. Unfortunately, the results are often disappointing because of movement on the water's surface or a high contrast between the surface illumination and the reflection. It is important to know where the light is coming from. If you are looking down at the water from a 45-degree angle, the water is reflecting the scene in the background 45 degrees above the water. Following this principle, you can pick the best position from which to see a reflection. Here, the photographer adds another dimension by capturing the silhouette of the feather floating above the reflection.

HOW TO CAPTURE LIGHT ON WATER

- **Use a medium** telephoto lens to isolate a section of the reflection.

- **Focus in the middle** of the scene. Then close down the aperture to get enough depth of field to keep the water's surface in focus. The reflection should be out of focus.

- **Try to balance** the intensity of the reflected light and the ambient light to get a good exposure.

- **Look for** foreground objects or floating items to create a third dimension.

»WHO IS STALKING WHOM?

Photographing a wild African leopard in dense foliage is no easy task. The first order of business is to locate a leopard. These predators are active at night and in the early morning, so whether you are on safari or at a local zoo, these are usually the best times for photography. In this image, eye-to-eye contact between the photographer and the leopard first draws in the viewer. The pattern of the coat is so different from the surrounding vegetation that the leopard stands out, though its body is mostly obscured. The leopard's piercing eyes, peering out through the vegetation, add to the mystery and the sense of discovering an elusive creature.

HOW TO "CAPTURE" A CAT

- **Understand the habits** and behaviors of the animal you are hoping to photograph. Learning to anticipate the animal's movements, will help you take a great photo.

- **A long lens of 500mm** or greater is a must unless you are using a remote camera with an infrared trigger.

- **A blind can help** get you closer if you know which area the animals frequent.

- **Take your time.** The best wildlife photographs rarely happen right away.

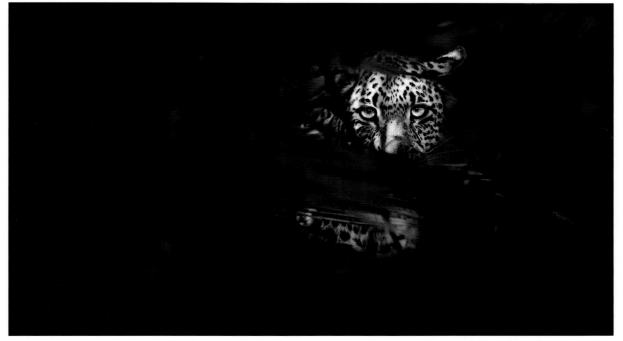

MORKEL ERASMUS — KRUGER NATIONAL PARK, SOUTH AFRICA

»GOING WITH THE FLOW

The natural shapes in this photograph are extraordinary. We see rivers of water and silt flowing into the windswept waves of the ocean. The framing—what the photographer chose to include and exclude—gives the photograph form and balance. You first see the main flow of the river, which leads the eye into the frame from left to right. The secondary elements—horizontal white water on the right and two dark water channels on the left—fill in the space to create visual equilibrium. What's even more amazing is that the photographer shot this scene from an airplane—a testament to the power of a great eye and a serious zoom lens.

THE PHOTOGRAPHER'S STORY

"This is an aerial of the delta of the Fulakvisl River and Lake Hvítárvatn in the Icelandic highlands. The river contains silt from the glacier Langjökull and forms a magnificent delta. The conditions were very windy, and I had to abort the flight shortly after taking this picture due to motion sickness. I used a Hasselblad digital medium format camera for the shot. The altitude was about 400 meters above the lake." —Hans Strand

LAKE HVÍTÁRVATN, ICELAND

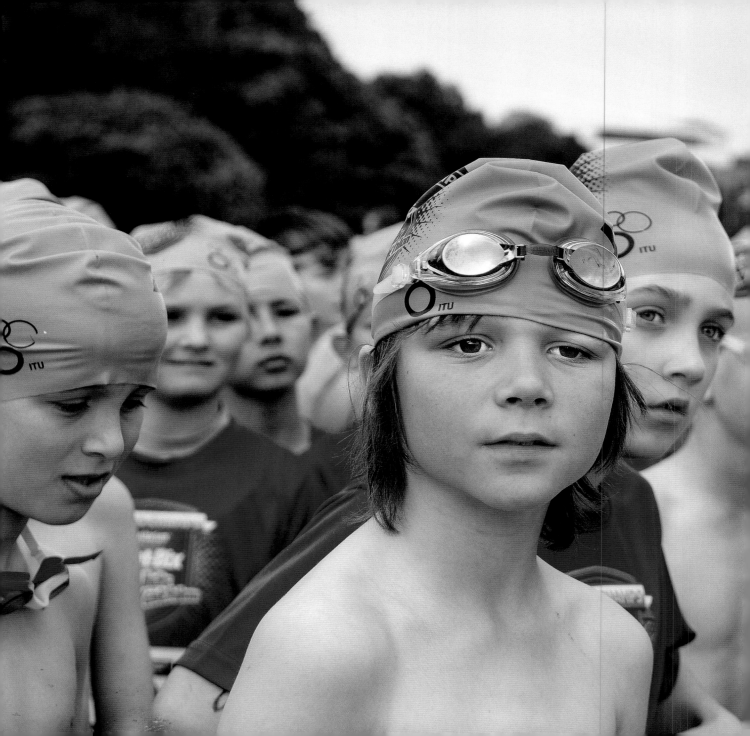

HOW CLOSE CAN YOU GET?

BY ED KASHI

BY ED KASHI
THE ART OF INTIMACY

Getting close is not only about physical proximity. It's about capturing a feeling, a mood, an emotion, or a sense of intimacy. It's the quality in a photograph that gives the viewer a feeling of being there in the scene as a silent, unseen observer. I call this "candid intimacy," and it's a quality I strive for relentlessly in my photography. I love being close to my subjects—not just physically, within touching range, but psychologically and emotionally.

For this assignment I want you to find a subject—preferably a human subject—and make an image that feels close. Avoid relying on a long or medium telephoto lens. Instead, move in closer physically and learn how to navigate the emotional and psychological landscapes where human (and, yes, animal) moments occur. The goal is to capture the essence of a moment, a person, or a scene.

To get close you must make eye contact and gain acceptance. The culture you are working in also dictates the appropriate distance or proximity to maintain. Gender plays a role as well. Invariably, if you work in a respectful, humble, and gentle manner, people of most cultures will accept you.

Here are my rules to shoot by: Be curious and open. Don't judge. Exude warmth, comfort, and safety. And be confident and sure of yourself. If you believe in what you are doing, others will accept you more easily and feel comfortable with your presence.

Getting permission before shooting is not just advisable; it is the right thing to do whenever possible. Always respect your subjects, and remember that you have no reason, in the normal world, to be there with a camera. Use your camera as your passport when entering these worlds.

ABOUT THE ASSIGNMENT EDITOR

Ed Kashi, NATIONAL GEOGRAPHIC PHOTOGRAPHER

An award-winning photojournalist and filmmaker, Kashi has produced 17 stories for *National Geographic* magazine. He has been a multimedia pioneer, documenting the social and political issues that define our times.

JAMES DUONG — HO CHI MINH CITY, VIETNAM

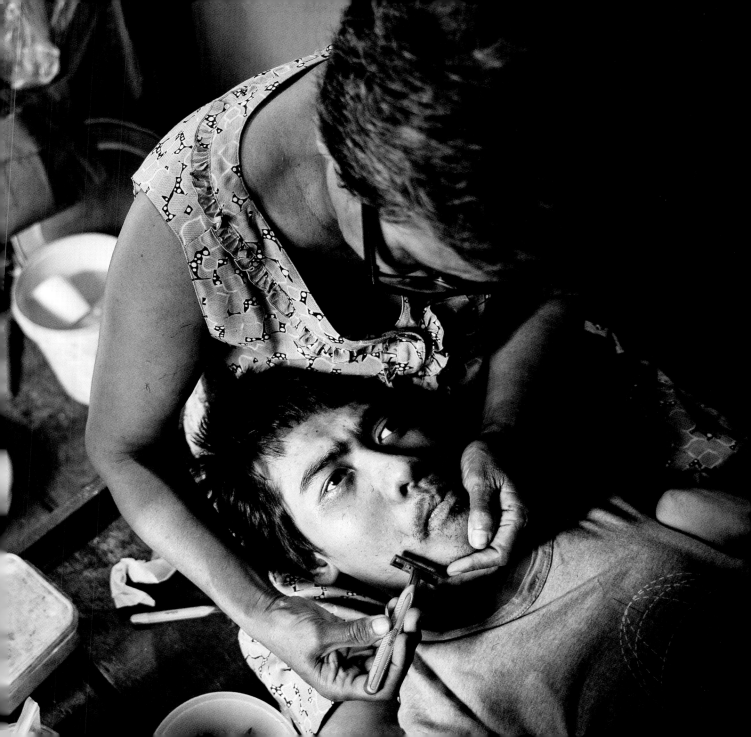

DEBASISH GHOSH / CHARCOAL PRODUCTION

»A PAINFUL **GAZE**

Photography is a privilege. Sometimes getting close means capturing something that would otherwise go unseen. Here, we glimpse a mysterious scene that outsiders normally do not witness. The man's eyes, peering through his head covering, create a sense of secrecy. The downward perspective and the smoke add to the moodiness, and the composition creates a strong visual statement. The repetition of circular shapes—the hole in the ground, the person's head, and the basket—binds the photo's elements together. The muted bluish hue of the image makes the man's face pop out of the mask. We feel a powerful desire to know what this photo is about.

HOW TO GAIN ACCESS

- **A photograph like this** requires access, trust of the subject, and quite possibly official permission to enter the workplace. Obtaining this requires grace, charm, some-times an official letter, and knowing the right person.

- **Wait for the right moment** for maximum impact. If the worker's head had been down, or if he had been looking away from the cam-era, this magical image would not have been possible.

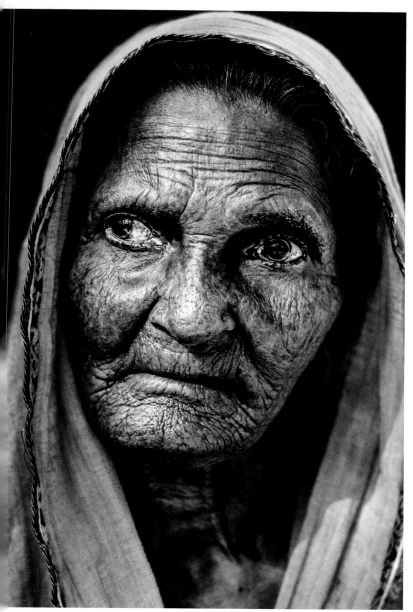

S. M. MAMUN — SYLHET, BANGLADESH

»IN HER **EYES**

We say that the lines of a face show the character of the person. That statement perfectly describes this captivating image. The eyes. The face. The grace of the head scarf. These elements, along with light and texture, make this photograph a standout. The woman's cloudy cataracts add a devastatingly powerful accent. Capturing this simple image did not require fancy photography tricks, but it is nonetheless striking and beautiful. The slight tilt of the head, the direction of the eyes, the way the woman's scarf falls—these small details are the difference between a pedestrian image and visual poetry.

HOW TO SHOOT AN INTIMATE PORTRAIT

- **You would need** a medium telephoto lens, with a focal length between 50mm and 105mm, to photograph a portrait like this one.

- **When your subject** has a face like this, don't be afraid to keep it simple and honor the subject. Sometimes simple is better.

- **Pay attention** to eye contact in portraits. Direct eye contact can reveal the soul and spirit of the subject, while an averted glance may tell more about your story.

»GROOMING RITUALS

Working with the foreground, middle ground, and background of an image can add drama and visual tension. Creating these layers is challenging, but it allows you to tell a story. In this photo, the position of the woman's face and her incredible eye in the extreme foreground set up a dynamic tension between the subjects. The fact that his eyes are looking back makes the scene all the more compelling. This photograph tells a story by including two subjects who seem dislocated in space but connected by eye contact. Notice the wonderful detail of the lipstick marks beside the man. This photo makes us feel chemistry between the subjects and wonder, even speculate, about their relationship.

HOW TO LAYER WITHIN A FRAME

- **Use a focal length of** 28mm to 50mm to accomplish this kind of layering. If you go too wide, the background recedes into the distance and causes distortion along the edges. You'll need an f-stop of f/8 or f/16. Increase your ISO to suit the light level.

- **When layering,** pay attention to your point of focus. Would this image be more effective if the woman were in sharp focus and the man were out of focus?

ANGELO FORMATO — NAPLES, ITALY

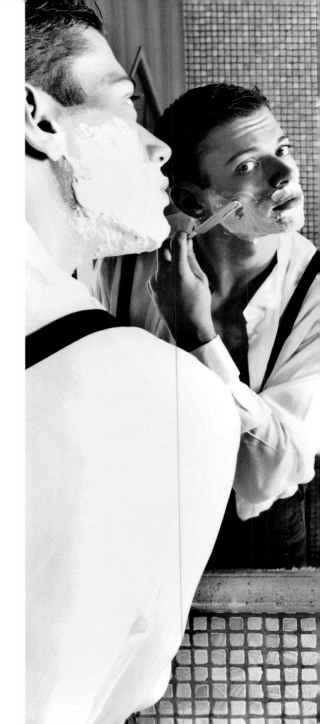

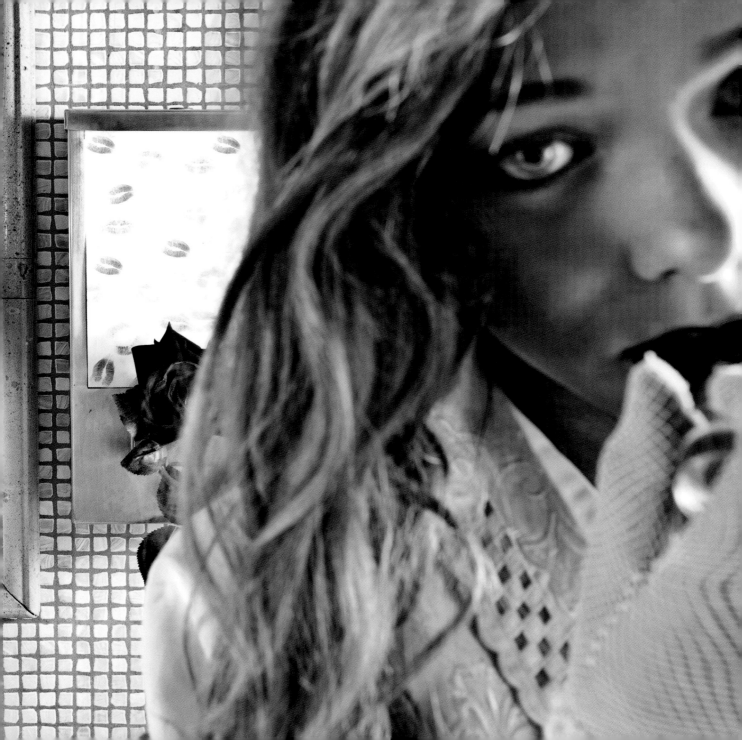

CHRISTOPHER DORMOY

»TECHNICOLOR **DREAM**

get lost in this image as I traverse the colorful textures of the powder, the beautiful features of the woman's face, her insanely lush eyelashes, and the soulful expression of her downcast eyes. Great light delineates the clean and vibrant details. From this close perspective, the viewer can absorb it all and luxuriate in the magic. As photographers, we seek out subjects that photograph well. These subjects call to us as "can't-miss" opportunities. But an ideal subject doesn't always guarantee a successful photo. What sets this image apart is the photographer's dignified and graceful approach to a striking subject.

HOW TO CAPTURE THE DETAILS

• **Shooting in bright,** but not contrasting, light allows details and colors to pop without losing anything in the highlight or shadows.

• **Select the right depth of field** for your subject. In this image, if the depth of field were too shallow, parts of the woman's face would be out of focus.

• **Play and experiment** with different expressions. How would this image have looked if the woman had directed her glance at the camera?

»DEVILISH FUN

This image pulls us right into the middle of the action. Fantastic lighting from the fireworks creates excitement and energy. The character with sunglasses creates a human point of reference, making the photo about more than special effects or cool lighting. The position of the hand over the burst of light is key to the success of this photo. The viewer's eye always goes to the brightest point, so without the hand, the burst would have drawn attention away from the rest of the frame. The photographer put all of these qualities together, creating a marvelous image with energy, character, and color.

HOW TO SHOOT A FESTIVAL AT NIGHT

• **In a scene** with extreme highlights—such as the light from these sparklers—make sure the people have light on them in order to avoid blown-out highlights or deep shadows.

• **When shooting fireworks,** expose for the highlights.

• **This image requires** a wide-angle lens. In this case, avoid having objects or people on the edges of the frames, as they will get distorted.

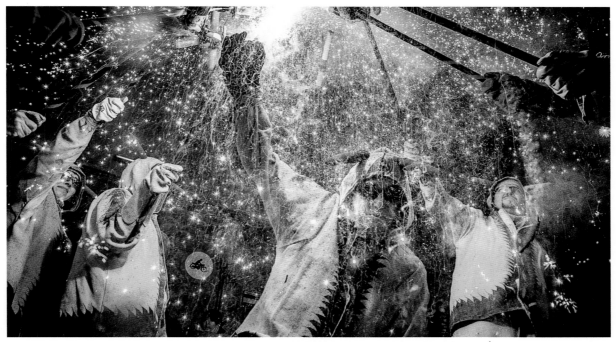

ANIBAL TREJO / CORREFOC FESTIVAL PERFORMANCE — SANT QUINTÍ DE MEDIONA, CATALONIA, SPAIN

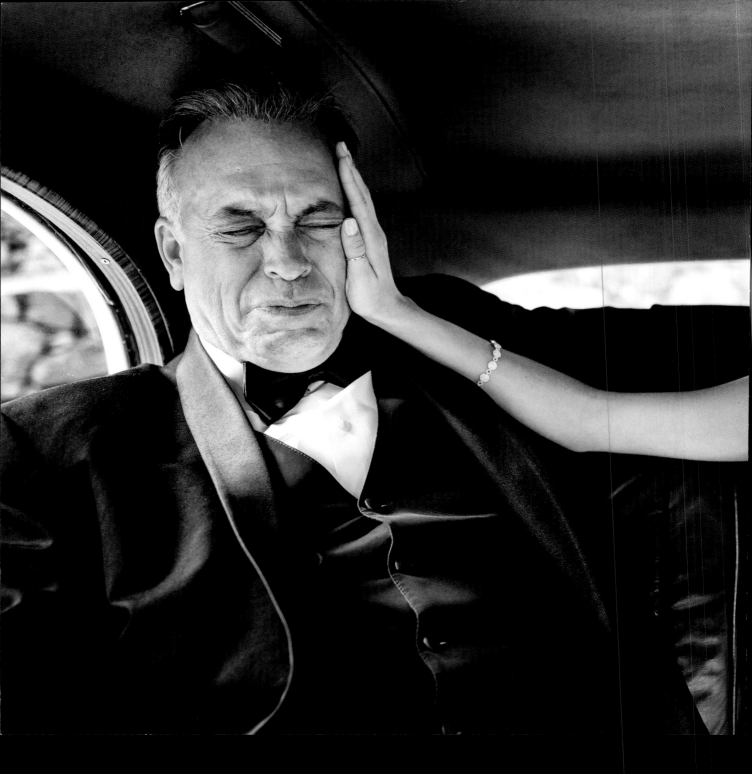

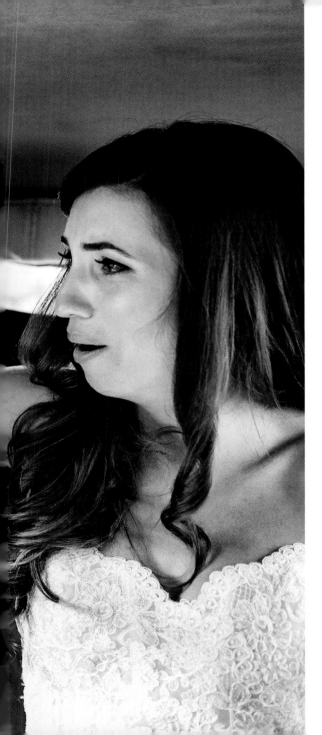

»A FATHER'S LOVE

Raw with emotion, this moment captures a universal aspect of a father-daughter relationship. Only a photograph can capture this moving and, in some ways, crushingly beautiful scene—the comforting hand on the cheek, the expressions on the subjects' faces, the distance between the photographer and the subjects. What an honor to be allowed to witness, let alone capture, this moment. These are the situations that remind me why we must honor and respect our subjects. Capturing a photo like this requires instinct, anticipation, and the reflexes of an athlete. You can't know when those touching moments will happen, so be observant, pay attention to emotional cues, and have your camera settings ready so you can snap at a moment's notice.

THE PHOTOGRAPHER'S STORY

"Iki's Dad, Bud, breaks down en route to the church to give away his little girl on her wedding day. A hundred percent trust and access are big parts of a wedding photographer's job. I sat backward in the front seat and just waited; I was only a few feet away when this moment transpired. Bud's love for his daughter was very poignant and beautiful to witness." —Tracey Buyce

LAKE GEORGE, NEW YORK

»A SACRED MOMENT

What a pose! What a composition! In this close-up of a human being who is vulnerable and exposed, I feel her dignity and beauty preserved. Magic! This image has everything—color, composition, lighting, a candid moment, emotion, drama, and mystery. The wonderful relationship between the main figure and the shadows creates a second story. At first glance, you might think she is alone. What is she doing? What's wrong with her? But as you notice the shadows, you realize she has an audience. Sometimes good photography asks as many questions as it answers.

HOW TO MASTER BODY LANGUAGE

- **Pay attention** to what people communicate with their bodies. As this photo demonstrates, sometimes the way a person moves tells a story.

- **To get a great close-up,** you want to your subject to forget you are there. Try to make yourself invisible. Make yourself as unobtrusive as possible by dressing in a way that does not draw attention and working slowly.

- **Use a fast shutter speed** to stop the action without blurring.

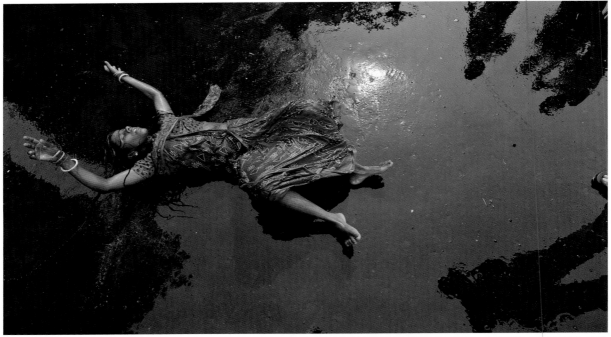

SOMNATH CHAKRABORTY / PRACTICE FOR THE DONDI RITUAL — CALCUTTA, WEST BENGAL, INDIA

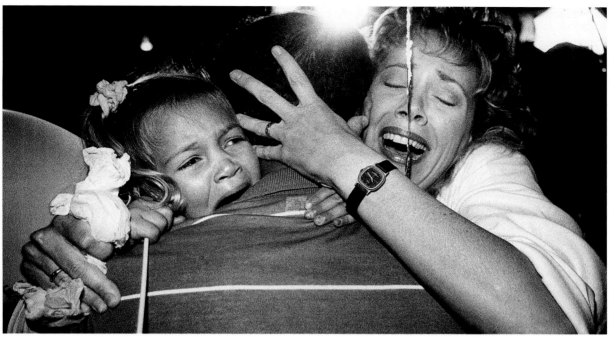

JOHN WARNER / A RELEASED HOSTAGE EMRACES HIS FAMILY. A BALLOON STRING IS CAUGHT IN THE EMBRACE. — INDIANAPOLIS, INDIANA

»HOSTAGE **RELEASE**

What is going on? Who is this person? Why so much emotion? This is an absolutely brilliant and real moment. A telephoto shot of this scene would not have put the viewer inside the moment like this close-up does. Proximity, plus emotion, plus a candid moment equal a great picture. Accomplishing all of this while shooting at a news event, as this photographer did, is a tremendous feat. The subject and the action are always unpredictable, but your job is to capture them. That's why it's essential to know your gear, to be prepared, and to be hyperaware of all that's going on.

HOW TO SHOOT AT A NEWS EVENT

- **The use of flash was essential** in creating this image. It lit the subjects cleanly and clearly, and set them apart from the background.

- **Anticipating the action** is key to taking great photographs.

- **When shooting in a crowd,** figure out the best place to stand to get your shot. Pick your angle carefully to reveal the most compelling aspects of the subject or scene.

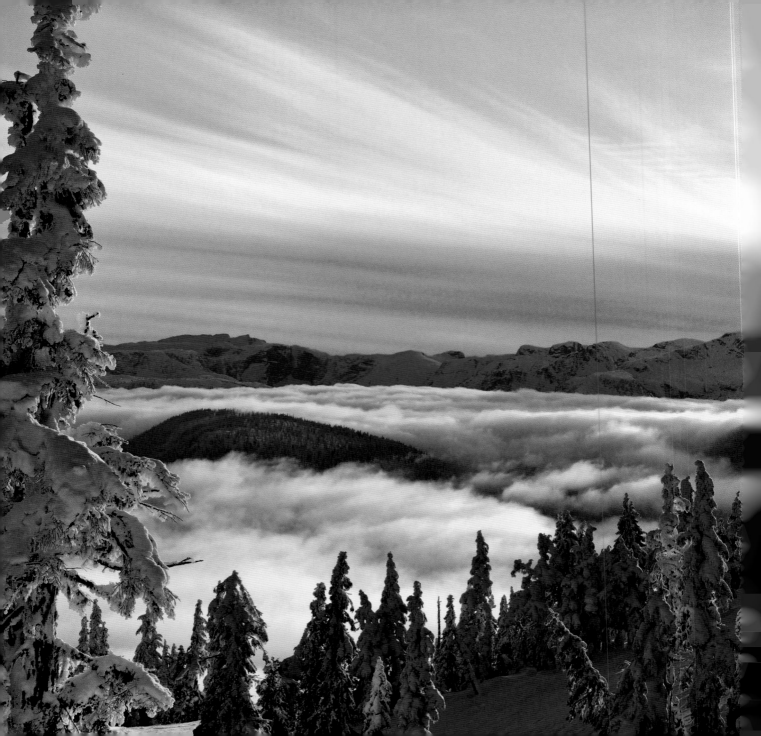

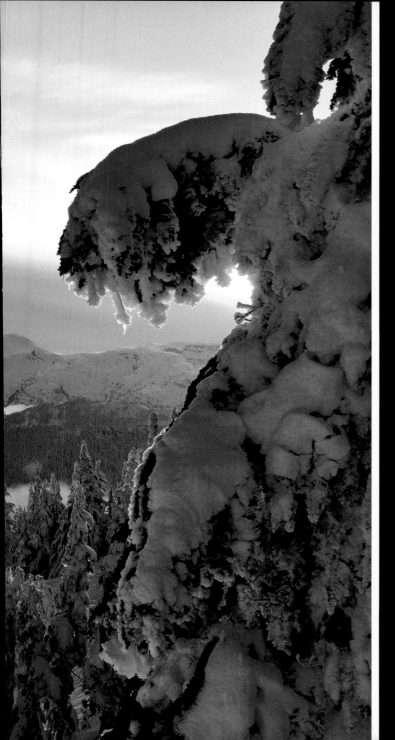

IMAGINE IF

ANN NYGREN — MOUNT WASHINGTON, COMOX VALLEY, VANCOUVER ISLAND

BY MONICA CLARE CORCORAN
DARE TO DREAM

Reimagine your life. These three words make some people smile and others shudder with anxiety. This assignment is an opportunity to daydream like you did as a kid. It's a chance to find your North Star—that person, place, or thing that calls to you. Take a picture of something that launches you in the direction of your dreams. Maybe it's a friend achieving a seemingly impossible goal, or a Death Valley sunset inspiring you to reconsider your path, or an antique rocking chair on a farm porch in Vermont that makes you yearn for simplicity.

Have you ever put a photo somewhere so that you could see it every day? Maybe it serves as a motivational tool and helps you keep your eyes on the prize. This is your chance to take that picture for yourself. What is your prize? What does living your dream look like? It's never too late to try something new and to go down a different path. Let out the photo in your mind.

Photography can inspire us to reach higher and to dream bigger. It can show us the possibilities in life. Once you've determined your life's dream, visualize yourself in that place, with that person, doing that thing you love.

Get creative with this assignment. You can play with light, reflections, or time lapse to give your photo a more dreamy or conceptual feeling. Put yourself in the picture, either literally or figuratively. I'm partial to photos that are more than what they seem and allow the viewer to imagine the rest of the story. What am I really looking at, and what does it mean?

Follow your dreams. Be inspired. And let your imagination run free. When you get that shot that says it all, take the next step and write a caption. Can you put the importance of the image or feeling into words? Perhaps that will take you one step closer to making your dream come true.

ABOUT THE ASSIGNMENT EDITOR

Monica Clare Corcoran, NATIONAL GEOGRAPHIC YOUR SHOT

Corcoran is an award-winning photography producer with more than 15 years of experience in visual story-telling. She is the senior managing editor of Your Shot, National Geographic's photo community.

JAMES HILGENBERG — OBERSTDORF, BAVARIA, GERMANY

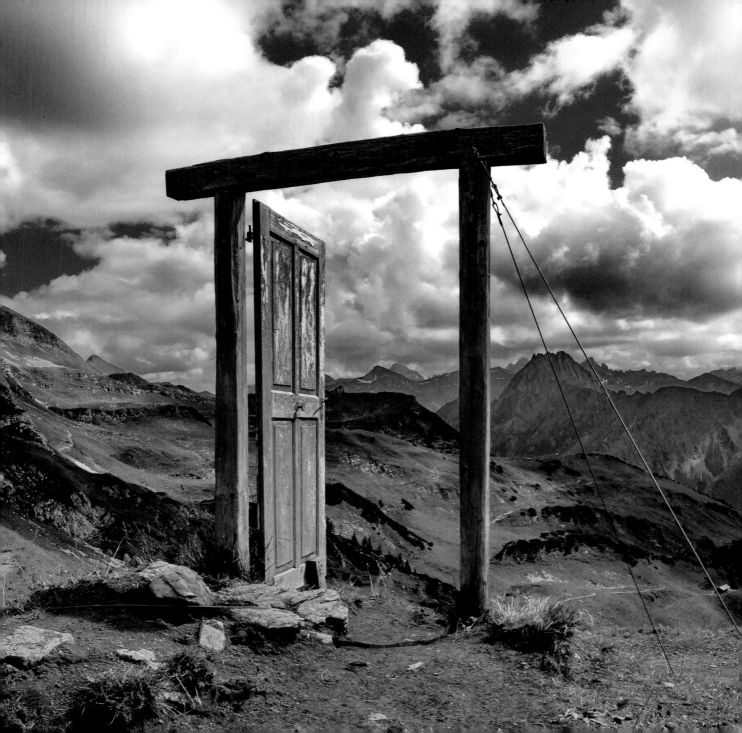

»LAMU DREAMER

The layers of this image come together perfectly to tell a story—or many different stories—if you use your imagination. The photographer uses composition and lighting to draw us in and to focus our attention on the main character. The barefoot young woman, bathed in light and frozen in action, pops out of the foreground. She dribbles her ball and dreams of her future beyond these streets. The photo inspires us to think about the subject's life and to consider our own. The shrouded woman walking in the shadows adds another element to the story and provides a bit of tension. Meanwhile, the moving figure anchors the background and allows your eye to wander around the frame and take in the entire scene. But perhaps the most powerful aspect of this photo is that it presents two women on completely different life paths.

THE PHOTOGRAPHER'S STORY

"Sauda has always dreamed of playing football [soccer] since she was three years old and has held on to this dream, despite growing up in a culture that doesn't really encourage dreams of this nature. She loves to dribble and freestyle on the narrow streets of Lamu, in coastal Kenya, with passersby admiring her skill and love for the game. She's a girl of very few words, but her energy is as big and beautiful as her future. I think it's just a matter of time before her dream becomes her reality." —Migz Nthigah

LAMU, KENYA

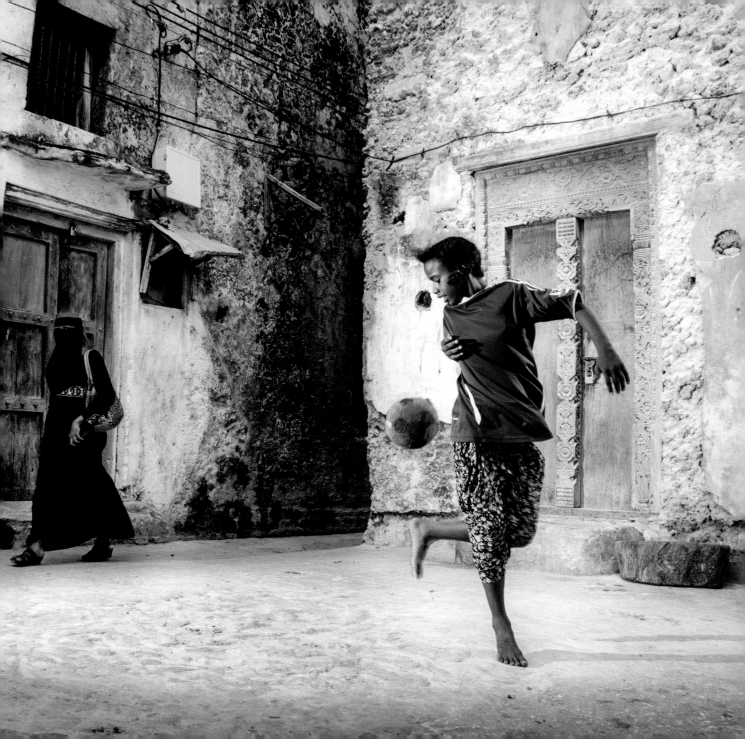

» -35°F IN ALASKA

Self-portraits are unique opportunities for a photographer to tell his or her own story at the moment it is happening. In this photo, the photographer is frozen in time, encrusted in ice and snow, and standing outside in the elements after hours of exertion. What is this man thinking as he looks away from the camera? The eerie blue light on his face signals the end to another day alone in the wilderness. Is his look one of determination or despair? By coming in close and leaving very little of the environment in the frame, the photographer gives the viewer nothing to look at but himself. This is unsettling yet intentional. The photographer's choices have created a moody image that entrances the viewer.

HOW TO SHOOT A SELFIE

- **Be intentional.** What do you want the viewer to feel? Should you look away from the camera or stare directly into it? Each strategy can mean something different.

- **Set the mood.** Think about how light dramatically alters a scene and plays with the viewer's emotions.

- **Share your soul.** A good self-portrait should offer insight into who you are at that moment.

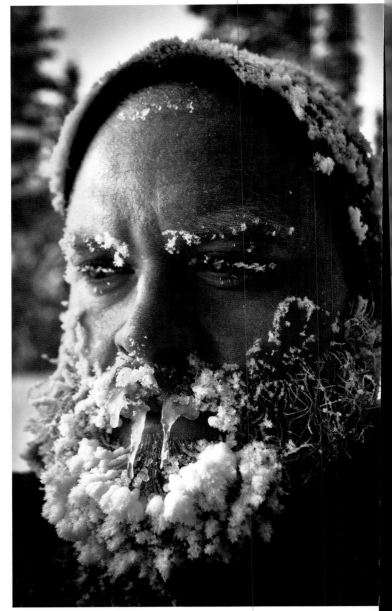

JACOB W. FRANK — DENALI NATIONAL PARK, ALASKA

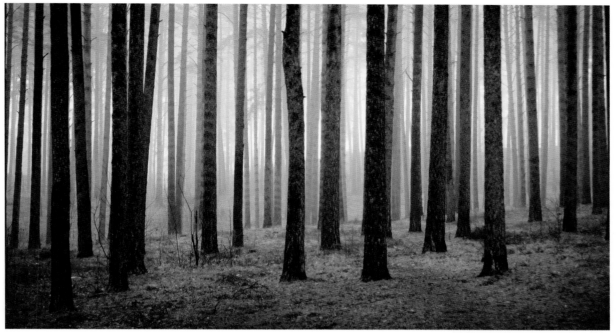

HELĒNA SPRIDZĀNE — BERĢI, RIGA, LATVIA

»WOODS **OF LATVIA**

These woods are both inviting and slightly off-putting. Fog descends on row after row of limbless tree trunks standing at attention like sentinels. The dreamy scene beckons viewers closer and dares them to step inside. What lurks in this forest? The hazy light plays with your mind and tricks the eye: Is this landscape never ending? The tall, thin trunks take up every inch as they repeat across the frame, and the viewer continues to scan the photo in search of something in this seemingly empty environment. In this photo devoid of humans, viewers can easily place themselves in this magical mystery world.

HOW TO MAKE MAGIC

- **When shooting outside,** take into account the time of day and the weather. These elements can turn an otherwise ordinary scene into a fantasy.

- **Compose the shot** in your camera and not after the fact by cropping the photo. Create with purpose. It shows in the final product.

- **Sometimes leaving** a landscape empty is better than waiting for someone to walk by.

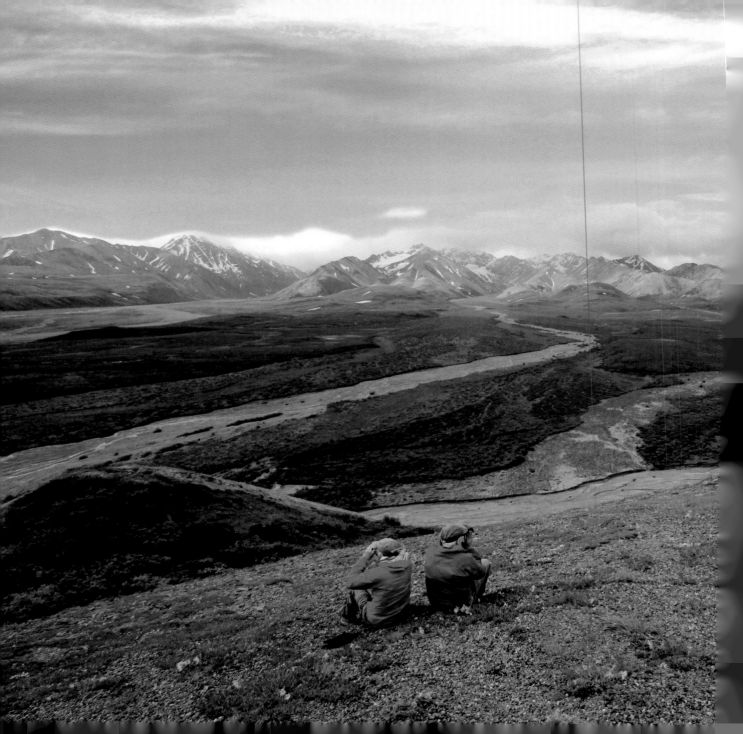

»THE RED **COATS**

There are certain factors—like the weather—that a photographer simply cannot control. This means it's important to know what you *can* control and plan accordingly. Traveling to Alaska's Denali National Park in late summer means that the landscape will be green and lush, that the water from the mountains will rush through the valley, and that other travelers will be there.

Being in the right place at the right time is usually a lot of hard work in addition to a bit of luck. Add in two people wearing almost identical blue caps and red jackets, and you've got a great scene. The photographer easily could have overlooked the couple and shot a beautiful landscape image. However, taking a step back and incorporating them into the frame made the photo more memorable and the story richer.

HOW TO GO BEYOND THE POSTCARD

• **Find your focal point.** Look for an element—it can be a person, an animal, or even an inanimate object—that will draw viewers in and let them focus on something immediately.

• **Take a step back.** Don't always go for the obvious. Look for different angles. Spend time taking in the scene and allowing it to unfold. Then shoot like mad.

VINEETH RAJAGOPAL — FAIRBANKS, ALASKA

»FLYING **ORIGAMI**

My initial reaction to this photo: How was this accomplished? But very quickly after that come feelings of joy and whimsy—and memories of playing in make-believe worlds where anything was possible and everything was full of wonder. Some photos make you feel like a kid again, even for just a moment. The shallow depth of field blurs out the background and lets you focus on the origami swan and the outstretched hands. Are the cupped hands waiting to catch the swan, or did they just let it go? The inner kid in me doesn't sweat the details and starts dreaming about paper swans flying up, up, and away.

HOW TO PLAY WITH DEPTH OF FIELD

- **What's important?** Shallow depth of field blurs the foreground and the background, eliminates distracting elements, and highlights the subject.

- **When photographing** a person, experiment with how changing the depth of focus alters the mood of the image.

- **Have fun.** Don't worry about the result. Enjoy the process and learn new photographic techniques. Mistakes can turn into masterpieces.

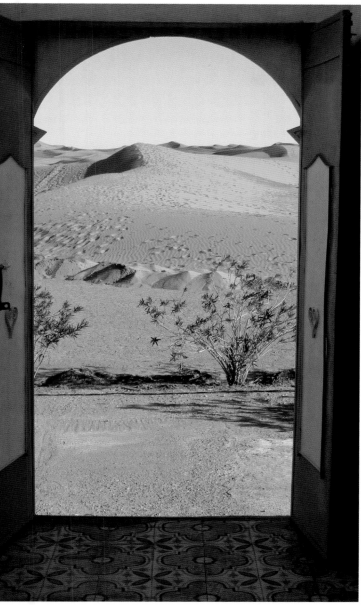

»BEHIND **EACH DOOR**

This creative composition shows the much photographed Sahara in a unique way. Door frames, arches, and tunnels can add a sense of mystery and adventure to an image. Where will this path lead? Who will I meet, and what will I encounter? If you aim to create images that have narrative, you need to spark the viewer's curiosity. The more questions the viewer has, the better. This type of photo makes us ponder and stay awhile as we visualize the story. Because the desert is framed in a doorway, we also learn a little about who lives there. The tiles, colors, and door design provide bits of information about the desert dwellers. And the photographer gets out of the harsh sunlight and takes you along, thus creating an easy entry into the photo.

HOW TO ADAPT IN THE FIELD

• **Turn negatives into positives.** A sudden rainstorm could actually be a blessing in disguise.

• **Don't take yourself** or your subject too seriously. You might be so busy worrying that you miss the perfect shot.

• **Keep moving.** Walk around and get a good sense of the place you are in. Notice the details. Take in your surroundings, and keep shooting.

»HOME **ONCE MORE**

Dramatic weather and a body of water can be a powerful combination in a photograph. The reflection in the pond creates a window into the past, present, and future of this seemingly unchanged place. Even without the caption, you can feel the emotions in this image, as they stimulate your imagination. Maybe this photo affects me emotionally because I lived for a short time on the farm where my father was born. Or maybe it's that we had a dog—like the one in the photo—who would stand next to our creek and look back at us. When it comes to photography, the reasons why you like a particular image are wholly subjective and very personal. But as the photographer, you should be thinking about what best tells the story about this particular person, place, or thing. Strive for photos that make you want to look at them again and again, because their story is never ending—photos that allow the viewer to imagine if . . .

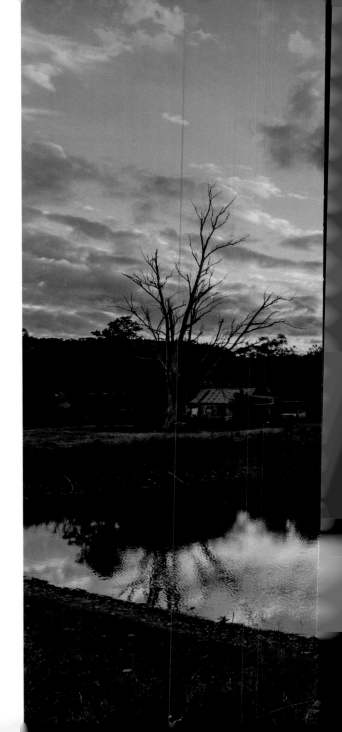

THE PHOTOGRAPHER'S STORY

"It seems so long ago that I spent my childhood with this scenery, that it almost seems a dream. It's a piece, however important, of my imagination—memories that fade in and out of my mind. Is what I recall of this place what happened? Have I re-created it? What I do know is that when I return, strong emotions that I can't explain overwhelm me. Nostalgia runs deep. I love my new home; however, the home of my childhood will forever run wild in my imagination." —James Abbott

SCONE, NEW SOUTH WALES, AUSTRALIA

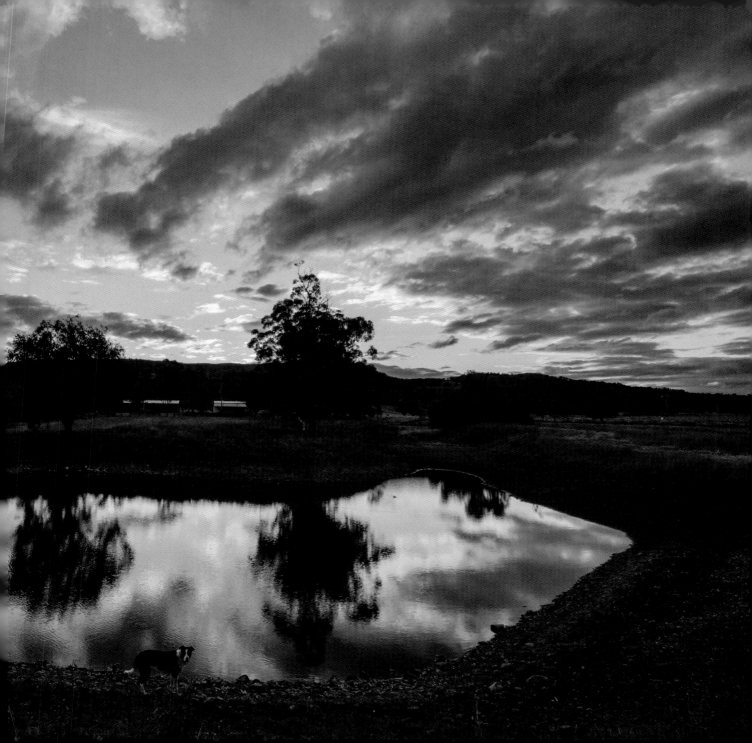

Glossary

APERTURE The adjustable opening inside of the lens that allows light to pass through. Measured in f-stops (a higher number signifies a smaller opening), aperture controls the depth of field in a photo.

ASPECT RATIO The ratio of width to height in an image or image sensor.

AUTOFOCUS A mode in which the camera automatically focuses on the subject in the center of the frame.

BOKEH The aesthetic quality visible in blurred, or out-of-focus, areas of an image. This term comes from the Japanese word for "fuzziness."

BRACKETING Taking a series of photos of the same subject at different exposures.

BURST MODE Also known as continuous mode, a setting that allows a digital camera to take several shots in less than a second.

CABLE SHUTTER RELEASE A mechanical or electronic cable used to trigger a mounted camera without touching it directly.

COMPRESSION The process used to decrease the size of a digital image file by combining or averaging data.

CONTRAST The range of brightness of a subject; the difference between the lightest and darkest parts of an image. A scene with high contrast includes both extreme highlights and very dark shadows.

DEPTH OF FIELD The distance between the nearest and farthest objects that appear in sharp focus in a photo.

DIGITAL ZOOM A camera function that digitally magnifies the center of the frame.

DISTORTION An optical change that causes straight lines near the edges of an image to be bent, either inward (known as pin-cushioning) or outward (known as barreling). When the perspective in a photo is unusual, some people refer to this as distorted perspective.

DSLR (DIGITAL SINGLE-LENS REFLEX) An electronically operated camera that uses mirrors to show the potential image through the viewfinder.

DYNAMIC RANGE The range of darkest to lightest parts of an image.

EXPOSURE The total amount of light that reaches the camera's sensor while taking a photograph.

FILTER A piece of colored and/or coated glass or plastic, placed in front of the camera lens, that alters or enhances the light reaching the sensor.

FLARE A degradation of picture quality, caused by reflections inside the lens, that reduces contrast or forms unwanted patches of light.

FOCUS Clear definition of a photo element and its outlines; lack of blurriness.

F-STOP The setting of a lens's aperture, which is equal to the focal length divided by the diameter of the aperture. The smaller the number, the larger the lens opening.

HISTOGRAM A bar graph showing the relative number of pixels in different brightness ranges in a digital image, from dark to light.

HUE The overall color of a photo.

ISO A standard for image sensor rating; the higher the number, the more light sensitive the sensor becomes. ISO stands for International Standards Organization, which sets the standards used to rate the speed or light sensitivity of film. Now the term is used to measure sensitivity of digital camera sensors.

MACRO Photography of small subjects at a very short distance. The image on the sensor is close to the real-life size of the subject, or even larger.

MEGAPIXEL (MP) One million pixels; a unit of modern digital camera resolution.

METADATA Mechanical information that a digital camera automatically attaches to each image.

NOISE The digital equivalent of grain in film photography, noise occurs when photographs are shot with a high ISO in low light.

PANORAMA A picture with an exceptionally wide field of view, created either by an ultra wide-angle lens or digital composite.

PIXEL Abbreviation for picture (*pix-*) element (*-el*). Pixels are the smallest bits of information that combine to form a digital image. The more pixels, the higher the resolution.

POSTPRODUCTION EDITING Using software to make adjustments to a photo after the image has been captured.

PRIME LENS A lens with a fixed focal length (as opposed to a zoom lens, which has variable focal length).

RAW FILE A type of image file that captures the maximum amount of data possible, allowing photographers to manipulate the image as they like in postproduction.

RED-EYE Red dots that appear in a person's eyes in a photograph. Red-eye occurs when light from a camera's flash reflects in the retinas.

RESOLUTION A measurement of the ability to resolve fine detail; the amount of information included in an image (in pixels). Determines the clarity and sharpness of a printed photograph.

SATURATION The intensity of color in an image.

SENSOR A chip with light-sensitive pixels that converts an optical image into an electric signal. The larger the sensor and the more pixels it has, the more information the sensor collects.

SHUTTER The mechanism built into the lens or camera that controls how much light reaches the sensor. It opens to expose the sensor to light entering through the lens aperture, and then it closes.

SHUTTER SPEED The speed of the shutter as it opens and closes (to allow light to reach the sensor). Expressed in seconds or fractions of a second, such as 1/60 or 1/250.

STROBE An electronic flash unit that produces an intense, short-duration burst of light.

TELEPHOTO LENS A lens that offers focal lengths longer than the standard. Often used to refer to any long lens.

WHITE BALANCE A control used to balance the color of an image to the scene's color so that the lighting looks natural.

WIDE-ANGLE LENS A lens with a focal length shorter than normal for the format, or any lens whose angle of view is wider than about 50 degrees.

ZOOM LENS A lens with variable, user-controlled focal length (as opposed to a prime lens, which has a fixed focal length).

The Photographer's Notebook

FRONT OF BOOK

• **PP. 2–3 Eric Peterson** LOCATION: Woodland Hills, California *

• **PP. 4–5 Shamim Tirmizi** LOCATION: Dhaka, Bangladesh CAMERA: Nikon D5100 FOCAL LENGTH: 55mm SHUTTER SPEED: 1/320 sec APERTURE: f/13 ISO: 400

• **PP. 6–7 Aggelos Zoupas** LOCATION: Skála Rachoníou, East Macedonia, and Thrace, Greece CAMERA: Nikon D5100 FOCAL LENGTH: 44mm SHUTTER SPEED: 1/640 sec APERTURE: f/7.1 ISO: 200

• **P. 8 Kevin Dietrich** LOCATION: Anchorage, Alaska *

• **P. 11 Lynn Johnson** LOCATION: Dimen, Guizhou Province, China CAMERA: Leica M FOCAL LENGTH: 21mm SHUTTER SPEED: 1/250 sec APERTURE: f/5.6 ISO: 400

• **P. 12 Konstadinos Xenos** LOCATION: Not available CAMERA: Nikon D700 FOCAL LENGTH: 120mm SHUTTER SPEED: 1/15 sec APERTURE: f/5.6 ISO: 3200

TOOL KIT

• **PP. 16–17 Mike Black** LOCATION: Conowingo, Maryland CAMERA: Canon EOS-1D X FOCAL LENGTH: 800mm SHUTTER SPEED: 1/1600 sec APERTURE: f/14 ISO: 12800

• **P. 22 Patrick Bagley** LOCATION: Arlington, Virginia CAMERA: Canon EOS-5D Mark II (left) FOCAL LENGTH: 24mm SHUTTER SPEED: 1/60 sec APERTURE: f/13 ISO: 100 (right top) FOCAL LENGTH: 24mm SHUTTER SPEED: 1/50 sec APERTURE: f/4 ISO: 100 (right bottom) FOCAL LENGTH: 105mm SHUTTER SPEED: 1/50 sec APERTURE: f/4 ISO: 100

• **P. 23 Moshe Demri** LOCATION: New York, New York *

• **P. 26 Veronika Kolev** *

• **P. 27 Gaston Lacombe** LOCATION: Pelči, Rucavas Novads, Latvia CAMERA: Canon EOS 5D Mark III FOCAL LENGTH: 130mm SHUTTER SPEED: 1/640 sec APERTURE: f/6.3 ISO: 400

• **P. 29 Glenn Barclay** LOCATION: Parkdale, Montana CAMERA: Not available FOCAL LENGTH: 4.3mm SHUTTER SPEED: 100/99999 sec APERTURE: f/4 ISO: 80

• **P. 30 Leonardo Neves** LOCATION: Teahupoo, Tahiti CAMERA: Canon EOS 7D FOCAL LENGTH: 10mm SHUTTER SPEED: 1/1250 sec APERTURE: f/5.6 ISO: 200

• **P. 31 Mark Bridgwater** LOCATION: Stewart Island, New Zealand *

• **P. 32 LEFT PJ van Schalkwyk** LOCATION: Muizenberg, Western Cape, South Africa CAMERA: Canon EOS 5D FOCAL LENGTH: 23mm SHUTTER SPEED: 1/80 sec APERTURE: f/8 ISO: 50

• **P. 32 RIGHT Cedric Favero** LOCATION: Pichingoto, Cusco, Peru CAMERA: Sony ILCE-7 FOCAL LENGTH: 53mm SHUTTER SPEED: 1/100 sec APERTURE: f/22 ISO: 200

• **P. 33 Oscar Ruiz Cardeña** LOCATION: San Buenaventura, Ixtapaluca, Mexico CAMERA: Sony Cyber-shot FOCAL LENGTH: 14.1mm SHUTTER SPEED: 1/500 sec APERTURE: f/4.5 ISO: 320

• **P. 34 David Tao** LOCATION: Queanbeyan, New South Wales, Australia CAMERA: Canon EOS 5D Mark III FOCAL LENGTH: 35mm SHUTTER SPEED: 1/80 sec APERTURE: f/2 ISO: 320

• **P. 35 TOP Larry Beard** LOCATION: Newport Beach, California *

• **P. 35 MIDDLE Sophie Porritt** LOCATION: Airton, England, United Kingdom CAMERA: Canon EOS 7D FOCAL LENGTH: 15mm SHUTTER SPEED: 1 sec APERTURE: f/20 ISO: 100

• **P. 35 BOTTOM Jr. Marquina** LOCATION: Malibu, California CAMERA: Canon EOS REBEL T1i FOCAL LENGTH: 21mm SHUTTER SPEED: 20 sec APERTURE: f/22 ISO: 100

• **P. 36 LEFT Emiliano Capozoli** LOCATION: São Gabriel da Cachoeira, Amazonas, Brazil *

• **P. 36 RIGHT B. Yen** LOCATION: Bacolod City, Western Visayas, Philippines CAMERA: Not available FOCAL LENGTH: 17mm SHUTTER SPEED: Not available APERTURE: f/2.79 ISO: 800

• **P. 37 Thomas Nord** LOCATION: Birmingham, Alabama CAMERA: Canon EOS 5D Mark II FOCAL LENGTH: 100mm SHUTTER SPEED: 1/80 sec APERTURE: f/2.8 ISO: 3200

• **P. 39 Patrick Bagley** LOCATION: Baltimore, Maryland CAMERA: Canon EOS 7D FOCAL LENGTH: 24mm SHUTTER SPEED: 1/60 sec APERTURE: f/6.3 ISO: 200

THE ASSIGNMENTS

• **PP. 40–41 Tracey Buyce** LOCATION: La Paz, Bolivia CAMERA: Canon EOS 5D Mark III FOCAL LENGTH: 200mm SHUTTER SPEED: 1/1250 sec APERTURE: f/5 ISO: 640

CATCH THE LIGHT

• **PP. 42–43 Samrat Goswami** LOCATION: Bishnupur, West

Bengal, India CAMERA: Nikon D7000 FOCAL LENGTH: 22mm SHUTTER SPEED: 1/250 sec APERTURE: f/10 ISO: 200

· **P. 45 Himal Reece** LOCATION: Bridgetown, Saint Michael, Barbados CAMERA: Canon EOS 7D FOCAL LENGTH: 78mm SHUTTER SPEED: 1/250 sec APERTURE: f/4.5 ISO: 100

· **PP. 46–47 Ken Dyball** LOCATION: Walvis Bay, Erongo, Namibia CAMERA: Nikon D7000 FOCAL LENGTH: 300mm SHUTTER SPEED: 1/40 sec APERTURE: f/13 ISO: 200

· **P. 48 Carol Worrell** LOCATION: Mount Vernon, Washington CAMERA: Canon EOS REBEL T2i FOCAL LENGTH: 90mm SHUTTER SPEED: 1/200 sec APERTURE: f/18 ISO: 400

· **P. 49 Natalia Pryanishnikova** LOCATION: Al Ghardaqah, Al Bahr al Ahmar, Egypt CAMERA: Canon EOS 5D FOCAL LENGTH: 15mm SHUTTER SPEED: 1/320 sec APERTURE: f/8 ISO: 320

· **PP. 50–51 Freddy Booth** LOCATION: Hawaii CAMERA: Canon GoPro HERO3 FOCAL LENGTH: 2.77mm SHUTTER SPEED: 1/503 sec APERTURE: f/2.8 ISO: 100

· **P. 52 Karin Eibenberger** LOCATION: Dobbiaco, Trentino-Alto Adige, Italy CAMERA: Canon EOS 5D Mark III FOCAL LENGTH: 18mm SHUTTER SPEED: 1/125 sec APERTURE: f/13 ISO: 200

· **P. 53 Alexis Gerard** LOCATION: San Mateo, California CAMERA: Sony DSC-RX100 FOCAL LENGTH: 20.85mm SHUTTER SPEED: 1/100 sec APERTURE: f/4 ISO: 125

· **PP. 54–55 Spencer Black** LOCATION: Brevard, North Carolina CAMERA: Nikon D35 FOCAL LENGTH: 31mm SHUTTER SPEED: 35 sec APERTURE: f/2.8 ISO: 3200

SELF-PORTRAIT
· **PP. 56–57 Mrittika Purba** LOCATION: Not available CAMERA: Nikon D7000 FOCAL LENGTH: 32mm SHUTTER SPEED: 1/6 sec APERTURE: f/4.8 ISO: 800

· **P. 59 Estefanía Hernández** LOCATION: Not available CAMERA: Canon EOS 5D FOCAL LENGTH: 50mm SHUTTER SPEED: 1/25 sec APERTURE: f/1.8 ISO: 160

· **PP. 60–61 Kevin Prodin** LOCATION: Yangjia, Shanghai Shi, China CAMERA: Nikon D800E FOCAL LENGTH: 24mm SHUTTER SPEED: 1/60 sec APERTURE: f/11 ISO: 100

· **P. 62 Helene Barbe** LOCATION: Jan Juc, Victoria, Australia CAMERA: HP Photosmart B110 *

· **P. 63 Tytia Habing** LOCATION: Watson, Illinois *

· **PP. 64–65 Lex Schulte** LOCATION: Ewinkel, North Brabant, Netherlands CAMERA: Nikon D90 FOCAL LENGTH: Not available

SHUTTER SPEED: 13/10 sec APERTURE: Not available ISO: 200

· **P. 66 Amanda Dawn O'Donoughue** LOCATION: Gainesville, Florida CAMERA: Canon EOS 6D FOCAL LENGTH: 50mm SHUTTER SPEED: 1/1250 sec APERTURE: f/1.4 ISO: 1000

· **P. 67 Darcie Naylor** LOCATION: Phoenix, Arizona CAMERA: Nikon D7000 FOCAL LENGTH: 18mm SHUTTER SPEED: 1/250 sec APERTURE: f/22 ISO: 800

· **PP. 68–69 Margaret Smith** LOCATION: Not available CAMERA: Not available FOCAL LENGTH: 100mm SHUTTER SPEED: 1/125 sec APERTURE: f/8 ISO: Not available

HOME
· **PP. 70–71 Carl Yared** LOCATION: Dbayeh, Mont-Liban, Lebanon CAMERA: Canon EOS 5D Mark III FOCAL LENGTH: 24mm SHUTTER SPEED: 5 sec APERTURE: Canon EOS 5D Mark III ISO: 1000

· **P. 73 Larry Deemer** LOCATION: Chéticamp, Nova Scotia, Canada CAMERA: Canon PowerShot D20 FOCAL LENGTH: 5mm SHUTTER SPEED: 1/640 sec APERTURE: f/3.9 ISO: 200

· **PP. 74–75 Rui Caria** LOCATION: Praia da Vitória, Azores, Portugal CAMERA: Nikon D4 FOCAL LENGTH: 200mm SHUTTER SPEED: 1/800 sec APERTURE: f/2.8 ISO: 125

· **P. 76 Anneke Paterson** LOCATION: Austin, Texas CAMERA: Canon EOS 5D Mark II FOCAL LENGTH: 16mm SHUTTER SPEED: 3/10 sec APERTURE: f/2.8 ISO: 3200

· **P. 77 Justin A. Moeller** LOCATION: Gardēz, Paktia, Afghanistan CAMERA: Canon EOS 7D FOCAL LENGTH: 200mm SHUTTER SPEED: 1/80 sec APERTURE: f/5.6 ISO: 320

· **PP. 78–79 Levan Adikashvili** LOCATION: Tbilisi, Republic of Georgia CAMERA: Nikon D200 FOCAL LENGTH: 135mm SHUTTER SPEED: 1/250 sec APERTURE: f/4.2 ISO: 250

· **P. 80 Sotia Douka** LOCATION: Rotterdam, Netherlands CAMERA: Nikon D5000 FOCAL LENGTH: 18mm SHUTTER SPEED: 1/125 sec APERTURE: f/5.6 ISO: 320

· **P. 81 Urdoi Catalin** LOCATION: Not available CAMERA: Canon EOS 100D FOCAL LENGTH: 15mm SHUTTER SPEED: 1/25 sec APERTURE: f/4.5 ISO: 800

· **PP. 82–83 Amy Sacka** LOCATION: Detroit, Michigan CAMERA: Canon EOS 5D Mark III FOCAL LENGTH: 26mm SHUTTER SPEED: 1/250 sec APERTURE: f/10 ISO: 200

SPONTANEOUS ADVENTURE
· **PP. 84–85 Danilo Dungo** LOCATION: Rainbow Bridge, Tokyo, Japan CAMERA: Nikon D800 FOCAL LENGTH: 12mm SHUTTER SPEED: 1/2 sec APERTURE: f/16 ISO: 200

P. 87 **Douglas Gimesy** LOCATION: Torres del Paine National Park, Magallanes, Chile CAMERA: Olympus E-M5 FOCAL LENGTH: 35mm SHUTTER SPEED: 1/4000 sec APERTURE: f/4.5 ISO: 640

P. 88 **Yasha Shantha** LOCATION: Pinnawala, Sri Lanka CAMERA: Canon EOS 50D FOCAL LENGTH: 80mm SHUTTER SPEED: 1/100 sec APERTURE: f/5.6 ISO: 100

P. 89 **Sarah Choi** LOCATION: Hong Kong, China CAMERA: Leica X2 FOCAL LENGTH: 24mm SHUTTER SPEED: 1/30 sec APERTURE: f/2.8 ISO: 320

PP. 90–91 **Julia Cumes** LOCATION: Dennis, Massachusetts CAMERA: Canon EOS 5D Mark II FOCAL LENGTH: 34mm SHUTTER SPEED: 1/30 sec APERTURE: f/3.2 ISO: 4000

P. 92 **Steve Demeranville** LOCATION: Seattle, Washington CAMERA: Nikon D800 FOCAL LENGTH: 82mm SHUTTER SPEED: 1/1500 sec APERTURE: f/5 ISO: 250

P. 93 **Serge Bouvet** LOCATION: Pralognan-la-Vanoise, Rhône-Alpes, France *

PP. 94–95 **Shahnewaz Karim** LOCATION: Dhaka, Bangladesh CAMERA: Nikon D300S FOCAL LENGTH: 35mm SHUTTER SPEED: 1/30 sec APERTURE: f/14 ISO: 500

P. 96 **Jay Mantri** LOCATION: Earth's stratosphere (above southern California) CAMERA: GoPro3 *

P. 97 **Charlie Nuttelman** LOCATION: Supai, Arizona *

THE ANIMALS WE LOVE
PP. 98–99 **Hasib Wahab** LOCATION: Jahājmāra, Chittagong, Bangladesh CAMERA: Canon EOS REBEL T2i FOCAL LENGTH: 70mm SHUTTER SPEED: 1/400 sec APERTURE: f/4 ISO: 100

P. 101 **Juan C. Torres** LOCATION: Playa de Guayanilla, Puerto Rico CAMERA: Canon EOS 7D FOCAL LENGTH: 10mm SHUTTER SPEED: 1/15 sec APERTURE: f/22 ISO: 200

P. 102 **Nirmalya Chakraborty** LOCATION: Central India CAMERA: Sony DSC-HX1 FOCAL LENGTH: 50.6mm SHUTTER SPEED: 1/320 sec APERTURE: f/4.5 ISO: 125

P. 103 **Kristoffer Vaikla** LOCATION: Suurupi, Harjumaa, Estonia CAMERA: Canon EOS 5D Mark II FOCAL LENGTH: 105mm SHUTTER SPEED: 1/125 sec APERTURE: f/4 ISO: 125

PP. 104–105 **Takeshi Marumoto** LOCATION: Tokyo, Japan CAMERA: Sony ILCE-7R FOCAL LENGTH: 400mm SHUTTER SPEED: 1/125 sec APERTURE: f/5.6 ISO: 1600

P. 106 **Stéphanie Amaudruz** LOCATION: Thailand CAMERA: Nikon D5000 FOCAL LENGTH: 55mm SHUTTER SPEED: 1/60 sec APERTURE: f/8 ISO: 200

P. 107 **Hannah Harvey** LOCATION: Massachusetts CAMERA: Apple iPhone 5 FOCAL LENGTH: 2.18mm SHUTTER SPEED: 1/30 sec APERTURE: f/2.4 ISO: 80

PP. 108–109 **Julia Cumes** LOCATION: Kāziranga, Assam, India *

P. 110 **Jose A. San Luis** LOCATION: Kalinga, Cagayan Valley, Philippines CAMERA: Nikon D5100 FOCAL LENGTH: 36mm SHUTTER SPEED: 1/30 sec APERTURE: f/5 ISO: 640

P. 111 **Aslam Saiyad** LOCATION: Pandharpur, Maharashtra, India CAMERA: Canon EOS 500D FOCAL LENGTH: 23mm SHUTTER SPEED: 1/400 sec APERTURE: f/3.5 ISO: 200

AFTER MIDNIGHT
PP. 112–113 **Csaba Horvath** LOCATION: Köptanya, Somogy, Hungary *

P. 115 **Juan Osorio** LOCATION: New York, New York CAMERA: Canon EOS 7D FOCAL LENGTH: 24mm SHUTTER SPEED: 1/80 sec APERTURE: f/4 ISO: 1250

PP. 116–117 **John Warner** LOCATION: Boulder River, Montana CAMERA: Nikon D700 FOCAL LENGTH: 23mm SHUTTER SPEED: 30.75 sec APERTURE: f/5.6 ISO: 1600

P. 118 **Alejandro Merizalde** LOCATION: New York, New York CAMERA: Nikon D610 FOCAL LENGTH: 28mm SHUTTER SPEED: 1/13 sec APERTURE: f/4.2 ISO: 2500

P. 119 **Michael Wagner** LOCATION: Albany, New York *

PP. 120–121 **Adrian Miller** LOCATION: Campbell River, British Columbia, Canada CAMERA: Canon EOS 60D FOCAL LENGTH: 50mm SHUTTER SPEED: 30 sec APERTURE: f/1.8 ISO: 200

P. 122 **Joydeep Dam** LOCATION: Darmstadt, Hesse, Germany CAMERA: Fujifilm FinePix HS10 HS11 FOCAL LENGTH: 8.9mm SHUTTER SPEED: 1/5 sec APERTURE: f/3.6 ISO: 100

P. 123 **Ronn Murray** LOCATION: Fairbanks, Alaska CAMERA: Canon EOS 5D Mark III FOCAL LENGTH: 20mm SHUTTER SPEED: 1/125 sec APERTURE: f/16 ISO: 6400

FOODSCAPES
PP. 124–125 **Nicole Louis** LOCATION: Hôi An, Quang Nam, Vietnam CAMERA: Canon EOS 1000D FOCAL LENGTH: 39mm SHUTTER SPEED: 1/160 sec APERTURE: f/9 ISO: 400

P. 127 **Soma Chakraborty Debnath** LOCATION: West Bengal, India CAMERA: Nikon D90 FOCAL LENGTH: 50mm SHUTTER SPEED: 1/500 sec APERTURE: f/1.8 ISO: 400

PP. 128–129 **Kári Jóhannsson** LOCATION: Krabi, Thailand CAMERA:

Nikon D7000 FOCAL LENGTH: 30mm SHUTTER SPEED: 1/160 sec APERTURE: f/6.3 ISO: 200

• **P. 130 Ali Hamed Haghdoust** LOCATION: Legalān, East Azerbaijan, Iran CAMERA: Canon EOS 30D FOCAL LENGTH: 22mm SHUTTER SPEED: 1/160 sec APERTURE: f/4 ISO: 400

• **P. 131 Kaushal Singh** LOCATION: Lucknow, Uttar Pradesh, India *

• **PP. 132–133 Joshua Van Lare** LOCATION: Yangon, Myanmar CAMERA: Canon EOS 600D FOCAL LENGTH: 28mm SHUTTER SPEED: 1/125 sec APERTURE: f/6.3 ISO: 400

• **P. 134 Srimanta Ray** LOCATION: Kailāshahar, Tripura, India CAMERA: Canon EOS 30D FOCAL LENGTH: 43mm SHUTTER SPEED: 1/125 sec APERTURE: f/6.3 ISO: 400

• **P. 135 Mitul Shah** LOCATION: Ahmedabad, Gujarat, India CAMERA: Nikon D90 FOCAL LENGTH: 17mm SHUTTER SPEED: 1/500 sec APERTURE: f/2.8 ISO: 400

• **PP. 136–137 Wesley Thomas Wong** LOCATION: Harbin, Heilongjiang, China CAMERA: Sony DSC–RX100 FOCAL LENGTH: 10.91mm SHUTTER SPEED: 1/80 sec APERTURE: f/2 ISO: 400

LOVE SNAP
• **PP. 138–139 Ankit Narang** LOCATION: Delhi, India CAMERA: Canon EOS 5D Mark III FOCAL LENGTH: 41mm SHUTTER SPEED: 1/4000 sec APERTURE: f/2.8 ISO: 200

• **P. 141 Elizabeth Flora Ross** LOCATION: United States CAMERA: Apple iPhone 5S FOCAL LENGTH: 4.12mm SHUTTER SPEED: 1/30 sec APERTURE: f/2.2 ISO: 160

• **PP. 142–143 Rafael Hernandez** LOCATION: Pemba, Cabo Delgado, Mozambique *

• **P. 144 Thompson Gurrero** LOCATION: Kokrajhar, Assam, India CAMERA: Nokia N8-00 FOCAL LENGTH: 5.898mm SHUTTER SPEED: 3450/1000000 sec APERTURE: f/2.797 ISO: 105

• **P. 145 Lori Coupez** LOCATION: Chico, California CAMERA: Apple iPhone 4S FOCAL LENGTH: 4.28mm SHUTTER SPEED: 1/20 sec APERTURE: f/4.2 ISO: 125

• **PP. 146–147 Karla Maria Sotelo** LOCATION: Arteaga, Coahuila, Mexico CAMERA: Canon EOS 5D Mark II FOCAL LENGTH: 85mm SHUTTER SPEED: 1/5000 sec APERTURE: f/3.5 ISO: 640

• **P. 148 Brandy Metzger** LOCATION: Shreveport, Louisiana CAMERA: Canon EOS 60D FOCAL LENGTH: 50mm SHUTTER SPEED: 1/160 sec APERTURE: f/2 ISO: 320

• **P. 149 Meyrem Bulucek** LOCATION: Savannah, Georgia *

• **PP. 150–151 Peter Frank** LOCATION: Not available CAMERA: Nikon D7000 FOCAL LENGTH: 50mm SHUTTER SPEED: 1/60 sec APERTURE: f/3.5 ISO: 500

I HEART MY CITY
• **PP. 152–153 Ander Aguirre** LOCATION: Lisbon, Portugal CAMERA: Canon EOS 5D Mark II FOCAL LENGTH: 15mm SHUTTER SPEED: 1/125 sec APERTURE: f/7.1 ISO: 200

• **P. 155 Karl Duncan** LOCATION: Amsterdam, Netherlands CAMERA: Nikon D700 FOCAL LENGTH: 24mm SHUTTER SPEED: 1/80 sec APERTURE: f/2.8 ISO: 3200

• **PP. 156–157 Philippa D.** LOCATION: Istanbul, Turkey CAMERA: Canon EOS 5D Mark II FOCAL LENGTH: 24mm SHUTTER SPEED: 1/25 sec APERTURE: f/4 ISO: 800

• **P. 158 Andrea Jako Giacomini** LOCATION: Los Angeles, California CAMERA: Sony NEX-6 FOCAL LENGTH: 16mm SHUTTER SPEED: 1/50 sec APERTURE: f/2.8 ISO: 1600

• **P. 159 Bin Yu** LOCATION: Luwan, Shanghai Shi, China CAMERA: Canon EOS 5D Mark III FOCAL LENGTH: 24mm SHUTTER SPEED: 47 sec APERTURE: f/13 ISO: 50

• **PP. 160–161 Tony Ramos** LOCATION: Munich, Bavaria, Germany CAMERA: Nikon D3200 FOCAL LENGTH: 18mm SHUTTER SPEED: 1/13 sec APERTURE: f/13 ISO: 800

• **P. 162 Richard Vdovjak** LOCATION: Huangshan, China *

• **P. 163 Sigita Sica** LOCATION: Riga, Latvia CAMERA: Pentax K100D Super FOCAL LENGTH: 43mm SHUTTER SPEED: 1/90 sec APERTURE: f/8 ISO: 200

• **PP. 164–165 Mat Rick** LOCATION: San Francisco, California CAMERA: Canon EOS 5D Mark II FOCAL LENGTH: 35mm SHUTTER SPEED: 1/50 sec APERTURE: f/2.8 ISO: 800

BIODIVERSITY
• **PP. 166–167 Azim Mustag** LOCATION: Maldives CAMERA: Nikon D90 FOCAL LENGTH: 12mm SHUTTER SPEED: 1/125 sec APERTURE: f/8 ISO: 200

• **P. 169 Rafael Pires** LOCATION: Portugal CAMERA: Canon EOS 400D FOCAL LENGTH: 17mm SHUTTER SPEED: 1/800 sec APERTURE: f/2.8 ISO: 800

• **PP. 170–171 Sebastian-Alexander Stamatis** LOCATION: Denmark *

• **P. 172 Shai Oron** LOCATION: Eilat, Southern District, Israel CAMERA: Olympus E-PL1 FOCAL LENGTH: 42mm SHUTTER SPEED: 1/160 sec APERTURE: f/11 ISO: 100

• **P. 173 Lucas Firgau** LOCATION: Buabeng-Fiema Monkey Sanctuary, Ghana *

• **PP. 174–175 Vitor Hugo Moura** LOCATION: Lausanne, Vaud, Switzerland *

• **P. 176 Cheryl Burnham** LOCATION: Not available CAMERA: Nikon D700 FOCAL LENGTH: 105mm SHUTTER SPEED: 1/80 sec APERTURE: f/13 ISO: 800

• **P. 177 Daiga Robinson** LOCATION: Finse, Norway CAMERA: Nikon COOLPIX P4 FOCAL LENGTH: 7.5mm SHUTTER SPEED: 1/295 sec APERTURE: f/6.1 ISO: 50

• **PP. 178–179 Shane Kalyn** LOCATION: Prince George, British Columbia, Canada CAMERA: Nikon D90 FOCAL LENGTH: 70mm SHUTTER SPEED: 1/125 sec APERTURE: f/5.3 ISO: 200

FAMILY PORTRAIT
• **PP. 180–181 Monika Strzelecka** LOCATION: Poland CAMERA: Nikon D700 FOCAL LENGTH: 35mm SHUTTER SPEED: 1/100 sec APERTURE: f/6.3 ISO: 1250

• **P. 183 Marc Manabat** LOCATION: North Hollywood, California CAMERA: Fujifilm X100S FOCAL LENGTH: 23mm SHUTTER SPEED: 1/500 sec APERTURE: f/2.8 ISO: 1600

• **PP. 184–185 Vasile Tomoiaga** LOCATION: Bucharest, Romania CAMERA: Canon EOS 1000D FOCAL LENGTH: 18mm SHUTTER SPEED: 1/200 sec APERTURE: f/5.6 ISO: 800

• **P. 186 Adelina Iliev** LOCATION: Burgas, Bulgaria CAMERA: Canon EOS 5D Mark II FOCAL LENGTH: 28mm SHUTTER SPEED: 1/13 sec APERTURE: f/5 ISO: 1000

• **P. 187 Adrian Crapciu** LOCATION: Not available CAMERA: Canon EOS 60D FOCAL LENGTH: 24mm SHUTTER SPEED: 1/1600 sec APERTURE: f/2.8 ISO: 160

• **PP. 188–189 Sean Scott** LOCATION: Gold Coast, Queensland, Australia CAMERA: Canon EOS 5D Mark III FOCAL LENGTH: 14mm SHUTTER SPEED: 1/640 sec APERTURE: f/13 ISO: 200

• **P. 190 Andrew Lever** LOCATION: Bournemouth, England, United Kingdom CAMERA: Nikon D200 FOCAL LENGTH: 55mm SHUTTER SPEED: 1/320 sec APERTURE: f/5.6 ISO: 100

• **P. 191 Karine Puret** LOCATION: Paris, France CAMERA: Canon EOS 5D Mark II FOCAL LENGTH: 35mm SHUTTER SPEED: 1/60 sec APERTURE: f/4.5 ISO: 125

• **PP. 192–193 Abir Choudhury** LOCATION: Calcutta, West Bengal, India CAMERA: Nikon D90 FOCAL LENGTH: 18mm SHUTTER SPEED: 1/400 sec APERTURE: f/4 ISO: 200

THE MOMENT
• **PP. 194–195 Diego Fabriccio Diaz Palomo** LOCATION: Acatenango Volcano, Guatemala CAMERA: Canon EOS Rebel T3 FOCAL LENGTH: 18mm SHUTTER SPEED: 89 sec APERTURE: f/4.5 ISO: 100

• **P. 197 Betty Catharine Hygrell** LOCATION: Tengboche Monastery, Nepal CAMERA: Leica V-LUX 20 FOCAL LENGTH: 8.5mm SHUTTER SPEED: 1/30 sec APERTURE: f/3.8 ISO: 500

• **PP. 198–199 Christy Dickinson-Davis** LOCATION: Denver, Colorado CAMERA: Canon EOS Rebel T3 FOCAL LENGTH: 50mm SHUTTER SPEED: 1/500 sec APERTURE: f/1.8 ISO: 200

• **P. 200 Barbara Beltramello** LOCATION: Itaparica Island, Bahia, Brazil CAMERA: Nikon D5000 FOCAL LENGTH: 38mm SHUTTER SPEED: 1/2500 sec APERTURE: f/4.8 ISO: 200

• **P. 201 Bridgena Barnard** LOCATION: Kgalagadi, Botswana CAMERA: Nikon D700 FOCAL LENGTH: 850mm SHUTTER SPEED: 1/4000 sec APERTURE: f/6.7 ISO: 1600

• **PP. 202–203 Sebastião Correia de Campos** LOCATION: Monte Estoril, Lisbon, Portugal *

• **P. 204 Pyiet Oo Aung** LOCATION: Ngwe Saung Beach, Pathein, Ayeyarwady, Myanmar *

• **P. 205 J. Goodman** LOCATION: Venice Beach, California CAMERA: Canon EOS Rebel T3i FOCAL LENGTH: 110mm SHUTTER SPEED: 1/800 sec APERTURE: f/4.5 ISO: 200

• **PP. 206–207 Courtney Platt** LOCATION: George Town, Cayman Islands *

EMBRACE THE UNTAMED
• **PP. 208–209 Ido Meirovich** LOCATION: Ne'ot Mordekhay, Northern District, Israel CAMERA: Nikon D300 FOCAL LENGTH: 190mm SHUTTER SPEED: 1/500 sec APERTURE: f/5.6 ISO: 280

• **P. 211 Terry Shapiro** LOCATION: Livermore, Colorado CAMERA: Nikon D700 FOCAL LENGTH: 58mm SHUTTER SPEED: 1/90 sec APERTURE: f/8 ISO: 200

• **PP. 212–213 Ian Rutherford** LOCATION: Etosha National Park, Namibia CAMERA: Canon EOS 7D FOCAL LENGTH: 289mm SHUTTER SPEED: 1/1600 sec APERTURE: f/10 ISO: 2000

• **P. 214 Paul Weeks** LOCATION: Rhododendron, Oregon *

• **P. 215 Jeremy Aerts** LOCATION: Daegu, South Korea CAMERA: Sony NEX-5N FOCAL LENGTH: 69mm SHUTTER SPEED: 1/125 sec APERTURE: f/5.6 ISO: 1250

• **PP. 216–217 Manish Mamtani** LOCATION: Joshua Tree National

Park, California camera: Not available focal length: Not available shutter speed: Not available aperture: f/4 ISO: 4000

• **P. 218 Majed al Za'abi** location: Nairobi, Kenya camera: Nikon D4 focal length: 310mm shutter speed: 1/500 sec aperture: f/5 ISO: 1000

• **P. 219 Keith Szafranski** location: Snow Hill Island, Antarctica*

• **PP. 220–221 Dharshana Jagoda** location: Juntacha, Potosí, Bolivia camera: Canon EOS 6D focal length: 50mm shutter speed: 1/160 sec aperture: f/16 ISO: 100

EXPLORE OUR CHANGING WORLD
• **PP. 222–223 Diosdado Bautista** location: Ta'if, Saudi Arabia camera: Nikon D300S focal length: 20mm shutter speed: 30 sec aperture: f/11 ISO: 200

• **P. 225 Michele Martinelli** location: Ranohira, Madagascar camera: Nikon D5000 focal length: 24mm shutter speed: 1/200 sec aperture: f/9 ISO: 200

• **P. 226 Juan Osorio** location: Rochdale Village, Jamaica, New York camera: Canon EOS 7D focal length: 10mm shutter speed: 8 sec aperture: f/8 ISO: 160

• **P. 227 Emmanuel Coupe** location: Iceland camera: Nikon D800E focal length: 60mm shutter speed: 1/1000 sec aperture: f/4.5 ISO: 200

• **PP. 228–229 Danny Victoriano** location: Antipolo, Calabarzon, Philippines camera: Canon EOS 5D Mark II focal length: 97mm shutter speed: 1/50 sec aperture: f/10 ISO: 400

• **P. 230 Jonathan Prince Tucker** location: Alaska camera: Nikon D800E focal length: 14mm shutter speed: 15 sec aperture: f/16 ISO: 100

• **P. 231 Sam Ber** location: West Village Houses, New York, New York camera: Canon EOS 7D focal length: 25mm shutter speed: 1/1600 sec aperture: f/5.6 ISO: 1600

• **PP. 232–233 Karen Lunney** location: Maasai Mara, Great Rift Valley, Kenya camera: Leica M 240 focal length: Not available shutter speed: 1/500 sec aperture: f/4.8 ISO: 200

• **P. 234 Hoang Giang Hai** location: Thua Thien-Hue Province, Vietnam camera: Canon EOS 7D focal length: 100mm shutter speed: 1/320 sec aperture: f/4 ISO: 200

• **P. 235 Joy Acharyya** location: Varanasi, Uttar Pradesh, India *

NATURE IN BLACK & WHITE
• **PP. 236–237 Himadri Bhuyan** location: Ahmedabad,

Gujarat, India *

• **P. 239 Manish Mamtani** location: Yosemite Valley, California camera: Canon EOS 5D Mark III focal length: 16mm shutter speed: 20 sec aperture: f/2.8 ISO: 100

• **PP. 240–241 Veronika Pekkerne Toth** location: Grand Canyon, Arizona camera: Canon EOS Rebel T4i focal length: 70mm shutter speed: 1/400 sec aperture: f/8 ISO: 400

• **P. 242 Maryanne Gobble** location: Whiskeytown, California camera: Canon EOS Rebel XSi focal length: 19mm shutter speed: 1/4 sec aperture: f/8 ISO: 100

• **P. 243 Peri Paleracio** location: Anilao, Calabarzon, Philippines camera: Nikon D2H focal length: 65mm shutter speed: 1/250 sec aperture: f/10 ISO: 200

• **PP. 244–245 Rudi Gunawan** location: Tanjung Lesung, West Java, Indonesia camera: Nikon D90 focal length: 18mm shutter speed: 30 sec aperture: f/8 ISO: 100

• **P. 246 Veronika Kolev** *

• **P. 247 Morkel Erasmus** location: Kruger National Park, South Africa camera: Nikon D3S focal length: 500mm shutter speed: 1/800 sec aperture: f/4 ISO: 450

• **PP. 248–249 Hans Strand** location: Lake Hvítárvatn, Iceland camera: Hasselblad H3DII-50 focal length: 80 mm shutter speed: 1/800 sec aperture: f/4.8 ISO: 200

HOW CLOSE CAN YOU GET
• **PP. 250–251 Andrew Lever** location: Auckland, New Zealand camera: Nikon D7000 focal length: 55mm shutter speed: 1/320 sec aperture: f/5 ISO: 100

• **P. 253 James Duong** location: Ho Chi Minh City, Vietnam camera: Nikon Df focal length: 24mm shutter speed: 1/125 sec aperture: f/2.8 ISO: 1600

• **P. 254 Debasish Ghosh** location: Not available camera: Nikon D2Xs focal length: 20mm shutter speed: 1/80 sec aperture: f/2.8 ISO: 100

• **P. 255 S. M. Mamun** location: Sylhet, Bangladesh camera: Canon EOS 600D focal length: 50mm shutter speed: 1/250 sec aperture: f/2.8 ISO: 100

• **PP. 256–257 Angelo Formato** location: Naples, Italy camera: Canon EOS 5D Mark II focal length: 35mm shutter speed: 1/60 sec aperture: f/9 ISO: 200

• **P. 258 Christopher Dormoy** location: Not available *

• **P. 259 Anibal Trejo** LOCATION: Sant Quintí de Mediona, Catalonia, Spain *

• **PP. 260–261 Tracey Buyce** LOCATION: Lake George, New York CAMERA: Canon EOS5D Mark III FOCAL LENGTH: 35mm SHUTTER SPEED: 1/800 sec APERTURE: f/2.5 ISO: 1600

• **P. 262 Somnath Chakraborty** LOCATION: Calcutta, West Bengal, India CAMERA: Nikon D7000 FOCAL LENGTH: 12mm SHUTTER SPEED: 1/1000 sec APERTURE: f/6.3 ISO: 200

• **P. 263 John Warner** LOCATION: Indianapolis, Indiana *

IMAGINE IF
• **PP. 264–265 Ann Nygren** LOCATION: Not available CAMERA: Nikon D5000 FOCAL LENGTH: 38mm SHUTTER SPEED: 1/400 sec APERTURE: f/10 ISO: 200

• **P. 267 James Hilgenberg** LOCATION: Oberstdorf, Bavaria, Germany *

• **PP. 268–269 Migz Nthigah** LOCATION: Lamu, Kenya CAMERA: Nikon D5100 FOCAL LENGTH: 18mm SHUTTER SPEED: 1/200 sec APERTURE: f/7.1 ISO: 640

• **P. 270 Jacob W. Frank** LOCATION: Denali National Park, Alaska CAMERA: Canon EOS 5D Mark II FOCAL LENGTH: 29mm SHUTTER SPEED: 1/160 sec APERTURE: f/4 ISO: 400

• **P. 271 Helēna Spridzāne** LOCATION: Berģi, Riga, Latvia CAMERA: Canon EOS 600D FOCAL LENGTH: 50mm SHUTTER SPEED: 1/30 sec APERTURE: f/0 ISO: 200

• **PP. 272–273 Vineeth Rajagopal** LOCATION: Fairbanks, Alaska CAMERA: Canon EOS Rebel T2i FOCAL LENGTH: 10mm SHUTTER SPEED: 1/200 sec APERTURE: f/14 ISO: 400

• **P. 274 Tommy Seo** LOCATION: United States CAMERA: Canon EOS 5D Mark III FOCAL LENGTH: 24mm SHUTTER SPEED: 1/200 sec APERTURE: f/1.4 ISO: 250

• **P. 275 Claire Robinson** LOCATION: Sahara CAMERA: Panasonic DMC-TZ30 FOCAL LENGTH: 9.7mm SHUTTER SPEED: 1/640 sec APERTURE: f/4.6 ISO: 100

• **P. 276 James Abbott** LOCATION: Scone, New South Wales, Australia CAMERA: Nikon D5100 FOCAL LENGTH: 11mm SHUTTER SPEED: 1/40 sec APERTURE: f/9 ISO: 100

Acknowledgments

National Geographic Books would like to thank our talented colleagues at Your Shot, Monica Clare Corcoran, Jeanne Modderman, Stephen Mefford, and Keith Jenkins, who have been tremendous partners in creating this book, and who nurture and inspire the Your Shot photography community every day. Many thanks to National Geographic photographer Lynn Johnson for her beautiful introduction, and for lending us her expertise in the creation of this book. We would also like to extend our deepest appreciation to the National Geographic photographers and experts who participated in this book: John Burcham, Diane Cook, Penny De Los Santos, Jay Dickman, Peter Essick, Ben Fitch, Becky Hale, Evelyn Hockstein, Len Jenshel, Ed Kashi, Alexa Keefe, Elizabeth Krist, David Liittschwager, Sarah Polger, Sadie Quarrier, Cory Richards, Robin Schwartz, Maggie Steber, Mark Thiessen, and Susan Welchman. You are all the heart and soul of this book.

Getting Your Shot

Prepared by the Book Division

Hector Sierra, *Senior Vice President and General Manager*

Lisa Thomas, *Senior Vice President and Editorial Director*

Jonathan Halling, *Creative Director*

Marianne R. Koszorus, *Design Director*

Robin Terry-Brown, *Senior Editor*

R. Gary Colbert, *Production Director*

Jennifer A. Thornton, *Director of Managing Editorial*

Susan S. Blair, *Director of Photography*

Meredith C. Wilcox, *Director, Administration and Rights Clearance*

Staff for This Book

Elisa Gibson, *Art Director*

Patrick Bagley, *Illustrations Editor*

Michelle Cassidy, Zachary Galasi, *Editorial Assistants*

Marshall Kiker, *Associate Managing Editor*

Judith Klein, *Senior Production Editor*

Lisa A. Walker, *Production Manager*

Galen Young, *Rights Clearance Specialist*

Katie Olsen, *Design Production Specialist*

Nicole Miller, *Design Production Assistant*

Bobby Barr, *Manager, Production Services*

Rahsaan Jackson, *Imaging*

Additional Credits

Front cover: (birds in hand) Lynn Johnson/National Geographic Creative; (horses) Verdrana Tafra; (dog) Raffaele Montepaone. Back cover: (otters) Roman Golubenko. Interior: 11, Lynn Johnson/National Geographic Creative; 20, Sashkin/Shutterstock; 21, MrGarry/Shutterstock; 24 (LE), tap10/iStockphoto; 24 (RT), servickuz/iStockphoto; 25 (LE), ekinyalgin/iStockphoto; 25 (RT), LeventKonuk/iStockphoto.com.

Since 1888, the National Geographic Society has funded more than 12,000 research, exploration, and preservation projects around the world. National Geographic Partners distributes a portion of the funds it receives from your purchase to National Geographic Society to support programs including the conservation of animals and their habitats.

National Geographic Partners, LLC
1145 17th Street NW
Washington, DC 20036-4688 USA

Become a member of National Geographic and activate your benefits today at natgeo.com/jointoday.

For information about special discounts for bulk purchases, please contact National Geographic Books Special Sales: ngspecsales@ngs.org

For rights or permissions inquiries, please contact National Geographic Books Subsidiary Rights: ngbookrights@ngs.org

Library of Congress Cataloging-in-Publication Data
Getting your shot : stunning photos, how-to tips, and endless inspiration from the pros.
 pages cm
Includes bibliographical references.
 ISBN 978-1-4262-1534-6 (paperback)
 1. Photography--Miscellanea. 2. Photography--Technique. 3. Photography, Artistic. I. National Geographic Society (U.S.)
 TR146.G45 2015
 303.3--dc23
 2014047188

Printed in China

16/RRDS/2

NATIONAL GEOGRAPHIC

WELCOME TO THE WORLD'S
PHOTO HUB

Implementing Investigations in Kindergarten

Infinity Prime Donna Casey

"This fractal is a classic spiral, which is my favorite, and I'm always amazed at the variations and the endlessly repeating patterns that can be created out of such a primary shape." – **Donna Casey**

Investigations

IN NUMBER, DATA, AND SPACE®

Many of the designations used by manufacturers and sellers to distinguish their products are claimed as trademarks. Where those designations appear in this book, and Scott Foresman was aware of a trademark claim, the designations have been printed with initial capitals and in cases of multiple usage have also been marked with either ® or ™ where they first appear.

PEARSON
Scott
Foresman

scottforesman.com

Editorial offices: Glenview, Illinois • Parsippany, New Jersey • New York, New York
Sales offices: Boston, Massachusetts • Duluth, Georgia
Glenview, Illinois • Coppell, Texas • Sacramento, California • Mesa, Arizona

T E R C

The Investigations Curriculum was developed by TERC, Cambridge, MA.

This material is based on work supported by the National Science Foundation ("NSF") under Grant No. ESI-0095450. Any opinions, findings, and conclusions or recommendations expressed in this material are those of the author(s) and do not necessarily reflect the views of the National Science Foundation.

ISBN: 0-328-24916-5
ISBN: 978-0-328-24916-9

10 V063 12 11 10

T E R C

Co-Principal Investigators

Susan Jo Russell

Karen Economopoulos

Authors

Lucy Wittenberg
Director Grades 3–5

Karen Economopoulos
Director Grades K–2

Virginia Bastable
(SummerMath for Teachers,
Mt. Holyoke College)

Katie Hickey Bloomfield

Keith Cochran

Darrell Earnest

Arusha Hollister

Nancy Horowitz

Erin Leidl

Megan Murray

Young Oh

Beth W. Perry

Susan Jo Russell

Deborah Schifter
(Education
Development Center)

Kathy Sillman

Note: Unless otherwise noted, all contributors listed above were staff of the Education Research Collaborative at TERC during their work on the curriculum. Other affiliations during the time of development are listed.

Administrative Staff

Amy Taber
Project Manager

Beth Bergeron

Lorraine Brooks

Emi Fujiwara

Contributing Authors

Denise Baumann

Jennifer DiBrienza

Hollee Freeman

Paula Hooper

Jan Mokros

Stephen Monk
(University of Washington)

Mary Beth O'Connor

Judy Storeygard

Cornelia Tierney

Elizabeth Van Cleef

Carol Wright

Technology

Jim Hammerman

Classroom Field Work

Amy Appell

Rachel E. Davis

Traci Higgins

Julia Thompson

Collaborating Teachers

This group of dedicated teachers carried out extensive field testing in their classrooms, met regularly to discuss issues of teaching and learning mathematics, provided feedback to staff, welcomed staff into their classrooms to document students' work, and contributed both suggestions and written material that has been incorporated into the curriculum.

Bethany Altchek

Linda Amaral

Kimberly Beauregard

Barbara Bernard

Nancy Buell

Rose Christiansen

Chris Colbath-Hess

Lisette Colon

Kim Cook

Frances Cooper

Kathleen Drew

Rebeka Eston Salemi

Thomas Fisher

Michael Flynn

Holly Ghazey

Susan Gillis

Danielle Harrington

Elaine Herzog

Francine Hiller

Kirsten Lee Howard

Liliana Klass

Leslie Kramer

Melissa Lee Andrichak

Kelley Lee Sadowski

Jennifer Levitan

Mary Lou LoVecchio

Kristen McEnaney

Maura McGrail

Kathe Millett

Florence Molyneaux

Amy Monkiewicz

Elizabeth Monopoli

Carol Murray

Robyn Musser

Christine Norrman

Deborah O'Brien

Timothy O'Connor

Anne Marie O'Reilly

Mark Paige

Margaret Riddle

Karen Schweitzer

Elisabeth Seyferth

Susan Smith

Debra Sorvillo

Shoshanah Starr

Janice Szymaszek

Karen Tobin

JoAnn Trauschke

Ana Vaisenstein

Yvonne Watson

Michelle Woods

Mary Wright

Advisors

Deborah Lowenberg Ball,
University of Michigan

Hyman Bass, Professor of Mathematics and Mathematics Education
University of Michigan

Mary Canner, Principal, Natick Public Schools

Thomas Carpenter, Professor of Curriculum and Instruction,
University of Wisconsin–Madison

Janis Freckmann, Elementary Mathematics Coordinator,
Milwaukee Public Schools

Lynne Godfrey, Mathematics Coach,
Cambridge Public Schools

Ginger Hanlon, Instructional Specialist in Mathematics,
New York City Public Schools

DeAnn Huinker, Director, Center for Mathematics and
Science Education Research, University of Wisconsin–Milwaukee

James Kaput, Professor of Mathematics,
University of Massachusetts–Dartmouth

Kate Kline, Associate Professor, Department of Mathematics
and Statistics, Western Michigan University

Jim Lewis, Professor of Mathematics,
University of Nebraska–Lincoln

William McCallum, Professor of Mathematics,
University of Arizona

Harriet Pollatsek, Professor of Mathematics,
Mt. Holyoke College

Debra Shein-Gerson, Elementary Mathematics Specialist,
Weston Public Schools

Gary Shevell, Assistant Principal,
New York City Public Schools

Liz Sweeney, Elementary Math Department,
Boston Public Schools

Lucy West, Consultant,
Metamorphosis: Teaching Learning Communities, Inc.

This revision of the curriculum was built on the work of the many authors who contributed to the first edition (published between 1994 and 1998). We acknowledge the critical contributions of these authors in developing the content and pedagogy of *Investigations*:

Authors

Joan Akers

Michael T. Battista

Douglas H. Clements

Karen Economopoulos

Marlene Kliman

Jan Mokros

Megan Murray

Ricardo Nemirovsky

Andee Rubin

Susan Jo Russell

Cornelia Tierney

Contributing Authors

Mary Berle-Carman

Rebecca B. Corwin

Rebeka Eston

Claryce Evans

Anne Goodrow

Cliff Konold

Chris Mainhart

Sue McMillen

Jerrie Moffet

Tracy Noble

Kim O'Neil

Mark Ogonowski

Julie Sarama

Amy Shulman Weinberg

Margie Singer

Virginia Woolley

Tracey Wright

Collaborating with the Authors

Goals and Guiding Principles

Investigations in Number, Data, and Space is a K–5 mathematics curriculum designed to engage students in making sense of mathematical ideas. Six major goals guided the development of this curriculum. The curriculum is designed to

- Support students to make sense of mathematics and learn that they can be mathematical thinkers.

- Focus on computational fluency with whole numbers as a major goal of the elementary grades.

- Provide substantive work in important areas of mathematics—rational numbers, geometry, measurement, data, and early algebra—and connections among them.

- Emphasize reasoning about mathematical ideas.

- Communicate mathematics content and pedagogy to teachers.

- Engage the range of learners in understanding mathematics.

Underlying these goals are three guiding principles that are touchstones for the *Investigations* team as we approach both students and teachers as agents of their own learning:

1. *Students have mathematical ideas.* Students come to school with ideas about numbers, shapes, measurements, patterns, and data. If given the opportunity to learn in an environment that stresses making sense of mathematics, students build on the ideas they already have and learn about new mathematics they have never encountered. They learn mathematical content and develop fluency and skill that is well grounded in meaning. Students learn that they are capable of having mathematical ideas, applying what they know to new situations, and thinking and reasoning about unfamiliar problems.

2. *Teachers are engaged in ongoing learning* about mathematics content, pedagogy, and student learning. The curriculum provides material for professional development, to be used by teachers individually or in groups, that supports teachers' continued learning as they use the curriculum over several years. The *Investigations* curriculum materials are designed as much to be a dialogue with teachers as to be a core of content for students.

3. *Teachers collaborate with the students and curriculum materials* to create the curriculum as enacted in the classroom. The only way for a good curriculum to be used well is for teachers to be active participants in implementing it. Teachers use the curriculum to maintain a clear, focused, and coherent agenda for mathematics teaching. At the same time, they observe and listen carefully to students, try to understand how they are thinking, and make teaching decisions based on these observations.

The Teacher-Student-Curriculum Partnership

Mathematics teaching and learning at its best is a collaboration among teachers, students, and the curriculum. Both the teacher and the curriculum contribute to this partnership in important ways. The curriculum materials provide a coherent, carefully sequenced core of mathematics content for students and supportive professional development material for teachers. Teachers are active partners in learning the curriculum well, understanding how each mathematical focus is developed, and implementing the curriculum in a way that accommodates the needs of their particular students.

The *Investigations* curriculum was field-tested in many different classrooms, representing a range of students and teachers, over several years. Thousands of hours of classroom observation, documentation, analysis of student work, and meetings with teachers were involved. Activities and the way they are presented to students were revised again and again.

Each time a curriculum unit was tested in a classroom, no matter how many times it had been tried and revised before, there was always more to discover about how students learn and how activities can be revised and modified to support them. This process, we have come to believe, can be endless. Just as you, a classroom teacher, learn more about students' learning each year, so do those of us who develop the curriculum. At some point we decide that, considering all the evidence, the curriculum has been sufficiently tested and works well for a wide range of students.

This lengthy and detailed process has resulted in a coherent core curriculum that is based on the real needs of real students and teachers. The process has also provided ample evidence that the collaboration of the teacher is essential. Only the teacher can understand and support the particular learning needs of a particular class of students in a particular school year. Only the teacher is present every day in the classroom, observing students' work, listening to their discourse, and developing an understanding of their mathematical ideas by analyzing what they say and do. In mathematics, as in any subject, only the teacher can continually assess students' strengths and needs and think through how best to accommodate differences to involve all students in substantive and challenging work.

How *Investigations* Supports the Teacher's Role

Modifying the curriculum and making it work in your classroom requires knowing the curriculum well. It means taking the time to understand the mathematics focus of each lesson and how the mathematical ideas build over many lessons. Learning the curriculum well means holding back the urge to change activities because you think they are too easy or too difficult for your students before you have tried them and actually seen your students' work. Keep in mind that the way ideas are developed and sequenced has been researched and tested in multiple classrooms, and many suggestions for accommodations are already built into the

curriculum. Teachers tell us that they generally follow the curriculum as it is written the first year, and that they learn a great deal when activities that they thought would not work with their students turn out to be crucial to student learning.

You are an active partner in this teacher-student-curriculum partnership, and the curriculum must support your complex job by providing information about mathematics content and student learning. From the beginning, our intention in developing *Investigations* has been to create a professional development tool for teachers—a tool that provides opportunities for learning about mathematics content, how students learn, and effective pedagogy. Our design focuses as much on the teacher as learner as on the student as learner.

Two sections at the beginning of each curriculum unit, Mathematics in This Unit and Assessment in This Unit, provide an overview of the mathematics content, Math Focus Points, and benchmarks for student learning. The Math Focus Points for each session and the assessment benchmarks tell the mathematical story line of each curriculum unit so that you can productively guide students' work. Math Focus Points make explicit the purposes of the activities in each session and help you make choices about how to guide discussions. The assessment benchmarks for each curriculum unit are an aid in determining priorities and interpreting students' work.

The "teacher talk" printed in blue in each session is also an aid for focusing an activity and choosing questions to ask. It is not a script for how to address your students; it is a guide based on classroom experience with different ways of talking about mathematical ideas, introducing activities, and asking effective questions.

Teacher Notes collected at the end of each curriculum unit focus on key mathematical ideas and how students learn them. Because having students reason about, articulate, and justify their ideas is such a central part of the curriculum, Dialogue Boxes provide examples of student discussion and teachers' efforts to focus this discussion. Additionally,

examples of what students might say in class appear within the session descriptions.

To further support your work with the curriculum, this *Implementing Investigations in Kindergarten* book provides an overview of the math content for the entire year (Part 3), a set of Teacher Notes that applies to the curriculum as a whole (Part 6), and a set of classroom cases written by teachers that provides examples of how they work with the range of learners in their classrooms (Part 7).

Teachers who use the *Investigations* curriculum over several years find that, as they teach a curriculum unit more than once, they gradually read more and more of the supporting material and incorporate it into their work with students. Teachers also use features such as the Teacher Notes and Dialogue Boxes as part of grade-level study groups or within other professional development structures. The better you know the curriculum and your students, the more you can internalize the mathematics focus and sequence and the better decisions you can make to support your students' learning.

Using *Investigations*

Components of the Program

Curriculum Units

The curriculum at each grade level is organized into nine units (seven for Kindergarten). These curriculum units are your teaching guides for the program. The unit organization is further described in the next section, "Using the Curriculum Units."

Each curriculum unit in Kindergarten offers from $3\frac{1}{2}$ to 5 weeks of work, and focuses on the area of mathematics identified in the unit's subtitle.

This pacing is based on a school year that starts in early September, ends in late June, and has vacation weeks in February and April. The pacing will vary according to school calendars but may also vary depending on the needs of students, the school's years of experience with this curriculum, and other local factors.

Kindergarten Curriculum Units

Unit	Title	Number of Sessions	Suggested Pacing
1	**Who Is in School Today?** Classroom Routines and Materials	18	September–early October
2	**Counting and Comparing** Measurement and the Number System 1	24	Early October– November
3	**What Comes Next?** Patterns and Functions	22	November– December
4	**Measuring and Counting** Measurement and the Number System 2	26	December– January
5	**Make a Shape, Build a Block** 2-D and 3-D Geometry	20	February–March
6	**How Many Do You Have?** Addition, Subtraction, and the Number System	26	March–April
7	**Sorting and Surveys** Data Analysis	17	May–June

The curriculum units are designed for use in the sequence shown. Each succeeding unit builds on the previous unit, both within and across strands. For example, the three units that focus on the number system (Units 2, 4, and 6) develop a sequence of ideas across the three units. These ideas are built on throughout the Kindergarten curriculum, for example, as students determine the number of objects in the Counting Jar (all units); figure out the total number of repeating units in a repeating pattern in Unit 3 (Patterns and Functions); and as they collect, count, and represent data in Unit 7 (Data Analysis).

Resources Binder

A binder for each grade level contains the reproducible Resource Masters and Transparencies that support your classroom instruction. These are also available on a CD. The binder also includes a CD with the *Shapes* Software appropriate to a particular grade level. The use of all these materials for particular Investigations is specified in the curriculum units.

Investigations Software

Shapes Software for Kindergarten provides an environment in which students investigate a variety of geometric ideas, including relationships between shapes; how shapes combine to make other shapes; symmetry; and geometric transformations such as rotations (turns), translations (slides), and reflections (flips). This software is provided as a disk to be used with Unit 5, *Make a Shape, Build a Block,* and is also available through the Pearson website.

Student Activity Book

A booklet accompanying the entire curriculum for Kindergarten contains the consumable pages for student work, including in-class work, game recording sheets, and all pages for daily practice and for homework.

Student Math Handbook Flip Chart

This flip chart offers a valuable reference to the math words and ideas introduced in the curriculum units, as well as visual prompts for repeating activities.

Manipulatives Kit

A kit of materials is coordinated with the activities and games at each grade level. The Kindergarten kit includes class sets of the following items:

Connecting cubes

Pattern blocks

Attribute blocks

Geoblocks

Wooden geometric solids

Geoboards with rubber bands

Buttons

Pennies

Color tiles

Two-color counters

Craft sticks

Teddy bear counters

Blank cubes and labels

Dot cubes

Number cubes

Monthly calendar with removable numbers

100 chart

Class number line

Cards in Card Kit

Manufactured cards are used with some of the activities and games at each grade level. The cards for Kindergarten are as follows:

Arrow Cards for the Pocket Chart

Attribute Cards

Car Cards

Primary Number Cards

Question Mark Cards

Ten-Frames

Implementing *Investigations* in Kindergarten

At each grade level, this guide to implementing *Investigations* includes an overview of the curriculum; suggestions for using the curriculum units in your classroom; a closer look at the mathematics content of that particular grade, including lists of the Math Focus Points for each curriculum unit; program-wide Teacher Notes that explain some key ideas underlying the curriculum; and a set of case studies about working with a range of learners that can be used for professional development.

The Curriculum Units

The curriculum unit is your main teaching tool. It is your blueprint for the sequence and purpose of the daily lessons; it also contains guidelines for assessment, suggestions for differentiating instruction, and professional development materials to support your teaching.

Structure of a Curriculum Unit

Each curriculum unit is divided into Investigations. An Investigation focuses on a set of related mathematical ideas, coordinating students' work in hands-on activities, written activities, and class discussions over a period of several days.

Investigations are divided into 30- to 45-minute sessions, or lessons. Sessions include the following features:

- *Math Focus Points:* This list of what students will be doing mathematically highlights the goals of each session.

- *Activities:* A session contains from one to three activities, organized as work for the whole class, pairs, small groups, or individuals.

- *Discussion:* Many sessions include whole-class time during which students compare methods and results and share conclusions. A subset of the session's Focus Points helps you guide each discussion.

- *Math Workshop:* In some sessions, students work in a Math Workshop format. Individually, in pairs, or in small groups, they choose from and cycle through a set of related activities. This setup is further discussed in a later section, "All About Math Workshop" (pp. 12–14).

- *Assessment:* Students are assessed through both written activities and observations; see "Assessment in this Unit" for further information.

- *Session Follow-up:* Homework is occasionally provided in Kindergarten. Each Investigation includes a page for Daily Practice. These pages offer directed practice of content in the current curriculum unit. They can be used either for additional homework or for in-class practice. Relevant pages in the *Student Math Handbook Flip Chart* are also referenced here.

Your Math Day

The *Investigations* curriculum assumes that you spend 30–45 minutes of each classroom day on mathematics, in addition to conducting brief Classroom Routines (further described later in this section and in Part 4 of this book). A chart called Today's Plan appears at the beginning of each session, laying out the suggested pacing for the activities in that 30- to 45-minute session. While you may need to adapt this structure to your particular classroom needs, be aware that it is important to move through all the activities because they are carefully designed to offer continued work on the key mathematical ideas. It is also essential that you allow time for class discussions, where students have an opportunity to articulate their own ideas, compare solutions, and consolidate understanding. See Teacher Note: Discussing Mathematical Ideas, on pages 52–54, for further information on the importance of these class discussions.

Differentiated Instruction

Within the sessions, you will regularly see a feature titled "Differentiation: Supporting the Range of Learners." This feature offers ideas for intervention or extensions related to the particular work of that session. Ideas for helping English Language Learners are offered at the beginning of the curriculum unit and where applicable in the sessions. In addition, Part 7 of this book, "Working with the Range of Learners: Classroom Cases," presents situations from actual *Investigations* classrooms and invites you to consider how these case studies can inform your own teaching practice.

Classroom Routines

These brief activities, described in a box below Today's Plan for each session, require about 10 minutes of additional daily work outside of math time. These routines, an important part of the *Investigations* curriculum, offer ongoing skill building, practice, and review that support the regular math work. They also reinforce work students have done in previous units; and help students increase their repertoire of strategies for mental calculation and problem solving. Part 4 of this book, "Classroom Routines," provides detailed explanations of the activities to plan for Kindergarten.

Assessment in This Unit

Opportunities for assessment are carefully woven throughout the curriculum units at each grade level. A section at the beginning of each curriculum unit identifies the benchmarks students will be expected to meet and specifies key activities you can observe, as well as the particular assessment activities where students will produce written work for your review. In Kindergarten, checklists are provided for each benchmark and are used for taking notes about what students understand as they engage in activities. As the last session of the curriculum unit approaches, teachers should look over the checklists to determine who has not yet met the benchmarks. While other students participate in a Math Workshop, the teacher then meets individually with those students to do one or more tasks during the End-of-Unit Assessment Session. Teacher Notes provide information about the mathematics of each benchmark, and Assessment Teacher Notes present a teacher's observations of her students while at work on the relevant activity or activities.

▲ An example of an Assessment Checklist

"Ongoing Assessment: Observing Students at Work" is a regular feature of the sessions. It identifies the particular math focus and lists questions for you to consider as you observe your students solving problems, playing math games, and working on activities. Teacher observations are an important part of ongoing assessment. Although individual observations may be little more than snapshots of a student's experience with a single activity, when considered together over time, they can provide an informative and detailed picture. These observations can be useful in documenting and assessing a student's growth and offer important sources of information when preparing for family conferences or writing student reports.

You may want to develop a system to record and keep track of your observations of students. The most important aspect of a record-keeping system is that it be both manageable and useful for you. Some teachers use systems such as the following:

- Jot down observations of students' work on a class list of names. Because the space is somewhat limited, it is not possible to write lengthy notes; however, when kept over time, these short observations provide important information.

- Place stick-on address labels on a clipboard. Take notes on individual students and then peel these labels off and put them in a file for each student.

- Jot down brief notes at the end of each week. Some teachers find that this is a useful way of reflecting on the class as a whole, on the curriculum, and on individual students. Planning for the next week's activities can benefit from these weekly reflections.

Observation checklists, student work on written assessments, and other examples of students' written work can be collected in a portfolio. Suggestions for particular work that might be saved in a portfolio are listed at the beginning of each curriculum unit, under "Assessment in This Unit."

Professional Development

One guiding principle of the *Investigations* curriculum is to provide support that helps teachers improve their own understanding of the mathematics that they are teaching and the learning that they observe in their students. To this end, the following materials are included in the curriculum for teachers' professional development:

- *Mathematics in This Unit:* An essay at the beginning of each unit explains in detail the Mathematical Emphases of the unit, the Math Focus Points related to each area of emphasis, and the work students will be doing in each area.

- *Algebra Connections in This Unit:* This essay, appearing in each of the number and operations units and in the patterns, functions, and change units, explains how the activities and ideas of the unit are laying a foundation for students' later work with algebra.

- *Math Notes, Teaching Notes, and Algebra Notes:* Found in the margins of the sessions, these brief notes provide information about mathematics content or student thinking, as well as teaching tips to help teachers better understand the work of that session.

- *Teacher Notes:* These essays, collected at the end of each curriculum unit, provide further practical information about the mathematics content and how students learn it. Many of the notes were written in response to questions from teachers or to discuss important issues that arose in field-test classrooms. They offer teachers help with thinking about mathematical ideas that may be unfamiliar to them; they also provide guidance for observing and assessing students' work.

- *Dialogue Boxes:* Also at the end of each curriculum unit are Dialogue Boxes that reflect classroom scenarios related to the activities of the unit. Since these Dialogue Boxes are based on actual teacher-student interactions, you learn how students typically express their mathematical ideas, what issues and confusions arise in their thinking, and how some teachers have chosen to guide particular class discussions.

Working with Families

Families are important partners with schools in the process of teaching mathematics. Because the teaching of mathematics has been evolving, many families may be unfamiliar with the approaches taken by the *Investigations* curriculum. For this reason, a number of Family Letters are provided. In Kindergarten, these letters include the following:

- The first Family Letter in each curriculum unit, About the Mathematics in This Unit, introduces families to the mathematics that their children will be doing and to the benchmarks for that unit.

- A second letter in each curriculum unit, Related Activities to Try at Home, is sent home some time after the first. It suggests related activities that families can do together and children's books that support students' work in mathematics.

▲ An example of a Family Letter

Setting Up the *Investigations* Classroom

As you begin using the *Investigations* curriculum, you may find yourself making decisions about how to set up the tables and chairs in your classroom and where to keep your materials. Students will at various times need to work individually, in pairs or small groups, and as a whole class. When working in pairs or small groups, they need to be able to see one another's work and listen to one another's ideas. Bringing students together for whole-group discussion is also a regular feature of the curriculum, and during these discussions it is important that students can easily see and hear one another. Ways of making this work are further discussed in the Teacher Note: Discussing Mathematical Ideas, pages 52–54. You must also find ways to make materials and games easily accessible and consider how to organize the room for Math Workshops.

Materials as Tools for Learning

Tools and materials are used throughout the *Investigations* curriculum. Students of all ages benefit from being able to use materials to model and solve problems and explain their thinking. Encourage all students to use tools and materials and to explain how they use them. If materials are used only when someone is having difficulty, students can get the mistaken idea that using materials is a less sophisticated and less valued way of solving a problem or modeling a solution. Therefore, they should see how different people, including the teacher, use a variety of materials to solve the same problem.

Get to Know the Materials Familiarize yourself with some of the main materials students will use. In Kindergarten these include connecting cubes, pattern blocks, Geoblocks, Geoboards, and Attribute Blocks. In some units there are Teacher Notes that describe particular materials in detail. For example, these might provide the names and mathematical definitions of the shapes in a given set, illustrations of each shape, and information about how to talk about them with students.

Storing Materials Many of the *Investigations* materials come in large containers. Split these sets into smaller, equivalent subsets and store each in a clear container or shoe box, labeled with the name and a picture of the material. Include a small cup to use as a scoop. Store materials where they are easily accessible to students, perhaps on a bookshelf or along a windowsill. In addition to pattern blocks, Geoblocks, and connecting cubes, assorted counters and paper (blank and grid) are important mathematical tools that should be available to students. Individual units also provide suggestions on preparing some materials for classroom use.

Introducing a New Material Students need time to explore a new material before using it in structured activities. By freely exploring a material, students will discover many of its important characteristics and will have some understanding of when it might make sense to use it. Although some free exploration is built into regular math time, many teachers make materials available to students during free time or before or after school.

Plan How Students Will Use Materials The more available materials are, the more likely students are to use them. Having materials available means that they are readily accessible and that students are allowed to make decisions about which tools to use and when and how to use them. In much the same way that you choose the best tool to use for certain projects or tasks, students also should be encouraged to think about which material best meets their needs. Initially you may need to place materials close to students as they work. Gradually students should be expected to decide what they need and get materials on their own.

In order to make such a system work, you will need to establish clear expectations about how materials will be used and cared for.

- **Sharing Materials.** Even though a scoop should guarantee an ample assortment and quantity of materials, students might not get the exact piece they desire. Conversations about sharing are critical.

- **Using Materials Appropriately.** Rules and policies for the appropriate use of materials should be established at the beginning of the year. This might include things such as not throwing the materials, not drawing on them, and so on. Consider asking the students to suggest rules for how materials should and should not be used. Students are often more attentive to rules and policies that they have helped create.

- **Cleaning Up Materials.** Making an announcement a few minutes before the end of a work time helps prepare students for the transition that is about to occur. You can then give students several minutes to return materials to their containers and shelves and to double-check the floor for any stray materials.

Games in the *Investigations* Curriculum

The games included in this curriculum are a central part of the mathematics in each curriculum unit, not just enrichment activities. Games are used to develop concepts and to practice skills, such as learning to count and compare quantities, learning to sort and classify objects, finding different combinations that make a number, or sequencing numbers. The rationale for using games is as follows:

- Games provide engaging opportunities for students to deepen their understanding of numbers and operations and to practice computation.

- Playing games encourages strategic mathematical thinking as students find an optimal way (rather than just any way) of "winning" the game.

- Games provide repeated practice without requiring the teacher to provide new problems.

- While students are playing the games, the teacher is free to observe students or to work with individuals or small groups.

Before introducing a game to students, it is important that you play the game yourself or with colleagues. By doing so you will learn the rules of the game, explore the mathematical ideas that students will encounter as they play, and figure out the materials needed for the game. This will also help you determine the preparation needed (for instance, cutting out cards, gathering other materials, making "game packs") and helps you decide the best way to introduce the game to your students (pre-teaching it to some students, small or whole group introduction, etc.). For some games, variations are offered. Before using these variations, or any

others you might think of, consider how changing the rules of the game changes the mathematical ideas with which students are working.

Because students find them engaging, games are an excellent vehicle for providing repeated practice, without the need for the teacher to provide new problems. Therefore, students play games repeatedly, over time, throughout the *Investigations* curriculum. The more students play, the better. Therefore, some teachers encourage students to play games at other times as well: in the morning as students arrive, during indoor recess, as choices when other work is finished, and for homework. Consider making "game packs" for such times by placing the directions and needed materials in resealable plastic bags. Students can check them out during free times or take them home to play with a family member.

▲ **An example of a game recording sheet**

All About Math Workshop

Math Workshop provides an opportunity for students to work on a variety of activities that usually focus on similar mathematical content. The activities are not sequential; as students move among them, they continually revisit the important concepts and ideas they are learning. By repeatedly playing a game, or solving similar problems, students are able to refine strategies, use different contexts, and bring new knowledge to familiar experiences. Math Workshop is designed to

- Provide students with repeated experience with the concepts being learned and time to practice important skills and refine strategies.

- Provide time for the teacher to work with individuals and small groups and to assess students' learning and understanding.

- Help students develop independence and learn to take responsibility for their own learning as they choose activities, keep track of their work, use and take care of classroom materials, and work with others.

It is important to structure Math Workshop in ways that work for you and your students. The following questions can guide decision-making about how to set up Math Workshop in your classroom. You may need to experiment before finding the way that works best for you and your students.

How should the activities be organized? How will the materials be made available?

Some teachers set activities up at centers or stations around the room. At each center students find the materials needed to complete the activity. Others store materials in a central location and have students bring materials to their desks or tables. In either case, materials should be readily accessible to students, and students should be expected to take responsibility for cleaning up and returning materials to their appropriate storage locations. Giving students a "five minutes until cleanup" warning before the end of an activity session allows them to finish what they are working on and prepare for the upcoming transition.

How do I decide how many students can work on an activity at once?

Most teachers limit the number of students who work on a Math Workshop activity at one time. Because students often want to do a new activity immediately after it is introduced, you will need to reassure them that everyone will have repeated chances to do each activity. In many cases, the quantity of materials available limits the number of students who can do an activity at any one time. Even if this is not the case, set guidelines about the number of students that work on each choice. This gives students the opportunity to work in smaller groups and to make decisions about what they want and need to do. It also provides a chance to do visit activities repeatedly.

How will the class know what the activities are, and how many students can work on an activity at once?

Primary teachers have different ways of communicating such information to students. For example, some list the activities on the board, on the overhead, or on a piece of chart paper and sketch a picture next to each to help students who cannot yet read the activity names. Others use a pocket chart or laminate a piece of tag-board to create a Math Workshop board that they can easily update as new activities are added from session to session and old activities are no longer offered.

Math Workshop

Sorting Attribute Blocks	Abby, Hugo, Russell
Counting Jar	Kyle, Emma, Rebecca, Jae
Exploring Color Tiles	Beth, Carmen, Mitchell
Break the Train	Jason, Kiyo, Brad

Some teachers label each activity with a number, or with drawings of stick figures, to show how many students can do the activity at once. Others explain that the number of chairs at a particular table or station show how many students it can accommodate.

How do I help students make choices about the activities they will do and use their time productively?

Initially you may need to help students plan what they do when. Support students in making decisions about the activities they do, rather than organizing students into groups and circulating the groups every fifteen minutes or making Math Workshops whole class activities. Making choices, planning their time, and taking responsibility for their own learning are important aspects of students' school experiences. If some students return to the same activity over and over again without trying others, suggest that they make a different first choice and then do the favorite activity as a second choice. Other students may need to be encouraged to use their time efficiently to complete all activities.

In any classroom there will be a range of how much work students can complete. Making Math Workshop activities available at other times during the day allows students to revisit favorite activities; gives students who need it more time to finish their work; and can provide targeted practice for all students. Many Math Workshop activities include extensions and/or additional problems for students to do when they have completed their required work. You can also encourage students to return to activities they have done before, solve another problem or two, or play a game again.

How do I keep track, and help students keep track, of the activities they have completed and the work they have done?

Some teachers design a Math Workshop board that keeps track of which activities students are choosing. Some use a class list to jot notes as students make choices at the beginning of each Math Workshop. Others ask students to record the name and/or a picture of the activity on a blank sheet of paper when they have finished. Still others post a sheet for each activity—with the name and the corresponding picture—at the front of the room or at each station. When students have completed an activity, they print their name on the corresponding sheet.

Whenever students do work on paper during Math Workshop, you should handle this as you do any other completed or yet-to-be finished math work (e.g., a math folder, binder, desk, cubby, etc.). Keeping a date stamp at the front of the room (or at each Math Workshop station), makes it easy for students to record the date, which can also help you keep track of their work.

How do I help students work independently, cooperatively, and productively?

As you introduce Math Workshop, and as students experience it over time, it is critical to establish clear guidelines and to clearly communicate your expectations. Be sure to describe and discuss students' responsibilities:

• Be productively engaged during Math Workshop.

• Work on every activity [at least once].

• If you don't understand or feel stuck, [ask a friend]. (Some teachers establish an "ask three, then me" rule, requiring students to check with three peers before coming to the teacher for help.)

Plan to spend a few minutes at the end of Math Workshop, particularly early in the year, discussing what went smoothly, what sorts of issues arose and how they were resolved, and what students enjoyed or found difficult. Having students share the work they have been doing often sparks interest in an activity. Some days, you might ask two or three volunteers to talk about their work. On other days, you might pose a question that someone asked you during Math Workshop, so that other students might respond to it. Encourage students to be involved in the process of finding solutions to problems that come up in the classroom. In doing so, they take some responsibility for their own behavior and become involved with establishing classroom policies.

What should I be doing during Math Workshop?

Initially, much of your time during Math Workshop will be spent circulating around the classroom, helping students get settled into activities, monitoring the process of moving from one choice to another, and generally managing the classroom. Once routines are familiar and well established, students will become more independent and responsible for their work during Math Workshop. This will allow you to spend more concentrated periods of time observing the class as a whole or working with individuals and small groups.

Once Math Workshop is running smoothly, this structure provides you with the opportunity to observe and listen to students while they work. Because students are working on different activities at the same time, you can structure and adapt activities to fit their varying needs. Also, you can meet with individual students, pairs, or small groups who need help or more challenge, or whom you haven't had a chance to observe before, or to do individual assessments. Recording your observations of students will help you keep track of how they are interacting with materials and solving problems. See *Assessment in This Unit* (pp. 7–8), which offers some strategies for recording and using observations of students.

Mathematics in Kindergarten

Number and Operations: Whole Numbers

Counting and the Number System

A main focus in Kindergarten is counting, which is the basis for understanding the number system and for almost all the number work in the primary grades. Students hear and use the counting sequence (the number names, in order) in a variety of contexts. They have many opportunities to connect the number names with the written numbers and with the quantities they represent. They have repeated experiences counting sets of objects, along with matching and making sets of a given size. As students count sets of objects and make equal sets, they begin to see the importance of counting each object once and only once and of having a system for keeping track of what has been counted and what still remains to be counted. Students engage in repeated practice with counting and develop visual images for quantities up to 10.

As students are developing accurate counting strategies, they are also building an understanding of how numbers in the counting sequence are related: Each number is one more (or one less) than the number before (or after) it. Students develop an understanding of the concepts of greater than, fewer than, and equal to and develop language for describing quantitative comparisons (e.g., bigger, more, smaller, fewer, less, same, equal) as they count and compare quantities.

Example: Write the names of people in your home. Circle the name with the most letters.

Daniel	Matt	(Kaitlyn)
Sara	Mom	Dad

Mathematical Emphases

Counting and Quantity

- Developing strategies for accurately counting a set of objects by ones

- Developing an understanding of the magnitude and position of numbers

- Developing the idea of equivalence

Benchmarks (Compiled from Units 2, 4, and 6)

- Count a set of up to 10 objects.

- Compare two quantities up to 10 to see which is greater.

- Count a set of up to 15 objects.

- Figure out what is one more or one fewer than a number.

- Write the numbers up to 10.

- Count a set of up to 20 objects.

▲ This student used pictures, numbers, and words to show that he counted 13 nuts. He drew a circle for each nut and wrote both the number and the word—"13 nts." When he recounted his circles to check, he realized he had one too many, so he scribbled out one circle.

Addition and Subtraction

Young students develop their understanding of addition and subtraction by having many opportunities to count, visualize, model, solve, and discuss different types of problems. Many of the counting activities in Kindergarten build a bridge to the operations of addition and subtraction, as students add a small amount to a set or remove a small amount from a set and figure out "How many now?" One of the ways students are introduced to addition and subtraction is via story problems about combining and separating. They retell the stories, act them out, and solve them by modeling the action involved and using counting strategies. Students also play a variety of games that model both addition and subtraction. They have repeated experiences joining two or more amounts and removing an amount from a whole.

Later in the year, students work with combinations of quantities that they can count fluently. As they find ways to arrange and describe sets of 5–10 square tiles or record combinations of two-color counters, they begin to see that numbers can be composed in different ways. They work on activities that involve seeing and describing a given quantity (e.g., 6 tiles) as made up of groups (e.g., a group of 4 and a group of 2). They are also asked to decompose quantities (e.g., 6 can be split into 4 and 2) and to find one or more combinations for a quantity (e.g., 6 can also be decomposed as 6 and 0, 3 and 3, or 5 and 1). This work lays the foundation for making meaningful sense of $4 + 2 = 6$ and $6 - 4 = 2$ in subsequent grades.

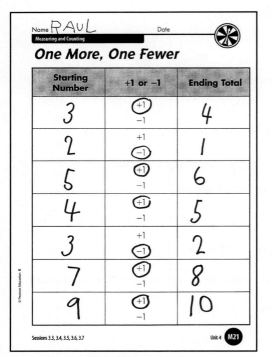

▲ Sample student work from the activity
One More, One Fewer

Students record their arrangements of six tiles and indicate how they know there are six tiles in all.

Example: Record the total number of chips. Toss the chips. Record the number that are red and the number that are yellow.

Total Number: __6__

Red	Yellow
2	4
5	1
3	3
3	3
4	2

Students use mathematical tools and representations to model and solve problems to clarify and communicate their thinking. Kindergartners are just beginning to learn how to represent their mathematical work on paper and are encouraged to do so in ways that make sense to them. Many use combinations of pictures, words, and numbers.

Mathematical Emphases

Whole Number Operations

• Making sense of and developing strategies to solve addition and subtraction problems with small numbers

• Using manipulatives, drawings, tools, and notation to show strategies and solutions

Benchmark

• Combine two small quantities.

Measurement

In Kindergarten, students are introduced to length and linear measurement through measuring by direct comparison. As they compare several objects to determine the longest object, they discuss and make sense of important aspects of accurate measurement, such as choosing which dimension to measure.

Students begin to think about the different dimensions of objects.

They also hear, become comfortable with, and use language to describe length—long, short, wide, tall, high (and their comparative forms—longer, wider, etc.). Later in the year, students use multiple nonstandard units (e.g., craft sticks or cubes) to quantify length: "How many craft sticks long is this desk? the path from the window to the door?" "How many cubes long is my shoe? this pencil?" As they measure lengths around their classroom, students think about what happens if the nonstandard units are (or are not) laid straight or if there are (or are not) gaps or overlaps between them.

Students begin to think about measuring accurately.

Mathematical Emphasis

Linear Measurement

• Understanding length and using linear units

Benchmarks

• Decide which of two objects is longer.

• Measure the length of an object by lining up multiple units.

Geometry

The geometry work in Kindergarten builds on students' firsthand knowledge of shapes to further develop their spatial sense and deepen their understanding of the two-dimensional (2-D) and three-dimensional (3-D) world in which they live. As students identify the different shapes that make up the world, they are encouraged to use their own words to describe both 2-D and 3-D shapes. In this way, they form images of familiar shapes by associating them with familiar objects.

Students explore the geometric idea that shapes can be combined or subdivided to make other shapes. For example, they investigate how 3-D shapes can be combined to form a particular rectangular prism.

Different types of blocks can be combined to form the same rectangular prism.

By putting shapes together and taking shapes apart, students deepen their understanding of the attributes of shapes and how shapes are related.

Students also construct 2-D and 3-D shapes with clay and on Geoboards. As they construct shapes, they form mental images of the shapes and think about the attributes of particular shapes.

▲ Students construct shapes on Geoboards.

The *Shapes* Software is introduced as a tool for extending and deepening this work. This tool is designed for K–2 students to explore how different shapes can be combined to form other shapes, experiment with different types of geometric transformations (rotation, translation, reflection), make patterns, and investigate symmetry.

Mathematical Emphases

Features of Shape

• Composing and decomposing 2-D and 3-D shapes

• Describing, identifying, comparing, and sorting 2-D and 3-D shapes

Benchmarks

• Describe the overall size, shape, function, and/or features of familiar 2-D and 3-D shapes.

• Construct 2-D and 3-D shapes.

• Make 2-D and 3-D shapes by combining shapes.

Patterns and Functions

Kindergarten students construct, describe, extend, and determine what comes next in repeating patterns. To identify and construct repeating patterns, students must be able to identify the attributes of the objects in the pattern. Therefore, students first work on sorting objects by their attributes, before they begin to construct their own patterns. Students encounter repeating patterns with two (AB, AAB, ABB) or three (ABC) elements. As students construct and describe many different patterns, they become more familiar with the structure of patterns, are able to identify what comes next in a pattern, and can begin to think about how two patterns are similar and different.

Example: What is the same about these cube trains? What is different?

After having many opportunities to construct their own patterns and extend patterns made by others, students begin to analyze the structure of a repeating pattern by identifying the *unit* of the pattern—the part of the pattern that repeats over and over.

Example: What is the repeating unit of this pattern?

Mathematical Emphases

Repeating Patterns

• Constructing, describing, and extending repeating patterns

• Identifying the unit of a repeating pattern

Benchmarks

• Copy, construct, and extend simple repeating patterns, such as AB and ABC.

• Begin to identify the unit of a repeating pattern.

Data Analysis

Sorting and classifying are central to organizing and interpreting data. Kindergarten students have many opportunities to identify the attributes of groups of objects, determine how the objects are the same and different, and sort them into groups according to their attributes. Students apply these skills to organizing data when they sort their favorite lunch foods into categories.

What We Like for Lunch

One way students sorted their lunch data.

Students think about how these pieces of information are the same and different when determining how the data might be grouped and how those groups can be defined.

Important to any data collection activity is the need to establish the group of people or objects being considered. Students begin their work on data by determining the number of students in the class and finding a way to represent this number on paper. As students collect data about themselves, they think about the one-to-one correspondence between the number of people and the number of pieces of data. Developing strategies for keeping track of who has responded to a survey, recording data, and representing this information are important parts of Kindergarten work.

To begin to understand the processes involved in data analysis, kindergartners are involved in all phases of conducting a survey: They choose and pose a question, determine how to record responses, and count and make sense of the results.

Example: Do you like ☁ ?

Yes	No
Carmen	Dennis
Mitchell	Timothy
Mary	Sarah
Tammy	Lisa
Raul	Kiyo
Jennifer	Latoya
	Lionel
	Manuel
	Yoshio
	Beth
	Russell

Students also use some of the data they collect to solve mathematical problems connected to their classroom. For example,

"25 students are in our class. 4 are absent. How many are here?"

Mathematical Emphases

Data Analysis

- Representing data

- Sorting and classifying

- Carrying out a data investigation

Benchmarks

- Represent a set of data.

- Use data to solve a problem.

- Sort a set of objects according to their attributes.

Curriculum Unit	1	2	3	4	5	6	7
Classroom Routines							
Attendance	•	•	•	•	•	•	•
Calendar	•	•	•	•	•	•	•
Today's Question		•	•	•	•	•	•
Patterns on the Pocket Chart			•	•	•	•	•

Preview

Classroom Routines and Ten-Minute Math activities offer practice and review of key concepts at each grade level. The two types of activities differ mainly in how and when they are integrated into your class day. Classroom Routines appear throughout Grades K–2, and two are included in Grade 3. Ten-Minute Math activities appear in Grades 3–5.

Classroom Routines occur at regular intervals, perhaps during morning meeting, at the beginning of math class, or at another convenient time. These short activities, designed to take no longer than 10 minutes, support and balance the in-depth work of each curriculum unit. After their first introduction in a math session, they are intended for use outside of math time. Some teachers use them at the beginning or end of the day.

In Kindergarten, four Classroom Routines are woven through the seven curriculum units. The following pages contain complete procedures for these activities, including the variations intended for use in Kindergarten. Specific suggestions for use are found in Today's Plan for each session. It is recommended that you begin with suggested daily problems and adapt them to fit the needs of your students throughout the year. Any needed preparation is noted in the Investigation Planner.

Attendance

Students count their classmates to take attendance. Counting the class helps students develop strategies for counting accurately. Because classroom attendance data are important (i.e., submitted to the school office daily), *Attendance* offers a particularly good context for conversations about strategies for counting and keeping track, the importance of accuracy, and the need for double-checking a count.

Math Focus Points

Attendance provides regular practice with counting a quantity that is significant to students—the number of people in their class.

◆ Developing strategies for counting accurately

Materials and Preparation

- Make name tags by printing each student's name on a 4 × 6 index card. If possible, include a photo of the child. (These will also be used in *Today's Question*.)

Examples of students' nametags from one Kindergarten class

- *(Optional)* Make a sheet for recording each day's data and laminate it.

Attendance

We have _____ students in our class.

_____ students are here today.

_____ students are absent.

- Connecting cubes of one color (1 cube per student)—used to create an Attendance Stick

- Connecting cubes of one color (1 cube per student) and stick-on dots labeled with the numbers 1 through the total number of students in your class—used to create a numbered Attendance Stick

The basic activity is introduced gradually, over the course of Unit 1, *Who Is in School Today?*

Basic Activity

Step 1 Establish who is absent. Use the name tags to establish who is in the classroom and who is absent. (If each student finds and takes his or her name tag, the ones unclaimed represent students who are absent.)

Step 2 Count the students in two ways. Early in the year, point to each student as you count them aloud; then ask the class to count along with you. (See Session 1.1 in Unit 1, *Who Is in School Today?*) Counting around the Circle is introduced as one way to double-check the count. (See Session 1.2 in Unit 1, *Who Is in School Today?*)

As students become more comfortable with the counting sequence, they suggest and explore other ways to count and keep track; students also take on more responsibility for the actual counting and keeping track. For example, as one way of counting, a rotating attendance helper eventually counts the students in many primary classrooms. (The rotation could be on either a daily or weekly basis.)

Step 3 Record the data. After counting, record the total number of students in your class, the number present, and the number absent on your attendance recording sheet. (Alternatively, record it on the board or chart paper.)

Attendance

We have __25__ students in our class.
__23__ students are here today.
__2__ students are absent.

We made a tower to show the number of students here today and another tower to show how many are absent. If I place those towers next to our numbered Attendance Stick, what do you notice?

Step 4 Use the Attendance Stick to represent the data. Ask students to help you break the Attendance Stick so that it represents the class today—one tower representing the number of students present and one tower representing those who are absent. (The class creates and first thinks about the Attendance Stick in Session 1.6 in Unit 1, *Who Is in School Today?*)

We counted and determined that Corey and Jason are absent. Right now, our Attendance Stick has 25 cubes in it. How can we make it show how many students are in school *today*? What should I do to show that Corey and Jason are absent?

Rebecca said to take 2 cubes off. There are 25 cubes in our stick, and I took 2 cubes off, one for Corey and one for Jason. How many cubes do you think are in the other part of our Attendance Stick, the part that shows how many students are here today?

After gathering ideas, ask the students to count as you point to each cube, to confirm the number. Discuss what the towers show and how they relate to the data you counted and recorded in steps 1 and 2.

Step 5 Compare the towers to the numbered Attendance Stick. Use the numbered Attendance Stick to think about how the number of students present (or absent) compares to the number of students in the class. Place the towers generated in step 3 next to the numbered Attendance Stick and encourage students to describe what they notice. (The class is introduced to the numbered Attendance Stick in Session 2.5 in Unit 1, *Who Is in School Today?*)

Variations

How Many Have Counted?

As usual, count around the circle to determine the total number of students present. In this variation, pause several times during the count to ask students how many people have counted.

Jack just said 7. How many people have counted so far? How do you know?

This variation helps students connect the counting numbers to the quantity they are counting—the number each student says stands for the number of people who have counted so far, and the last number represents the total number of students in class today. You can also use this variation to introduce and use terms like first, second, third, and so on, in a meaningful context:

So Jack said 7 because he was the seventh person in our circle. Who counted first? (Jae) What number did [Jae] say? (1)

What If We Start With . . . ?

Math Focus Point

◆ Considering whether order matters when you count

As usual, students count around the circle to determine the total number of students present. Then choose a different student and ask what will happen if the count starts with that student.

We started with Abby and counted around the circle. We found out that there are 24 students here today. What do you think would happen if we started with Carmen? Why do you think so?

Encourage students to explain their thinking. Then recount and discuss the results.

Comparing Groups

Math Focus Point

◆ Comparing quantities

This variation asks students to compare two groups, for example, the number present and absent or the number of girls and boys. After counting as usual, ask students if there are more students present or students absent and how they know. Once this is established, challenge students to determine how many more there are and to share their strategies. Have the Attendance Stick available for representing the situation and for modeling students' strategies. When comparing the number of girls and boys, students can line up to model the situation.

Counting Forward and Back

Math Focus Point

◆ Counting forward and backward

In this variation, students count around the circle to determine the total number of students in class today. Then they count backward from that total to 1. Beginning with the student who counted last means that each student will say the same number, but the count will be backward rather than forward. This variation helps students become familiar with the counting sequence in reverse, see counting back as another way to double-check a count, and begin to see the connection between counting forward and backward.

A Note About Counting Backward

Just like counting forward, students need to know the rote counting sequence and coordinate this with saying one number for each object. However, when counting backward, the first number said represents the total amount and each number subsequently said represents the removal of one object.

Calendar

Students count to establish the day and date. They use the calendar as a real-world tool for keeping track of time and events.

Math Focus Points

Calendar provides regular practice with the numbers and counting sequence to 31 plus a consistent review of the names and sequences of the days of the week.

◆ Using the calendar as a tool for keeping track of time

◆ Developing strategies for counting accurately

Materials and Preparation

Each month, prepare and post the current month on your pocket calendar, with all the dates showing. Make and place cards or tags for "Today" and for any special events that will happen (e.g., field trips, students' birthdays, visitors, school celebrations, holidays, days off), with a picture depicting the event (e.g., a cupcake with a candle or a sketch of the zoo).

An example of a pocket calendar for September

The basic activity is introduced over the course of Investigation 1 in Unit 1, *Who Is in School Today?*

Basic Activity

Step 1 Determine the day and date. Count up to today's date to establish the day and date. Help students connect those numbers to quantities by relating them to the number of days in the month so far: "1, 2, 3, 4, 5, So, there have been [5] days so far in September."

Look at the calendar to find the tag that shows Today. What is today's date? How can we figure out what number Today is?

Latoya counted 1, 2, 3, 4, 5, 6, 7 [*touching each number card*]. So today is the [seventh] day of [September]. The date is [September 7th].

As students become more comfortable with the calendar and the counting sequence, they take on more responsibility for the actual counting and keeping track. For example, a rotating calendar helper often leads this routine in many primary classrooms. Note that while many students can take on this role straightforwardly, some need an opportunity to preview what is expected of them before they lead the class in this routine. (The rotation could be on either a daily or weekly basis.)

Step 2 Occasionally, ask students about the tags that mark special days. (These tags are introduced in Session 1.3 in Unit 1, *Who Is in School Today?*)

Vary your questions, sometimes asking what day or date an event will (or did) happen, other times asking what will (or did) happen on a particular day or date. Still other times, focus on words and phrases, such as today, tomorrow, this week, next week, and last week. For example,

What day of the week will it be when we go to the zoo?

What will the date be when we go to the zoo?

Are we going to the zoo today? Tomorrow? Next week?

What is happening on Friday of this week?

What happened on the 12th day of October?

Keep in mind that there are different ways to refer to a date, for example, October 5, October 5th, and the 5th day of October. Vary the way you refer to dates so that students become comfortable with different forms. Saying "the 5th day of October" reinforces the idea that the calendar is a way to keep track of days in a month.

Teaching Note

Patterns on the Calendar

The Kindergarten calendar routine focuses on patterns inherent in the calendar and its structure: the counting sequence, 7 days in a week, the repeating cycle of 7 days (and 12 months), and so on. A classroom routine that focuses on repeating patterns is introduced in Unit 3, *What Comes Next?* See page 29 for more information about this routine.

Variations

A New Month

At the start of each month, change the monthly calendar to show the new month. Ask students what they notice about the new month. Some students focus on the arrangement of numbers or total number of days, while others note special events or pictures or designs on the calendar.

As the year progresses, encourage students to make comparisons between the months. Post the calendar for the new month next to the calendar for the month that is ending. Ask students to share their ideas about how the two calendars are similar and different.

Days of the Week

Use the calendar to review the days of the week, noting which days are school days and which are weekend (or nonschool) days.

How Many Days . . . ?

Ask students to figure out how long until (or since) a special event, such as a birthday, vacation, class trip, or holiday. For example,

How many more days until the storyteller comes to visit?

How many days has it been since our field trip to the aquarium?

Today is October 5. How many more days is it until October 15?

Students use the calendar to determine how many days and share their strategies for figuring this out.

What's Missing?

Choose a date or two (or cards for the days of the week) and remove them. Challenge the students to tell you which cards are missing and how they know.

Mixed-Up Calendar

Choose a date or two (or cards for the days of the week) and change their position on the calendar so that they are out of order. Challenge the students to find the mistakes and to help you fix them.

Today's Question

Students record their answer to a survey question with two possible answers on a two-column table. The class discussion focuses on describing and interpreting the data.

Math Focus Points

Today's Question provides students with regular opportunities to collect, record, and discuss data. It is also designed to provide regular practice with counting and comparing quantities.

◆ Collecting, counting, representing, describing, and comparing data

Today's Question is introduced in Sessions 3.1 and 3.5 in Unit 1, *Who Is in School Today?*

Materials

- Chart paper for making *Today's Question* charts according to specifications

- Markers

- Name tags (1 per student)

Basic Activity

Step 1 Prepare a chart for collecting the data, as suggested in the daily routine write-up. All recording sheets suggest some variation of a two-column table. For example,

Today's Question: Do You Have a Pet?	
Yes	No

Today's Question: Do You Have a Pet?	
Yes	No

Today's Question: Do You Have a Pet?	
Yes	
No	

Step 2 Explain the survey and collect the data. Read the question aloud and explain that students are to respond by writing their names in the appropriate column. They can use their name tags as a model for how to spell and write their names. Also, explain when students are to respond (e.g., as they arrive in the morning, during Math Workshop, during free time throughout the day).

Step 3 Discuss the data. Ask questions that encourage students to read the representation and to describe and interpret the data. For example,

What is this chart telling us?

What can you tell about [pets in our class] by looking at this chart?

How many people [have a pet]? How many people [don't have a pet]? Which group has *more*?

What else do you notice about the chart?

How many people responded to the survey? How do you know?

If we went to another classroom, collected the same kind of data, and made a chart, do you think that chart would look the same as or different from ours?

As this routine becomes familiar, students are asked to suggest different ways to organize the data as you collect it, to make it easier to see which group has more. Students' suggestions, such as writing names one over [under] the other, or drawing lines on the chart, are used to make subsequent *Today's Question* charts.

Today's Question: Do You Have a Pet?	
Yes	No

Patterns on the Pocket Chart

Students see part of a repeating pattern. They describe and extend the pattern, determining what would come next if the pattern were to continue. The focus is on repeating patterns made with two or three colors (shapes, etc.): AB [blue-green] patterns, ABC [blue-green-yellow] patterns, AAB [blue-blue-green] patterns, ABB [blue-green-green] patterns, and AABB [blue-blue-green-green] patterns.

Math Focus Points

When young students examine patterns, they look for relationships among the elements and explore how that information can be used to determine what comes next.

◆ Determining what comes next in a repeating pattern

◆ Describing repeating patterns

Materials

- Materials for making patterns (e.g., colored construction paper squares, square tiles, pattern blocks, arrow cards) that fit in the pockets on your chart

- Paper cup or baggie (1 per pair)

- A 10-by-10 pocket chart

- Resource Master M5, Question Mark Cards, from Unit 3, *What Comes Next?* (a set of 20–30)

Teaching Note

Pocket Charts

In this activity, students use the pocket 100 chart in the Kindergarten manipulatives kit. When you present longer patterns on this chart, you will have to help students understand that, when the row ends, the pattern continues on the second line. Some teachers use two pocket charts side by side, or a sentence pocket chart, so that students can look at and extend longer patterns without having the pattern "wrap around" to the next row.

Preparation

Prepare a small paper cup or plastic baggie per pair of students with at least one of each possible element of the pattern. For example, if you will investigate a pattern made from [colored square tiles], place one [square tile of each color] in each cup or bag. Because some students need to build the visible part of the pattern to figure out what might come next, prepare a few cups or baggies with *several* [tiles of each color].

Patterns on the Pocket Chart is introduced over the course of Investigation 2 in Unit 3, *What Comes Next?*

Basic Activity

Step 1 Secretly create a pattern in the first row of the chart. Arrange the repeating pattern specified in the daily routine write-up in the first row of the pocket chart. Cover the last four or five [square tiles] with Question Mark Cards.

An example of What Comes Next? *using square tiles in an AB repeating pattern*

Step 2 Card by card, reveal and discuss the pattern. Direct students' attention to the pocket chart. Discuss what students notice and then explain that you have built a pattern on the pocket chart, and that each time they see a Question Mark Card, they should think "What comes next?" and decide what [color] might be under that card.

If the pattern continues in the same way, what [color tile] do you think is under the first Question Mark Card? Talk to your partner and hold up the [tile] you think comes next.

Some students find it helpful to build the visible part of the pattern to determine what they think comes next.

Ask students to explain their choices. Then reveal the [tile] and follow the same process for each question mark. When the entire pattern is visible, say the name of each [color] aloud together, in order. Verbalizing the pattern they are considering often helps students internalize it, recognize any errors in the pattern, and determine what comes next. (See Session 2.2 in *What Comes Next?*)

Variations

Make Your Own Patterns

If the pocket 100 chart is hung where students can reach it, pairs can work together to make their own patterns during Math Workshop or free time. Pairs or small groups can also do *Patterns on the Pocket Chart,* with one student or pair creating a pattern and hiding some of it beneath Question Mark Cards and others determining what is beneath each question mark.

Wraparound Patterns

When students are familiar with the basic activity, they can investigate what happens to a pattern when it wraps around and continues to the next line. For example, if an AB pattern continues in a left-to-right progression, the pattern that emerges is the same one older students see when they investigate the patterns of odd and even numbers on the 100 chart.

An example of a Wraparound Pattern *using square tiles in an AB repeating pattern*

What Comes Here?

Determining what comes next is an important idea in learning about patterns. Also important is being able to look ahead and determine what comes here? even further down the line. Instead of asking for the next [color] in a pattern sequence, point to a pocket three or four squares along and ask students to say what [color] is under that question mark.

The teacher poses a What Comes Here? *question about an AB repeating pattern*

As you collect responses, ask students to explain how they determined the [color]. Some start at the beginning of the pattern, saying the [color] of each [tile] and then continuing that pattern as they touch the Question Mark Cards. Others use a similar strategy but start from the last visible [tile]:

The last [tile] showing is [pink]. [Green] comes after [pink], then [pink], then [green], then [pink].

A few may use what they know about the unit of the pattern (e.g., green-pink) and think about groups of two. These students might touch two cards at a time, knowing that the first in each pair is [green] and the second is [pink].

Technology in *Investigations*

Preview

The *Investigations* curriculum incorporates two forms of technology: calculators and computers. In the early grades, students can begin to see how calculators can be used as mathematical tools. Computers are explicitly linked to one unit at each grade level through software that is provided with the curriculum.

Using Calculators with the Curriculum

During elementary school, students should become comfortable using a basic calculator as a tool that is common in their homes and communities. Increasingly sophisticated calculators are being developed and used in settings ranging from high school mathematics courses to science, business, and construction. Students need to learn how to use the calculator effectively and appropriately as a tool, just as they need to learn to read a clock, interpret a map, measure with a ruler, or use coins. They should use calculators for sensible purposes—just as you would do—not as a replacement for mental calculations or for pencil and paper calculations they are learning to do. While calculators are not explicitly used in Kindergarten, you can encourage students to use calculators to double-check calculations, as an aid if they have many calculations to carry out outside of math class, or to solve problems for which they can think out a solution but don't yet have the experience to carry out the computation.

For example, in one primary classroom, students became interested in the number of days in the year. Although these students were not yet able to add a string of 12 double-digit numbers, they could articulate a sound strategy—adding the number of days in each month—and use a calculator to carry it out.

Look for situations in the classroom such as this one, where the purpose of the mathematical activity is not developing computational fluency and when the numbers and calculations are beyond the students' skills in written or mental computation. These situations provide opportunities for students to practice estimating reasonable results, then carrying out the calculation with a calculator.

Students enjoy using what they perceive as an adult tool. Investigating with the calculator gives students an opportunity to notice mathematical patterns and to ask questions about mathematical symbols. For example, in a second-grade class, students were dividing lots of numbers by 2, which led to a discussion of the meaning of 0.5. In a fourth-grade class, some students became intrigued with the square root sign. The teacher challenged them to systematically keep track of the results of applying the square root symbol to whole numbers, starting with 1, and to come up with an idea about its meaning.

The calculator is an efficient tool for many purposes in life, and students should learn to use it sensibly, knowing that using it well depends on the user's correct analysis and organization of the problem, comparing its results with reasonable estimates, and double-checking.

Introducing and Managing the *Shapes* Software in Kindergarten

Shapes Software is provided as a component of the *Investigations* curriculum. The *Software Support Reference Guide* provides a complete description of the software and instructions for using the software activities.

The *Shapes* Software is formally introduced in Kindergarten, Unit 5, *Make a Shape, Build a Block*. The software activities are integrated into Math Workshop and both extend and deepen the mathematical ideas emphasized in this unit. In some cases the software activities allow students to work with geometric shapes in ways that they are not able to in the noncomputer activities. Therefore, while using this software is optional, we recommend its use if you have computers either in your classroom or in your school's computer lab.

Read the **Teacher Notes:** Introducing and Managing the *Shapes* Software (Unit 5, p. 138) and About the Math in the *Shapes* Software (Unit 5, p. 141) for further information about the software, about introducing and integrating computer work into your classroom, about the mathematics content of the activities, and about managing the computer environment.

Options for Introducing the *Shapes* Software

How you introduce and incorporate these computer activities into your curriculum depends on the number of computers and computer technology that you have available.

- *Computer lab:* If you have a computer laboratory with one computer for each pair of students, the entire class can become familiar with the computer activities at the same time. In this case, you will not need to devote time during math class to introduce the new software activity. Once an activity has been introduced, students can do it either during Math Workshop (if you have classroom computers) or during their scheduled lab time.

- *Large projection screen:* If you have a large projection screen, you can introduce the software activities to the whole class during a math session, immediately before Math Workshop or at another time of the day.

- *Small groups of students:* With fewer classroom computers, you can introduce the activities to small groups either before or during Math Workshop. These students can then be paired and become peer "teachers" of the software.

Regardless of the number of computers available, students generally benefit from working on these activities in pairs. This not only maximizes computer resources but also encourages students to consult, monitor, and teach one another. Generally, more than two students at one computer find it difficult to share. You may need to monitor computer use more closely than the other Math Workshop choices to ensure that all students get sufficient computer time. Each pair should spend at least 15–20 minutes at the computer for each activity.

Managing the Computer Environment

Students should be using the *Shapes* Software consistently throughout Unit 5 and periodically for the rest of the school year. If you have daily access to a computer lab, you might take advantage of this to supplement your regular math class. If your school has a computer teacher, you might collaborate with that teacher to have students work on *Shapes* activities during some of their scheduled lab time.

More typically, a classroom will have a small number of computers. With computers in the classroom, pairs of students can cycle through the software activities during Math Workshop, just as they cycle through the other choices. Three to five classroom computers is ideal, but even with only one or two, students can have a successful computer experience. When you have fewer computers, find additional computer time for students throughout the day, outside of math.

Using *Shapes* All Year

Unit 5 is the only unit in the Kindergarten sequence that explicitly uses the *Shapes* software. However, we recommend that students continue using it for the remainder of the school year. With more experience, they become more fluent in the mechanics of the software itself and can better focus on the designs they want to make and how to select and arrange shapes for those designs. They can work with the tangram shapes as well as the pattern block and power polygon shapes, can solve the many different kinds of puzzles that come with the software, and make their own puzzles.

Professional Development

Teacher Notes in *Investigations*

Teacher Notes are one of the most important professional development tools in *Investigations*. Each curriculum unit contains a collection of Teacher Notes that offer information about the mathematical content of that unit and how students learn it.

In this section of *Implementing Investigations in Kindergarten,* you will find a set of Teacher Notes that addresses topics and issues applicable to the curriculum as a whole rather than to specific curriculum units.

These Teacher Notes provide important background about approaches to mathematics teaching and learning, about critical features of the mathematics classroom, and about how to develop an inclusive mathematics community in which all students participate. You can benefit from reading these notes, either individually or as the basis for discussion in teacher study groups, before starting to use the curriculum. Alternatively, you can read these notes gradually throughout the year while you are using the curriculum in your classroom. These brief essays take on new resonance and meaning as you have more experience with student learning and the *Investigations* curriculum. Plan to return to this collection periodically to review the ideas and reflect on the implications for classroom practice.

A complete list of the Teacher Note titles from each of the nine curriculum units is included on pages 61–62.

Computational Fluency and Place Value

Computational fluency includes accuracy, flexibility, and efficiency. When fluency with a particular operation is achieved, students can look at the problem as a whole, choose a solution strategy that they can carry out easily without becoming bogged down or losing track of their steps, use their strategy to solve the problem accurately, recognize whether the result is reasonable, and double-check their work. Students who are fluent have a repertoire that includes mental strategies, strategies in which only intermediate steps are jotted down while other steps are carried out mentally, and strategies that require a complete written solution. They are flexible in their choice of algorithm or procedure, and they can use one method to check another.

Developing computational fluency with whole numbers is central to the elementary curriculum. This development includes the building blocks of computation:

- Understanding the base-ten number system and its place value notation

- Understanding the meaning of the operations and their relationships

- Knowing the basic addition and multiplication number combinations (the "facts") and their counterparts for subtraction and division

- Estimating reasonable results

- Interpreting problems embedded in contexts and applying the operations correctly to these problems

- Learning, practicing, and consolidating accurate and efficient strategies for computing

- Developing curiosity about numbers and operations, their characteristics, and how they work

- Learning to articulate, represent, and justify generalizations

At each grade level, computational fluency looks different. Students are progressing in learning the meaning of the four arithmetic operations with whole numbers, developing methods grounded in this meaning, and gradually solving problems of greater difficulty through the grades. At each grade level, benchmarks for whole number computation indicate what is expected of all students by the end of each curriculum unit and each grade, although work at each grade level goes beyond these benchmarks. Gradually, approaches to problems become more efficient, flexible, and accurate. For example, in Grade 1, many students begin the year adding by direct modeling of the problem with objects and counting the sum by ones. By the end of the year, students are expected to start with one of the quantities and count on the other, and for some combinations students "just know" the sum or use known combinations to solve others ("I know $4 + 4 = 8$, so $4 + 5 = 9$"). In Grade 4, many students start the year solving some multiplication problems by skip counting, but by the end of the year, they are expected to solve multidigit multiplication problems such as 34×68 by breaking problems into subproblems, based on the distributive property.

$$30 \times 60 = 1800$$
$$30 \times 8 = 240$$
$$4 \times 60 = 240$$
$$4 \times 8 = 32$$
$$4$$
$$\underline{\qquad}$$
$$\boxed{2312}$$

$68 \text{ round to } 70$

$34 + 34 = 68$

$$70 \times 4 = 280$$
$$70 \times 30 = 2100$$
$$\underline{\qquad}$$
$$2380 - 68 = \boxed{2312}$$

Sample Student Work

Understanding the Base-Ten Number System

Learning about whole number computation is closely connected to learning about the base-ten number system. The base-ten number system is a "place value" system. That is, any numeral, say 2, can represent different values, depending on where it appears in a written number: it can represent 2 ones, 2 tens, 2 hundreds, 2 thousands, as well as 2 tenths, 2 hundredths, and so forth. Understanding this place value system requires coordinating the way we write the numerals that represent a particular number (e.g., 217) and the way we name numbers in words (e.g., two hundred seventeen) with how those symbols represent quantities.

The heart of this work is relating written numerals to the quantity and to how the quantity is composed. It builds from work on tens and ones in Grades 1 and 2 to a focus on numbers in the hundreds and thousands in Grade 3, and work with numbers in the ten thousands, hundred thousands, and beyond in Grades 4 and 5. Knowing place value is not simply a matter of saying that 217 "has 2 hundreds, 1 ten, and 7 ones," which students can easily learn to do by following a pattern without attaching much meaning to what they are saying. Students must learn to visualize how 217 is built up from hundreds, tens, and ones, in a way that helps them relate its value to other quantities. Understanding the place value of a number such as 217 entails knowing, for example, that 217 is closer to 200 than to 300, that it is 100 more than 117, that it is 17 more than 200, that it is 3 less than 220, and that it is composed of 21 tens and 7 ones.

A thorough understanding of the base-ten number system is one of the critical building blocks for developing computational fluency. Understanding place value is at the heart of estimating and computing. For example, consider adding two different quantities to 32:

$32 + 30 =$ _____

$32 + 3 =$ _____

How much will 32 increase in each case? Students think about how the first sum will now have 6 tens, but the ones will not change, whereas in the second sum, the ones will change, but the tens remain the same. Adding three *tens* almost doubles 32, while adding three *ones* increases its value by a small amount. Considering the place value of numbers that are being added, subtracted, multiplied, or divided provides the basis for developing a reasonable estimate of the result.

The composition of numbers from multiples of 1, 10, 100, 1,000, and so forth, is the basis for most of the strategies students adopt for whole number operations. Students' computational algorithms and procedures depend on knowing how to decompose numbers and knowing the effects of operating with multiples of 10. For example, one of the most common algorithms for addition is adding by place. Each number is decomposed into ones, tens, hundreds, and so forth; these parts are then combined. For example,

$326 + 493$

$300 + 400 = 700$

$20 + 90 = 110$

$6 + 3 = 9$

$700 + 110 + 9 = 819$

To carry out this algorithm fluently, students must know a great deal about place value, not just how to decompose numbers. They must also be able to apply their knowledge of single-digit sums such as $3 + 4$ and $2 + 9$ to sums such as $300 + 400$ and $20 + 90$. In other words, they know how to interpret the place value of numbers *as they operate with them*—in this case, that just as 2 ones plus 9 ones equals 11 ones, 2 tens plus 9 tens equals 11 tens, or 110.

As with addition, algorithms for multidigit multiplication also depend on knowing how the place value of numbers is interpreted as numbers are multiplied. Again, students must understand how they can apply knowledge of single-digit combinations such as 3×4 to solve problems such as 36×42.

For example,

36×42

$30 \times 40 = 1,200$

$30 \times 2 = 60$

$6 \times 40 = 240$

$6 \times 2 = 12$

$1,200 + 240 + 60 + 12 = 1,512$

Students gradually learn how a knowledge of 3×4 helps them solve 30×4, 3×40, 30×40, 3×400, and so forth.

Building Computational Fluency Over Time

There is a tremendous amount of work to do in the area of numbers and operations in Grades K–5.

- Kindergartners and first graders are still working on coordinating written and spoken numbers with their quantitative meaning.

- Second graders are uncovering the relationship between 10 ones and 1 ten and between 10 tens and 1 hundred.

- Third graders are immersed in how the properties of multiplication differ from the properties of addition.

- Fourth and fifth graders are solving multidigit problems and becoming flexible in their use of a number of algorithms.

This list provides only a brief glimpse of how much work there is to do in these grades.

Students gain computational fluency in each operation through several years of careful development. Extended time across several grades is spent on each operation. Students build computational fluency with small numbers as they learn about the meaning and properties of the operation. Then they gradually expand their work to more difficult

problems as they develop, analyze, compare, and practice general methods.

Let's use subtraction as an example of this process:

- In Kindergarten and Grade 1, students solve subtraction problems by modeling the action of subtraction.

- By Grade 2, students are articulating and using the inverse relationship between addition and subtraction to solve problems like the following: "If I have 10 cookies, how many more cookies do I need to bake so I have 24?"

- During Grades 2 and 3, students become fluent with the subtraction "facts" and model and solve a variety of types of subtraction problems, including comparison and missing part problems. By Grade 3, as students' understanding of the base-ten number system grows, they use their understanding of place value to solve problems with larger numbers.

- In Grades 3 and 4, students articulate, represent, and justify important generalizations about subtraction. For example, if you add the same amount to (or subtract it from) each number in a subtraction expression, the difference does not change, as in the equation $483 - 197 = 486 - 200$. In these grades, students also choose one or two procedures, practice them, and expand their command of these procedures with multidigit numbers.

- In Grades 4 and 5, as their fluency with subtraction increases, students analyze and compare strategies for solving subtraction problems. Because they are fluent with more "transparent" algorithms for subtraction in which the place value of the numbers is clear, they are now in a position to appreciate the shortcut notation of the U.S. traditional regrouping algorithm for subtraction, analyze how it works, and compare it to other algorithms. (See the Teacher Note, Computational Algorithms and Methods.)

This account gives only a glimpse of the work involved in understanding subtraction across the grades. Each operation has a similar complexity. It is critical that the time and depth required for the careful development of ideas is devoted to this strand. For this reason, in each of Grades 1–4, there are four units spread throughout the year that focus on whole numbers, operations, and the base-ten number system. In Kindergarten, three units focus on counting, quantity, and modeling addition and subtraction. In Grade 5, because of the increased emphasis on rational numbers, three units focus on whole numbers and two units focus on fractions, decimals, and percents. The whole number units within each grade build on each other in a careful sequence.

As you work with your students on whole number computation, here are some questions to keep in mind as you assess their progress toward computational fluency [adapted from Russell, 2000, p. 158]:

- Do students know and draw on basic facts and other number relationships?

- Do students use and understand the structure of the base-ten number system? For example, do students know the result of adding 100 to 2,340 or multiplying 40×500?

- Do students recognize related problems that can help with the problem?

- Do students use relationships among operations?

- Do students know what each number and numeral in the problem means (including subproblems)?

- Can students explain why the steps being used actually work?

- Do students have a clear way to record and keep track of their procedures?

- Do students have more than one approach for solving problems in each operation? Can they determine which problems lend themselves to different methods?

Supporting Computational Fluency Across the Curriculum

Work in the other content areas also connects to and supports the work on computational fluency in the number and operations units. For example, an emphasis on the foundations of algebra across the grades opens up important opportunities to strengthen work with numbers and operations. Within the number and operations units themselves, articulation, representation, and justification of general claims about the operations (an aspect of early algebraic thinking) strengthen students' understanding of the operations (see the Teacher Note, Foundations of Algebra in the Elementary Grades, and the Algebra Connections essay in each of the number and operations units). The work with functions provides interesting problem contexts in which students' work on ratio and on constant rates of change connect to and support their work on multiplication (see the Teacher Note, Foundations of Algebra in the Elementary Grades, and the Algebra Connections essay in each of the patterns, functions, and change units). Geometry and measurement units also provide contexts in which students revisit multiplication. Finally, the Classroom Routines (in Grades K–3) and Ten-Minute Math (in Grades 3–5) provide ongoing, regular practice of estimation and computation.

Reference

Russell, S. J. (2000). Developing computational fluency with whole numbers. *Teaching Children Mathematics 7*, 154–158.

Computational Algorithms and Methods

In the elementary grades, a central part of students' work is learning about addition, subtraction, multiplication, and division and becoming fluent and flexible in solving whole number computation problems. In the *Investigations* curriculum, students use methods and algorithms in which they can see clearly the steps of their solution and focus on the mathematical sense of what they are doing. They use and compare several different methods to deepen their understanding of the properties of the operations and to develop flexibility in solving problems. They practice methods for each operation so that they can use them efficiently to solve problems.

What Is an Algorithm?

An algorithm is a series of well-defined steps used to solve a certain class of problem (for example, all addition problems). Often, the sequence of steps is repeated with successive parts of the problem. For example, here is an example of an addition algorithm:

$$249 + 674$$
$$200 + 600 = 800$$
$$40 + 70 = 110$$
$$9 + 4 = 13$$
$$800 + 110 + 13 = 923$$

Written instructions for this algorithm might begin as follows:

1. Find the left-most place represented in the addends and add all the amounts in that place.

2. Move one place to the right and add all the amounts in that place in all the addends.

3. Repeat step 2 until all parts of all addends have been added.

4. Add the sums of each place.

To specify these instructions, as if we were going to teach them to a computer, we would have more work to do to make them even more specific and precise. For example, how is step 4 carried out? Should each place be added separately again and then combined? In practice, when students and adults use this algorithm, the partial sums that must be added in step 4 are generally easy enough to add mentally, as they are in this problem, although occasionally one might again break up some of the numbers.

Algorithms like this one, once understood and practiced, are general methods that can be used for a whole class of problems. The adding by place algorithm, for example, can be generalized for use with any addition problem. As students' knowledge of the number system expands, they learn to apply this algorithm to, for example, larger numbers or to decimals. Students also learn how to use clear and concise notation, to carry out some steps mentally, and to record those intermediate steps needed so that they can keep track of the solution process.

Nonalgorithmic Methods for Computing with Whole Numbers

Students also learn methods for computing with whole numbers that are not algorithmic—that is, one cannot completely specify the steps for carrying them out, and they do not generally involve a repetition of steps. However, these methods are studied because they are useful for solving certain problems. In thinking through why and how they work, students also deepen their understanding of the properties of the various operations. This work provides opportunities for students to articulate generalizations about the operations and to represent and justify them.

For example, here is one method a third grader might use to solve this problem:

$$\$7.46 + \$3.28 = \$7.50 + \$3.24 = \$10.74$$

The student changed the addition expression to an equivalent expression with numbers that made it easier to find the sum mentally. First graders often use this idea as they learn some of their addition combinations, transforming a combination they are learning into an equivalent combination they already know: $7 + 5 = 6 + 6 = 12$.

When students try to use the same method to make a subtraction problem easier to solve, they find that they must modify their method to create an equivalent problem. Instead of adding an amount to one number and subtracting it from the other, as in addition, they must add the same amount to (or subtract it from) each number:

$$182 - 69 = 183 - 70 = 113$$

Throughout the *Investigations* curriculum, methods like these are introduced and studied to deepen students' understanding of how these operations work and to engage them in proving their ideas using representations of the operations.

Because the ways in which a problem might be changed to make an equivalent problem that is easier to solve can vary (although it might be possible to precisely specify a particular variant of one of these methods), these methods are not algorithms. Students do not generally use such methods to solve a whole class of problems (e.g., any addition problem); rather, students who are flexible in their understanding of numbers and operations use finding equivalent expressions as one possible method and notice when a problem lends itself to solving in this way.

Learning Algorithms Across the Grades

In *Investigations,* students develop, use, and compare algorithms and other methods. These are not "invented" but are constructed with teacher support, as students' understanding of the operations and the base-ten number system grow (see the Teacher Note, Computational Fluency and Place Value). Because the algorithms that students learn are so grounded in knowledge of the operation and the number system, most of them arise naturally as students progress from single-digit to multidigit problems. For example, the adding by place addition algorithm shown earlier naturally grows out of what students are learning about how a number such as 24 is composed of 2 tens and 4 ones. It is part of the teacher's role to make these methods explicit, help students understand and practice them, and support students to gradually use more efficient methods. For example, a second grader who is adding on one number in parts might solve $49 + 34$ by adding on 10, then another 10, then another 10, then 4 to 49 ($49 + 10 + 10 + 10 + 4$). By having this student compare solutions with another student's whose first step is $49 + 30$, the teacher helps the first student analyze what is the same and different about their solutions and opens up the possibility for the first student of a more efficient method—adding on a multiple of 10 all at once rather than breaking it into 10s.

The algorithms and other methods that students learn about and use in *Investigations* for multidigit problems are characterized by their *transparency*. Transparent algorithms

• make the properties of the operations visible.

• show the place value of the numbers in the problem.

• make clear how a problem is broken into subproblems and how the results of these subproblems are recombined.

These characteristics are critical for students while they are learning the meaning of the operations and are building their understanding of the base-ten system. Here is an example of a transparent multiplication algorithm that might be used by a fourth grader:

$$
\begin{array}{r}
34 \\
\times\ 78 \\
\hline
2100 \\
280 \\
240 \\
32 \\
\hline
\end{array}
$$

$$2{,}000 + 500 + 150 + 2 = 2{,}652$$

In this algorithm, students record all numbers fully, showing the place value of all the digits. Because the result of each multiplication is shown, the application of the distributive property is kept track of clearly.

There is a misperception that many different algorithms might arise in a single classroom and that this multitude of algorithms will be confusing. In fact, there are only a few basic algorithms and methods for each operation that arise from students' work and that are emphasized in the curriculum. Each is tied closely to how students solve problems and to the basic characteristics and properties of the operation. Teacher Notes throughout the curriculum provide more detail about these methods.

Students can and do develop efficiency and fluency with these more transparent algorithms. As they do, they do some steps mentally and may no longer need to write out every step to keep track of their work. For example, in using the adding by place algorithm to add 249 + 674, a competent user might simply jot down 800, 110, 13, and then add those partial sums mentally and record the answer. There may be times when you require students to write out their complete solution method so that you can see how they are solving problems, but for everyday use, efficient users of such algorithms will record only the steps they need.

These algorithms and methods are studied, compared, and analyzed for different reasons. All of them are transparent, preserve place value, and make visible important properties such as distributivity. Some can be practiced and provide general, efficient methods. Others are useful only for particular problems but are studied because of what they illuminate about the operations.

Studying the U.S. Standard Algorithms

The U.S. standard algorithms for addition, subtraction, and multiplication are also explicitly studied in *Investigations* but only after students are fully grounded in understanding the operation and using transparent algorithms for multidigit computation. These algorithms were developed for efficiency and compactness for handwritten computation. When these algorithms are used as a primary teaching tool, their very compactness, which can be an advantage for experienced users, becomes a disadvantage for young learners because they obscure the place value of the numbers and the properties of the operation.

Some students do use the standard algorithms with understanding. As these algorithms come up in class, they should be incorporated into the list of class strategies. Teachers should make sure that students who use them understand what the shortcut notation represents and that they can explain why these algorithms make sense. They should also know and understand other methods. In Grade 4, students revisit the U.S. standard addition algorithm formally, analyze how and why it works, and compare it to other algorithms they are using. In Grade 5, students revisit the U.S. standard subtraction and multiplication algorithms in the same way. Division methods studied in this curriculum focus on the inverse relationship between multiplication and division.

Representations and Contexts for Mathematical Work

Mathematics involves describing and analyzing all kinds of mathematical relationships. Throughout the *Investigations* curriculum, students use representations and contexts to help them visualize these mathematical relationships. Thinking with representations and contexts allows students to express and further develop their ideas and enables students to engage with each other's ideas. Whether solving a multiplication problem, finding the area of a rectangle, describing the relationship between two variables, or ordering fractions, students use representations and contexts to investigate and explain.

The *Investigations* curriculum introduces a limited number of carefully chosen representations and contexts because they provide representations of mathematical relationships that students can use to solve problems and/or to show their ideas and solutions to others. Students may first use representations or contexts concretely, drawing or modeling with materials. Later, they incorporate these representations and contexts into mental models that they can call on to visualize the structure of problems and their solutions. Students develop the habit of making drawings, building models, and using representations to think with and to explain their thinking to others. They develop a repertoire of representations that they know well and can apply when faced with unfamiliar problem situations.

Good contexts and representations have the following characteristics:

- They are useful for a whole class of problems (e.g., addition problems).

- They can be extended to accommodate more complex problems and/or students' expanding repertoire of numbers.

- They do not overwhelm or interfere with the focus on mathematical content.

- Their structure embodies important characteristics of the mathematical relationships.

This Teacher Note provides some examples of how models, materials, and contexts are used by students across the grades.

Representations

Basic representations in the *Investigations* curriculum include connecting cubes, the 100 chart (and its variants, the 300, 1,000, and 10,000 charts), number lines, arrays, and sets of two-dimensional (2-D) and three-dimensional (3-D) shapes. Each representation provides access to certain characteristics, actions, and properties of numbers and operations or of geometric properties and relationships. Here are two examples.

Connecting Cubes

Connecting cubes are a basic material for counting and for modeling addition and subtraction in Grades K–2. The cubes are a discrete model of whole numbers and provide a uniform counting material for representing ones. Because they connect, they can be organized into sticks of ten cubes so that students can use them to represent tens and ones.

The individual cubes are visible in the connected stick of ten, so students can visualize how this stick represents the equivalence of 1 ten and 10 ones and then how 10 ten-sticks is equivalent to 1 hundred and 100 ones. Connecting cubes are a flexible material. They are well suited for modeling the basic actions of joining and separating. They can also be used

to construct rectangular arrays for studying multiplication and area. Students also use the cubes to construct rectangular prisms and to analyze and visualize how the volume of the shape consists of a certain number of layers, each of which has the same dimensions.

Each layer is 3 × 4. There are six layers.

The Number Line

The number line is another key representation of numbers. This continuous representation offers students another view of the number sequence and number relationships. Students' beginning work with number lines involves number lines that are already marked with the counting numbers.

$$13 + 9$$

I jumped up 10 to 23, then back 1.

Later, students choose the part of the number line they need and which points on it should be marked as they use it to solve problems.

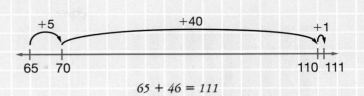

$$65 + 46 = 111$$

The number line provides access to the idea that numbers are infinite. At first, students come to this idea in relation to the counting sequence of whole numbers. Later, as they encounter negative numbers, they consider how the number line extends in both directions, that both positive and negative numbers "go on forever." In their study of rational numbers, they use the number line to model fractions and decimal fractions and consider how the segments of the number line between two successive whole numbers can be divided into smaller and smaller pieces. In later years, they will come to understand that there are an infinite number of numbers between any two successive integers.

For students to use a representation well, they need enough experience with it so that they understand its basic characteristics and can then use it themselves to model and solve problems. For example, using an unmarked number line flexibly requires that students have enough prior experience using the marked number line to count, add, and subtract.

Using Different Representations

Different representations offer different models of the mathematics and access to different mathematical ideas. For example, both place value models and number lines are useful in students' study of subtraction, but they each allow students to see different aspects of subtraction. A student solving the problem $103 - 37$ might think about subtracting 37 in parts by visualizing a place value model of the numbers, subtracting 3 tens and then 7 ones (which, for ease of subtraction from 103, the student might split into $3 + 4$).

Another student might think about creating an easier, equivalent problem: $103 - 37 = 106 - 40$. This student might visualize "sliding" the interval from 37 to 103 along a number line to determine how to change the numbers, while preserving the difference between them.

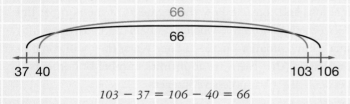

$$103 - 37 = 106 - 40 = 66$$

More details about these and other representations are provided throughout the curriculum units.

Contexts

Contexts and stories are also used to represent mathematical relationships. A good context can be created from familiar events or fantasy. Contexts that students can imagine and visualize give them access to ways of thinking about the mathematical ideas and relationships they are studying. For a context to be useful, it must be connected enough to students' experience that students can imagine and represent the actions and relationships. At the same time, the details of the context need not be elaborate, so that the nonmathematical aspects of the context stay in the background. Here are two examples.

The Penny Jar

One of the contexts in the patterns and functions units in Grades 1 and 4 is the Penny Jar. The Penny Jar contains some number of pennies (the starting amount) and then has a certain number of pennies added to it each day or with each round (the constant rate of change). This is one of the contexts used to engage students in exploring a function—the relationship of the number of days to the total number of pennies—that involves a constant rate of change. Students' knowledge of similar real-world contexts engages students quickly in the mathematics and helps them visualize the mathematical relationships, but it is not so elaborate that it obscures or distracts from the mathematics.

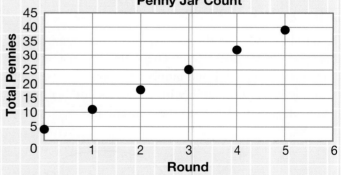

Number of Rounds	Total Number of Pennies
Start	4
1	11
2	18
3	25
4	32
5	39

Once students are familiar with the Penny Jar context, they can represent it in multiple ways, using pictures, tables, and graphs, to describe and analyze the relationship between the two variables.

Travel Stories

In Grade 3, travel stories are used as a context for subtraction. Students are familiar with taking trips by car or bus or have encountered such trips in stories or movies. They know about a trip having a starting point, an ending point, and a certain distance traveled. They are also familiar with stopping along the way for a meal or to take a break and with discussing how much of the distance has been covered and how much is still ahead of them.

▲ Grade 3 Unit 3 *Student Activity Book,* page 58

Helping Students Connect to Contexts

Teachers often personalize these contexts for students to help them visualize and use it. For example, when using the Penny Jar context, one first-grade teacher had a brief discussion about places they or someone else they know used

to hold money and some reasons that money might get added to any of these. The teacher then referred to some of these situations as they discussed problems, "Let's say we're talking about Andre's situation when he is doing his chores. He has 3 pennies in the jar, and he is going to put in 2 pennies for each chore he completes." In using the travel story context, teachers also refer to situations that are familiar to students: "So let's say Janelle and her family are setting off to visit her grandma, like they did last summer, and the whole trip is 274 miles. …"

More details about these and other contexts are provided throughout the curriculum units.

Using Representations and Contexts

Representations and contexts are central in mathematics at all levels for investigating, explaining, and justifying mathematical ideas. Students should move toward developing mental models of mathematical relationships that they call on routinely and will often use pictures, diagrams, and objects when they encounter new kinds of problems.

Students should use representations and contexts judiciously and with purpose. A first grader who is solving word problems that involve addition and subtraction might model every problem with cubes. Another student in the same class might model one or two problems; then, having visually confirmed the action of the operation, the student might solve the rest by imagining one quantity and counting on. A third student—or the same student later in the year—might reason about the numbers without using an image or model. In class discussions, both the teacher and students use representations to clarify and investigate mathematical ideas and to help all students focus on what is being discussed.

As a teacher, one of your roles is to support students in using representations and contexts and to help them develop mental images that they can call on. On the one hand, students need not show a picture for a problem when they have developed more efficient numerical tools and methods. For example, when one fourth grader was asked to solve a multiplication problem in two ways, he solved the problem by breaking it

up efficiently, using the distributive property, and then showed a solution using groups of tally marks. His teacher let him know that using tally marks was not what she was looking for from him and reminded him of the work the class had been doing on changing one of the numbers in the problem and then adjusting the product.

On the other hand, students should understand that the use of representations and models is not a "crutch" in mathematics but are a powerful set of tools for investigating problem situations. In the classroom, encourage representation as a central part of mathematics activity. Make a habit of asking questions such as these:

- Is there a way you can show us your thinking using the number line or the 100 chart?

- Can you explain how your strategy makes sense using the travel context we have been using for some of the problems?

- You used a number line and Chris used a place-value sketch showing tens and ones. What is similar or different about these two approaches? Where can you see the four tens in Chris's place value sketch on Luc's number line solution?

- Karen, you are thinking of the multiplication problem as representing 47 classrooms with 23 students in each class. How did this context help you keep track of the parts of the problem?

- Can you show us with a picture or on the Geoboard what you mean when you say "a triangle is half of a rectangle"?

- What if you needed to explain or prove what you are saying to someone who came to visit our classroom? Is there a way you can show me why what you are saying is true with a picture or diagram?

When students are accustomed to incorporating representations in their daily mathematics work and considering what representations can be helpful for explaining mathematical ideas, they can also create their own images appropriate to a particular problem situation. Help students make these images simple enough so that they serve the mathematics rather than obscure it. The use of representations in class discussions helps illuminate students' ideas for each other and, by putting out an image that is available to all students, clarifies what mathematical relationships are being considered and invites more students into the conversation.

For further examples of students' use of representations, see the classroom stories in the section "Language and Representation" in Part 7, Working with the Range of Learners: Classroom Cases.

Foundations of Algebra in the Elementary Grades

Algebra is a multifaceted area of mathematics content that has been described and classified in different ways. Across many of the classification schemes, four areas foundational to the study of algebra stand out: (1) generalizing and formalizing patterns; (2) representing and analyzing the structure of numbers and operations; (3) using symbolic notation to express functions and relations; and (4) representing and analyzing change.

In the *Investigations* curriculum, these areas of early algebra are addressed in two major ways: (1) work within the counting, number, and operations units focusing on generalizations that arise in the course of students' study of numbers and operations and (2) a coherent strand, consisting of one unit in each grade, K–5, that focuses on patterns, functions, and change. These two areas of emphasis are described here, followed by some additional information about the goals of work on early algebra in the curriculum.

Early Algebra: Making General Claims About Numbers and Operations

Each *Investigations* unit on counting, numbers, and operations includes a focus on reasoning and generalizing about numbers and operations. Even in beginning work with numbers and operations in Kindergarten and Grade 1, students are already noticing regularities about numbers and operations. For example, in the K–1 game *Double Compare,* each student in the pair selects two number cards. The student with the greater sum says "me." In this early work, before students know their single-digit addition combinations, most students are counting all or counting on to determine the sum. But consider how students are reasoning in the following brief episode:

> Bridget and Siva are playing *Double Compare.* Bridget draws a 5 and a 2; Siva draws a 5 and a 3 and immediately says "me," indicating that he has the greater sum. Siva usually counts both amounts by ones to get the sum, so the teacher asks him, "How did you know you have more?" Siva responds, "Because I have a 3 and she has a 2, and 3 is bigger." Bridget is nodding vigorously and adds, "The 5s don't count."

How are the students in this episode figuring out who has the greater sum? Why does Siva only compare 3 with 2, and what does Bridget mean when she says the "5s don't count"? Implicit in these students' work is a general claim about adding numbers that many young students use: If you are comparing two addition expressions, and one of the addends in the first expression is the same as one of the addends in the second, then you need only compare the other two addends to determine which expression has the greater sum. This is a mouthful to put into words, and students might not be able to articulate this idea completely; nevertheless, they are reasoning based on this idea. In later years, this idea can be represented with symbolic notation:

For any numbers a, b, c, and d when $a = c$ and $b < d$, then $a + b < c + d$.

$a = c$	$b < d$	$a + b < c + d$
$5 = 5$	$2 < 3$	$5 + 2 < 5 + 3$

Part of the teaching work in the elementary grades is to help students articulate, represent, investigate, and justify such general claims that arise naturally in the course of their work with numbers and operations. In each of the number and operations units in Grades K–5, the Algebra Connections essay highlights several of these general ideas about properties and relationships relevant to the work in that curriculum unit, with examples of how students think about and represent them. Investigation and discussion of some of these generalizations are built into unit sessions; for others, Algebra Notes alert the teacher to activities or discussions in which these ideas are likely to arise and could be pursued.

In the course of articulating, representing, and justifying their ideas about such general claims, students in the elementary grades are beginning to engage in proving—a central part of mathematics. They consider the questions: Does this generalization apply to *all* numbers (in the domain under consideration, usually whole numbers)? Why does it work? How do you know? In two of the number and operations units in each grade, 2–5, you will find a Teacher Note that focuses on proof and justification. These Teacher Notes provide examples of the ways that students at that grade level engage in proving and how their proofs, based on representations, are related to the proofs a mathematician might carry out.

Examples of the general claims highlighted in the curriculum in Grades K–2 are as follows:

- Counting the same set of objects in different orders results in the same count.

- If one number is larger than another, and the same number is added to each, the first total will be larger than the second: $3 + 5 > 2 + 5$.

- You can add two numbers in either order: $6 + 3 = 3 + 6$.

- If you add an amount to one addend and subtract it from another addend, the sum remains the same: $6 + 6 = 12$; $7 + 5 = 12$.

- Addition and subtraction are related. If adding two numbers gives a certain sum, then subtracting one of the addends from the sum results in the other addend: $6 + 7 = 13$; $13 − 7 = 6$; $13 − 6 = 7$.

- You can break numbers into parts to add them: $6 + 8 = 6 + (4 + 4) = (6 + 4) + 4$.

- If you add two even numbers, the sum is even. If you add two odd numbers, the sum is even. If you add an even number and an odd number, the sum is odd.

Some of the generalizations investigated in Grades K–2 are revisited in Grades 3–5 with higher numbers and more complex problems. In addition, new general claims are investigated. Examples of general claims highlighted in Grades 3–5 are as follows:

- If you add the same amount to both numbers in a subtraction problem, the difference does not change: $145 − 97 = 148 − 100$.

- You can multiply two numbers in either order: $32 \times 20 = 20 \times 32$.

- You can break numbers into parts to multiply them, but each part of each number must be multiplied by each part of the other number: $7 \times 24 = 7 \times (20 + 4) = (7 \times 20) + (7 \times 4)$.

- Multiplication and division are related. If multiplying two numbers gives a certain product, then dividing that product by one of the original factors results in the other factor: $9 \times 8 = 72$; $72 \div 8 = 9$; $72 \div 9 = 8$.

- A factor of a number is a factor of multiples of that number: 3 is a factor of 15; 15 is a factor of 30, so 3 is a factor of 30.

- If you double (or triple) one of the factors in a multiplication problem and halve (or third) the other, the product remains the same: $164 \times 4 = 328 \times 2$.

Early Algebra: Patterns, Functions, and Change

Investigations includes a coherent K–5 strand on patterns, functions, and change, with one unit in each grade. The content of these units starts with repeating patterns and number sequences in Grades K and 1, connects these patterns and sequences to functional relationships beginning in Grade 2, and then develops ideas about linear and nonlinear contexts that involve relationships between two variables in Grades 3–5. In each of these units in K–5, the Algebra Connections essay highlights some of the ideas students work on in that unit, and how they connect to later work in algebra.

Patterns and Functions in Grades K–2

Work with repeating patterns has long been a staple of mathematics work in the primary grades, but it often seems to have little connection to work in later grades. In the *Investigations* sequence, students' study of the structure of repeating patterns is connected to work with ratios and linear functions by associating the repeating pattern with the counting numbers. Consider this example:

Students have been building repeating color patterns using connecting cubes. This red-blue-green repeating pattern has been numbered with the counting numbers, starting with 1. Students are considering which numbers are associated with the green cubes:

Kamala says that the greens have a "counting by 3s" pattern: 3, 6, 9, 12. Esperanza says, "it will always be on the threes because every time you skip two, then it's green." Theo adds, remembering a previous Investigation in which they built buildings from connecting cubes with the same number of cubes in each layer: "It's like the same pattern we made when we made the building. It's always adding threes. One floor is three, two floors is six, and you keep adding three— 3, 6, 9, um, 12, and you keep going by 3s."

Students are recognizing the underlying 1:3 ratio in both situations. In the repeating pattern, there is a relationship between the position of each green cube among all green cubes and its position among all the cubes: the *first* green is in position 3 in the sequence, the *second* green in position 6, the *third* green in position 9, and so forth. In the cube building, there are 3 cubes for each floor: one floor has

3 cubes, 2 floors have 6 cubes, 3 floors have 9 cubes, and so forth. These constant ratio situations are students' first examples of linear change—change at a constant rate.

Examples of ideas investigated in Grades K–2 in these units are as follows:

- Repeating patterns can be described as iterations of a unit. This repeating color pattern can be divided into its units, the part that repeats:

- When the elements of a repeating pattern are numbered with the counting numbers, elements in the pattern can be characterized by a particular number sequence. In a red-blue-red-blue connecting cube train, the blue cubes are numbered 2, 4, 6, 8, . . . , and the red cubes are numbered 1, 3, 5, 7,

- The same number sequence can represent different situations. The blue cubes in a red-blue repeating pattern and the claps in a tap-clap repeating pattern fall in the same numbered positions.

- In a ratio situation, as one quantity changes by a certain amount, the other quantity always changes by a certain amount (for each day, there are 3 pennies added to the jar).

- Tables are a representation that can be used to show how one variable changes in relation to another.

- The same ratio relationship can occur in different contexts (e.g., 3 pennies per day, 3 cubes per "floor").

Patterns, Functions, and Change in Grades 3–5

In Grades 3–5, students focus on both linear and nonlinear change. Students study situations with a constant rate of change, in which two variables are related in ways that can be expressed in a verbal rule or an equation (such as the relationship between the total number of pennies in a jar and the number of days pennies have been collected, when a fixed number of pennies is added to the jar each day). They learn to take into account any starting amount (i.e., the number of pennies in the jar at the beginning) and the rate of change (i.e., the number of pennies added to the jar each day). They also study relationships in which the value of one variable cannot be determined based on the value of the other (such as the relationship between temperature and time in Grade 3 and between plant growth and time in Grade 4). In Grades 4 and 5, they also encounter situations in which the relationship between the two variables can be determined, but the change is not occurring at a constant rate, for example, a Penny Jar in which the number of pennies doubles each day.

Students work extensively with ways of representing relationships between two variables: with words, with tables and graphs, with numbers, and (starting in Grade 4) with symbolic notation. These units reinforce and connect with work in other units on multiplication, ratio, area, volume, and graphing. The Algebra Connections essay in each of the patterns, functions, and change units provides more detailed information about this sequence of students' work and how it connects to algebra.

Examples of ideas investigated in these units in Grades 3–5 (in addition to some of those in the K–2 list that continue to be studied in new contexts) are as follows:

- Line graphs are a representation that can show the relationship between two variables. A line graph represents both individual values of the variable and the rate of change of one variable in relation to another.

- In a situation with a constant rate of change, the value of one variable can be determined, given the value of the other.

- The relationship between two variables in a situation with a constant rate of change can be described in words and with symbolic notation.

- In some situations, the rate of change is determined but not constant. In these situations, the rate of change may be, for example, increasing by a constant amount.

Early Algebra Is Fundamental

Underlying the work in early algebra are, according to one of the *Investigations'* mathematician advisors, "foundational principles"—principles that connect elementary students' work in arithmetic to later work in algebra. For example, when second graders consider how changing the order of numbers in an addition or subtraction problem affects the sum or difference, they can engage in reasoning about foundational ideas, in this case, that addition is commutative, but subtraction is not: $a + b = b + a$, but $c - d \neq d - c$. Even though they may not yet have the experience with negative numbers to allow them to completely make sense of $14 - 26$, they see, through modeling and representing this problem, that it does not have the same difference as $26 - 14$. In later years, they will come to see that there *is* a regularity here, that if $c - d = a$, then $d - c = -a$, or $c - d = -(d - c)$.

Similarly, when fifth graders develop representations to show why halving one factor in a multiplication problem and doubling the other results in the same product, they are applying knowledge of foundational properties of multiplication and division. In later years, they may explain the more general claim that dividing one factor by any number (except 0) and multiplying the other factor by the same number maintains the same product by reference to the associative property of multiplication and to multiplication by 1—the identity element for multiplication. Through a series of steps, based on these properties of multiplication, one can show that, if a, b, and n are numbers $(n \neq 0)$, then $a \times b = a \times b \times \frac{n}{n} = (a \times n) \times \left(\frac{b}{n}\right)$.

For most adults, notation such as the use of variables, operations, and equal signs is the chief identifying feature of algebra. Although students use symbolic notation in Grades 4 and 5, the notation is not the focus of activity in Grades K–5. Underlying the notation are ways of reasoning about how the operations work. This *reasoning* about how numbers can be put together and taken apart under different operations or about relationships between two changing quantities, *not* the notation, is the central work of elementary students in algebra.

Algebra for All Students

Work in early algebra in the elementary classroom has the potential of enhancing the learning of *all* students. The teachers with whom the *Investigations* team collaborated during the development of the curriculum commented on this potential in their classrooms. Teacher collaborators reported that students who tend to have difficulty in mathematics become stronger mathematical thinkers through this work. As one teacher wrote, "When I began to work on generalizations with my students, I noticed a shift in my less capable learners. Things seemed more accessible to them." When the generalizations are made explicit—through language and representations used to justify them—they become accessible to more students and can become the foundation for greater computational fluency. Furthermore, the disposition to create a representation when a mathematical question arises supports students in reasoning through their confusions.

At the same time, students who generally outperform their peers in mathematics find this content challenging and stimulating. The study of numbers and operations extends beyond efficient computation to the excitement of making and proving conjectures about mathematical relationships that apply to an infinite class of numbers. A teacher explained, "Students develop a habit of mind of looking beyond the activity to search for something more, some broader mathematical context to fit the experience into."

Early algebra is not an add-on. The foundations of algebra arise naturally throughout students' work with numbers, operations, and patterns and by using familiar and accessible contexts to investigate how one set of values changes in relation to another. This work anchors students' concepts of the operations and underlies greater computational flexibility.

Discussing Mathematical Ideas

Throughout the *Investigations* curriculum, whole-class discussion is a key aspect of students' mathematical activity. Class discussion provides a time for students to

- articulate their mathematical ideas.

- share different approaches to solving a problem.

- identify and investigate what they don't understand.

- analyze why a solution works or how it is flawed.

- pose conjectures and identify evidence to support them.

- collaborate to build ideas or solve problems.

- develop mathematical language.

- use representations to describe mathematical relationships.

- compare and connect students' various ideas, representations, and solutions.

- learn to consider and question each other's ideas.

By carefully selecting problems, representations, and solutions for the whole class to consider, the teacher focuses discussion on key mathematical ideas and works with the class as a whole to move students' thinking forward.

Building a Mathematical Community

In the first weeks of school, teachers help the class develop norms for classroom discussion and work with students on attitudes and behavior that will support productive math discussions. Most teachers find that they need to work quite explicitly with students throughout the school year to first establish and then maintain expectations for class discussion. During discussions, teachers keep the flow of ideas organized and remind students about the appropriate focus. For example, "Right now I want comments that are either agreeing with, disagreeing with, or commenting on Yolanda's idea," or "So we now have three different approaches to this problem on the board. Is there a way in which Jill's is similar

to Corey's?" Teachers also find opportunities to comment directly on student actions, behavior, and contributions that support productive discourse:

> Because Stephen was willing to talk through what was confusing him when he got an answer that he knew wasn't right, it seemed to really help all of us understand this kind of problem better.

> When Kamala put up her picture of the problem, I heard some of you say, "Ooh!" What was it you understood when you saw that picture? Did anyone else have a picture or a diagram that helped you understand how to solve this problem?

And from time to time teachers discuss directly with the class what aspects of class discussions have been helping or hindering students' participation:

> What helps you be willing to share your work or make an observation during class discussion? Are there times you don't feel comfortable speaking? Why is that?

Building an inclusive mathematics classroom involves a focus on respect for student ideas and acceptance of differences. Working on establishing this community with students will vary across grades and even from one year to another, depending on the needs and experiences of your students. (See the section "Setting Up the Mathematical Community" in Part 7, Working with the Range of Learners: Classroom Cases for some teachers' thoughts on building the classroom mathematics community.)

Focusing Class Discussions

Students' ideas are important and are, in fact, central to discussion. But if a discussion bounces among too many different ideas or tries to include too many different approaches, the discussion becomes ungrounded and hard for students to follow. Simply listing one problem-solving approach after another doesn't engage students beyond the few moments when they are contributing their own idea.

The Math Focus Points for Discussion and sample teacher dialogue found in the text for every discussion will help you guide the discussion. In preparing for class, ask yourself:

- What do I want this discussion to accomplish?

- What do I want all students to take away from this discussion?

- How will the time spent as a whole class enhance the work students have done individually or in pairs or groups?

During work that precedes the discussion, observe students' work with the upcoming discussion in mind. Ask yourself:

- What is a difficulty that many students are having?

- What is a problem that many students are struggling with?

- Is there a question that one pair or group came up with that it would be fruitful for the whole class to discuss?

- What are the basic approaches to solving this problem that students are using?

- Which students or groups have ideas or approaches that should be shared?

Student Participation

Whole-class discussion time is precious class time; it should serve to consolidate or move ahead the math thinking of all students. Find ways during discussions to elicit responses from different students. Although all students may not participate in any one discussion, all of your students' voices should be heard over the course of several discussions. There are many ways to work with students to encourage them to participate. For example, listen carefully to students' ideas and look carefully at their work during activities. Help particular students prepare to share one of their ideas. At first, some students might be more comfortable if you put their solution, representation, or idea on the board or a

transparency and present it to the class yourself; alternatively, the student might explain a certain part of the solution, while you add to the student's explanation.

Think of ways to invite all students' participation during each discussion by asking students to raise hands if they used the same approach or if they agree or disagree with a statement you or another student makes. Pose a question and have students discuss it for a few minutes in pairs before having the whole class consider it. Use wait time judiciously and think about ways that students can use quiet signals when they are ready to respond (e.g., thumbs up rather than hands waving); then students who are still thinking are not distracted.

Ideas are bound to come up that you cannot pursue during class discussions. Sometimes you cannot follow or decipher a student's idea at the moment or you are not sure about how it relates to what is being discussed. If you don't understand what a student is saying, you might ask another student to interpret or talk to the student later. Don't be afraid to let students know that you have to think about something and get back to them or follow up with them after the discussion. You can always bring an idea back to the class later if you decide it would be important for the class to think about it.

You can find other ways to follow up on a student's idea that is not central or accessible for the whole class: "I was thinking about your idea, and here's a problem I thought you could try it on." Some teachers have a "parking lot" poster for ideas that come up during class but they don't have time to pursue. These ideas may come up again later or can be referred to when they become relevant. The better you know the curriculum, the more you will know when they might come up.

Setting Up the Classroom for Discussion

It is critical that students are sitting in such a way that everyone is focused on the discussion and everyone can hear. If there are representations that students need to see during the discussions, they must be large enough and dark enough so that everyone can see them.

A variety of seating arrangements for class discussions can work, as long as there are clear expectations connected to them. In some classrooms, students gather on a rug for the class meeting and then return to their places or choose places for work time. In other classrooms, students often stay at their own desks for meetings. Some teachers vary the setting, with students staying at their desks when the meeting will be short and gathering together when a longer time is needed.

To facilitate a smooth transition to meeting on the rug, some teachers assign students places to sit on the rug, changing them every month or so. Others place circles, mats, or white boards to clearly mark the places available for students to sit. Others allow students to sit wherever they want in a circle as long as they can see the teacher and all of the other students. They might remind students to make a good choice about sitting in a position and next to classmates that enables them to focus on the discussion. While some students can pay attention while sitting on the floor, others do better in a chair.

Guidelines for Whole-Class Discussions

In summary, here are some guidelines to keep in mind for your class's whole-group discussions:

- Set up norms and review them frequently; point out examples in which they are working.

- Plan a clear purpose and focus for each discussion, based on the listed Focus Points.

- Use wait time to give students time to think.

- Ask students to use quiet student signals to indicate they are ready to respond.

- Prepare with some students ahead of time to participate in the discussion.

- Have clear visuals that everyone can see and refer to.

- Establish a routine arrangement that ensures that everyone can hear and see.

- Select only a few students to share solutions.

When all students come to a discussion prepared to listen actively and to contribute ideas, the class discussions provide an important forum in which they can articulate, represent, connect, and consolidate the mathematical ideas they have been working on.

Racial and Linguistic Diversity in the Classroom: What Does Equity Mean in Today's Math Classroom?

... we have no patterns for relating across our human differences as equals. As a result, those differences have been misnamed and misused in the service of separation and confusion.[1]

Audre Lorde

We must not, in trying to think about how we can make a big difference, ignore the small daily differences we can make which, over time, add up to big differences that we often cannot foresee.[2]

Marian Wright Edelman

U.S. public schools are responsible for educating students who are more racially and linguistically diverse than at any other time in our history. The beginning of the 21st century in the United States is marked by an influx of immigrants, and schools and teachers are at the front door meeting these students. Hence, many teachers work in classrooms with increasing numbers of immigrant students, students of color, and linguistically diverse students who often face unique challenges related to language proficiency, cultural and social adaptation, and poverty. What are the issues and challenges for teachers in these diverse classrooms?

While developing this curriculum, the *Investigations* staff and field-test teachers worked together to continue educating ourselves about this question. Many of us have had direct experience teaching in schools where students come from diverse racial, cultural, and linguistic backgrounds. In many cases, the students' culture, race, ethnicity, and first language are different from those of the teacher. This Teacher Note provides a glimpse into the complex issues about racial, cultural, and linguistic diversity being discussed in the field of education today. It also provides resources for further reading, including those we found helpful in our own professional development.

Equity in the Mathematics Classroom

Equity does not mean that every student should receive identical instruction; instead, it demands that reasonable and appropriate accommodations be made as needed to promote access and attainment for all students. (NCTM, 2000, p. 11)

Investigations was developed with the assumption that all learners can engage in challenging and substantive mathematics. Assumptions about students' capacity and inclination to learn in school can undermine their access to and participation in significant mathematics learning. An extensive body of literature documents the persistence of these assumptions and their effects on students' opportunity to learn. For example, students of color and those whose first language is not English are often seen in terms of what they lack instead of what they bring to the learning environment (termed in the literature a *deficit thinking* model). Student underperformance in school may be explained by student and family shortcomings, behavior that does not match a particular set of norms, immaturity, or lack of intelligence. Students who do not speak fluent English may be judged as having poor or underdeveloped conceptual understanding because they cannot yet express the complexity of their thinking in English. Misunderstanding cultural differences can lead schools to inappropriately place children into special education and low-ability groups and to expect less from them than from other children. For instance, Entwistle and Alexander (1989) report that poor black children are often described as less mature, and, consequently, school personnel may hold lower expectations for them than for children whose socioeconomic status is higher.

[1] From a paper delivered at the Copeland Colloquium, Amherst College, in April, 1980. The paper was entitled, "Age, Race, Class, and Sex: Women Redefining Difference."

[2] Marian Wright Edelman, "Families in Peril: An Agenda for Social Change," The W. E. B. Du Bois Lectures (Cambridge, Mass.: Harvard University Press, 1987), p. 107.

Many teachers are working hard to improve learning opportunities for these students, with the goal of enhancing both the learning climate and students' educational performance. In this work, teachers must consider the broader issues as well as practices, procedures, strategies, and other key aspects of schooling. In an educational setting, equity indicates a state in which all children—students of color and white students, males and females, successful students and those who have fallen behind, and students who have been denied access in the past—have equal opportunities to learn, participate in challenging programs, and have equal access to the services they need to benefit from that education. Equity has sometimes been oversimplified to mean that all students should be treated the same—neutrally and without differentiation. Rather, differences matter, and matter in specific ways. Successful learning experiences depend on teachers building on the contributions of all students and recognizing the differences that matter to them.

In the mathematics education literature, researchers from four projects, three in the United States and one in South Africa, looked across their projects to identify features of classrooms "essential for supporting students' understanding" in mathematics (Hiebert et al., 1997). They organize these in five dimensions, one of which is "equity and accessibility." The authors describe this dimension as fundamental:

> [E]quity . . . is not an add-on or an optional dimension. It is an integral part of a system of instruction that sets students' understanding of mathematics as the goal. Without equity, the other dimensions are restricted and the system does not function well. (p. 12)

Race and Linguistic Diversity

While teaching a seminar on race in education several years ago, one of the authors of this essay was met with a remarkable silence and little open discussion of race, racism, and the ways they come up in classroom teaching. Some think that racism is no longer an issue in schools, and that "color blindness" is the way to approach a diverse class of students. However, many in the field believe that explicit classroom attention to race, ethnicity, and home language results in increased communication and learning.

Race (or ethnicity) can have overlapping and coexisting categories of meaning. Sometimes, race signifies being economically, socially, politically, and educationally oppressed. Other times it signifies a sense of community and belonging, involving valuable associations with a particular group, history, cultural codes, and sensibilities. Race conveys multiple meanings, and racism takes on multiple forms, subject to context and situation. Whether expressed subtly or with crude directness, the effects of racism are felt in everyday school experience. Preconceptions about who students are, which are based on surface behaviors, can mask important potential.

For example, in one classroom, a Hmong girl is quiet, well behaved, and does little to demand attention. But although she is well behaved, she is not engaged and does not quite know what's going on in the lesson. In another classroom, a young black boy is distracted and disruptive, eager to contribute, but often "in trouble." The Hmong girl might be seen as a model student—quiet, hard working, high achieving, and nonchallenging of classroom norms. In contrast, the black boy might be seen as loud, threatening, noncompliant, dysfunctional, and low achieving. The characterization of the Hmong girl seems positive, even flattering, in comparison to the characterization of the black boy. However, both views may be silencing the voices, needs, and potential contributions of these children in different ways. For the Hmong girl, a focus on seemingly compliant behavior may lead the teacher to ignore her educational needs. For the black boy, a focus on seemingly bad behavior may distract the teacher from recognizing his educational strengths.

To understand all students' experiences—to support them in rigorous learning and to respect the variety of their language practices, histories, and identities—educators must continue to learn about the issues of race and racism, cultural and linguistic diversity, and teaching practices and strategies that support the learning of all students.

Teaching Practices and Strategies

Many important insights about teaching practices and strategies that support students of color and English language learners can be gleaned from those who have been studying and writing in the field. Some of these educators and researchers focus specifically on the mathematics classroom, but there are also accounts from science and literacy that have a great deal to offer the teaching of mathematics.

Gloria Ladson-Billings studied exemplary teachers of African-American students and has written about an approach of "culturally relevant teaching." Although the teachers she studied differed in the way they structured their classrooms—some appeared more "traditional," while others were more "progressive" in their teaching strategies—their conceptions of and beliefs about teaching and learning had many commonalities. Here is a subset of characteristics of these teachers adapted from Ladson-Billings' list (1995). These teachers:

- believed that all students are capable of academic success.

- saw their pedagogy as always in process.

- developed a community of learners.

- encouraged students to learn collaboratively and be responsible for each other.

- believed that knowledge is shared, recycled, and constructed.

- believed they themselves must be passionate about learning.

- believed they must scaffold, or build bridges, to facilitate learning.

- believed assessment must be multifaceted.

Overall, these teachers supported their students and held them to high standards:

> Students were not permitted to choose failure in their classrooms. They cajoled, nagged, pestered, and bribed

the students to work at high intellectual levels. Absent from their discourse was the "language of lacking." . . . Instead, teachers talked about their own shortcomings and limitations and ways they needed to change to ensure student success. (p. 479)

Critical to teaching students who bring a variety of cultural, social, and linguistic experience into the classroom is what Marilyn Cochran-Smith (1995b) calls "understanding children's understanding":

> [C]entral to learning to teach in a culturally and linguistically diverse society is understanding children's understanding or exploring what it means to know a child, to consider his or her background, behaviors, and interactions with others, and to try to do what Duckworth calls "give reason" to the ways the child constructs meanings and interpretations, drawing on experiences and knowledge developed both inside and outside the classroom. (p. 511)

Eleanor Duckworth, whom Cochran-Smith cites above, may have originated the phrase *understanding children's understanding* in her essay of the same name (1996). In that essay, she discusses the idea of "giving children reason" as she describes a group of teachers in a study group who set themselves this challenge: "[E]very time a child did or said something whose meaning was not immediately obvious . . . [they] sought to understand the way in which . . . [it] could be construed to make sense" (pp. 86–87).

This work of hearing and understanding students' ideas, discourse, and representations and involving all of them in significant intellectual work can be especially challenging when students come from backgrounds quite different from the teacher's own. Cindy Ballenger's *Teaching Other People's Children* (1999) and Vivian Paley's *White Teacher* (1989) provide first-person accounts of teachers who are actively examining their own preconceptions about the behavior and discourse of the students they teach. Ballenger expresses how her initial belief that all students could learn was not enough:

I began with these children expecting deficits, not because I believed they or their background was deficient—I was definitely against such a view—but because I did not know how to see their strengths . . . I came to see . . . strengths . . . that are part of an intellectual tradition, not always a schooled tradition, but an intellectual one nonetheless, and one that, therefore, had a great deal to say to teaching and learning. (p. 3)

Ballenger recounts her journey in learning to listen to the sense of her students, both "honoring the child's home discourse" and engaging the student in "school-based and discipline-based ways of talking, acting, and knowing" (p. 6).

Working in English with students whose first language is not English presents two challenges to teachers who do not share the student's first language: (1) how to learn about, respect, and support the discourse practices that students can contribute from their own knowledge and communities; and (2) how to bring students into the language of the discipline of mathematics in English. Judit Moschkovich (1999) identifies two critical functions of mathematical discussions for English language learners: "uncovering the mathematical content in student contributions and bringing different ways of talking and points of view into contact" (p. 11). She identifies several important instructional strategies that support these students' participation in math discussions (p. 11):

- using several expressions for the same concept

- using gestures and objects to clarify meaning

- accepting and building on student responses

- revoicing student statements with more technical terms

- focusing not only on vocabulary development but also on mathematical content and argumentation practices

Josiane Hudicourt-Barnes (2003) writes about the participation of students whose home language is Haitian Creole. Her research highlights the way that understanding the forms of discourse students contribute from their own culture enables teachers to uncover and appreciate how students are making sense of subject matter. Although she writes about science learning, her observations are applicable to the mathematics classroom: "To be 'responsive to the children and responsible to the subject matter' (Ball, 1997, p. 776), we must be able to hear children's diverse voices and create opportunities for them to pursue their ideas and questions (p. 17)." Further, she argues that classroom discourse that follows a rigid, restrictive format "may mean that children from families of non-Western traditions are shut out of classroom participation and that skills from other traditions are devalued and subtracted from children's cognitive repertoires, and therefore also made unavailable to their fellow students" (p. 17).

Being "responsive to the children and responsive to the subject matter" is highlighted by many of the writers in this field. They emphasize that the teacher's responsibility is *both* to the students' ideas, sense making, and forms of discourse *and* to bringing these students in to the ideas, vocabulary, and ways of working in the discipline of the content area. Gloria Ladson-Billings (2002) sums up her observations of a teacher whose urban, largely African American, students, initially hated writing:

To meet the academic goals he had set, Carter had to rethink his practice in some fundamental ways. . . . He had to keep a sense of uncertainty and a willingness to question in the forefront of his teaching. . . . while Carter empathized with the students' struggle to write he understood that his job was to teach them to do it. He didn't put them down for not enjoying writing or writing well, but he also did not let them off the hook. He had to help them appreciate the power and fulfillment of writing and he had to preserve each student's sense of self. (p. 118)

Continuing to Learn

Continuing to learn is something we all can do. This Teacher Note attempts only to introduce you to some authors and resources who can contribute to that learning. Many of the resources cited here include rich examples from classrooms that can evoke productive interaction when read and discussed with peers. You may have opportunities to take advantage of courses, seminars, or study groups, such as the one that Lawrence and Tatum (1997) describe, or to self-organize peer discussions of articles in the field.

Teachers can also pose their own questions and study their own classrooms. Writing brief case studies in which you raise your own questions about these issues in your teaching and then sharing your writing can be a rich source of learning. You might start by reading what other teachers have written about their own practice as they reflect on their teaching of diverse students. For example, in *What's Happening in Math Class?* (Schifter, 1996), Alissa Sheinbach writes about three students who are struggling in mathematics (vol. 1, pp. 115–129), Allen Gagnon writes about his Spanish-speaking students (vol. 1, pp. 129–136), and Nora Toney recounts her own experiences with racism as a student (when she was bused into a largely white school) and later as a teacher herself (vol. 2, pp. 26–36). After describing some successful experiences in mathematics she had as an adult that contrasted with her experience in the "low group" as a student, Toney concludes by identifying factors that have been important to her own learning:

> I have discovered the ingredients necessary for me to learn and achieve success: high teacher expectation, fairness, inclusiveness, engaging contextual material, constant monitoring and feedback, discussions/debates, and reflective writing. Generally speaking, I need numerous opportunities to connect my thinking and ideas to new concepts and ideas. These factors facilitated my *learning* of mathematics, so now I am trying to incorporate these same factors into *teaching* mathematics. (p. 36)

References and Additional Readings

Ball, D. (1997). What do students know? Facing challenges of distance, context, and desire in trying to hear children. In T. Biddle, T. Good, & I. Goodson (Eds.), *International handbook on teachers and teaching* (pp. 769–817). Dordrecht, Netherlands: Kluwer Press.

Ballenger, C. (1999). *Teaching other people's children: Literacy and learning in a bilingual classroom.* New York: Teachers College Press.

Cochran-Smith, M. (1995a). Uncertain allies: Understanding the boundaries of race and teaching. *Harvard Educational Review, 63,* 541–570.

Cochran-Smith, M. (1995b). Color blindness and basket making are not the answers: Confronting the dilemmas of race, culture, and language diversity in teacher education. *American Educational Research Journal, 32,* 493–522.

Duckworth, E. (1996). *"The having of wonderful ideas" and other essays on teaching and learning.* New York: Teachers College Press.

Entwistle, D., and Alexander, K. (1989). Early schooling as a "critical period" phenomenon. In K. Namboodiri & R. Corwin (Eds.), *Research in Sociology of Education and Socialization,* Volume 8, (pp. 27–55) Greenwich, CT: Jai Press.

Heath, S. B. (1983). *Ways with words: Language, life, and work in communities and classrooms.* New York: Cambridge University Press.

Hiebert, J., Carpenter, T. P., Fennema, E., Fuson, K. C., Wearne, D., Murray, H., et al. (1997). *Making sense: Teaching and learning mathematics with understanding.* Portsmouth, NH: Heinemann.

Hudicourt-Barnes, J. (2003). The use of argumentation in Haitian Creole science classrooms. *Harvard Educational Review, 73*(1), 73–93.

King, J. (1991). Dysconscious racism: Ideology, identity, and the miseducation of teachers. *The Journal of Negro Education, 60,* 133–146.

Ladson-Billings, G. (1994). *The dreamkeepers: Successful teaching for African American students.* San Francisco: Jossey-Bass.

Ladson-Billings, G. (1995). Toward a theory of culturally relevant pedagogy. *American Educational Research Journal, 32,* 465–491.

Ladson-Billings, G. (2002). I ain't writin' nuttin': Permission to fail and demands to succeed in urban classrooms. In L. Delpit & J. K. Dowdy (Eds.), *The skin that we speak: Thoughts on language and culture in the classroom* (pp. 107–120). New York: The New Press.

Lawrence, S. M., & Tatum, B. D. (1997). White educators as allies: Moving from awareness to action. In M. Fine, L. Weis, L. C. Powell, & L. M. Wong (Eds.), *Off white: Readings on race, power, and society* (pp. 333–342). New York: Routledge.

Lewis, A. (2003). *Race in the schoolyard: Negotiating the color line in classrooms and communities.* New Brunswick, New Jersey and London: Rutgers University Press.

Moschkovich, J. (1999). Supporting the participation of English language learners in mathematical discussions. *For the Learning of Mathematics, 19*(1), 11–19.

National Council of Teachers of Mathematics. (2000). *Principles and standards for school mathematics.* Reston, VA: Author.

Obidah, J., & Teel, K. M. (1996). The impact of race on cultural differences on the teacher/student relationship: A collaborative classroom study by an African American and Caucasian teacher research team. *Kansas Association for Supervision and Curriculum Development Record, 14,* 70–86.

Obidah, J., & Teel, K. M. (2001). *Because of the kids.* New York: Teachers College Press.

Paley, V. G. (1989). *White teacher.* Cambridge, MA: Harvard University Press.

Schifter, D. (1996). *What's happening in math class? Vol. 1: Envisioning new practices through teacher narratives ; Vol. 2: Reconstructing professional identities.* New York: Teachers College Press.

Titles of Kindergarten Teacher Notes by Unit

Working with the Range of Learners

Preview

All teachers are faced with the challenge of meeting the needs of a range of learners in their classrooms. The range of learners can include students who struggle in certain areas of mathematics, those who excel in math, students who are English Language Learners, and students who have particular learning needs.

This section contains a series of case studies written by Kindergarten teachers from urban, suburban, and rural schools, telling how they implemented the *Investigations* program in their classrooms. The students in these classrooms vary on many dimensions, including gender, language, culture and ethnicity, and special needs. They present a range of strengths and needs in their prior experience with mathematics and their confidence in the classroom.

Through their writing, these teachers bring us into their classrooms and invite us to participate in how they think about supporting their range of learners. As they captured moments in time in their classrooms, the teachers did not intend to provide exemplary actions to be emulated or a how-to manual of what to do for particular students or with particular activities. Rather, they offer the kind of thinking teachers do as a matter of course in their teaching. Through the hundreds of interactions they have with their students each day, teachers try to understand what those students bring to their learning and how to support them in moving further. In these case studies, they share some of that thinking.

We collected these cases together in this book, rather than including them with the curriculum units, because they are not designed to illustrate "how to do" a particular activity. Rather, as a group, they provide examples and questions to inspire your own questioning and reflection. You may want to use this set of cases on your own or discuss them with a group of colleagues.

Keep in mind that each case provides only a glimpse into a teacher's classroom. Just as you would not expect anyone to understand the complexity of the issues you face in your own classroom from such a brief glimpse, the cases cannot provide all the background information you might need to understand a particular teacher's decision with a particular student on a particular day. But you do not need to know more detail to use these cases for your own professional development. Use them as starting points when considering similar issues that you face with your students. The questions at the end of each case provide a starting point for discussion. If you discuss these cases with colleagues in a cross-grade group, you will have even more examples to consider by combining the sets of cases from two or more grades.

The classroom cases are grouped into three themes, focusing on some of the most important issues teachers face as they work to meet the needs of their students. In the first section, "Setting Up the Mathematical Community," teachers write about how they create a supportive and productive learning environment in their classrooms. In the second section, "Accommodations for Learning," teachers focus on specific modifications they make to meet the needs of some of their learners. Because these teachers chose to write about particular students in their classrooms, the cases do not cover all the kinds of needs and accommodations you might encounter. However, even though the specific students discussed may differ from students in your own classroom, these teachers consistently found that accommodations they had made for one student often spilled over to benefit other students with related needs. In the last section, "Language and Representation," teachers share how they help students use representations and develop language to investigate and express mathematical ideas.

There is, of course, much overlap. Some cases illustrate ideas that could fall into more than one of these sections. You will find ideas from one section cropping up in the cases in other sections. For example, when teachers develop accommodations for learning, they are often using mathematical representations or helping students connect their language to the mathematical ideas.

Note: Pseudonyms have been used for all student and teacher names.

Summary of Cases

Setting Up the Mathematical Community

Getting Started: Using the *Calendar* Routine to Develop a Math Community

Michelle Rutherford uses the *Calendar* routine as one occasion for her students to learn about how to participate in a mathematical community.

Supporting Student Participation in Discussions

Carolejo Li works with her students to create a mathematical community in which students are able to share ideas and learn from each other.

Accommodations for Learning

Linus: The Journey Begins

This is the first of three cases that follow Linus, a student in Samantha MacDonald's class, on his journey to adjust both academically and socially to Kindergarten.

Linus: Building Numbers Greater Than 4

Samantha MacDonald designs a game to help Linus and other students in her class model quantities represented by written numerals.

It's Like a Cheer: Linus's Journey Continues

In the last case in the series, Linus's growth is evident as he makes a contribution to a mathematical discussion about patterns.

Change It: How Students Adapt Activities

Samantha MacDonald finds that an accommodation made for one student meets the needs of her range of learners in unexpected ways.

How Many Students Are in Our Class?

Meghan Mallon shares a data activity that meets the needs of all her learners while providing an extra challenge for some of her students.

Language and Representation

Sharing Marbles: Representing and Solving a Division Problem

The students in Susan Sharrow's class use the mathematical skills they have developed over the year to represent and solve a new type of problem.

Reflections on *Collect 10 Together*

Through reflection and redirection, Meghan Mallon makes the goals of *Collect 10 Together* more explicit for herself and her students.

"Heptagons" and Twins

Samantha MacDonald finds that the ideas in the geometry unit are accessible to all of her learners.

The Red One Doesn't Have a Match: A Counting Jar Discussion

Michelle Rutherford creates an experience that stretches her students to think about odd numbers.

How Do You Draw the Ones That Are Gone? Showing the Action of a Subtraction Problem

A few of Susan Sharrow's students create a visual representation of a subtraction story problem and share their ideas with the class.

Helping Students Build on Each Other's Ideas

Meghan Mallon encourages her students to experiment with the mathematical ideas raised by two of their classmates.

Setting Up the Mathematical Community

Getting Started: Using the *Calendar* Routine to Develop a Math Community

Creating a classroom culture that allows students to share ideas, listen to, and learn from each other takes a great deal of thought and work on the part of the teacher. These skills and practices develop over time. The first month of school is when teachers begin to establish the classroom atmosphere that they would like to see unfold throughout the year. In this case, Michelle Rutherford reflects on her thoughts at the beginning of the school year.

There is much on my mind each September as the school bell rings for the first time, when a new set of 5- and 6-year-olds gathers in front of me on their first day of Kindergarten. I wonder, "Who are these students? What new adventures await us? Will I be able to excite their imaginations and their quest for knowledge and independence? How will I meet their needs socially, academically, and cognitively? What will be our successes this year? What will be our biggest challenge?" As I take a deep breath and begin my greeting, one thing is for sure, I have felt these feelings before; no matter how long I have been a Kindergarten teacher, I know the days ahead will be full of bursts of successes, some frustrations, and enlightenment for both myself and my students.

From our initial conversations in using the calendar and in taking attendance, I can tell that this group of students is eager to share what they know about numbers. The calendar is a focal point in the Kindergarten classroom, as many of my students are already familiar with it from their work in preschool. Students chime right in as I sing our days of the week song and are bursting at the seams to tell me what number they think is showing on the calendar for today. I feel like I have barely taken hold of the reins, and we are off and running at full speed. When I ask the students what they notice about the calendar, many seem energized by the question. Some are shouting out answers, others are eagerly waving their hands in the air, while still others seem silenced by all the commotion.

Jackie says aloud, "I see a 6." I also hear Evan, "I have a calendar at my house. My birthday is in October. I am going to be 6." At the same time Sandy turns to Janice, "I had fun at your birthday party." The conversation is spontaneous, but I fear it may get away from us. Talk of birthdays can do this in a Kindergarten. While these vocal students are chiming in with enthusiasm, I see Carl, Will, Pat, and Debbie sitting more removed from the group. At the same time, Mike's body is in constant motion, and Sharon looks like she may cry. I know that she already misses her family. How do all these students feel in this new place? Do they seem removed, anxious, or scared because they are unsure of what is expected? Is this an indication of their overall disposition to learning? It is so important to make room for all learners from the very first day.

I want so much to capture the natural curiosity and tap into the mathematical instincts of these Kindergartners. At the same time, my goal is to set the expectation that everyone has a role in these discussions and to develop a sense of responsibility toward self and others. These students seem so alive while talking about numbers and the calendar. All at once I want to know everything they know and think about numbers, but then I realize we have only been in school 15 minutes. How can I harness this positive energy, while making room for those students whom I can tell are already overwhelmed by this level of intensity around learning? One thing I know for sure: I need to quickly and consistently establish some expectations for who we are as a class, for learning and sharing, and for listening and speaking. I also know that our daily routines are opportunities to work on these expectations.

I use the *Calendar* routine as a time to focus on helping students build relationships with each other and engage in mathematics thinking and learning. Working as a whole class on the *Calendar* routine allows the tension that some students feel to come to the surface very quickly so that we can recognize it and begin to deal with it. I model how the routine works the first three days; then I select one helper per day to facilitate the routine for the class. Each day the helper leads the class in our days of the week song and then

determines which number comes next on the calendar as a way of determining the date.

By having one helper per day, the students come to anticipate that they will each get a turn and to recognize that they are expected to participate. The verbally precocious students learn to share the stage. The more reserved students learn that they are expected to take a turn, and that I am there, along with their classmates, to support them if they are hesitant, uncertain, or confused. Over time, the familiarity of the routine helps to ease the minds of those who are anxious.

Working with students on the *Calendar* routine seems so simple, but it is an important first step for setting a tone of inclusion, respect, and responsibility. The kinds of conversations that begin with our focus on the calendar also help my students learn that we will be talking a lot about numbers and math concepts in this class.

Michelle Rutherford uses the daily Calendar *routine as a time to model her expectations for what participating in a mathematics community will entail, both mathematically and socially. By doing so, she helps her students develop the skills they will need to become mathematically powerful thinkers who are able to listen to the ideas of others and to explain their own strategies and ideas.*

Questions for Discussion

1. **As Ms. Rutherford observes her students' participation in the *Calendar* routine, what concerns does she express about the range of learners in her classroom? What specific skills does she believe all students will need to grow together as a mathematics community? How does she use this routine to help all students develop these skills?**

2. **What specific activities do you focus on at the beginning of the year to model your expectations for the type of community you wish to establish in your classroom?**

Supporting Student Participation in Discussions

To create a classroom community in which learners are able to communicate effectively with each other, teachers must support their students' participation in mathematical discussions. Educational researchers in mathematics suggest that teachers enhance meaningful participation in mathematical discussions by

- *encouraging student conjectures.*

- *asking for explanations and evidence from students.*

- *focusing on the process of problem solving and the reasoning behind it.*

- *providing students with opportunities to compare methods, solutions, and explanations.*

- *engaging students in developing arguments to support their mathematical statements.*

- *asking students to paraphrase each other's statements and structuring activities so that students seek to understand each other's methods.*

Carolejo Li, a Kindergarten teacher, begins the year with many of these ideas in mind. Here she describes her efforts to create a mathematical community in which all learners participate and are able to listen to and build on each other's ideas.

Creating a math community in a Kindergarten classroom is challenging yet rewarding. One strategy I use in my classroom is to develop a discussion format that allows me to include and validate all of my students' ideas. I see these discussions as essential for bringing out the mathematics in the *Investigations* activities. I also see them as essential in helping students learn how to communicate their own mathematical thinking. This communication piece is a big part of helping my students see themselves as mathematicians and a big part of helping our class become a community of mathematicians.

One of my first conversations every year is about counting. Every morning we count the students in our class to determine how many students came to school that day. At the beginning of the year, there are always some students who don't apply one-to-one correspondence yet. Also, some students can count accurately when they are doing the counting, but when they observe another student who does not use one-to-one correspondence, they don't quite see where the inaccuracy comes from.

One year I decided to have a conversation about counting. I started with a simple question, "What is counting?" I really wasn't sure what I would get in response, but I decided to try it and hoped I would be able to shape the conversation into something valuable for everyone. Over the years I have restructured this discussion and now it goes something like this: I count the students that day as usual, but I do it wrong (usually without one-to-one correspondence). The students all react quite strongly. Then I let them describe what I am doing (they love to do that) and what I need to do to count accurately.

Somehow this discussion ends up being one where the students don't have to raise hands and everyone listens to each other. Ideally, I would like this to happen for all of our discussions. I feel that the best conversations that we have in my classroom are the ones that just flow—no one has to raise a hand to speak and everyone listens to each other. In fact, at times my interjections are minimal.

Because counting is our first discussion of the year, I make sure anyone who wants to say something has an opportunity to do so and that every idea is validated in some way. This conversation sets the tone that one of the things we talk about in our classroom is math and that everyone has important thoughts to contribute.

Another type of mathematical discussion we have is based on the question "What do you notice?" I use this question to launch a new activity or to wrap it up. I love asking this question because there are no wrong answers, and I am often very surprised by how sophisticated my students' observations can be. Initially, I get more responses than I would with a more specific question that has a correct answer. As time

goes on, I often get almost the whole class raising hands to respond to this question. I think that my students feel safe in these discussions because they realize that their ideas are important. I try to be very careful about how I respond to their observations and do so in a nonjudgmental manner. I usually repeat or rephrase what a student offers. I often ask if anyone wants to respond to an observation. Sometimes I will just make a list of observations. Most of the time we will launch from an observation into a discussion about the observation. I believe the last of these approaches helps my students feel like their ideas are valuable. A student or a group of students offers an observation, and then we have a rich discussion centered on that observation.

I feel that creating a class of students who can share observations, share strategies, and discuss topics—all centered around math—is a process. We are always working to hone our communication skills in this manner, but in the end we look back in amazement at all the math we have learned over the year.

In this case, Ms. Li shares how she begins the process of teaching her students to participate in mathematical discussions. Her strategies include planning discussions that flow from open-ended questions and facilitating conversations that encourage student-to-student talk. Ms. Li recognizes that the art of successful mathematical discussions develops over time. As the year goes on, she continues to engage her students in mathematical conversations, giving them plenty of opportunity to practice and build on the important skills they are learning.

Questions for Discussion

1. **How does Ms. Li's use of open-ended questions like "What do you notice?" help foster a supportive environment for discussion in her classroom? What other strategies does she use to help her students develop into a community of math thinkers?**

2. **In what ways do you foster conversations in a whole-group setting? How do your strategies help all students feel they are a valued and important part of the mathematics community in your classroom?**

Accommodations for Learning

Linus: The Journey Begins

Each year teachers encounter a new group of learners with varying strengths and abilities. This makes it important for teachers to spend time at the beginning of the year closely observing their students to gain a sense of where these students are as learners. In this case, Kindergarten teacher Samantha MacDonald focuses on Linus, a student who is having a difficult time adjusting to the emotional and academic demands of Kindergarten. During the first weeks of school, Ms. MacDonald observes and interacts with Linus to learn more about what he knows and can do. This information will help her design the work she needs to do with Linus in the months to come. Here Ms. MacDonald describes Linus's behavior at the start of school.

From the first day of school, I could tell that Linus was not feeling very sure about his new class and the set of expectations that accompany coming to Kindergarten. In moments of confusion or commotion, he would find comfort in sucking his thumb. When a new task was introduced to the class, he often asked, "Will this be long?"

After watching Linus's participation in two daily math routines, Ms. MacDonald realizes that his apprehension may have to do with his limited number sense. As Linus participates in the activity Counting Around the Circle *(part of the attendance routine), she notices that he has trouble with the counting sequence beyond the number 5. She also notices that Linus calls out 18 at the end of the count, regardless of how many students are present. Here Ms. MacDonald describes his participation in another number activity*—The Counting Jar.

The *Counting Jar* activity brought up another challenge for Linus. I began the activity by placing three apples in the jar. All of my students seemed to recognize right away that there were three apples in the jar and did not find it necessary to count to confirm the total. Next, I passed out a plastic plate to each student and set out bear counters, connecting cubes, and color tiles. I asked them to use the tools I had set out to make an equivalent set of items on their plate. When they completed the task, they returned to our meeting area. With one glance around the circle, I could tell that most of my students made sense of the task and were quickly successful.

However, 4 of the 18 students had more than three items on their plates. Linus was one of them. I called the students back together to discuss the problem.

I asked the students to each explain what they did to solve this problem. When it was Linus's turn to share, he said, "I don't remember." Keeping in mind Linus's emotional tenuousness, I decided to move on. I felt tense as I tried to meet Linus's need while I simultaneously encouraged the next student to share.

Later, I asked Linus to do the *Counting Jar* activity with me individually. He was sure there were three apples in the jar. He counted them without taking the apples out of the jar. However, when it came to creating an equivalent set, he grabbed a handful of bear counters and dropped them on his plate without counting.

Teacher: How many bears do you have?

Linus: I don't know [thumb quickly moves to his mouth].

Teacher: How can you find out?

Linus: [quickly removing his thumb as he spoke] I can count.

With this, Linus began to randomly touch a bear and say the counting sequence. When he got to 10, he repeated 6, then said 7, 8, 10, 16, 4, 7, and 2. His number naming was as random as his pointing to the objects. As a signal for him to stop, I placed my hand over his. He did. Instantly his thumb went back in his mouth.

Teacher: How many bears do you have?

Linus: I don't know. Three?

Teacher: How many apples are in the jar?

Linus: Three.

Teacher: Do you have the same number of bears as apples?

Linus: No.

Teacher: Why not?

Linus: [pointing to the bears] These are more.

We stopped our conversation, and Linus went happily on to another activity with his friends. Our quick conversation had helped me to see the kinds of goals I need to put in place for Linus. Rote counting to 20 and beyond, one-to-one correspondence of a given set of objects, and establishing the purpose of counting to determine a quantity—these were all benchmark phrases that clicked through my mind to create an instructional map. The statements were clear, but what do they mean for right now and how do they help us move into the future? So many questions, and most pressing, as in every year, I wonder, how do we get from here to there with meaning and grace?

At the beginning of the year, Ms. MacDonald observes all her students carefully to assess their understanding of and facility with numbers. She assesses Linus during whole group activities, and then meets with him individually to help her understand more about his number knowledge and his approach to solving problems.

Questions for Discussion

1. What did Ms. MacDonald discover about what Linus does and does not understand about counting?

2. What goals does she have in mind for Linus in the area of counting? What could she now plan to support the development of Linus's counting skills?

3. What are ways you informally assess your students' counting skills at the beginning of the year? What experiences do you plan to help students develop these skills?

Linus: Building Numbers Greater Than 4

Two months have passed since Ms. MacDonald first wrote about Linus, a Kindergarten student who was having a hard time adjusting to the emotional and academic demands of school. Although Linus now appears to be more comfortable in school, his number concepts continue to lag far behind those of his classmates.

Ms. MacDonald has noticed that Linus has selected the game Compare *as his choice several days in a row. She observes that Linus is eager to play the game and has no trouble participating when the number on the card is less than or equal to 4. When the number on his card is greater than 4, however, Ms. MacDonald notices that Linus waits quietly until his partner supplies the correct answer. This brief session prompts Ms. MacDonald to design a new game* to encourage Linus to develop strategies for determining the quantity on the card and to push him to work with numbers higher than 4.*

After observing Linus, I realized that I needed to design a new activity to encourage more active participation from all students when playing the game *Compare*. I decided to introduce the class to a new game I developed—*Build It.* My purpose in designing this game was to take a situation that was already somewhat routine and comfortable for Linus and finesse a way to force him to attend to each number presented on the cards. I felt other students could also benefit from this modification. The focus on number recognition and establishing a quantity remained, though the focus on comparing one number to another temporarily took a back seat. In addition to the number cards that students already

*Ms. MacDonald was a field test teacher during the revision of *Investigations*. The accommodation *Build It,* which is described in this case, was successful not only with Linus but also with the range of students in Ms. MacDonald's classroom. As a result, the *Investigations* authors decided to incorporate this game into the revised curriculum. This case is an example of the power of teacher-designed accommodations and the partnership between teachers and curriculum writers in the development and use of this curriculum.

use in *Compare*, I gave students a Ten-Frame, which they would use to build the number, and chips. I chose chips because I wanted them to lay flat in the Ten-Frame to create a visual image of the number.

I gave the following directions for *Build It:*

• Player 1 turns over a card from the deck, establishes how many, and "builds" that same number on the Ten-Frame with chips.

• Both players need to agree that the number of chips matches, or is equal to, the number showing on the card.

• Once it is agreed the number was built correctly, the player ends his or her turn by removing all the chips from the Ten-Frame.

• Player 2 turns over a card and follows the same routine.

• Play continues until all the cards in the deck have been used.

As the students began to work with this new setup, I was delighted by how quickly they responded. I circled the room to see how the ideas were being established. Everyone seemed right on task. Then I turned my attention to Linus.

Linus was paired with Amy. I could tell that she was already frustrated because he would not take his turn.

Amy: Linus, you need to build the number. [Linus had turned over the first card, showing a 6.]

Linus did not respond. Was he waiting for her to turn over a second card as in the original *Compare* game? I watched for a few seconds.

Amy: Linus, take 6 chips and put them on the Ten-Frame.

Linus still did not respond. At this juncture I decided to intervene.

Teacher: Whose turn is it?

Amy: Linus won't play.

Linus: It's your turn.

Teacher: Can either of you tell me how to play this new game?

Amy: Linus needs to take 6 and put them on the Ten-Frame.

As Amy spoke, I noticed that Linus had looked away.

Teacher: Linus, let's try that. Can you take 6 chips and put them on the Ten-Frame?

Linus: Okay.

With this he counted out 6 chips and placed them in a pile on his Ten-Frame (rather than laying them flat as students were instructed to do). I could tell that Amy wanted to correct him, but I tried to interject before she could.

Teacher: How do you know there are 6?

Linus: I counted them.

Teacher: Is it easy to see that when they are all piled up?

Linus started to recount his chips.

Teacher: Can you show me another way to put them on the Ten-Frame so that it is easier to see? Can you put one chip in each box?

Linus complied. His Ten-Frame looked like this:

Amy turned over an 8 and carefully placed 8 chips on her Ten-Frame. Her Ten-Frame looked like this.

I watched as Linus turned over a 5 and placed 5 chips on his Ten-Frame. Amy then turned over a 9. As they continued to play, I was pleased to see that each student followed the routine and seemed to comprehend the concepts embedded in the game.

Two months into the school year, Linus is eager to participate in activities with which he feels comfortable. However, Ms. MacDonald's observation that he continues to hesitate when faced with new challenges results in a new activity designed to address his needs.

Questions for Discussion

1. What goals does Ms. MacDonald have in mind for Linus as he plays the new game *Build It?* How did she take into account both the mathematical ideas important for her students and the range of learning needs in her classroom?

2. After observing Linus play *Build It*, what might Ms. MacDonald's goal for Linus be for the next session of this game?

3. When you observe students struggling to understand a game, what do you take into account as you plan accommodations? Can you describe an instance in which this has happened?

It's Like a Cheer: Linus's Journey Continues

Although Ms. MacDonald's class of Kindergartners is now two weeks into the pattern unit, the work so far has been challenging for Linus. She has noticed that when Linus is asked to use cubes to make a repeating pattern, he snaps together random colors and is unable to begin a pattern on his own. She has also noticed that reading the patterns has been difficult for him. He often skips over a block or omits a section.

As this case begins, the class is discussing an AAB repeating pattern for the first time. The students seem to be comfortable with the shift from an AB pattern to an AAB pattern, except Linus who is fidgeting and looking uncomfortable.

Teacher: What comes next in this pattern?

Michelle: I think it will be yellow.

Robert: Amy said it was one color then the other color. That's this one [pointing to the AB pattern] but not this one [pointing to the AAB pattern].

I was ready to move on when Linus raised his hand.

Linus: It's like a cheer.

What did I hear? Was this the sound of Linus making a breakthrough?

Teacher: Linus, what do you mean, it's like a cheer?

Linus: It goes yellow, yellow, green [pause]; yellow, yellow, green [pause]; yellow, yellow, green [pause].

As Linus spoke, his voice was filled with gusto, and he even sat up on his knees and bounced a bit, much like a cheerleader. Did his vocalization and/or intonation help? Was it something about the rhythm? Was it a connection to something he knows more about outside of school? His mother often comments on how much he likes music.

Teacher: So by saying this part of the pattern [cupping my hands around one AAB unit], it's like a cheer you can say over and over. Does the cheer change?

Suzanne: No, but if you say yellow, green it changes. This would be a yellow, green, yellow, green cheer [pointing to the first pattern].

Needless to say, now our class often refers to the repeating unit of a pattern as a "cheer." It's taken on meaning and a life of its own. How exciting!

Ms. MacDonald noticed that the positive feedback Linus got from his classmates and from her helped to boost his confidence and seemed to spark his interest in math. Just two days after the pattern conversation, Linus was working on counting. For this activity, Ms. MacDonald placed three green bows, three gold bows, and three red bows in the counting jar. As Linus dumped out the bows, Ms. MacDonald heard him say, "Look, it's like a pattern."

Teacher: What do you mean it's *like* a pattern?

Linus: See green, red, gold; green, red, gold; green, red, gold [organizing the nine bows into an ABC pattern as he talked].

Teacher: Does this pattern have a cheer?

Linus: Yup; green, red, gold.

Teacher: Does the pattern help you figure out how many bows there are?

Linus looked up with a blank stare. Had I jumped too quickly again? I asked him how many greens he had, and he was able to quickly answer 3. Linus was able to tell me how many gold and red bows there were as well.

Teacher: So how many do you have all together?

Linus looked at me with that confused look.

Linus: It's a pattern?

Teacher: Yes, you made a pattern of green, red, gold.

Linus: That's the cheer!

Teacher: Yes, green, red, gold is the cheer. How many bows do you have in your whole pattern?

Linus: 1, 2, 3, 4, 5, 6, 7, 8, 9. Nine bows!

In this case, we see Linus, a student who up until now has held back, come forward and offer an idea that illuminates a class discussion. Contributing to the mathematical community gives Linus a much-needed boost that seems to be helping him develop the confidence to move forward with his mathematical thinking.

Questions for Discussion

1. How did Ms. MacDonald extend Linus's observation about patterns to build his understanding of numbers?

2. Ms. MacDonald could have missed an opportunity to further Linus's thinking and to bring his idea to the class. Can you think of a time when a student said something unexpected that at first glance seemed unrelated to the mathematics at hand? What did you do?

Change It: **How Students Adapt Activities**

Teachers often make accommodations to help individual learners in their classrooms. Many times teachers discover that an accommodation made for one student benefits other students in the class as well. In a previous case, Kindergarten teacher Samantha MacDonald created an accommodation to help one student (see "Linus: Building Numbers Greater Than 4"). She found that several other students benefited from more experience recognizing and representing numbers. In this case, two of her students create their own accommodation and, consequently, make even deeper mathematical connections.

After observing one of my struggling students play the game *Compare* in a way that allowed his partner to do most of the thinking, I realized that I needed to create a new game that still focused on number recognition and establishing a quantity but removed the focus on comparison. I hoped that this new game, *Build It,* would encourage more active participation from all students when they returned to the game *Compare.* Although my purpose in designing this game was to help a particular struggling student, I felt other students could also benefit from this accommodation.

As my students began to play *Build It,* alternately turning over a number card and building the quantity on a Ten-Frame, I was delighted by how quickly they responded. I circled the room to see how the ideas were being established. Everyone seemed right on task. They seemed to easily adapt to the new game.

I stopped to watch Lucy and John playing. I noticed that after John had placed 6 chips on his Ten-Frame, he did not take them off. Instead, when Lucy turned over a card, she quickly adjusted the set to make the Ten-Frame show the 3 that she was to represent. She did this by removing 3 chips. I thought I heard her say, "3 and 3 is 6." Their play continued in this same fashion for several turns.

Teacher: Tell me about how you are playing this game.

Lucy: It's easier to just change some of the chips than starting over.

John: Yeah, you just put out more or take some away.

After watching and listening, I realized that Lucy and John had modified their own game to make it "easier" and, in fact, more mathematically interesting. After one student built a number, the next student changed it in some way to show a new quantity. It was exciting to see how fluidly they either added or took away chips. I decided that I wanted to give all the students in my class an opportunity to try out this new version. At the end of the session, I asked Lucy and John to demonstrate their idea to the class.

Once the other students saw this version, we decided we could have two different games, *Build It* and *Change It.* I am eager to see which students prefer to play *Build It* and which prefer *Change It.*

Teachers sometimes fear that by adapting activities to help learners having difficulty, they might end up neglecting the needs of the more advanced students in the room. In this case, Ms. MacDonald creates an activity that allows students to work at a pace where they feel comfortable and is pleased to see some students modify her new activity in a way that creates a new challenge.

Questions for Discussion

1. Lucy and John create a new version of the game *Build It.* **What new ideas does the modified version, *Change It,* allow students to explore?**

2. **What accommodations have you or your students made to games or activities to provide support for students who need it and challenge for those ready to explore more advanced ideas?**

How Many Students Are in Our Class?

All teachers are faced with the task of meeting the needs of a diverse group of learners. In the following case, Kindergarten teacher Meghan Mallon writes about how allowing students to share their mathematical thinking provides a challenge for some of the students in her classroom.

Every year, I have a few Kindergartners whose understanding of math is broader and deeper than that of most of their peers. They make interesting observations that give some of their classmates new ideas to think about.

One such student, Andrea, came up to me during snack time one day and said, "There are 7 kids at my table, and if we count around the table 3 times, we get 21." As there are 21 students in our class, this was an exciting and noteworthy discovery. I expressed delight and asked Andrea how she came to know this. She said, "Because we did it." I have no idea what made them try this count, how it started, or what the original intent was. Not wanting to forget her great thinking, I wrote her idea on a piece of scrap paper and told her we would think about this some more later on.

The next day, we started the Kindergarten data unit. The first Investigation is about how many students are in the class and how to represent that data. I started with the acknowledgment that everyone knows we have 21 Kindergartners. Then I asked my students to consider the many ways we might check to be sure. I got a delightful range of responses, with students suggesting we count many of the objects we have in our classroom, including themselves, the names on a class list, the nametags on the cubbies, the writing folders, the self-portraits, and the cubes on our class attendance stick.

I then asked how they could show a total of 21 Kindergartners. We talked about using objects and making paper and pencil representations. Andrea very excitedly raised her hand and said, "I'm going to do that thing from the other day! I'm going to show 7 kids in one spot 3 times!" She was so happy. I had her explain her discovery to the class. Another student, Kirby,

said that he was going to do that, too. Other Kindergartners then said how they might show the total, and off they went.

Even though I have a range of learners in my classroom, every one of them was able to make some sense of the math, and almost all of them were able to successfully represent the 21 students in our class.

Most of my students made 21 of something—either stick figures, dots, lines, rubber stamps, or dot stickers. Some of their representations show each person in the classroom (names or initials, or this is so-and-so, this is me, this is . . ., etc.). Some students showed boys and girls in a generic way, and some showed the students in the boy and girl subgroups. Alex made an AB pattern of footballs for boys and hearts for girls, which (gender stereotyping aside) worked fine as there are 11 boys and 10 girls.

There were a few representations that stood out and showed some higher-level thinking. Andrea's was one of them. I noticed Andrea was finished in about 2 minutes. Her paper showed 3 distinct sets of 7 circles, with coloring around each set. She also wrote "7, 7, 7, 21." So, for Andrea, the 3 groups of 7, the 7 taken 3 times, translated comfortably from 7 students each saying or having 3 numbers, to 3 groups of 7 students.

I said, "So you knew that since 7 kids counted 3 times, 3 groups of 7 kids would be 21 kids." She nodded. I said, "So if this was your snack table (pointing to one of her groups of 7 circles), and I gave you 21 cookies to share, how many would you each get?" "Three!" "Suppose I gave you each three pencils. How many would that be?" "Twenty-one!" It seems Andrea has put something together not only about 7, 3, and 21 but also perhaps about multiplication and division more generally.

Sam stamped 7 flowers across the top of his paper and then put 3 dot stickers underneath them. He said, indicating the stickers, "This means do these [now indicating the flowers] 3 times. "Wow," I said. I then noted, not meaning to be critical, that if someone walked in and looked at his paper without him explaining it, that they might think we had 10 kids because there were 10 objects on his paper. He paused and added an "X" to mean "times" between the flowers and the dot stickers.

Walking away from the opening discussion, Kirby had said that he planned to draw 7 kids and write 3 numbers under each to show Andrea's idea. When I stopped by to see how he was doing, he showed me the following representation, dots to represent the 7 kids with 3 numbers under each dot:

● ● ● ● ● ● ●
1, 2, 3 4, 5, 6 7, 8, 9 10, 11, 12 13, 14, 15 16, 17, 18 19, 20, 21

I found that all of my students were engaged in this activity, including the ones who struggled with how to count out and make 21 dots or stick figures, those who were ready to include another level of information or organization, and those who were ready to think about 3 groups of 7 or 7 groups of 3. Representing the number of students in the class was an open-ended activity that students could enter in many ways and use to think about a range of mathematical ideas, from one-to-one correspondence to multiplication.

Andrea shared her idea, and some classmates picked up on it. I did not expect all of the students to be able to respond to her thinking, but her idea certainly pushed Sam and Kirby's thinking.

Is multiplication part of the Kindergarten curriculum? No. But are there students ready to think about it? Certainly! Will I "teach" more multiplication this year? Not formally, but I will tell some story problems that involve multiplication but that can also be solved by counting. I will look and listen for other signs of these ideas percolating in some of my students, and I will ask them what they are thinking.

In this case, Ms. Mallon demonstrates what happens when students are presented with a thoughtful, open-ended activity and plenty of time for student-to-student dialogue. Although she has a range of learners in her classroom, she found that all of her students were able to find some way to enter into and contribute to the mathematics happening in the classroom.

Questions for Discussion

1. **What was it about this activity that provided an entry point for a range of learners? How did Ms. Mallon respond to the needs of all of her learners while using Andrea's idea to also push the thinking of those students who were ready to engage with it?**

2. **Can you think of a time in your own classroom when a student shared an idea that some but not all students were ready to engage in? What did you do?**

Language and Representation

Sharing Marbles: Representing and Solving a Division Problem

Susan Sharrow's Kindergarten students have been working on addition and subtraction story problems. To prepare for a school-wide professional development day, Ms. Sharrow was asked to present her students with a division story problem. Although division is not part of the Kindergarten curriculum, Ms. Sharrow was interested in seeing if the range of students in her classroom would be able to apply the problem-solving strategies they had learned during the year to this new type of problem.

To prepare for a school-wide professional development day, all Kindergarten and first-grade teachers were asked to present a division problem to their classes. I gave my students the following problem:

How could 4 Kindergarten students share 12 marbles fairly?

I decided on this particular problem because lately my students had been manifesting a hard time sharing the limited supply of marbles we have in our classroom. I thought of starting with a smaller number of marbles to share, like 4 or 6, but I wanted the problem to reflect a real classroom scenario.

I found myself curious and interested about what the students might do to solve this new type of problem. Who would find a way into the problem and who would not? How would they use the marbles? Would they write or draw anything on the papers they were supplied with?

Just like when we prepare to solve addition and subtraction problems, I gathered the students together to make sure they understood the problem. I asked a few students to retell the story in their own words. Next, I had the students picture the situation in their minds. Finally, I asked them to describe the action of the problem and tried to help them pay particular attention to what was happening with the 4 students and the 12 marbles.

Satisfied that the students had a good understanding of the problem, I paired each student with a partner and sent each pair off with a cup containing 12 marbles. I was wondering how the students would do with this grouping arrangement. Although I was tempted to have them work in groups of four so they could act out the problem, I knew that 4 students in a group would not work in a Kindergarten setting. I couldn't wait to see how each pair would deal with the problem of dividing up marbles among 4 students.

Andrea recognized this problem right away. I was still distributing the materials when she said, "No one has 4 kids." I asked her if she could say more about that. She added, "Me and Sarah have only 2 kids, and everyone else has only 2 kids, so what are we supposed to do?" I sat down with them and noticed that each girl had 6 marbles in front of her. I asked if they could imagine 2 more Kindergartners coming over and asking for marbles. Sarah quickly responded, "Oh, we would each have 3." While she was answering, I noticed she split her pile of 6 marbles into two piles of 3 marbles. This small bit of using their imagination to visualize the problem seemed to really help Andrea and Sarah. They could imagine 2 students coming over and wanting their fair share of marbles, and they knew how to solve it right away.

Imagining the scenario seemed to help Mitch and Tom as well. When I arrived at their table, I noticed that they had arranged their 12 marbles into three piles of 4. Mitch said, "We only made piles for 3 kids. We don't have a pile for the fourth." I said, "But your piles have 4 . . . ," and he said, "But it's not enough for 4 kids." It seemed to me that he was pretty clear that he needed one more group but didn't have any marbles to make the fourth group. So I said, "Okay, I will be the third kid, and this is my pile. What if another student comes along and wants some marbles?" Tom quickly said, "We can each give her 1 marble." We each took 1 marble from our pile and created a fourth pile containing 3 marbles. I was surprised that Tom saw so quickly how to solve the problem, as he is a student who often has difficulty in math and has trouble counting.

Darlene and Anita were having a difficult time thinking about sharing among 4 kids with only two in the group. When I approached them, they had decided that 2 kids would each get 5 marbles and that there would be 2 left over. I tried to help them imagine two other generic students, but that did not help them make sense of the problem. I decided to do a little role-playing and began acting like a kid and pulled another student who was milling about into the group. I whined that it was not fair and that we wanted marbles, too. Darlene grinned and dealt the marbles out by ones.

Josie and Judith also dealt the marbles out to solve the problem. Josie said, "So we take 4 marbles out and leave the rest in." She then took 4 marbles out of the cup and spread them out on the table. I said, "Well, that looks fair but what about the rest of the marbles?" Judith dealt out another 4, putting one marble into each pile. Josie, delighted said, "Oh, there's 4 left!" and quickly dealt out a third marble to each pile. She then said, "Oh, we each get 3. Three, 3, 3, and 3 makes 12." While there was some dealing out by ones, it seemed that both of these girls were thinking about pulling out marbles in groups of 4.

When I asked Kirby how he solved it, he said, "It's 3 because 6 and 6 is 12 and 3 and 3 is 6." Simone added that if there were 4 kids, each pair would get 6, so each kid would get 3.

While this problem type was not familiar, I was really glad we worked on it today. The situation itself, sharing marbles, was near and dear to my students, and the mathematics was challenging, new, and interesting. I was so pleased by the way all of the pairs worked together, were able to make sense of the problem, came up with solutions, and were able to describe how they solved it. They were animated, excited, and proud of the work they did. I feel energized, and I can't wait to continue working on story problems about combining and separating.

This case illustrates what students can achieve when they have a strong mathematical background in problem solving. Although Ms. Sharrow's students had never solved a division story problem, they were able to use their previous experience solving addition and subtraction story problems, coupled with Ms. Sharrow's support of the range of learners, to approach a division situation with confidence.

Questions for Discussion

1. **What tools did Ms. Sharrow's students possess that enabled them to approach this new math with confidence? How did Ms. Sharrow encourage the students to use these tools when they were confused by the math?**

2. **Can you think of a time in your classroom when students were asked to solve a problem with unfamiliar content? What knowledge and strategies were they able to call on to solve this problem? What did you do in this situation to help them call on this knowledge?**

Reflections on *Collect 10 Together*

Meghan Mallon has been using Investigations *for over 10 years with her Kindergarten classes. During this time she has learned a great deal about the mathematics in which her students are involved and has developed specific strategies to support them in their growing understanding of math concepts. In this case, Ms. Mallon reflects on the activity* Collect 10 Together, *in which two players take turns rolling a dot cube, which has 1–3 dots on its various faces, to accumulate counters until they have 10. She recalls her past difficulties in "seeing" the mathematics inherent in this activity and shares how she needed to work through her own ideas about the mathematics involved in* Collect 10 Together *to make the game meaningful for her Kindergarten students.*

The use of *Collect 10 Together* has always been somewhat problematic for me in my classroom. I have always felt as though the math thinking in which students could be engaged was valuable and interesting. However, in my class *Collect 10 Together* was typically a game that students did quickly without ever counting higher than 3, figuring out their total, or thinking about how many they have left to reach the number 10. (Depending on what the students roll at the end, they may end up with exactly 10 counters or more than 10.) Thus, I felt as though there was not a great deal of math thinking going on.

I decided to clarify for myself the goals that I had for my students as they play *Collect 10 Together*. As I looked closely at the game, I concluded that the structure of the game provides an opportunity and encourages students to

• combine small numbers and to think about how far they are from 10.

• count on to figure out totals. Having lots of rolls that can either be a one or two pushes this idea of counting on. For instance, rolling a one encourages students to think about the next number in the counting sequence and the relationship between counting and adding.

• think about various big math ideas such as the commutative property (i.e., 2 + 3 and 3 + 2—both equaling 5) and using known facts such as doubles.

I was determined to look for all these math ideas as students played *Collect 10 Together*. Would I see counting by ones, counting on, or "just knowing?" Would students keep track of how many counters they had as they played or would they just keep accumulating counters without thinking about the total? What could I do to promote the type of math thinking that could be involved in this game? I realized that I needed to be more explicit with the students about my goals for the game.

During a class meeting, I told my students that I wanted them to play the game thoughtfully, and I explained what this meant. As I introduced the game, I was really specific about why we were playing it. In the demonstration game, I did not line the counters up in a neat row. I acknowledged that the game could be played very quickly and told them my expectation that they play again and again so they could do lots of counting and adding. Through the demonstration, I indicated that I did not want them to play quickly and without any counting or thinking. I also told students that I was interested in several things:

• How they played *Collect 10 Together*

• How they figured out how many counters they had

• How they figured out how many more counters were needed

The students gathered their dot cubes and counters. I had a clipboard and a sharp pencil, and we all went off to work. As I watched students play *Collect 10 Together*, I heard math conversations that were usually absent during this game. I was also able to prompt students to share their strategies and to work cooperatively with their partners.

As I looked at my notes, I began to think that *Collect 10 Together* is a game that can give Kindergartners a chance to work on counting and adding. It has the right number combinations built into it that allow them to begin counting on, adding, and using known facts.

I also think that if I, as the teacher, have a really clear idea about what the math in the activity is, I can then go after that in my explanations, teaching, conversations, and observations as I circulate. While it is important to be open to unexpected ideas that come from students, I also need to be clear about the math I want the students to think about.

It is important to continually reassess the mathematical goals of activities in light of the group of students with whom you work. In this case, Ms. Mallon shares her initial concerns about the mathematics involved in a particular activity that she has used with many groups of students. By reevaluating the goals of the game, her own goals, and the needs of her class, Ms. Mallon was able to present the activity in a way that made these goals explicit for students.

Questions for Discussion

1. How did Ms. Mallon focus students on the main mathematical ideas embedded in *Collect 10 Together*?

2. What questions can Ms. Mallon ask her students as they play *Collect 10 Together* to help them think about these mathematical ideas?

3. How might you apply this teaching strategy of reflection and redirection to a game your students know how to play but which is not moving their mathematical thinking forward?

"Heptagons" and Twins

In this case, Samantha MacDonald reflects on her students' work during the geometry unit, Make a Shape, Build a Block. *She finds that the mathematical ideas seem more tangible to her students than in other units and notices that even those learners who have struggled in the past seem comfortable working with geometry. She pays particular attention to her students' use of the new mathematical vocabulary they have learned and finds that despite their varying levels of discourse about the math, her students are able to understand each other and share ideas.*

Over the years I have noticed that all students have access to the ideas in this unit in a way that is not always true when learning other mathematical concepts. Though a student may not know the name of a particular shape or have previously differentiated the features of two-dimensional versus three-dimensional shapes, they all have had some experience

building and describing shapes. The students seem to pick up on the geometric vocabulary and are eager to give it a try. They may not always be accurate, but they get pretty excited about trying out new words. An example of this took place as a small group of students was working with the play dough we had made to support the work in this unit. I had added some cookie cutters to the basket of materials. One of the cutters was a six-pointed star. The students also had plastic knives and other modeling tools at their fingertips. As Norman and Sal worked, I heard the following exchange:

Norman: I see a heptagon in the star. Look I can cut off six triangles, and it's just like the yellow pattern block.

Sal: Can I try? I want to make a hexagon star, too.

Though Norman did not accurately pronounce "hexagon," it did not interfere with Sal's comprehension of his ideas. Norman passed the cutter to Sal, and Sal proceeded to roll out some dough, cut out the shape of the star and then cut off the six triangles. Their work looked like this:

Kim: Two hexagons and 12 triangles make 2 stars. Can I make one, too?

As we progressed from one Investigation to another, I never felt like I needed to modify the activities. This had not been the case with any other unit. Students who struggled with initial concepts in the pattern and number units did not struggle with geometry. Linus, for example, has been one student for whom I needed to make accommodations in most

prior units, even if the accommodation was only to be close by and restate expectations/directions or to model ideas or provide a scaffold for his thinking. I did not feel I needed to do this for the tasks in this unit. Linus worked independently or with a partner. In particular, he really enjoyed building with the Geoblocks.

Linus: I found a twin.

Teacher: What do you mean?

Linus: This block and this block are the same.

Linus held up two cubes of the same size.

Teacher: Can you find other twins?

Linus proceeded to make matches of identical blocks. He seemed to generate his own activity as he tried to find all the "twins." His enthusiasm encouraged other nearby students to find "twins" as well. This spontaneous activity preceded the work in the unit of introducing *Build a Block.* It seemed only natural to jump ahead to this task and offer it as an alternative to his work. Before long, Linus was composing and decomposing the blocks with a fury. It was so exciting to see him take the lead. Earlier in the year he had coined the word *cheer* when we were working on identifying the unit of a repeating pattern. Now Linus and his classmates were in constant conversations about "twins." I couldn't resist jumping in as Linus and Lucy were talking about cubes.

Lucy: I made 2 cubes. One is just a cube, and one is 2 triangles.

Linus: [handing Lucy an identical cube to her first block] This is a twin.

Teacher: Linus, can one "twin" be a cube made with one block and one "twin" a cube made of two triangular prisms?

Linus: You can make them look like a twin, but they aren't really.

Teacher: Why not?

Linus: 'Cause one and two are not twins. One and one is a twin.

Lucy: But they are both cubes. See. [Lucy proceeded to try and show Linus how the two triangular prisms made a cube.]

Linus: [again handing her the solid cube] No, you need one.

I was very intrigued with the way in which Linus was clarifying his definition of "twin." Though a shape could be composed of other shapes, it was not an exact match. It was exciting to hear his level of confidence, to see him take the lead, and to hold fast to his idea without wavering. This is a far cry from the little boy who wasn't sure how to count a set of 3 objects in September. I wonder if he would have generated the same ideas and voiced them in the same way had geometry been our first unit of the year. Was his access and success to the ideas in our geometry unit because of all that has come before, or was his success just the nature of learning about geometric ideas in Kindergarten?

As students represent geometric shapes in different media, they are describing features of the shapes, identifying similarities and differences of different shapes, and figuring out how one shape can be composed of other shapes. Students both use their own informal vocabulary and hear correct mathematical words for shapes used by the teacher.

Questions for Discussion

1. What mathematical ideas are the students working on in this case? How do students use models and language to communicate their ideas?

2. What lessons might Ms. MacDonald take from her students' experience with geometry, particularly students such as Linus who had struggled earlier in the year with basic number concepts? How might Linus's strength in geometry help him in other areas of the mathematics curriculum?

3. Have you had a similar experience with students who have struggled in other areas of the math curriculum but found new confidence and competence in the study of geometry? How have you used their strength with geometry to build their understanding of number and operations?

The Red One Doesn't Have a Match: A Counting Jar Discussion

Discussions are a critical component of mathematics instruction. In this case, Michelle Rutherford plans a discussion that enables her Kindergarten students to think about odd and even numbers. By asking her students for explanations and evidence to support their ideas and encouraging student-to-student talk, Ms. Rutherford facilitates a conversation in which the students are able to learn from each other.

Because of the cold weather this month, we have spent a lot of time talking about clothing that keeps us warm. Students have provided examples such as hats and mittens. I decided to incorporate the idea of mittens into the *Counting Jar* activity as a way to bring up the idea of odd and even numbers. To set up this experience, I found 6 pairs of gloves. I also found a single red glove. I put these items into the jar to give a total of 13 items for the students to consider.

As usual, toward the end of the lesson, I asked my students to come to the rug so they could share their thinking. The focus of the discussion was to confirm the total number of objects in the jar. I was also curious to see if any of the students might comment on the "odd" nature of the set I assembled.

Teacher: How many gloves are in the jar?

Many hands shot up immediately. I also heard students saying, "Thirteen." When I asked if everyone had counted 13 gloves, I saw many heads nod in agreement. I then asked the class why they all found the same total.

Steven: 'Cause there are 13. We all counted.

Teacher: Should we double-check?

Amy: I know it's 13, but we can count again, too.

I dumped the contents of the jar out onto the rug so all could see. Instantly Jason's hand shot up. I was delighted to see him take this initiative. It wasn't long ago that he sat at meeting time sucking his thumb, sat removed from the group, or fidgeted in his spot.

Jason: The red one doesn't have a match.

Teacher: What do you mean?

Jason: It is one.

Steven: Thirteen isn't equal.

Alan: It is odd.

Teacher: What do you mean?

Billie: Everyone has a match. No, not the red one [pointing to the single red glove].

Jason: Yeah, maybe someone took the other one to make a heart of a snowman. Maybe some animal took it. [Note: Jason's comments relate directly to two of the stories we had been discussing as a class during reading.]

Mitch: If we had another red glove, it would be equal.

Rob: Yeah, then we could count by twos and get 14.

Teacher: What do you mean count by twos?

Karen: Like 2, 4, 6, 8, 10.

Teacher: How will that help us with figuring out how many things are in the jar?

Rob: If I match them up (pointing to the gloves and mittens), they are two.

Teacher: Can you show us what you mean?

Rob carefully positioned each pair so that the two gloves in the pair were touching each other on the rug. He made sure to leave a space between each pairing.

Rob: Now you can count by twos.

Rob counted by twos until he got to 12.

Karen: See, 13 is not even. It doesn't have a match, so you can't count it by twos.

Rob: If we had one more red glove, it would make 14: 2, 4, 6, 8, 10, 12, 14!

Jason: But one is still missing, so we have 13!

By adding an "extra" glove to the jar, Ms. Rutherford creates for her students an experience that highlights ideas about odd and even numbers. To help her students probe their ideas more fully, she repeatedly asks them to explain their thinking and offer evidence for their ideas. Through this process, the students are encouraged to work together and are able to listen to and build on each other's ideas.

Questions for Discussion

1. **What decisions did Ms. Rutherford make in planning this activity? What mathematical ideas did her students express during the discussion?**

2. **How did Ms. Rutherford's questions extend students' mathematical thinking about odd and even numbers?**

3. **How have you used a small variation in classroom activities such as the *Counting Jar* to extend students' mathematical thinking?**

How Do You Draw the Ones That Are Gone? Showing the Action of a Subtraction Word Problem

In the following case, Susan Sharrow challenges her Kindergarten students to write their own story problems. She expects that most, if not all, of the students will write problems involving addition. When a few students decide to write a story problem about removing rather than combining, an interesting lesson emerges about the complexities of trying to show the action of a subtraction problem on paper.

My Kindergarten class had just finished the geometry unit. Before moving into the next unit, I decided to spend a little time thinking about numbers and computation with them. My class always liked acting out and solving story problems, but today I decided to add in a new challenge. I told them that they were going to make up their own story problem.

The majority of the students came up with an addition problem. They showed the two groups of objects with numerical labels and sometimes recorded the total. These problems felt like fine Kindergarten work to me; most of them were clear enough that I could tell from the student drawing what the basic story and action was in the problem.

The few students who decided to try a subtraction problem ran into some interesting issues about how to show the action of subtraction on their papers. Todd was the most expressive about the dilemma he faced. He handed me a paper that showed a jar with two granola bars inside.

I asked him to tell me the story behind the problem, and he said, "There were 4 granola bars in a jar and someone took 2 of them." I asked him how many were left, and he quickly responded with "Two." We both looked at the drawing of the 2 granola bars on his paper. We had the following exchange about his work.

Teacher: You know, I can see the 2 granola bars really clearly, but I can't see anything else that happened in your story.

Todd: I know; I didn't know how to draw it.

Teacher: What makes that tricky?

Todd: The other ones are gone.

Teacher: You mean the granola bars someone took?

Todd: Yeah.

Teacher: So do you feel like it doesn't make sense to draw them because they are gone? [He nodded.] Could you somehow add something to this picture to show that someone took some away?

Todd drew a hand reaching into the jar. He looked uncertain, so I pressed on.

Teacher: How might you show that the hand took 2 of the granola bars?

He drew 2 more granola bars, but now it looked like 4 in the jar.

Suddenly, he got that light bulb being lit look and continued working on his picture with renewed energy. What Todd came up with was a hand superimposed over the top 2 granola bars, which showed the granola bars being taken away. Todd came up with a way to show the action of the problem quite nicely.

Judith made up two rather complex subtraction problems and found a way to show the action of the problem in her pictures. **Problem 1:** "There were 6 peaches in my basket. I ate one and gave one to the queen." Judith's picture showed 6 peaches, one with an arrow leading to a stick figure's mouth and another with an arrow leading off stage right.

Problem 2: "There were 3 candies in a jar and 3 candies in another jar. I moved 1 candy from one jar into the other jar, and there were 4." Her picture showed the moment when there were 2 candies in one jar and 3 in the other, and 1 candy in transit via a hand.

There were several other students who made up subtraction story problems. But as with Todd's work, the students all drew either the starting point or the end point of the problem without feeling any tension about the whole story not showing. I was very interested in how Judith showed the action in a subtraction story problem. I wondered what to do with this. Were the other students ready to think about subtraction stories and how to represent them on paper? I decided to have Judith and Todd share their papers at the end of math discussion.

A few days later, I made writing math story problems one of the math choices. I reminded the class about Judith and Todd's work and sketched Todd's hand taking candy and Judith's arrows showing peaches being eaten. I had not introduced the word *subtraction* yet, so I suggested that students might want to make up problems where something went away, left, got eaten, got bought, got taken out, flew away, turned into a butterfly, and so forth, and to think about how to show that going away part on their papers. Someone right away called out, "Yeah, you could cross them out."

This time there were many removal problems and about half of the students were able to clearly show the action of the problem. Their papers were filled with arrows, cross-outs, and giant hands (adorned with nail polish, rings, watches, and tattoos!) to show that something was being taken away. Kirby's new way of showing something leaving was to make a speech bubble coming out of its mouth saying, "Bye, bye."

After this work session, I am convinced that with a little exploration and conversation, Kindergartners can make sense of subtraction stories and that showing the problem on paper can help them better understand what is happening in the problem. I was also interested to see how the ideas presented by a few students could have an impact on the thinking of so many classmates.

Although Ms. Sharrow is surprised when some of her students show an interest in subtraction story problems, she encourages them to think through their difficulties and share what they learned with the rest of the class. As a result, Ms. Sharrow finds that many of her students are eager to try writing their own removal problems.

Questions for Discussion

1. Ms. Sharrow asks her students to create drawings of the story problems they are writing. What effect does this have on their understanding of the mathematics?

2. When Todd has trouble showing the action of his removal problem in his drawing, how does Ms. Sharrow help Todd work through his difficulty?

3. How does Ms. Sharrow's decision to have Todd and Judith share their problems and representations with the class help other students write and represent problems involving subtraction?

4. Have you made a similar decision in your classroom to have a student or students share an unfamiliar problem or representation? What was the result of your decision?

Helping Students Build on Each Other's Ideas

Meghan Mallon has spent a considerable amount of time this year teaching her Kindergarten students how to explain their thinking and how to listen to each other's ideas. In this case, we see how creating such a community of learners can enhance the mathematical environment and make even everyday classroom routines more thoughtful and challenging.

My students each have a counting collection. The collection, which consists of small objects found in the classroom, is kept in a resealable plastic bag. The number in the collection is supposed to match the number of objects in the counting jar that week.

For their morning job one day, I asked my students to count each other's collections. There were 21 candy hearts in the jar, so most of the bags contained 21 items. Not long into the activity, Simone came up to me and showed me a page she had made. She explained that she had sorted Sam's tiles by color. She counted each color and then added them up. Her page showed 9 blue color tiles, 4 reds, 3 greens, and 5 yellows. By each line of color tiles she had written the number in that group. Across the top of the paper she had written $9 + 4 + 3 + 5 = 21$. On this particular day we did not have much time to actually discuss the morning job, so I let Simone quickly show her paper, and we then moved on to our next activity.

Later that day, during math, I taught the students how to play *Double Compare*. In *Double Compare* each player lays out two number cards for each round, and the winner is the player whose cards total the highest number. We played a few rounds of the game as a class so the students could get a sense of how the game is played. I did not yet want to discuss strategies for adding or for figuring out who has the highest total. As I was gathering up the cards and getting ready to send the students off to play, Laurie threw out the comment, "Well, if one person gets 3 and 5 and the other person gets 5 and 3, it's still the same." The class had been sitting for a while and was getting restless so, as with Simone's idea, we didn't have time to discuss what Laurie had shared. I told Laurie to keep her eye out for that situation as she played.

After school that day, I had time to think more about Simone's idea. I decided to make a poster of her paper to show the students the next day.

The next morning I gathered the students on the rug and had Simone explain her paper one more time. We then counted the pictures of color tiles on her paper and on the poster and found that the total was 21, just like the 21 hearts in the counting jar. Next, we added up the numbers in Simone's number sentence $9 + 4 + 3 + 5$ by counting on from 9 using our fingers and once again got 21 as the answer. I then showed the class a new collection of 4 red chips and 5 blue chips and said, "So, if Simone's way of showing Sam's

collection makes sense to you, you might want to try to use her idea to help you count the chips and show how many there are in this collection."

Only two students can go to the counting jar at a time. Since I wanted more students to have a chance to think about this idea, I quickly made up trays with objects for the students to count. I put between 6 and 10 objects on each tray, and each collection had items with two different colors. As I did this, I narrated for the class what I was doing and thinking:

I'll put yellow and black cubes on this tray, and green and red bears on this tray. There—now lots of kids can think about counting the two colors separately and adding them up.

Before setting the students off to work with their collection, I asked Laurie to explain her idea about *Double Compare* to the class again. She used the same numbers, 5 and 3, in her explanation.

Teacher: So do you think this is something special about 5 and 3, or do you think this works with any two numbers?

Laurie: Any two numbers.

Teacher: So if I got 6 and 3 and my partner got 3 and 6, we'd have the same score?

Laurie: Yes.

I told the class that if what Laurie said made sense to them, they should be on the lookout for times when they had the same numbers as their partners but in a different order and should see if they ended up with the same score. And off they went.

I observed my students closely as they worked. Many of them counted the objects they were working with by sorting them by color, counting the items in each group, and then combining the groups. I observed some students using known addition facts to combine their groups. I also saw students counting onto one group to find the total, and several students counting all of the objects in both groups to find the total. Their papers varied in how organized and clear they were. Some students included number sentences and others didn't, but everyone showed the two different subsets on their paper.

After the work time was over, we sat in the meeting area and looked at some of the papers. On most of the papers, students could see where each subset was and how many were in it and could see the total. When we got to Kirby's paper, I commented on the row of 9 squares across the top, 5 blue and 4 red. Kirby had also written the number 9 and his name in boxes underneath the top row. There was also a good deal of other marking on his paper, which didn't surprise me, as Kirby likes to draw paths through letters and words, color over things to show action, and write codes and abbreviations. I was about to move on when Kirby said, "But I did Laurie's thing, too." I looked, and one of his rows of boxes also had 9 colored in—4 reds first and then 5 blues. I asked Kirby to explain, and he said, "Like Laurie said, you can do it in either order, and it's the same." I was very impressed with the connection Kirby made between the two ideas with which we started our math class.

We've had many conversations about showing our ideas and answers on paper; Simone spontaneously and independently applied this to a situation where it wasn't required of her to communicate a new idea about the counting jar. Students had shown the color of the items in the jar before, but there had not been any conversation about counting up subsets and adding them to find the total. Simone knew from experience that ideas like this should be shared with the class. Laurie expressed her idea about combining numbers in *Double*

Compare spontaneously and comfortably. The class as a whole listened to these ideas and continued to make sense of them as they did their math work. And Kirby connected the two ideas.

When two students make interesting mathematical observations, Ms. Mallon goes beyond just having the students share their thinking with the class; she encourages the class to experiment with the ideas themselves and provides a situation in which they can do so.

Questions for Discussion

1. In what way does Ms. Mallon show her students that their ideas have value? How does she give students who are ready to think about the challenging math ideas raised by Simone and Laurie a chance to explore them without overwhelming the students who may not be ready to grapple with these ideas?

2. Can you think of a time in your own classroom when you were faced with a similar situation? What decision did you make about bringing the ideas of your students to the class as a whole? What was the outcome of your decision?

Scope and Sequence

The strands are divided into Math Emphases.

The Math Emphases may be covered in one or more units. The Math Emphases are further subdivided into Math Focus Points.

KINDERGARTEN

Number and Operations

Counting and Quantity Developing strategies for accurately counting a set of objects by ones

Unit 1 Math Focus Points

- Counting the number of students in the class
- Using the calendar to count days
- Connecting number names, numerals, and quantities
- Establishing one-to-one correspondence between equal groups (e.g. students and cubes)
- Developing strategies for accurately counting and keeping track of quantities up to the number of students in the class
- Creating an equivalent set
- Counting, creating, and representing quantities
- Developing language to describe shapes, position, and quantity

Unit 2 Math Focus Points

- Developing strategies for accurately counting and keeping track of quantities up to 12
- Connecting number words, numerals, and quantities
- Developing visual images for quantities up to 6
- Counting backwards

Each strand is labeled with a grade level.

The content is organized around five strands.

KINDERGARTEN

Number and Operations

Counting and Quantity Developing strategies for accurately counting a set of objects by ones

Unit 1 Math Focus Points

- Counting the number of students in the class
- Using the calendar to count days
- Connecting number names, numerals, and quantities
- Establishing one-to-one correspondence between equal groups (e.g., students and cubes)
- Developing strategies for accurately counting and keeping track of quantities up to the number of students in the class
- Creating an equivalent set
- Counting, creating, and representing quantities

Unit 2 Math Focus Points

- Developing strategies for accurately counting and keeping track of quantities up to 12
- Connecting number words, numerals, and quantities
- Developing visual images for quantities up to 6
- Counting backwards

Unit 3 Math Focus Points

- Counting, creating, and representing quantities
- Counting 12 objects

Unit 4 Math Focus Points

- Counting a set of objects and creating an equivalent set
- Connecting number words, numerals, and quantities
- Keeping track of a growing set of objects
- Counting spaces and moving on a game board
- Creating a set of a given size
- Developing and analyzing visual images for quantities up to 10

Unit 6 Math Focus Points

- Developing and analyzing visual images for quantities up to 10
- Developing strategies for accurately counting and keeping track of quantities up to 20
- Using subsets to count a set of objects
- Counting spaces and moving on a game board

Unit 7 Math Focus Points

- Counting and keeping track of quantities
- Matching sets with a 1–to–1 correspondence
- Working with 2–to–1 correspondence
- Counting by groups of 2

Counting and Quantity Developing an understanding of the magnitude and position of numbers

Unit 2 Math Focus Points

- Comparing two (or more) quantities to determine which is more
- Developing language for comparing quantities (more, greater, less, fewer, most, least, fewest, same, and equal to)
- Ordering quantities from least to most

Unit 4 Math Focus Points

- Developing an understanding of more than and fewer than
- Comparing two quantities to determine which is more

Unit 7 Math Focus Point

- Comparing two quantities to determine which is more

Counting and Quantity Developing the idea of equivalence

Unit 2 Math Focus Points
- Creating an equivalent set
- Considering whether order matters when you count

Unit 6 Math Focus Points
- Creating an equivalent set
- Counting and comparing quantities to 20 to determine which is more

Whole Number Operations Using manipulatives, drawings, tools, and notation to show strategies and solutions

Unit 1 Math Focus Points
- Exploring math manipulatives, and their attributes
- Using the calendar as a tool for keeping track of time and events
- Representing quantities with pictures, numbers, objects, and/or words

Unit 2 Math Focus Points
- Representing quantities with pictures, numbers, objects, and/or words
- Using numerals to represent quantities
- Using a Ten-Frame to develop visual images of quantities up to 10

Unit 4 Math Focus Points
- Recording measurements with pictures, numbers, and/or words
- Using numbers to represent quantities and to record how many
- Using a Ten-Frame to develop visual images of quantities up to 10
- Recording an arrangement of a quantity

Unit 6 Math Focus Points
- Using numbers, and/or addition notation, to describe arrangements of objects, to record how many, and to represent an addition situation
- Using numbers, pictures, and/or words to represent a quantity or measurement, or a solution to a problem

Whole Number Operations Making sense of and developing strategies to solve addition and subtraction problems with small numbers

Unit 4 Math Focus Points
- Finding the total after a small amount (1, 2, 3) is added to a set of up to 7
- Combining two amounts
- Modeling the action of combining and separating situations
- Separating one amount from another
- Adding or subtracting one to/from numbers up to 10
- Adding to or subtracting from one quantity to make another quantity
- Decomposing numbers in different ways
- Exploring combinations of a number (e.g., 6 is 3 and 3 and also 5 and 1)
- Thinking strategically about moves on a gameboard

Unit 6 Math Focus Points
- Decomposing numbers in different ways
- Finding the total after 1, 2, or 3 is added to, or subtracted from, a set
- Combining single-digit numbers, with totals to 20
- Modeling the action of combining and separating situations
- Separating one amount from another
- Developing strategies for solving addition and subtraction story problems
- Finding combinations of a five and six

- Considering combinations of a number (e.g., 6 is 3 and 3 and also 5 and 1)
- Beginning to recognize that some problems have more than one solution
- Thinking strategically about moves on a gameboard

Patterns and Functions

Repeating Patterns Constructing, describing, and extending repeating patterns

Unit 3 Math Focus Points

- Copying, constructing, comparing, describing, and recording repeating patterns
- Determining what comes next in a repeating pattern
- Comparing repeating and non-repeating arrangements
- Distinguishing between patterns and nonpatterns
- Constructing a variety of patterns using the same elements
- Comparing different kinds of patterns

Repeating Patterns Identifying the unit of a repeating pattern

Unit 3 Math Focus Points

- Identifying the unit of a repeating pattern
- Counting the number of units in a repeating pattern
- Extending a repeating pattern by adding on units to the pattern

Data Analysis

Data Analysis Sorting and classifying

Unit 1 Math Focus Points

- Identifying attributes (e.g. color, size, and shape) and developing language to describe them
- Comparing how objects are the same and different
- Finding objects that share one attribute
- Using attributes to sort a group of objects

Unit 3 Math Focus Points

- Finding objects that share one attribute
- Using attributes to sort a group of objects
- Comparing how objects are the same and different
- Observing and describing
- Using information to figure out what is missing

Unit 7 Math Focus Points

- Identifying the attributes of an object
- Identifying an attribute that is common to several objects
- Comparing how objects are the same and different
- Using attributes to sort a set of objects
- Grouping data into categories based on similar attributes
- Sorting a set of objects or data in different ways

Data Analysis Carrying out a data investigation

Unit 1 Math Focus Points

- Collecting and keeping track of survey data
- Describing and comparing the number of pieces of data in each category
- Interpreting results to a data investigation

Unit 7 Math Focus Points

◆ Choosing a survey question with two possible responses
◆ Collecting and keeping track of survey data
◆ Interpreting results of a data investigation
◆ Using data to solve a problem

Data Analysis Representing data

Unit 7 Math Focus Points

◆ Making a representation of a set of data
◆ Seeing the 1-to-1 correspondence between a set of data and a representation of this data

KINDERGARTEN

Geometry

Features of Shape Describing, identifying, comparing and sorting two- and three-dimensional shapes

Unit 1 Math Focus Point

◆ Developing language to describe shapes, position, and quantity

Unit 5 Math Focus Points

◆ Developing language to describe and compare 2-D and 3-D shapes and their attributes
◆ Relating 2-D and 3-D shapes to real-world objects
◆ Describing the attributes of circles and rectangles
◆ Describing the attributes of triangles and squares
◆ Exploring relationships among pattern block shapes
◆ Comparing the faces of different 3-D shapes and the faces of a single 3-D shape
◆ Exploring materials
◆ Relating 3-D objects to 2-D pictures of 3-D shapes

◆ Matching a 3-D block to a 2-D outline of one of the block faces
◆ Exploring Geoblocks and their attributes

Features of Shape Composing and decomposing two- and three- dimensional shapes

Unit 5 Math Focus Points

◆ Constructing 2-D shapes
◆ Finding combinations of shapes that fill an area
◆ Constructing 3-D shapes
◆ Combining 3-D shapes to make a given 3-D shapes

KINDERGARTEN

Measurement

Linear Measurement Understanding length

Unit 2 Math Focus Points

◆ Directly comparing two objects to determine which is longer
◆ Sorting objects into two categories, according to length
◆ Developing language to describe and compare lengths (long, longer than, short, shorter than, the same, equal to)

Linear Measurement Understanding length and using linear units

Unit 4 Math Focus Points

◆ Understanding what length is
◆ Identifying the longest dimension of an object
◆ Comparing lengths of different objects
◆ Repeating multiple nonstandard units to quantify length
◆ Developing strategies for measuring the length of an object

Unit 6 Math Focus Point

◆ Repeating multiple nonstandard units to quantify length

Classroom Routines

Today's Question

Units 2–7 Math Focus Points

◆ Collecting, counting, representing, describing, and comparing data

Patterns on the Pocket Chart

Units 3–7 Math Focus Points

◆ Determining what comes next in a repeating pattern
◆ Describing repeating patterns

Calendar

Units 1–7 Math Focus Points

◆ Using the calendar as a tool for keeping track of time
◆ Developing strategies for counting accurately

Attendance

Units 1–7 Math Focus Points

◆ Developing strategies for counting accurately
◆ Considering whether order matters when you count
◆ Comparing quantities
◆ Counting forward and backward

GRADE 1

Number and Operations

Counting and Quantity Developing an understanding of the magnitude and position of numbers

Unit 1 Math Focus Points

◆ Ordering a set of numbers and quantities up to 12
◆ Comparing two quantities up to 20 to see which is larger
◆ Developing an understanding of how the quantities in the counting sequence are related: each number is 1 more or 1 less than the number before or after it

Unit 6 Math Focus Points

◆ Reasoning about more, less, and equal amounts
◆ Finding a solution that fits several clues

Counting and Quantity Developing strategies for accurately counting a set of objects by ones and by groups

Unit 1 Math Focus Points

◆ Counting a set of up to 20 objects by 1s
◆ Practicing the rote counting sequence forward and backward, from 1 to 30
◆ Connecting number names and written numbers to the quantities they represent
◆ Developing and analyzing visual images for quantities up to 10

Unit 2 Math Focus Point

◆ Counting a set of objects

Unit 3 Math Focus Points

◆ Practicing the rote counting sequence forward and backward, starting from any number 1–60
◆ Developing and analyzing visual images for quantities
◆ Accurately counting a set of objects by ones, up to 60
◆ Practicing the oral counting sequence from 1 to 100
◆ Writing the sequence of numbers (as high as students know)
◆ Identifying and using patterns in the sequence of numbers to 100

Unit 6 Math Focus Point

◆ Developing strategies for counting and combining groups of dots

Unit 8 Math Focus Points

◆ Counting and keeping track of amounts up to 60
◆ Counting on from a known quantity
◆ Organizing objects to count them more efficiently
◆ Identifying and using patterns in the number sequence and on the 100 chart
◆ Identifying, reading, writing, and sequencing number to 100 and beyond
◆ Counting and combining things that come in groups of 1, 2, 4, 5, and 10
◆ Counting by 2s, 5s, and 10s
◆ Exploring a 2:1 (the number of hands in a group of people) and a 5:1 relationship (the number of fingers and hands in a group)
◆ Counting by numbers other than 1
◆ Developing strategies for organizing sets of objects so that they are easy to count and combine
◆ Developing meaning for counting by groups of ten
◆ Considering a 2-digit number as tens and ones

Number Composition Composing numbers up to 20 with two or more addends

Unit 1 Math Focus Points

◆ Finding and exploring relationships among combinations of numbers up to 10
◆ Recording combinations of two numbers that make a certain total
◆ Solving a problem with multiple solutions
◆ Solving a problem in which the total and one part are known

Unit 2 Math Focus Point

◆ Finding the sum of multiple addends

Unit 3 Math Focus Points

◆ Finding as many 2-addend combinations of a number as possible
◆ Finding and exploring relationships among combinations of numbers up to 15
◆ Solving a problem in which the total and one part are known
◆ Proving that all the possible combinations have been found
◆ Developing the strategy of counting on

Unit 6 Math Focus Points

◆ Developing fluency with the 2-addend combinations of 10
◆ Finding relationships among different combinations of numbers up to 20
◆ Using $5 + 5$ to reason about other combinations of 10
◆ Finding as many 2-addend combinations of a number as possible
◆ Trying to prove that all the possible 2-addend combinations of a number have been found

Unit 8 Math Focus Point

◆ Thinking about numbers to 20 in terms of how they relate to 10 (e.g., $10 + \rule{1cm}{0.1mm}$ or < 10)

Number Composition Representing numbers by using equivalent expressions

Unit 3 Math Focus Point

◆ Generating equivalent expressions for a number

Unit 6 Math Focus Point

◆ Generating equivalent expressions for a number

Unit 8 Math Focus Point

◆ Determining equivalent expressions for a given expression (e.g., $7 + 8 = 10 + \underline{\hspace{1cm}}$)

Whole Number Operations Making sense of and developing strategies to solve addition and subtraction problems with small numbers

Unit 1 Math Focus Points

◆ Visualizing and retelling the action in an addition situation

◆ Modeling the action of an addition problem with counters or drawings

◆ Finding the total of two or more quantities up to a total of 20 by counting all, counting on, or using number combinations

◆ Seeing that adding the same two numbers (e.g., 4 and 3) results in the same total, regardless of context (e.g., number cubes, cards, objects)

Unit 3 Math Focus Points

◆ Visualizing and retelling the action in addition and subtraction situations involving removal

◆ Estimating whether an amount is more or less than a given quantity

◆ Finding the total of two or more quantities up to a total of 20 by counting all, counting on, or using number combinations

◆ Modeling the action of an addition or subtraction (removal) problem with counters or drawings

◆ Developing counting on as a strategy for combining two numbers

◆ Subtracting one number from another, with initial totals of up to 12

◆ Developing strategies for solving addition and subtraction (removal) problems

◆ Seeing that subtracting the same two numbers (e.g., 6 from 10) results in the same difference regardless of context (e.g., number and dot cubes, cards, objects)

◆ Solving story problems about comparing lengths

Unit 6 Math Focus Points

◆ Solving related story problems

◆ Solving a problem in which the total and one part are known

◆ Adding 2 or more single-digit numbers

◆ Visualizing, retelling, and modeling the action in addition and subtraction (removal) situations

◆ Subtracting one number from another, with initial totals of up to 12

◆ Developing strategies for solving addition and subtraction story problems

◆ Solving addition and subtraction story problems

Unit 8 Math Focus Point

◆ Adding single-digit numbers

Unit 9 Math Focus Point

◆ Counting and adding to compare the distances of different paths

Whole Number Operations Using manipulatives, drawings, tools, and notation to show strategies and solutions

Unit 1 Math Focus Points
- Using the number line as a tool for counting
- Introducing standard notation for comparing quantities (greater than, less than, and equal to)
- Introducing and using standard notation (+ and =) to represent addition situations
- Recording a solution to a problem
- Representing number combinations with numbers, pictures, and/or words

Unit 3 Math Focus Points
- Using the number line as a tool for counting
- Connecting written numbers and standard notation ($>, <, +, -, =$) to the quantities and actions they represent
- Using numbers and standard notation ($>, <, +, -, =$) to record
- Recording solutions to a problem
- Using the equal sign to show equivalent expressions
- Developing methods for recording addition and subtraction (removal) strategies
- Seeing the 100 chart as a representation of the counting numbers to 100

Unit 6 Math Focus Points
- Using numbers and standard notation ($+, -, =$) to record
- Developing strategies for recording solutions to story problems

Unit 8 Math Focus Points
- Using addition notation ($+, =$) to record
- Recording strategies for counting and combining
- Considering notation for equivalent expressions (e.g., $7 + 8 = 10 + 5$)

Computational Fluency Knowing addition combinations of 10

Unit 8 Math Focus Points
- Developing fluency with the 2-addend combinations of 10
- Solving a problem in which the total (10) and one part are known

GRADE 1
Patterns and Functions

Repeating Patterns Constructing, describing, and extending repeating patterns

Unit 2 Math Focus Points
- Using a repeated unit to create a pattern
- Seeing how changing the unit affects the whole pattern

Unit 7 Math Focus Points
- Identifying what comes next in a repeating pattern
- Using the word *pattern* to describe some kind of regularity in a sequence

Repeating Patterns Identifying the unit of a repeating pattern

Unit 7 Math Focus Points
- Representing a repeating unit in more than one way (for example, representing a red–blue–red–blue cube pattern with the movements clap–slap knees–clap–slap knees)
- Comparing repeating and non-repeating sequences
- Describing a repeating pattern as a sequence built from a part that repeats over and over called the *unit*
- Identifying the unit of a repeating pattern
- Extending a repeating pattern by adding on units to the pattern

- Identifying what comes several steps beyond the visible part of a repeating patern
- Comparing repeating patterns that have the same structure (for example, ABC), but different elements (for example, red–blue–green and yellow–orange–black)
- Comparing repeating patterns that have the same length of unit, but different structures (for example, red–blue–green and red–red–blue both have 3-element units)

Number Sequences Constructing, describing, and extending number sequences with constant increments generated by various contexts

Unit 7 Math Focus Points

- Associating counting numbers with elements of a repeating pattern
- Determining the element of a repeating pattern associated with a particular counting number
- Determining and describing the number sequence associated with one of the elements in the unit of a repeating pattern (e.g., the numbers associated with B in an AB pattern are 2, 4, 6, 8...)
- Modeling a constant rate of increase with concrete materials
- Describing how a number sequence represents a situation with a constant rate of change
- Extending a number sequence associated with a situation with a constant rate of change
- Determining how and why the same number sequences can be generated by different contexts

Data Analysis

Data Analysis Sorting and classifying

Unit 4 Math Focus Points

- Describing attributes of objects
- Using attributes to sort a set of objects
- Looking carefully at a group of objects to determine how they have been sorted

Data Analysis Representing data

Unit 4 Math Focus Points

- Making a representation to communicate the results of a survey
- Making sense of data representations, including pictures, bar graphs, tallies, and Venn diagrams
- Comparing what different representations communicate about a set of data
- Using equations to show how the sum of the responses in each category equals the total responses collected
- Organizing data in numerical order

Data Analysis Describing data

Unit 4 Math Focus Points

- Describing and comparing the number of pieces of data in each category or at each value and interpreting what the data tell you about the group
- Understanding that the sum of the pieces of data in all the categories equals the number of people surveyed
- Using data to compare how two groups are similar or different

Data Analysis Designing and carrying out a data investigation

Unit 4 Math Focus Points

- Interpreting results of a data investigation
- Choosing a survey question
- Making a plan for gathering data
- Collecting and keeping track of survey data

GRADE 1

Geometry

Features of Shape Describing, identifying, and comparing two- and three-dimensional shapes

Unit 1 Math Focus Point

- Exploring the characteristics of cubes, pattern blocks, Geoblocks, and Power Polygons

Unit 2 Math Focus Points

- Identifying common attributes of a group of shapes
- Describing, comparing, and naming 2-D shapes
- Developing visual images of and language for describing 2-D shapes
- Recognizing that there are many types of quadrilaterals (e.g., rectangles, trapezoids, squares, rhombuses)
- Identifying and making triangles and quadrilaterals of different shapes and sizes
- Identifying characteristics of triangles and quadrilaterals
- Noticing shapes in the environment

Unit 9 Math Focus Points

- Developing vocabulary to describe 3-D shapes and their attributes
- Comparing size, shape, and orientation of objects
- Identifying the characteristics of 3-D objects by touch
- Describing a rectangular prism
- Comparing rectangular prisms
- Observing and describing characteristics of 3-D shapes
- Recognizing shapes in the world
- Describing 3-D structures
- Relating size and shape of an object to its use
- Planning a geometric structure with limited space and materials

Features of Shape Composing and decomposing two-dimensional shapes

Unit 2 Math Focus Points

- Covering a region without gaps or overlaps using multiple shapes
- Decomposing shapes in different ways
- Finding different combinations of shapes that fill the same area
- Seeing relationships between squares and triangles
- Altering designs to use more or fewer pieces to cover the same space
- Examining how shapes can be combined to make other shapes

Features of Shape Exploring the relationships between two- and three-dimensional shapes

Unit 9 Math Focus Points

- Matching a 3-D object to a 2-D outline of one of its faces
- Matching a 3-D object to a 2-D picture of the object
- Making 3-D objects out of 2-D pieces
- Making a 2-D representation of a 3-D object or structure
- Building a 3-D construction from a 2-D representation
- Visualizing and estimating the paces and turns required to follow a particular path
- Giving, following, and recording directions for following a path

GRADE 1

Measurement

Linear Measurement Understanding length

Unit 3 Math Focus Point

- Considering attributes that can be measured (e.g., length, perimeter, area)

Unit 5 Math Focus Points

- Understanding what length is and how it can be measured
- Measuring lengths using different-sized units
- Identifying the longest dimension of an object
- Comparing lengths to determine which is longer
- Identifying contexts in which measurement is used
- Understanding the meaning of at least in the context of linear measurement

Linear Measurement Using linear units

Unit 5 Math Focus Points

- Developing accurate measurement techniques
- Describing measurements that are in between whole numbers of units
- Understanding that measurements of the same length should be the same when they are measured twice or by different people using the same unit
- Understanding that measuring an object using different-lengths units will result in different measurements
- Measuring length by iterating a single unit

Linear Measurement Measuring with standard units

Unit 5 Math Focus Point

- Using inch tiles to measure objects in inches

GRADE 1

Classroom Routines

Start With/Get To

Units 1-8 Math Focus Points

- Connecting written numbers and number names
- Using the number line as a tool for counting
- Practicing the forward and backward counting sequences with numbers up to 100
- Counting by 5s and 10s

Morning Meeting

Units 1–9 Math Focus Points

◆ Developing strategies for counting accurately (Attendance, Calendar, Weather)

◆ Using the calendar as a tool for keeping track of time (Calendar)

◆ Developing vocabulary to talk about time (morning, noon, midday, afternoon, etc.) and sequence (first, next, last, before, after, etc.) (The Daily Schedule, Calendar)

◆ Collecting and recording data (Weather)

◆ Estimating quantities up to about 30

◆ Adding small amounts to or subtracting small amounts from a familiar number

◆ Investigating numbers that can (and cannot) be made into groups of two

◆ Naming and telling time to the hour on digital and analog clocks

◆ Associating times on the hour with daily events

◆ Counting, describing, and comparing data

◆ Making sense of a variety of representations of data

Quick Images

Units 1–6 and 8–9 Math Focus Points

◆ Developing and analyzing visual images for quantities up to 10

◆ Recreating an arrangement of objects

◆ Finding the total of two or more single-digit quantities

◆ Developing visual images of, and language for describing, 2-D shapes

◆ Identifying names and attributes of 2-D shapes

◆ Finding the total of two or more equals groups

◆ Identifying and naming coins

◆ Developing fluency with the addition combinations that make 10

◆ Using known combinations (i.e. combinations that make 10) to combine numbers

◆ Using standard notation ($+, -, =$) to write equations

Tell a Story

Units 7–9 Math Focus Points

◆ Connecting standard notation ($+, -, =$) to the actions and relationships they represent

◆ Creating a story problem for a given expression

◆ Developing strategies for adding and subtracting small numbers

◆ Solving related problems

Quick Surveys

Units 5–7 and 9 Math Focus Points

◆ Collecting, counting, representing, describing, and comparing data

◆ Interpreting different representations of data including: pictures, bar graphs, tallies and Venn diagrams

NCTM Curriculum Focal Points and Connections

The set of three curriculum focal points and related connections for mathematics in Kindergarten follow. These topics are the recommended content emphases for this grade level. It is essential that these focal points be addressed in contexts that promote problem solving, reasoning, communication, making connections, and designing and analyzing representations.

Kindergarten Curriculum Focal Points	Investigations Units
Number and Operations: Representing, comparing, and ordering whole numbers and joining and separating sets Children use numbers, including written numerals, to represent quantities and to solve quantitative problems, such as counting objects in a set, creating a set with a given number of objects, comparing and ordering sets or numerals by using both cardinal and ordinal meanings, and modeling simple joining and separating situations with objects. They choose, combine, and apply effective strategies for answering quantitative questions, including quickly recognizing the number in a small set, counting and producing sets of given sizes, counting the number in combined sets, and counting backward.	**Addressed in the work of:** • *Counting and Comparing* (Measurement and the Number System 1) • *Measuring and Counting* (Measurement and the Number System 2) • *How Many Do You Have?* (Addition, Subtraction, and the Number System) • Classroom Routine: *Attendance* **Also supported in the work of:** • *Who Is in School Today?* (Classroom Routines and Materials) • *What Comes Next?* (Patterns and Functions) • *Sorting and Surveys* (Data Analysis) • Classroom Routine: *Today's Question, Calendar*
Geometry: Describing shapes and space Children interpret the physical world with geometric ideas (e.g., shape, orientation, spatial relations) and describe it with corresponding vocabulary. They identify, name, and describe a variety of shapes, such as squares, triangles, circles, rectangles, (regular) hexagons, and (isosceles) trapezoids presented in a variety of ways (e.g., with different sizes or orientations), as well as such three-dimensional shapes as spheres, cubes, and cylinders. They use basic shapes and spatial reasoning to model objects in their environment and to construct more complex shapes.	**Addressed in the work of:** • *What Comes Next?* (Patterns and Functions) • *Make a Shape, Build a Block* (2D and 3D Geometry) • Technology: *Shapes Software* **Also supported in the work of:** • *Who Is in School Today?* (Classroom Routines and Materials)
Measurement: Ordering objects by measurable attributes Children use measurable attributes, such as length or weight, to solve problems by comparing and ordering objects. They compare the lengths of two objects both directly (by comparing them with each other) and indirectly (by comparing both with a third object), and they order several objects according to length.	**Addressed in the work of:** • *Counting and Comparing* (Measurement and the Number System 1) • *Measuring and Counting* (Measurement and the Number System 2) **Also supported in the work of:** • Technology: *Shapes* Software

Connections to the Focal Points	Investigations Units
Data Analysis: Children sort objects and use one or more attributes to solve problems. For example, they might sort solids that roll easily from those that do not. Or they might collect data and use counting to answer such questions as, "What is our favorite snack?" They re-sort objects by using new attributes (e.g., after sorting solids according to which ones roll, they might re-sort the solids according to which ones stack easily).	**Addressed in the work of:** • *Who Is in School Today?* (Classroom Routines and Materials) • *Sorting and Surveys* (Data Analysis) • Classroom Routine: *Today's Question* **Also supported in the work of:** • *Make a Shape, Build a Block* (2-D and 3-D Geometry)
Geometry: Children integrate their understandings of geometry, measurement, and number. For example, they understand, discuss, and create simple navigational directions (e.g., "Walk forward 10 steps, turn right, and walk forward 5 steps").	**Addressed in the work of:** • *Make a Shape, Build a Block* (2-D and 3-D Geometry) • Technology: *Shapes 2* Software **Also supported in the work of:** • *Counting and Comparing* (Measurement and the Number System 1) • *Measuring and Counting* (Measurement and the Number System 2)
Algebra: Children identify, duplicate, and extend simple number patterns and sequential and growing patterns (e.g., patterns made with shapes) as preparation for creating rules that describe relationships.	**Addressed in the work of:** • *What Comes Next?* (Patterns and Functions) • Classroom Routine: *Patterns on the Pocket Chart* **Also supported in the work of:** • *Sorting and Surveys* (Data Analysis)

Each entry is identified by the Curriculum Unit number (in yellow) and its page number(s).

Grade K Curriculum Units

U1 Who Is in School Today?
U2 Counting and Comparing
U3 What Comes Next?
U4 Measuring and Counting
U5 Make a Shape, Build a Block
U6 How Many Do You Have?
U7 Sorting and Surveys

order and, U2: 11, 16–17, 53–54, 165–166; U4: 18, 77

quantities, U1: 10, 59, 66, 74, 80, 87–88, 101–104, 108, 113, 117, 122, 135, 142–143; U2: 11–12, 40–41, 48, 52, 56–59, 62, 72, 86, 89, 92, 119, 124, 131, 152, 167; U3: 132; U4: 171; U5: 74–75, 78, 82, 100, 108, 114, 120; U6: 12, 47–48, 71–73, 75–77, 81, 85, 92–94, 108, 113–114; U7: 107–108, 112, 120

quantities greater than 20, U7: 26–30, 32–33, 45–47, 51, 54–55

relationship to addition, U6: 13

by rote, U1: 48–49, 65–66, 70, 76, 83–86, 94, 98–99, 106, 115, 124, 127; U2: 10, 151; U4: 170–171; U6: 166

same quantities with different attributes, U3: 63–64

sets of objects, U2: 40–41, 48, 52, 56–59, 62, 72, 86, 89, 92, 119, 124, 131; U4: 18–19, 144–145, 151, 154, 155–156, 161

size of objects and, U2: 108–109, 111; U3: 132–133

story problems, U4: 96–98, 103, 111–112, 137, 152

strategies for
double-checking, U1: 98; U2: 50, 92–93, 97, 167

keeping track of what has been counted, U1: 11, 98, 135; U2: 10, 167; U4: 12–13, 59–61, 62–63, 67–69, 70, 72–74, 83–84, 90–94, 98, 107, 110, 114–115, 118, 137, 141; U6: 13, 72, 166

laying object and tool next to each other, U2: 169

move or touch objects you count, U1: 87, 98, 135; U2: 50, 167; U4: 75, 171; U6: 72–73, 76, 165

organizing the objects, U2: 11, 16–17, 50, 73, 108–109, 152, 167; U4: 171; U6: 73, 165; U7: 51–52

saying one number for each object, U1: 11, 87, 98, 135; U2: 10, 49–50; U4: 75, 171; U6: 72, 166; U7: 10, 25, 38

strategies for creating an equivalent set, U1: 88

two sets, U4: 14, 66–69, 74, 83, 98, 103, 105–107, 110, 115, 118, 119–120, 178–180

units of measurement, U4: 12–13

visualizing numbers, U2: 12, 57–59, 62, 72

by writing numbers, U2: 10, 44–45, 48, 52, 59, 62, 72, 152; U4: 171

Counting all strategy, U4: 69, 73, 77, 79, 83–84, 97, 119, 155, 174, 178–179, 182; U6: 75, 84, 88, 103, 108, 114, 116, 174

Counting back strategy, U4: 97, 174; U6: 116, 174

Counting backwards, U2: 92–93

Counting each object once strategy, U2: 10, 49–50

Counting on fingers strategy, U6: 103, 116

Counting on strategy, U4: 60, 69, 74, 77, 79, 174, 179; U6: 69, 75, 84, 103, 108, 114, 174–175

Counting up strategy. *See* Counting on strategy.

Cubes, U5: 110, 115, 143

Cylinders, U5: 94, 109–110, 131

D

Data
classifying, U7: 11, 144–145

collecting, U1: 12, 95–97, 113–114; U7: 10, 12, 25–26, 44–47, 55, 89–91, 103–104, 107, 116–117, 139–140

describing/interpreting, U1: 12, 95, 97–99, 117–119, 141; U7: 93

recording, U1: 12, 96–97, 114

representations of, U1: 12; U7: 10, 26–30, 116–117, 123–125

solving problems with, U7: 12, 44–47, 51, 54–55, 116–117, 120–121, 135–137

sorting, U7: 11

Days of the week, U1: 38, 44, 47, 58, 64, 82, 100, 110, 140

Decomposing numbers
combinations of 5, U6: 139–142, 179–181

combinations of 6, U6: 31–34, 37–40, 147, 156, 160–161

Describing
circles, U5: 30–32, 147–148

data, U1: 95, 97–99, 117–119

ovals, U5: 147–148

spheres, U5: 93–94

three-dimensional shapes, U5: 93–94, 100–103, 109–110, 150, 151

triangles, U5: 147

two-dimensional shapes, U5: 10, 30–32, 37–39, 148–149

Diamonds. *See also* Rhombuses. U5: 23–24

Different, U2: 12

Double-checking, U1: 33, 60, 98, 142–143; U2: 50, 67, 92–93, 167; U4: 129; U6: 75

Drawings, U1: 122

E

Eliminating doubles strategy, U4: 119

Equal, U2: 12, 129

Equals sign (=), U6: 114, 164

Equations, U6: 30, 38–39, 43, 44, 60, 114, 148, 156, 160–161, 163–164

Equilateral triangles, U5: 38

Equivalence, U2: 11; U4: 18

Estimation, U2: 34, 41, 72, 95–98, 107–108, 115, 119, 129–130, 136, 140, 146, 161–162; U4: 59–62

R

Reasoning, U6: 174–175
Recording
 addition, **U4:** 60–61, 62–63, 70, 74,
 101–102, 110, 115, 118, 176–177
 arrangements of 5 to 10, **U6:** 42, 45
 combinations of 5, **U6:** 183
 combinations of 6, **U4:** 131; **U6:** 36–37,
 144–145, 148–149, 153–154, 156,
 160–161
 data, **U1:** 95–97; **U7:** 49–50
 designs, **U1:** 128; **U5:** 46, 51
 lengths, **U4:** 34–36, 39–40, 42, 46,
 49–50, 63–64, 74
 measurements, **U6:** 80–81
 number composition, **U4:** 166–167
 numbers, **U1:** 101–104, 108, 113, 117,
 122–123, 142–143; **U4:** 77–79,
 83–84, 98, 103, 139–141, 145, 154;
 U6: 101–103, 107–108, 113, 117, 121,
 125, 130; **U7:** 35, 45–47, 51, 54–55
 purpose of, **U4:** 15
 quantities, **U3:** 37–38, 48, 62–64, 121,
 127, 132–133; **U5:** 74–75, 78, 82,
 114, 120; **U6:** 47–48, 71, 75–77,
 92–94, 103, 108, 113–114
 repeating patterns, **U3:** 71–73, 77–79,
 83–84, 88, 91–92, 93, 97, 105,
 135–137, 140, 145
 separation problems, **U6:** 124–125
 sets, **U4:** 36–37, 43, 46, 50, 83, 98, 103,
 136–137, 141, 145, 151, 154; **U7:** 34,
 47, 51–52, 54, 107–108, 112, 120
 story problems, **U6:** 120, 122,
 129–130, 131
 strategies for, **U3:** 71–72, 78, 87–88
 subtraction, **U6:** 116–117, 125
 survey responses, **U7:** 109–110,
 112–113, 132–134
 three-dimensional shapes, **U5:** 95
 units of repeating patterns,
 U3: 117–118, 120–121, 127, 130–131,
 140, 145
Rectangles, U5: 23–25, 30–32, 37,
 48, 135

Rectangular prisms, U1: 130–131;
 U5: 94–97, 109–110, 115, 143
Related problems, U4: 97, 103,
 173–175; **U6:** 103–104, 111–112,
 118, 171
Removal problems. *See also*
 Separating problems;
 Subtraction. **U6:** 116–117, 125
Repeating patterns
 associating with counting numbers,
 U3: 16
 body movement patterns, **U3:** 36–37,
 41, 46, 59, 96, 144
 comparing, **U3:** 48–49, 141–142,
 145–146, 157–158
 constructing, **U3:** 11, 42–43, 47,
 59–62, 67–69, 73, 86–88, 92, 97,
 105, 115–118, 120–122, 125–127,
 131, 135–137, 139–140, 145,
 153–154, 163–164
 copying, **U3:** 36, 41, 46, 59, 86–88, 92,
 96–97, 105
 describing, **U3:** 11, 36–37, 41, 46,
 48–49, 59, 71, 76, 81–82, 91–92,
 97, 105
 determining what comes next,
 U3: 11, 16–17, 36, 41, 44, 46, 49, 59,
 71, 76, 81–82, 96, 105–107,
 147–148, 161–162, 163–164
 extending, **U3:** 11, 36–37, 41, 46, 59,
 66–67, 71, 82, 96–97, 102, 104,
 122, 139, 144, 161–162
 identifying, **U3:** 10, 36–37, 41, 46, 59
 identifying the unit of, **U3:** 11,
 115–118, 120, 123, 125–127, 129,
 131, 135–137, 141–142, 144–145,
 147, 152–154
 nonrepeating arrangements vs.,
 U3: 41–44, 93–94, 141–142,
 155–156, 159–160
 one-two patterns, **U3:** 81–83, 88, 93,
 97, 105
 recording, **U3:** 11, 71–73, 83–84, 88,
 91–92, 97, 105
 sharing, **U3:** 106–107

Representations
 characteristic of Kindergarteners,
 U7: 123–125
 combinations of numbers,
 U6: 139–142, 152–154, 160–161,
 179–181
 of combining problems, **U6:** 120, 122
 of data, **U7:** 26–30, 39–42, 51–52,
 94, 116–117, 120–121, 126–127,
 132–134
 of increasing sets, **U4:** 61, 62–63,
 70, 74
 of numbers and quantities,
 U2: 12–13, 27–32, 36–37, 41, 48, 52,
 59, 62, 63, 157–159, 164
 purpose of, **U4:** 15
 of quantities on paper, **U1:** 10, 12,
 101–104, 108, 113, 117, 122–123,
 142–143; **U3:** 37–38, 48, 63–64, 121,
 127, 132–133
 of repeating patterns, **U3:** 71–73,
 77–79, 83–84, 88, 91–92, 93, 97,
 105, 135–137, 140, 145
 of sets, **U2:** 34, 41, 48, 66–70, 72, 86,
 89, 92, 98, 119, 161; **U6:** 47–48, 57,
 60, 71, 75–77, 92–94, 113–114;
 U7: 34, 47, 51–52, 54, 107–108, 120
 of subtraction, **U6:** 124–125, 126–127
 of unit of repeating pattern,
 U3: 117–118, 120–123, 127, 131,
 140, 145
Rhombuses, U1: 128; **U5:** 23–25, 30, 37,
 48, 70–72, 75, 83–84, 137

S

Same, U2: 12, 122
Saying one number for each object strategy, U1: 11, 87, 98, 135; U2: 10, 49–50, 73; U4: 75, 171; U6: 72, 166; U7: 10, 25
Scalene triangles, U5: 38
Separating problems. *See also* Subtraction. U6: 14, 18
 removing 1, U4: 101–102, 107, 110, 176–177
 with small numbers, U4: 90–94, 103, 107, 110, 114–115, 118, 137; U6: 116–117, 125
 story problems, U4: 13–14, 97–98, 103, 112, 137, 152, 172–175, 183; U6: 103, 111–112
 strategies for, U4: 97, 174–175
Sets, U2: 16; U4: 18–19
Shapes. *See also* Three-dimensional shapes; Two-dimensional shapes; *specific shape.* U5: 10–11
***Shapes* Software**
 classroom management, U5: 139
 composing/decomposing shapes, U5: 11
 Free Explore, U5: 34–37, 48, 52, 62, 119, 123, 126, 139–140
 introducing the software, U5: 11, 138
 mathematics in, U5: 141
 printing student work, U5: 140
 Quick Images , U5: 81–82, 100, 108, 114, 119, 123, 126, 130
 reference guide, U5: 34
 saving student work, U5: 37, 140
 Solving Puzzles, U5: 66–67, 75, 78, 83, 119, 123, 126
Short, U2: 160
Shorter, U2: 125–127, 160, 168–169
Shortest, U2: 131
Sides. *See* Faces of three-dimensional shapes.
Size, quantity and, U2: 63–64, 108–109, 111
Smaller, U2: 12, 108
Smallest, U2: 129
Solids. *See* Three-dimensional shapes; *specific type of three-dimensional shape.*

Sorting
 by attributes, U1: 13, 111–112, 117, 122, 136; U3: 10, 31, 33–34, 38, 48
 boxes, bottles, and cans, U7: 76–77, 78–80
 coats, U7: 141–142
 data, U7: 11, 92–95, 129–130
 people, U1: 107, 116, 121, 125; U7: 63–65
 repeating patterns, U3: 43
 self-portraits, U7: 67–68, 72, 78, 82, 87
 shapes, U7: 33–35, 47, 51
Special days, U1: 42, 44, 47, 58, 64, 82, 100, 110, 140
Spheres, U5: 93, 94–97, 109–110, 136, 150
Square prisms, U1: 130–131; U5: 143
Squares, U1: 128; U5: 23–25, 39, 48, 135, 137
Story contexts, U4: 172–173
Story problems
 acting it out, U4: 96–98, 103, 111–112, 137, 152, 182; U6: 14, 103–104, 111, 118, 120–121
 with addition, U4: 13–14, 96–98, 103, 111–112, 137, 152, 182; U6: 103–104, 111–112, 118, 120–122, 129–130, 172–173 174–175
 approaches to teaching, U4: 98
 comparing, U6: 104, 112,
 contexts of, U6: 170–171
 creating your own, U4: 172–173; U6: 170–171
 presentation of, U4: 174
 reasoning about operations, U4: 174–175, 183
 related problems, U6: 103–104, 111–112, 118, 171
 representations of solutions, U6: 14, 120–121, 124–125, 126–127
 strategies for, U4: 174, 182; U6: 103–104, 175
 structure of, U6: 171
 with subtraction, U4: 13–14, 96–98, 103, 111–112, 137, 152, 182; U6: 103–104, 111–112, 118, 124–125, 172–173, 174–175
 visualizing, U6: 14, 18, 103

Subtraction
 of 0, U6: 18–19
 of 1, U4: 14, 101–102, 107, 110, 115, 118, 176–177
 of 1, 2, or 3, U6: 84
 How many of each? problems, U6: 139–142, 152, 153–154, 156, 160–161, 180–182
 notation for, U6: 116
 related problems, U6: 111, 118
 relationship to addition, U4: 97, 103
 removal problems, U6: 124
 representations of, U6: 14, 126–127
 separating problems, U6: 103–104, 124–125
 with small numbers, U6: 116–117, 125
 story problems, U4: 13–14, 97–98, 103, 112, 137, 152, 172–175, 183; U6: 103–104, 111–112, 118, 124–125, 172–173, 174–175
 strategies for
 counting all, U4: 174; U6: 84, 116
 counting back, U4: 97, 174; U6: 103, 116, 175
 counting on, U6: 84
 counting on fingers, U6: 116
 counting what's left, U4: 97, 174
 "just knowing," U4: 97
 using addition combinations, U4: 174–175
 underlying assumption of, U6: 18
Survey questions, U1: 12, 95–97, 113–114
Surveys
 choosing questions for, U7: 12, 103, 104–105, 131
 interpreting data, U7: 112–113
 keeping track of responses, U7: 12, 104
 organizing results, U7: 11
 recording responses, U7: 109–110, 112, 132–134, 144–145
 sharing, U7: 112–113, 118
Symmetry, U1: 133

T

Tables
of data, U7: 52
of repeating patterns, U3: 16–17
Taller than, U2: 83, 168–169
Tally marks, U1: 142–143; U3: 64;
U6: 122, 183
Three-dimensional shapes. *See also*
Geoblocks; *specific type of three-dimensional shape.*
attributes of, U5: 99–100
comparing faces of different shapes,
U5: 16, 114–115, 122
comparing faces of same shapes,
U5: 114–115, 122
composing/decomposing,
U5: 122–123, 126, 130, 134
constructing, U5: 105, 106, 112–113,
119, 123–124, 126, 130, 133
describing, U5: 109–110
developing language to describe
and compare, U5: 130–131
matching faces of different shapes,
U5: 10, 107–108, 114–115, 124,
126, 130
matching faces to two-dimensional
outlines, U5: 10, 117–118, 123,
126, 130
relating to real world objects,
U5: 94, 109
Today's date, U1: 39, 120, 140
Trapezoids, U1: 128; U5: 70–72, 75,
83–84, 137
Triangles, U1: 128
attributes of, U5: 137
classifying, U5: 135
constructing, U5: 133
describing attributes, U5: 37–39,
133, 146
equilateral, U5: 38
isosceles, U5: 38
relating to real world objects,
U5: 23, 30, 37, 48
relationship to other two-
dimensional shapes, U5: 70–72,
75, 83–84
scalene, U5: 38
types of, U5: 38

Triangular prisms, U1: 130–131;
U5: 94, 109, 131, 143, 151
Triangular pyramids, U5: 136
Two-dimensional shapes. *See also
specific type of two-dimensional
shape.*
attributes of, U5: 16, 135
classifying, U5: 135
combining, U5: 46, 47–48, 62, 65–67,
72, 78, 83–84, 134
compared to three-dimensional
shapes, U5: 16
composing/decomposing,
U5: 70–72, 75, 78, 82–84, 134
constructing, U5: 41–42, 45, 47, 51,
62, 68, 133, 147–148
describing attributes, U5: 30–32,
37–39, 42–43, 147–148
naming and classifying, U5: 135
relating to real world objects,
U5: 23–25, 30, 37, 48, 51, 59–62,
78, 133, 145–146
relationship of shapes to each other,
U5: 70–72, 75, 78, 83–84

U

Units of measure, U4: 12
Units of repeating patterns
creating a pattern from, U3: 139
identifying, U3: 12, 16, 115–118,
120–121, 122–123, 127, 130–131,
142, 144, 145, 147, 152, 153–154
relationship of size to quantity,
U3: 141–142

V

Vertices, U5: 151

W

Weeks, U1: 38
Word patterns, U3: 36–37
Words, U7: 52
representing combining/separating
with, U6: 14, 75–77, 93–94
representing sets with, U6: 94
Writing numbers, U2: 44–45, 48, 52,
59, 62, 72, 152; U5: 95

Z

Zero, U2: 27, 102; U4: 144; U6: 18–19, 145